Art for Architecture
Moscow

Monumental Soviet Mosaics from 1925 to 1991

James Hill
Anna Petrova
Evgeniya Kudelina

With contributions by Anna Bronovitskaya

DOM
publishers

Contents

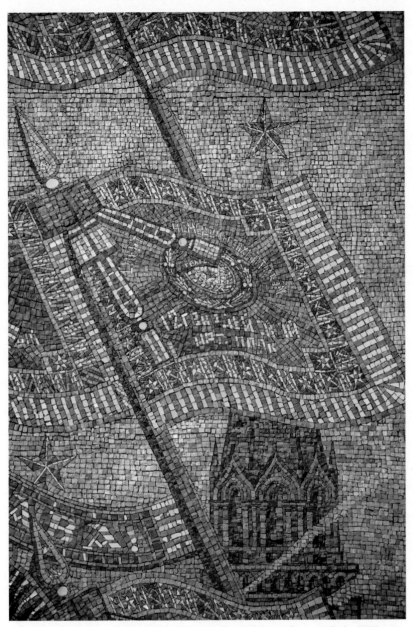

Rabinovich, I.M. 'Flags of victory', 1947. Baumanskaya metro station, vestibule. 007D

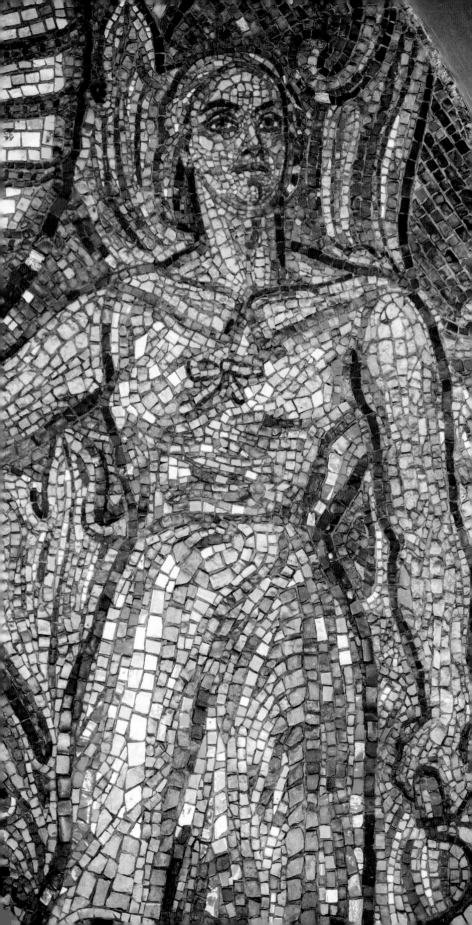

Moscow Mosaics –
Silent Monuments of Soviet Art

James Hill

When I left England and came to live in the Soviet Union in October 1991, just a few months before its official existence came to an end, I was immediately struck, in a visual sense, by how the streets were adorned with mosaics, bas-reliefs, and muscular statues.

Having never previously visited any communist countries in Eastern Europe, it was the extraordinary vividness of the mosaics that fascinated me most. Perhaps it was not a coincidence then that the first ones I saw were also the first mosaics displayed to the Soviet public in 1938: a series of 35 oval panels decorating the ceilings of Moscow's Mayakovskaya metro station. Designed by artist Alexander Deyneka, the panels depict '24 Hours in the Land of the Soviets' – moments imagined by the artist from the everyday lives of the citizens of this new nation, barely 20 years old. Their idealistic portrayal, far removed from the often torrid history of the 1930s in Russia, shows athletic or martial figures, drenched in both sunshine and innocence, as if shouting a last hurrah for the Russian avant-garde. 'Raise your heads, citizens, and see the sky in mosaics, bright and illuminated!' urged Deyneka. For the brightness of the mosaics, which still dazzle over 80 years later, Deyneka was largely indebted to Vladimir Frolov, who was one of the Tsarist era's most accomplished religious mosaic artists, for their fabrication, and who would tragically die of hunger a few years later during the siege of Leningrad.

When the war came, Deyneka would continue in this heroic vein, creating another set of mosaics portraying Soviet workers at Novokuznetskaya metro station. The designs are energetic and patriotic but more serious than those at Mayakovskaya. There is even a scene from a tractor factory in which male and female workers are dressed in blue dungarees – the women strangely not dissimilar in style to America's wartime icon, Rosie the Riveter.

It wasn't until after Stalin's death and the thaw ushered in by Khrushchev that mosaics began to widely appear all over Russia and the republics of the Soviet Union. Perceived largely as decorative elements of

Korin, P. D., 'The Worker and the Kolkhoz Woman', 1963. Paveletskaya metro station on the Circle Line, at the end wall of the underground hall. 040I

Polishchuk, L. G., Shcherbinina, S. I., 'Human healing', (1973)–1979.
Library of the 2nd Medical Institute. 090A

propaganda rather than artistic creations of individual merit, mosaics were created for all kinds of buildings from factories and schools to bus stops and swimming pools. They were practical – easy to clean and resistant to weather conditions when placed outside – and new factories producing mosaic pieces quickly made it simpler and less expensive to make them. These materials allowed for the mosaics to be made in almost any size and to any degree of complexity. They were pictorially adjusted according to the building they were intended to decorate, whether it was showing firemen rescuing a woman stranded in a tall building or workers standing next to looms at a textile factory.

There were of course many universally revered figures, particularly cosmonauts, whose unparalleled deeds – both of inspiration and in proving the prowess of the Soviet system – meant that their representations were placed everywhere from institutes to airports. Indeed, from the 1960s cosmonauts were the most common figures in mosaics, their depictions either based on Yuri Gagarin, the first man to travel into space, or Alexei Leonov, the first man to walk in space. A mosaic at the entrance to the Russian Meteorological Centre in Moscow shows Leonov parallel to the ground as if hanging to the edge of his spaceship as it spins around Earth.

The mosaics also transmitted other more subtle messages such as the role of women, a point that was made by portraying them to be the same height as men. The building designed by Rem Koolhaas at Moscow's new Garage Museum of Contemporary Art in Gorky Park was shaped around the shell

of a Soviet building that housed a restaurant called 'The Seasons of the Year' and a large mosaic depicting an elegant woman floating through a leafy park.

There is a strange sense of liberation in this image, which was started in 1968, and a whiff, though probably just a faint one, of the social upheaval shaking the world beyond the USSR that year. There is a mosaic from the early 1980s that is even more strident. It shows a woman wearing a yellow jumpsuit and high heels outside a women's fashion store in the east of Moscow, seemingly ready to put any *apparatchik* ('functional bureaucrat') in his place.

Today, as I walk around the Russian capital, I have the impression that Muscovites have become immune and impervious to these mosaics. Too many have already been removed as the buildings on which they stood have been torn down or redeveloped. Advertisements or shop signs sometimes obscure them. Simply finding many of them has been complicated by the fact that very little documentation remains from the time of their production. It is as if their existence in Soviet times was somehow natural but unremarkable, and today, as that era recedes into the distance, this sentiment appears to be even stronger. When I went to the Russian State University of Physical Education, I asked a student for directions to the large mosaic depicting an athletic relay team. He told me emphatically that there was no such mosaic. Alas, I walked around the corner and found it standing almost 30 metres in width. These photographs aim to help us not lose sight of these extraordinary objects that Deyneka instructed us to look at so intently.

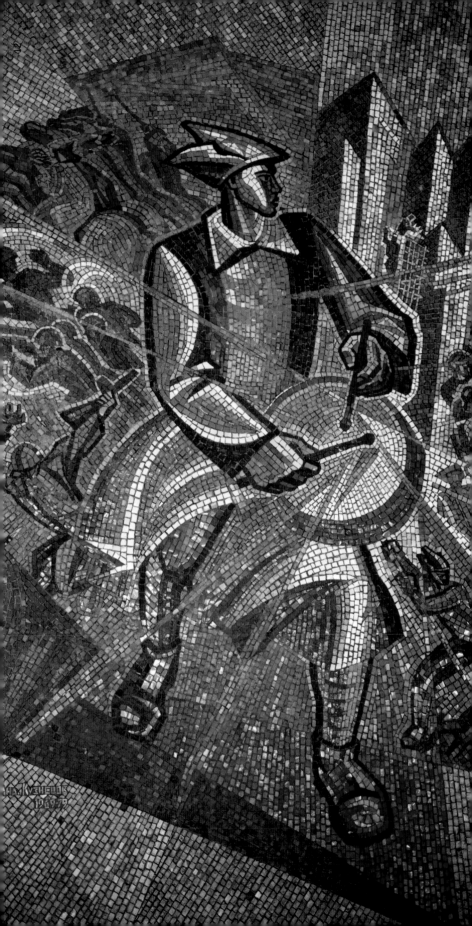

A Brief History of the Mosaic

Anna Bronovitskaya

Leaving aside instances from ancient times such as the patterns of ceramic cones 'imprinted' in the clay bodies of columns in Sumerian Ur, mosaics were invented by the Greeks. The Greeks made mosaics from white and black pebbles, laying out ornaments and thematic compositions on a floor covered with a binding material such as cement. The earliest surviving mosaics date from the fifth century BCE. In the Hellenistic era (third to first centuries BCE) coloured mosaics were sometimes made from stone broken into small cubes called 'tesserae', measuring 1–2 cm or sometimes even smaller. This is the form of mosaic that was adopted by the Romans, who began to use it on a larger scale. There were mosaic floors not just in palaces and the reception rooms of private houses, but also in public baths (thermae). In addition to floors, the Romans sometimes used mosaics to decorate the niches of small fountains set in walls (nymphaea) given that mosaics are not afraid of water.

The arrival of Christianity brought great changes. The vaults of Christian churches symbolise the sky and therefore require the most magnificent decoration. Following experiments using concrete as a base that would hold the tesserae fast, and with the mosaic material itself by replacing the natural stone with bright glass in different colours (smalt), the creators of Christian churches learned to attain truly celestial beauty in the sixth and seventh centuries. The tesserae were laid in a pattern and slightly unevenly on the surface so that they glinted in sunlight and twinkled in candlelight. It is a tragedy that most churches of that time were built in the Eastern Roman Empire (Byzantium), as the Western Roman Empire was being fought over by 'barbarians'. By the eighth century, Byzantium was in the grips of iconomachy (the campaign against holy images), and all mosaics previously created were destroyed

together with the icons. We can judge the character of the earlier mosaics from surviving works in the small city of Ravenna in northern Italy, which was the last capital of the dying Western Roman Empire, then belonged to Byzantium for a time, but had escaped from the latter's rule by the beginning of the iconomachy. The intensity and harmony of the colours and decorativeness and vitality of the Ravenna mosaics made them famous, especially at the end of the nineteenth century when the world of art learned to value these qualities once again. By the mid-ninth century, Byzantium had rejected iconomachy, which it declared a heresy, and once again began using mosaics to decorate churches. Not all churches, of course – only those considered the most important and those with rich patrons. Mosaic is a very expensive technique, and it became even more so when the use of a golden background became traditional; gold-coloured smalt was made by fusing real gold leaf into glass. In the ninth to twelfth centuries, churches with vaults covered with gold mosaics were also created on the borders of the Byzantine cultural world. The most famous churches featuring elaborate mosaic decorations are in Italy: the cathedral church of the Birth of the Virgin Mary in Monreale, Sicily (twelfth century), and St Mark's in Venice. Work on the mosaic decoration of the enormous St Mark's Basilica began at the end of the ninth century and continued until the end of the sixteenth. Some of the compositions are based on sketches designed by Jacopo Tintoretto, whose style left medieval Byzantium far behind. The surviving technology for making smalt and creating mosaics made it possible to cover the interior of the principal church in the Catholic world – St Peter's in Rome – with mosaic decoration. The architecture devised by Michelangelo clearly did not imply mosaic, but the papal curia considered it important to draw attention

Kuznetsov, A. N., 'Red Drummer', 1969. Krasnoselskaya metro station, vestibule. 073D

Myzin, A. V., in collaboration with others. Kievskaya metro station on the Circle Line, end wall of the underground hall, 1953. 030E

to the new cathedral's connection to early Christian basilicas in Rome, including Santa Maria Maggiore with its fifth-century mosaics and the Basilica di San Giovanni in Laterano, where the twelfth-century reconstruction involved the recreation of mosaics 'in the Byzantine style'. The process of creating the mosaics at St Peter's dragged on until 1800, just before the onset of historicism, a movement that took renewed interest in the mosaic technique. Indeed, it is another matter that by this time mosaic had become an expensive yet moisture- and time-resistant means of reproducing painting, thereby losing specific artistic qualities of its own.

In addition to traditional smalt mosaics, there is another type of mosaic that is important for our story: the Florentine mosaic. In ancient Rome this was known as opus sectile (individual, laminar mosaic). Essentially, this is similar to incrustation. Coloured stone is cut into thin wafers from which elements of an image are cut out; these wafers are then placed next to one another so closely that the boundaries between them are almost invisible. As the name itself suggests, the heyday of the Florentine mosaic was in Florence during the Renaissance when it caught the interest

of craftsmen as an analogue of marquetry, which is the technique for creating decorative images from precious types of wood. Florentine mosaic – so-called 'pietre dure' or 'hard stones' – was used in the creation of small decorative objects such as tabletops. However, we also know of instances of pietre dure being used in architectural decoration – at the Taj Mahal, for example. Shah Jahan brought in master craftsmen from Italy especially to decorate the mausoleum of his beloved wife. Decorative stone floors were also used in European churches and even palaces as the stone equivalent of patterned parquet.

Mosaic in Russia

For natives of what used to be the USSR, mosaics in urban settings are so familiar as to seem a natural and organic element of the local artistic tradition. In fact, in Kievan Rus', there were only two monuments in the eleventh to twelfth centuries that were worked on by Byzantine mosaicists and their Russian pupils: St Sophia's and St Michael's Golden-Domed Monastery, both in Kiev. The technique did not catch on and Russian churches were subsequently painted with frescoes. For all their

Orlov S. M., in collaboration with others. 'Maidens with Laurel Wreaths', 1954. Pavilion of the Ukrainian Soviet Socialist Republic (No. 58, 'Agriculture'). 014A

importance for the Russian cultural myth, Mikhail Lomonosov's experiments with mosaics remained an isolated episode in the mid-eighteenth century.

A renewed level of global interest in mosaics came in the historicist epoch, with increased attention being paid to the decorative surface of the wall and, as a result, the Byzantine legacy. From the mid-nineteenth century, albums kept by travellers in Italy invariably contained sketches of the mosaics in Ravenna and at St Mark's in Venice. At the same time, the restoration of the mosaics in St Mark's – itself highly controversial due to deviations from the originals – drew attention to this forgotten art form and helped the technology develop. The mosaic made a comeback in Russia following its use in decorating the interiors of St Isaac's Cathedral. When construction of the cathedral was complete, it emerged that in the St Petersburg climate, the damp inside such an enormous building would be an insuperable problem. There were fears that the paintings could not survive for long under such conditions. Montferrand, the cathedral's architect, proposed using mosaics. He had spent time in Venice and returned to Italy at the beginning of the 1840s intent on finding a solution for the interior of his

Korin, P. D., Lomonosov Moscow State University (MGU). Principal building, conference hall, stage, (1951)–1953. 021H

principal work in St Petersburg. On a visit to Rome in 1846, Emperor Nicholas I examined the mosaics on the vaults of St Peter's and approved a solution, suggesting an affinity between the main cathedrals of the Russian Empire and the Catholic world. In 1851 a mosaic workshop was established at the Imperial Academy of Arts with the help of Italian technologists and Russian artists who had trained in Rome. The smalt was bought in Italy, but Russians also started to produce it themselves, gradually expanding the range of colours. The idea was to gradually replace the cathedral's entire series of paintings; however, the traditional mosaic-making process was so time-consuming that the project was far from finished by the time of the revolution, and the reserves of smalt were still being used in the early 1950s.

The extreme labour-intensiveness and costliness of production could have stopped the spread of mosaics, but the nineteenth century was not to be deterred by such difficulties. The Venetian Antonio Salviati devised the indirect mosaic method in the 1860s. This simplified the process considerably. Instead of pressing the pieces of smalt into a surface covered with a binding cement, the pieces were laid out on painted card, their reverse sides were covered with resin, and they were then transferred to the wall. The St Petersburg Academy of Arts expressed interest in the new method and Aleksandr Frolov, an employee in the mosaic workshop, was sent to Italy in 1888 to find out more about it. He returned full of enthusiasm, but in the end the academy rejected 'Venetian composition' because it necessitated grout lines that are visible to the eye and made it impossible to create illusory copies of the paintings, which was the academy's goal. Frolov, on the other hand, believed that mosaic has its own decorative language that ideal evenness can only impede. He went on to establish his own workshop in 1890.

That this was the right moment to develop mosaic-making in Russia was confirmed

Ryleeva, Z. V., Emblem of the Ukrainian SSR, 1954. Pavilion of the Ukrainian Soviet Socialist Republic (No. 58, 'Agriculture').
014A

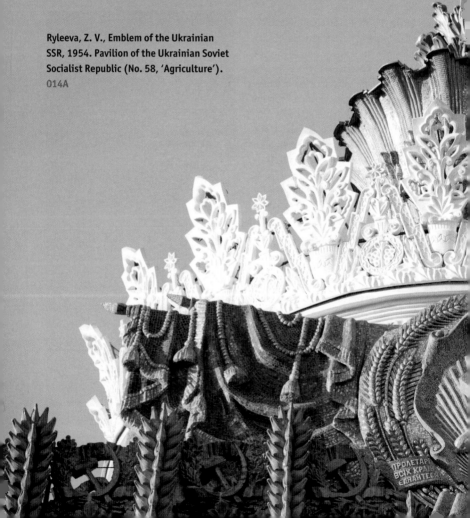

by the restoration of Kievan mosaics completed in the 1890s and by the simultaneous work carried out decorating the Church of Vladimir, also in Kiev. Mikhail Nesterov and Mikhail Vrubel, who both took part in this project, were sent by Adrian Prakhov, the art historian in charge of the project, to Venice and Ravenna specially in order to imbibe the Byzantine spirit and understand how real mosaics should look. Vrubel made no use of this experience; Nesterov, on the other hand, contributed significantly to the revival of Russian mosaics.

It was the Frolov family business, which in 1890 was headed by the founder's younger brother, Vladimir, that brought the art of the mosaic into the new age. The largest project of the turn of the century – the mosaic decoration of the Church of the Resurrection of Christ ('Our Saviour on the Blood'; 1895–1907) in St Petersburg – reaffirmed the leadership of the Frolovs' workshop. From then on, the workshop produced mosaics for Russian Orthodox churches in

various cities within the Russian Empire and beyond. When the additional decorativeness of art nouveau created a need for mosaics on the walls of civic buildings, Vladimir Frolov was ready to respond to this challenge. Indeed, he was the man invited by Fedor Shekhtel to execute the frieze on the Ryabushinsky mansion (1902). However, there was another Moscow commission that would be of greater significance for the future: the mosaic for Pokrovsky Cathedral at the Martha and Mary Convent (1912). Here the mosaicist Vladimir Frolov met the architect Aleksey Shchusev and artists Mikhail Nesterov and Pavel Korin.

The fate of monumental art after the revolution

Mosaics were no longer needed after the revolution. They were too conspicuously linked to the church and, more importantly, they were expensive. Moreover, the new style of architecture rejected decoration

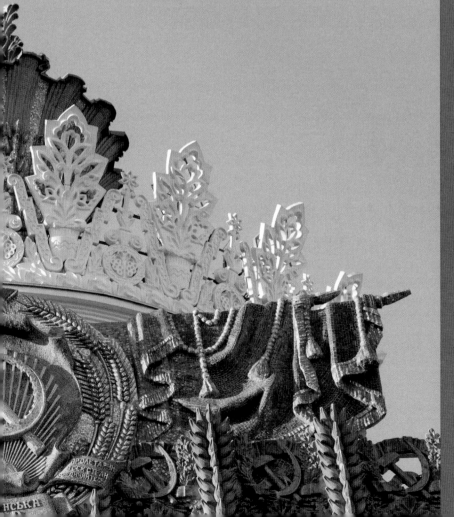

as a matter of principle: Soviet architects shared the conviction of their Austrian colleague Adolf Loos that ornamentation is akin to crime. The new age, being very agile, had a clear preference for temporary installations dealing with the issues of the day. Lenin took the idea of monumental propaganda from Tommaso Campanella and rejected frescoes as being unsuited to our climate; nevertheless, even if he opted instead for statues and reliefs, he gave sculptors the chance to work with temporary materials. This was probably deliberate: during the first years following the revolution it was first necessary to ensure that artists did not die of hunger, and this justified saving on materials; secondly, the ephemerality of artistic interventions provided a chance to develop a language that would be acceptable to the new regime and, more importantly, to determine the content of propaganda beyond the scope of the slogans of the moment. Even inexpensive polychrome ceramics found themselves superfluous to requirements, with the exception of Sergey Konenkov's 'In Memory of the Fallen' plaque on the wall of the Kremlin.

Frolov's private workshop and the mosaic workshop of the Academy of Arts were both closed, partly due to the energetic intervention of Vladimir Tatlin. Chaos reigned in the mosaic workshop by the mid-1920s; mosaics created for St Isaac's Cathedral were cast out into the courtyard. It was only after 1925 that Eduard Essen, the academy's rector, heeded Vladimir Frolov's request and tasked him with restoring order, which in turn led to the reserves of smalt being saved. By this time people had realised that smalt and mosaicists might still prove useful, even if only for the purpose of restoration.[1]

Soviet architecture first found a need for mosaics in 1929, but for the most iconic of reasons: the frieze of red standards in the mourning room of the Lenin Mausoleum. While designing a lasting masonry mausoleum to replace the existing wooden one, Shchusev wanted to incorporate mosaics into the interior. It was not for nothing that he had once lovingly painted watercolours of the interior of the Baptistery in Ravenna. Naturally, he entrusted the manufacture of the mosaic banners to a craftsman he knew well: Vladimir Frolov. The deep-red smalt

was taken from the Academy of Arts. Simultaneously resembling both the *polotentsa* ('wooden carvings') decorating ancient Russian cathedrals and Natan Altman's decoration of Palace Square for the first anniversary of the revolution, the flat, entirely conventional frieze showed that mosaic was by no means tied to a particular style. The general attitude to monumental art began to change at this time. Diego Rivera visited Moscow in 1927 and gave several lectures demonstrating the potential of frescoes as a medium for communist propaganda. Rivera became one of the founders of the Oktyabr artistic association in June 1928. Among those who joined the association was Alexander Deyneka, who was 'tired of easel painting'. The association's declaration was published in Pravda and stated: 'Consciously taking part in the proletariat's ideological class war against the forces that are hostile to it and in the convergence between peasants and nationalities and the proletariat, the spatial arts should serve the proletariat and the masses of workers that follow the proletariat in two fields that are indivisibly linked to one another: in the field of ideological propaganda (through pictures, frescoes, typography, sculptures, photos, film, etc.); and in the field of production and organisation of collective living itself (through architecture, the industrial arts, design of mass festivities, etc.).'[2] Alas, an emphasis on ideology was not enough to save 'Oktyabr' from the general fate of art associations, which were abolished in 1932 and replaced with single creative unions. However, the emphasis on narrative and monumental forms was now clear. It is notable that this shift also occurred in parallel in countries that were the ideological opponents of the USSR. Art deco architecture made willing use of figurative panels executed in a variety of media, and during the Great Depression the American government initiated a monumental artistic programme entitled the 'Public Works of Art Project' as part of its efforts to provide work for artists and improve the morale of the people. Participants in the project were largely under the influence of Diego Rivera and created artworks that were exceptionally similar to the socialist realism that was then taking shape in the USSR.

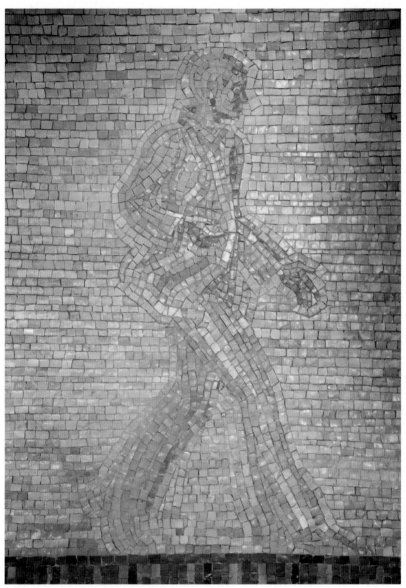

Bobyl, Y. P., Litvinova, L. V. , 'Festivity', 1977.
Palace of Culture of the '50th Anniversary of the USSR' Automatic Lines Factory, foyer. 109A

The Palace of Soviets and the revival of mosaic-making

With its symmetry and magnificent polished stone, the Lenin Mausoleum was a step away from avant-garde and towards art deco, but the true break came several years later when work began on the mega project of the age: the Palace of Soviets. Constructivism, which had eschewed décor, was now declared to be bourgeois formalism unworthy of Soviet men. Soviet architecture needed to absorb all the attainments of the past and embody synthesis of the arts on a new level. Monumental art was once again relevant. Alexander Deyneka wrote in 1934: 'We have no Soviet frescoes. And those that have already been made bear the unmistakable mark of contingency, a lack of practice ... The main and fundamental thing we learn when studying Renaissance frescoes and Russian church painting is the organic nature of the relationship between the image and the architecture. The artist helped expand the scale of the interior (making it deeper or higher) through images that are tantamount to architecture. Through the artist, the architect

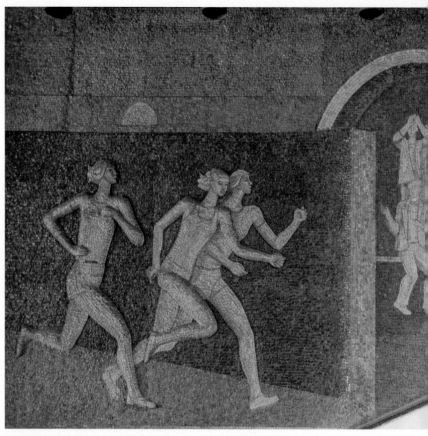

Kapustin, V. V. Krylya Sovetov Palace of Sport, (1977)–1981. 104A

achieved his objective, using colour to attain palatial magnificence and pomposity, for instance. ... Moscow is becoming a model proletarian capital city, and all the buildings that we erect have to be beautiful first and foremost ... Clubs, libraries, and sports halls need images that will memorialise our cultural attainments for a long time to come.'[3] Curiously, when speaking about the need to find and master materials for exterior 'frescoes', Deyneka lists coloured stone, graphite, and majolica, but does not mention smalt. This idea came to others. The principal building of the USSR needed to surpass all possible rivals, including American skyscrapers, and not just in height, but also in the magnificence of its finishes. The planners and designers of the Palace of Soviets paid close attention to what was happening in other countries, particularly to the most ambitious high-rise building from those years, such as the Rockefeller Centre in New York, where many forms of decorative art were used, including mosaic: a large frieze entitled 'Intelligence

Awakening Mankind' was installed in the vestibule of one of the centre's buildings in 1933.[4] Following the closing of the architectural competition in 1933, specialised workshops were established at the Office for Construction of the Palace of Soviets (UPDS) to develop ceramic facing, decorative fabrics, furniture, etc. However, the Mosaic Workshop of the Academy of Arts reopened in 1934. Its head was, of course, Vladimir Frolov and the workshop was officially transferred to the UPDS in 1938.

The third five-year plan (1938–1942) stipulated the establishment of sufficient production capacity to create the artistic decoration required for the Palace of Soviets and indeed other emblematic architectural structures. 'The creation of such bases is a major objective because, in addition to Izokombinat and a number of artistic workshops in Leningrad, we have republican centres and individual towns and cities all over the Union with the teams of the capable, knowledgeable craftsmen that we need. The task at hand for the coming years

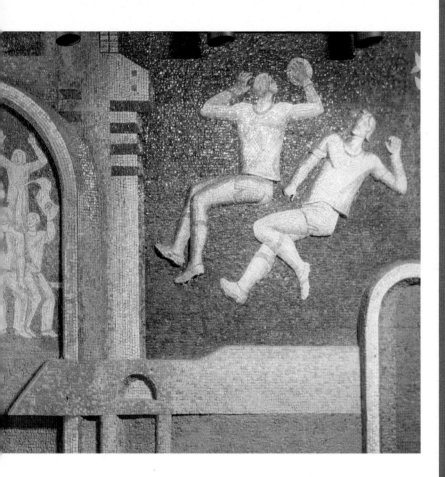

is to facilitate their work in the direction required for the construction of the Palace of Soviets and to train them to carry out the upcoming tasks ... All objects of artistic decoration should conform to the ideological content of the Palace and bear the mark of great artistic taste.'[5] This work was interrupted by the war, but it did not cease. It continued in new forms, even after the resolution of 1955 'on eliminating superfluity in design and construction', which fundamentally changed Soviet architecture and monumental art at the same time.

It was estimated in advance that the volume of mosaic decoration at the Palace of Soviets would be 3,800 square metres. A competition was held in 1939 to design two panels in the main vestibule, each of which was supposed to have an area of 690 square metres, and there was even talk of a panel with an area of between 5,000 and 7,000 square metres. To this end, it was necessary to establish the production of smalt, train craftsmen, and confirm what they were capable of in practice. A mosaic

workshop managed by Pavel Korin was established in Moscow in 1940, but it was not possible for production at the workshop to get underway before the war and the process of developing sketches for the Palace of Soviets dragged on until 1947, when it finally turned out that they were not required. The Palace of Soviets remained a phantom, but uses were found for the finishing techniques that had been devised with it in mind. In the case of mosaics, this predominantly meant at stations on the Moscow metro system, where the dampness was no less a threat to painted works of art than at St Isaac's Cathedral.

Mosaics in Stalin's metro

The stations on Moscow's first metro line, which began running in 1935, were designed entirely architecturally; the only additional piece of decoration was a polychrome ceramic panel by Evgeny Lansere at the entrance to Komsomolskaya metro station. Various forms of 'synthesis of the arts'

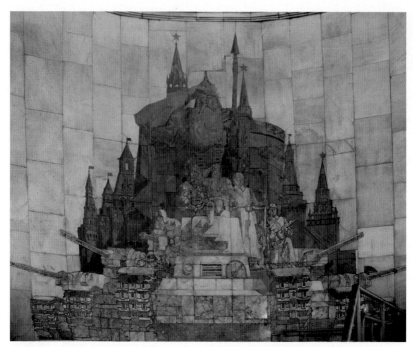

Bordichenko, V. F., Lekht, F. K., Pokrovsky, B. V. 'Heroes' ('Parade on Red Square'), (1940)–1943. Avtozavodskaya metro station, vestibule. 003I

were attempted at different stations during the second phase of construction. These included an in-the-round bronze sculpture at Ploshchad Revolyutsii metro station, porcelain bas reliefs at Dinamo, and smalt mosaics at Mayakovskaya.

Aleksey Dushkin tells the story of the creation of these mosaics in his memoirs. To begin, he decided to break up the station's single vault into sections divided by arches. Within these arches, he wanted to create oval, light-producing domes with mosaic medallions inside. The idea of making the sky the background for all the mosaics was suggested by the desire not only to overcome the unpleasant feeling of being underground, but also to connect the station's image with Mayakovsky, whose name was given to the square above the station in 1935. Dushkin remembered the lines 'Above me the sky. Blue silk!' and got the idea for a series of mosaics entitled 'A Day in the Life of the Country of the Soviets', which would play on motifs taken from the poetry of Mayakovsky. Dushkin consulted with the master-mosaicist Vladimir Frolov to choose an artist capable of combining the ancient mosaic technique with images depicting modernity.[6] Alexander Deyneka was chosen. Deyneka had recently returned from a

lengthy business trip to the US, France, and Italy, where he got to know the latest tendencies in monumental painting, including mosaics, and he had also seen with his own eyes ancient-classical mosaics in museums and early medieval mosaics in Rome. The mosaic technique, which implies a certain amount of artificiality, was to serve as protection from accusations of formalism such as had been levelled against Deyneka despite the fact that he was the artist behind a large painted panel in the USSR pavilion at the World Expo in Paris in 1937. The artistic success enjoyed by Deyneka's ceiling pieces, which were modern and contained no hint of church painting, determined the fate of mosaics in the Moscow metro system, although Deyneka himself remained extremely dissatisfied with his collaboration with Dushkin. 'The architect fragmented the domes,' he wrote, 'and made them excessively deep, with a double dome; the result is that the mosaics, concealed by the first dome, are hidden from the viewers. Their dimensions are in every case too small for the height at which they are suspended. It's almost the case that they are visible only when you're looking vertically upwards at them. This is a major and irremediable mistake. The number of mosaics is enormous:

Unknown artist, 1970s (?).
Institute for Research into Remote Radio Communications (NII DAR). 112A

35. Looking at them is difficult enough, and then there are so many of them. Naturally, all this is tiring for the viewer.'[7]

Nevertheless, at the beginning of 1939 the *Stroitelstvo Moskvy* ('Building Moscow') journal wrote: 'Many authors introduce painted panels into the decoration of vaults and walls or propose various types of coloured plaster, wall painting, etc. However, the techniques of painting are difficult to use in the conditions that exist in the metro system. We consider it far more interesting to look at the experience of Mayakovskaya station, where use has been made of mosaic made from smalt (coloured fused glass). This material is impermeable to water, long-lasting, and has a great variety of chromatic shades offering plentiful scope for the realisation of any artistic idea.'[8] Deyneka's choice to use unpolished mosaic, an approach that makes the facets of the pieces of smalt (tesserae) glint in various directions and create an impression of radiance, was deemed successful.

Phase three station design saw smalt mosaics incorporated into the interior-design projects for the underground halls – not just those designed by Aleksey Dushkin at Zavod imeni Stalina (now Avtozavodskaya), but also those by Viktor and Aleksandr

Vesnin at Donbasskaya (now Paveletskaya; this station was built according to a different design in the end). The Vesnins took into account the lessons that were learned at Mayakovskaya metro station, where the mosaics can only be seen if you deliberately tilt your head back. The mosaic panels are larger and placed in the surface of the vaulting, but a 1939 sketch for them makes it clear that mosaic is interpreted as a rupture in space here. Alexander Deyneka, who the architects invited to work alongside them, had recourse in his interpretation of industrial scenes to the techniques of the Italian baroque: the architectural volumes are heavily foreshortened, and the point of convergence is usually situated in the centre of the composition. Dushkin, on the other hand, wanted to use his first competition project to 'cut' a duct containing lighting into the entire length of the vaulting, with the surface of the duct being filled with mosaic. In his sketch we can make out a sky containing airplanes, airships, and parachutes – as at Mayakovskaya.

Nothing worked out as intended. The station was not completed before the war. Work on the mosaics for Paveletskaya – 14 octagonal panels with an area of 7 square metres each on the subject of the

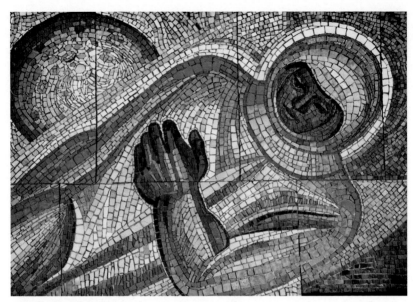

Korolev, Y. K. 'My Motherland' ('Russia'), (1966)–1971. Moscow Central Bus Station. 076A

Moscow–Donbass main railway line – began in 1940 and proceeded with considerable difficulty as the artist and mosaicists were in different cities and, even more importantly, there was a shortage of smalt in the workshop. Frolov had to ask Deyneka not to make the backgrounds monochrome because it was impossible to find so much smalt in a single colour.[9] Nevertheless, despite common belief, all of the panels for Paveletskaya were completed and brought to Moscow before the siege of Leningrad began. The mosaic pattern was made fast in light resin and set in concrete in Frolov's workshop at the Academy of Arts before being put in place in Moscow in the mosaic workshop of Metrostroy's Marble Factory, which mainly produced marble finishes for stations and other stately interiors, including Florentine mosaics made from stone. This factory was located in Dorogomilovo, roughly where the high-rise Ukraina Hotel was later built. Deyneka's memoirs shed light on how this work proceeded during the first months of the war: '... somewhere in the factory's yard the master craftsmen and I would cast the octagons. Every day at 11 in the evening they would begin bombing. When the morning came, we would begin doing our stuff all over again. The administration ordered us to swiftly remove the mosaics from the yard out of fear that the gold might glint and draw the enemy's attention. A powerful crane would lower the patterns of smalt, which had been placed in cement, into pits ...'[10] Construction of the metro was interrupted when the enemy drew close to Moscow and it did not begin again until the spring of 1942. It proved impossible to complete Paveletskaya station in accordance with the design project because the metal structures intended for it remained in occupied Dnepropetrovsk. Ivan Taranov, the architect of neighbouring Novokuznetskaya station, decided to use Deyneka's and Frolov's mosaics in his interior-design project, but was able to find room only for seven panels – six on the ceiling of the central hall and one in the vestibule. Nadezhda Bykova, Taranov's wife and co-author, thought the mosaics made the light vaulting, which was divided by grotesque moulding, seem too ponderous, but the station's look was nevertheless a success. Sadly, the other seven mosaic panels were lost. It is possible they are still lying underground somewhere near the hotel, which is now the Radisson Royal, although they may very well have been destroyed by chance during the construction work.

Although drained by the siege, mosaics were still being made in Leningrad for another station: Zavod imeni Stalina (now Avtozavodskaya). Vladimir Frolov worked on them in the final weeks of his life before he died of hunger on 2 February 1942.

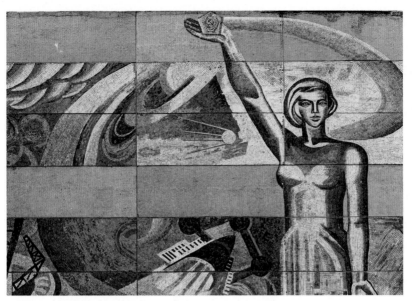

Gulov, V. I., Kazakov, B. I., Skripkov, Y. N. Ter-Grigoryan, S. L. 'Science', 1967.
Institute for Research Sapfir. 053A

Aleksey Dushkin, who became this station's architect again in late 1941, simplified the load-bearing structure, making the ceiling structure almost flat, and stretched eight mosaic panels in a non-continuous frieze over the trackside walls. The theme is an ideal example of socialist realism: scenes of the Soviet people at work during the years of the Great Fatherland War. However, these scenes have been elaborated with such delicacy that we sense a link with the art of symbolism. According to Dushkin, the authors were consulted by Evgeny Lansere, who had been a member of Mir iskusstva when they were designing the cartoons. During discussions about the sketches, the name Puvis de Chavannes was mentioned.[11] Artists Vasily Bordichenko, Boris Pokrovsky, and Fridrikh Lekht took care to ensure the images did not disrupt the planes of the wall and that the lines were fluid. A restrained colour palette was chosen – probably to make the image more coherent and hint at the fuggy atmosphere of the workshops. However, this turned out to be a mistake in the end: the images on the mosaics at Avtozavodskaya are quite difficult to make out. Nevertheless, it was a feat of great heroism that the exhausted craftsmen were able to create these mosaics in unheated and unlit workshops and have them transported over the Road of Life ice route over the frozen Lake Ladoga.

The second half of the 1940s brought a conspicuous change in the style of smalt mosaics. The short-lived improvement of relations with the Orthodox Church during the war years permitted more open citation of the motifs of church architecture and decoration. It was Aleksey Shchusev who exploited this most brilliantly in his final work: Komsomolskaya metro station on the Circle Line. In powerful, Rostov-Baroque cartouches on the axis of the high arch of the underground hall, Shchusev placed eight panels on the subject of the glory of Russian arms. The artist of the mosaic was Pavel Korin, who had begun his professional career as an icon painter. He had worked with Mikhail Nesterov to paint the cathedral of the Martha and Mary Convent, which Shchusev had designed, and then the tomb of Grand Duchess Elizaveta Fedorovna. Beginning his series of Russian generals with Aleksandr Nevsky and ending with Stalin, Korin gave them all the appearance of sacred warriors. He reinforced this association with golden backgrounds and flattened space and volumes. It is thought that Korin's well-proportioned images of horses benefitted from his training in Palekh craftsmanship. He was very familiar with the mosaics in the Cathedral of St Sophia as well as those at St Mikhail's Golden-Domed Monastery in Kiev. He had visited Kiev in 1934 when Vladimir Frolov was supervising

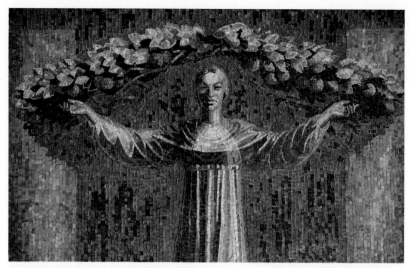

Unknown artist, 1976 (1983). Moscow State Institute of International Relations (MGIMO), conference hall. 105A

the removal and restoration of mosaics from the walls of the monastery, which was being demolished, and again in 1948 in connection with the restoration of the paintings in the Cathedral of St Vladimir. Shchusev had also refreshed his memories of the mosaics in Kiev very recently when he took part in restoring the city destroyed by war. For both Shchusev and Korin it was natural to join contradictory episodes in Russian history to make a unified sacral line. Not everyone found this approach successful. Alexander Deyneka was indignant: 'It is all the sadder when Soviet practice has seen the emergence of golden heavens – precisely heavens – rather than an abstract background in gold, as at St Sophia in Kiev. And it is absurd to see how a real landscape with people is embellished with golden heavens and clouds. The gold jars with the real painted setting, giving rise to decorative tastelessness.'[12] Korin thought nothing of such criticism. After devoting many years to the monumental painting that at Gorky's suggestion he called 'Departing Rus', it did not prevent him from picking up the 1940 commission for a gigantic mosaic panel entitled 'March into the Future' for the Palace of Soviets. It is no less symbolic that neither of these super-works was realised, although this did not harm their artist in any way. Shchusev did not live to see the opening of Komsomolskaya station. The images of Stalin and Beria soon disappeared from the mosaics too, unlike the banner

with 'the icon of Christ not made by human hand'. Korin meanwhile was awarded the USSR State Prize in 1954 for his mosaics at Komsomolskaya and elected a correspondent member of the USSR Academy of Arts at the same time, guaranteeing him – the lamenter of 'Departing Rus' – considerable privileges until the end of his long life. Deyneka, on the other hand, was relegated to the slow lane for a time following fresh accusations of 'formalism'. It is true that his foreshortened compositions owed a great deal to both Rodchenko and Dziga Vertov. You would search in vain for precedents in the national soil-oriented tradition of the *pochvenniki*. The triumphal pomp of the official culture of the post-war years made it possible to reference not just to ancient Rus, but also the Russian Empire style. At Komsomolskaya-Ring metro station, above the columns are 'triumphs' depicting various types of weapons. These were executed in gold mosaic not by Korin, but rather by S. M. Kazakov and A. M. Sergeev. The triumphal compositions glorifying victors are more extensive thanks to the help of symbols that have been sanctified by the centuries, including wreaths, cartouches, standards, palm branches, ears of wheat, and rays of light (including the Soviet red star in this series seems utterly organic). Korin too made skilful use of this vocabulary when he embellished the rotunda of the upper vestibule of Arbatskaya station on the Arbatsko-Pokrovskaya line with a

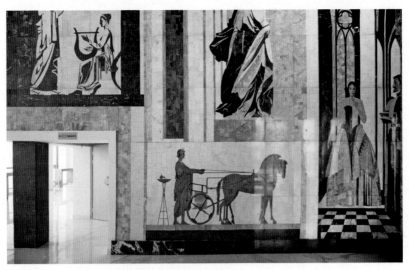

Zamkov, V. K. 'Culture, Art, Theatre', 1980.
The Cultural Centre at the Olympic Village , foyer. 087A

mosaic frieze and created the panel on the end wall of Novoslobodskaya station. It is possible that his aim here was to lighten the burden of the official propaganda on the beautiful stained glass made to his designs. The grandiloquent composition is softened somewhat by a private joke: Korin used Tamara Dushkina as his model for the image of the beautiful mother holding up her baby to the medallion with the profile of Stalin and he gave to the baby the features of her husband, Aleksey Dushkin – the station's architect. As was the case elsewhere, Stalin disappeared from the medallion at the beginning of the 1960s; his place was taken by soaring white doves.

The increased weight given to church associations in the architecture of post-war stations in the Moscow metro system and the repeated use of the motif of the triumphal arch led to the creation of decorative and symbolic compositions that were reminiscent even of early-Christian and ancient-classical painting. Such is the mosaic that in 1947 embellished the arch above the escalators at Baumanskaya station (the station itself was designed by Boris Iofan and opened in 1944). Isaak Rabinovich, a professor at the Faculty of Painting at Vkhutein (1926–1930), was hired by Iofan in the 1930s to work at the artistic workshop for the Palace of Soviets. He was a theatre designer by profession and designed the escalator tunnel leading down into Baumanskaya metro station as a solemn

theatre curtain 'sewn' from a large number of standards and fastened in the centre by the Order of Victory. Pompously called 'Stalin's Plan for Transforming Nature', the frieze is a colourful garland against a delicate landscape background that you could easily imagine decorating the interior of the Baptistry in Ravenna or a sumptuous Roman villa. The convergence of mosaic and textiles – something that also goes back to the architecture of Ravenna – can also be found in the above-ground vestibule of Dobryninskaya station, though the results here are far less convincing. The three mosaic carpets (designed by artists Georgy Rublev and Boris Iordansky) appeared against the wishes of the station's author, Leonid Pavlov. Without them the project would not have been approved by the chief architect of Moscow, Karo Alabyan. The mosaics introduced into the austere space of the metro station a stylistically alien luxury. On the other hand, the right-hand carpet became one of the most interesting instances of de-Stalinisation. In 1963 the portrait of Stalin on a streamer in the mosaic depicting a demonstration was replaced with a portrait of Gagarin, who journeyed into space some 11 years after the station opened.

The general direction of Soviet art during the post-Stalin years tended towards banal academicism of a kind that was a poor fit with the smalt-mosaic technique. The best thing that can be said about the mosaics

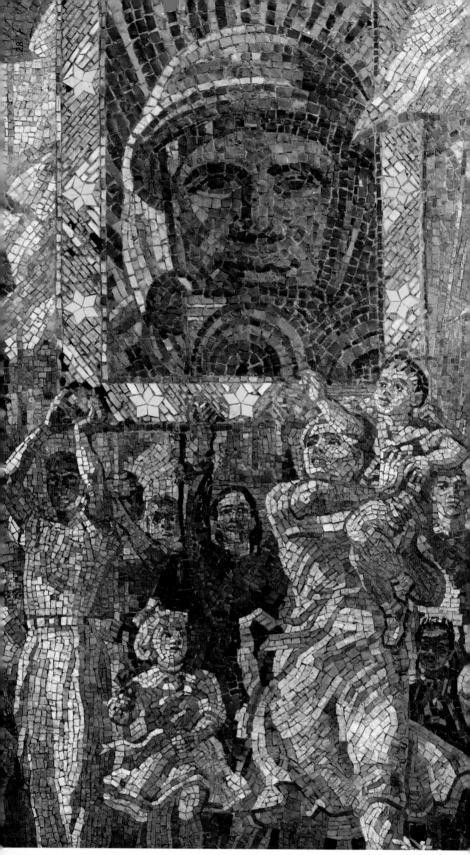

Rublev, G. I., Iordansky, B. V. 'Workers Parade'.
Dobryninskaya metro station, vestibule, 1951. 028I

in the underground hall of Kievskaya-Ring station, for example, is that they are chromatically joyous. The young mosaicists Tamara Shilovskaya and Boris Chernyshev, who helped Korin at Komsomolskaya and were later transferred to Kievskaya station (artists: Aleksandr Ivanov, A. V. Myzin, 1954), simply abandoned this project, having no wish to tolerate conventional socialist realism.[13]

Florentine episodes

The mosaic decoration in the Moscow metro is not limited to smalt mosaics. In addition to the latter, Florentine mosaic was also used in the metro as at other representative buildings. These mosaics were assembled from pieces of coloured stone cut out using a template. The technique was known in Russia since the eighteenth century and had never disappeared, not including the 15 years immediately after the revolution. From a technological point of view, making Florentine mosaics on a monumental scale is not a difficult matter as long as there is a supply of raw materials. Decorative stone was sought and quarried all over the USSR in anticipation of the construction of the Palace of Soviets and the metro. The Gulag system ensured both large volumes of quarrying and rapid delivery of the stone to Moscow. At the beginning of 1939 the *Stroitelstvo Moskvy* journal reported: 'At the present time supplies of raw materials at Metrostroy are much larger than they were previously and now include a number of new types of marble ... white Balandin marble, white Polevskoy marble with grey veins, red Tagil marble, yellow Fominsk; marbles from the Caucasus – black with gold veins (Davalu), black with white veins (Khorvirab), transparent onyx, red marble (Novaya Shrosha), decorative white marble with pink veins (Agveran); in the same category are pink marble from the far east with veins of violet (Birobidzhan), marble from Gazgan in Turkestan, and certain new types of marble from Georgia, the Crimea, and other quarries.'[14]

The marble factory that had been set up at Metrostroy even advertised its products and services to external clients. Its range included 'artistic mosaics from marbles and hard types of stone', 'mosaics in various

patterns (including slabs with a basis of coloured cement): brecciated, carpet-type, slab-type', and 'the design of patterns for customised marble and mosaic products'.[15] However, there was a problem with the patterns for the mosaics: unlike 'Roman' mosaic, which is capable of fairly accurate reproduction of paintings using small pieces of smalt or natural stone, Florentine mosaic is essentially collage, and it was easy for those who created collages in the 1930s and 1940s to lay themselves open to accusations of formalism. For this reason, to begin with, the architects of the Moscow metro used all the richness of their material in geometrical compositions (outstanding examples include the floor of Mayakovskaya metro station, which Dushkin himself considered a tribute to Malevich, and the facing of the corridor walls leading to the exit from Sokol metro station).

The designs for phase three stations did not include any provision for Florentine mosaics,[16] but these did appear simultaneously at four stations in 1943 – evidently as a result of instructions from above. Needless to say, all of these mosaics depicted military-patriotic themes and were created by a narrow circle of artists. At Zavod imeni Stalina and Novokuznetskaya stations, the mosaic compositions were placed on the station's end wall (after construction of the connecting passageway at Novokuznetskaya, the mosaic was moved to a higher position above the staircase) and are very similar, with people and weaponry in shades of grey projecting graphically against the background of the Kremlin. The difference between them is that at Novokuznetskaya, the mosaic depicts 'The Front and the Rear' – the groups of workers, soldiers, tanks, and machine-gun mountings are spread on either side of a fluttering flag, which of course features a profile of Stalin (though he as rather crudely replaced with Lenin in the 1960s). In contrast, at what is now Avtozavodskaya metro station, the group is more centric: in the 'Parade on Red Square' scene, a tank has its gun projecting right into the station hall and the silhouette is completed by an old-Russian *bogatyr* (heroic strongman) in a helmet. For all their physical stoniness, the images look like extremely magnified book illustrations. Evidently this reflects the experience of Boris

Potikyan, M. L., 'Sport and Children', 1964. Stadium of Young Pioneers (Tsarskaya Ploshchad residential complex). 034B

Pokrovsky, who often illustrated books. Pokrovsky was the sole designer of the mosaics at Novokuznetskaya station and was evidently the main designer of the mosaics at Avtozavodskaya (his co-designer, as for the smalt panels at this station, is recorded as being Vasily Bordichenko, who also had experience in book illustration, but had a greater inclination for delicate painting). At Baumanskaya station (1945), sole designer Bordichenko opted to go down a simpler route, turning the red standards with profiles of Stalin and Lenin (after 1963 Lenin was left on his own) parallel to the wall plane. The most interesting mosaic in this series is in the southern pavilion of Paveletskaya station. This pavilion was incorporated into the railway station building when the latter was being reconstructed. The mosaic is positioned above the escalators and has survived. Its original name was 'Fanfare to the Soviet People and its Leader, I. V. Stalin'. All that remains of Stalin is a nebulous circle in the sky. The fanfares are performed by dense lines of extremely tall, angel-like, red-marble warriors with wings that double as flags, while in the middle at the bottom is the recognisable silhouette of ancient Moscow, as if untouched by Stalin's reconstruction and so pale-greenish that it inevitably calls up associations with the city of Kitezh disappearing under the water.

Bordichenko's co-designer in this case was his wife, Elena Samoylenko-Mashkovtseva. She had a serious interest in anthroposophy, something to which we likely owe the mystic atmosphere of this patriotic work. After Paveletskaya-Ring station opened in 1953, a Florentine mosaic also appeared in the northern vestibule above the escalator, but it was on a small scale, consisting of a circular medallion with a depiction of Red Square, but in polychrome and composed in a manner more typical of socialist realist painting. The most decorative were the Florentine mosaics at Belorusskaya-Ring station (1952). Taranov and Bykova, the architects who designed Novokuznetskaya station, again divided the vaulting with intricate ancient-Roman coffers, but this time provided space in advance for 12 octagonal mosaic inserts. Mosaics depicting the emblem of the Belorussian Soviet Socialist Republic and the happy, peaceful life of the Belorussian people after the war were made according to sketches designed by Grigory Opryshko. The style is absolutely socialist realist, but the bright colours and the way that the stone has been cut into relatively large pieces make for a pleasant primitivist effect, which is further underlined by the folklore-like ornamentation of the frames. Until the reconstruction that was carried out in 1994, the ceiling mosaics

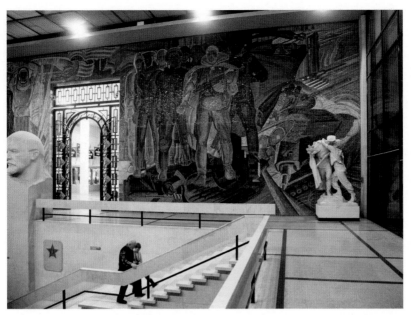

Korolev, Y. K. 'The People and the Army are One', (1961)–1965.
Central Museum of the Armed Forces of the Russian Federation. 039C

were echoed by the ceramic mosaic on the floor, which also had Belorussian ornamental motifs but was subsequently replaced with large slabs of granite.

Opryshko was also behind the design of the 'Triumph of the People of Soviet Ukraine' frieze under the vaulting in the southern vestibule of Kievskaya-Ring metro station. Passing behind the columns it clearly echoes Pheidias' frieze on the Parthenon in terms of its composition: as is the case in the Panathenaic Procession, men, women, and children carry gifts and lead animals to a symbolic altar on which the republic's crest shines radiantly. Florentine mosaic is complemented by a background of golden smalt; this is a wonderful combination – resplendent and with clearly visible figures.

As work on the Circle Line neared completion, mosaics left the metro for a long time. The lines that followed were built in accordance with an austere functionalism that softened only at the beginning of the 1970s. However, several mosaic inserts were nevertheless created even before this – such as when it was necessary to cover up a gap left by de-Stalinisation or to re-code a station that had been renamed. One specific example is on the end wall at Paveletskaya station: the marble relief depicting Lenin and Stalin was replaced with a mosaic designed by Korin, who was very elderly. That this

was made in the 1960s is clear not just from the expressiveness of the lines and the unusually large decorative elements, but also from the length of the kolkhoz-worker's skirt. Botanichesky Sad station was renamed Prospekt Mira in 1966. A year later, an absolutely modernist smalt panel entitled 'Mothers of the World' appeared on the wall of its vestibule in a spot that had been vacant since a depiction of Stalin had been removed in 1955. It was created by Andrey Kuznetsov not for the metro, but for a republican exhibition entitled 'Soviet Russia'. In 1969 'Red Drummer', another smalt panel by Kuznetsov, was installed for no clear reason at Krasnoselskaya station, which had been built back in 1935. At the same time, it seems the pavilion of Park Kultury, a station on a radial metro line, was embellished with a portrait of Gorky executed in the Florentine-mosaic technique by the artist Ryabov. It may be supposed that the absence of figurative art in the decoration of stations on the first line had begun to seem inappropriate.

Apotheosis on the eve of collapse: the mosaic decoration at VSHV and MGU. As work on the Central Line of the Moscow metro drew to a close, designers and mastercraftsmen moved on to other emblematic projects in Moscow. These were the highrises into which the unrealised Palace of

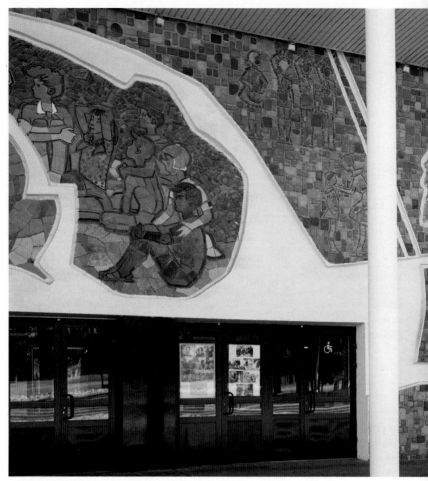

Ablin, E. M. and others. 'Young Followers of Lenin', (1959)–1962.
Moscow Palace of Pioneers on Leninskiye Gory. 033H

Soviets 'was broken up' and the All-Union Agricultural Exhibition (VSHV), which had to be rebuilt following a period of neglect and subsequently became the Exhibition of the Achievements of the National Economy (VDNH).

Of the seven high-rises built in Moscow, only the most socially important – the main building of Moscow State University (MGU) – was given mosaic décor. Undoubtedly the most honourable task fell to Pavel Korin: at the end of the assembly hall, behind the columns, Korin executed a decorative composition with a golden background, scarlet flags, attributes of knowledge, and a flaming brand of enlightenment directly beneath a hammer and sickle 'embroidered' in gold on the central standard, and a cartouche extending from end to end and containing the dates 1755–1953. Linking the year the high-rise was built with the date

of Moscow University's foundation in the reign of Elizaveta Petrovna, the cartouche explains the baroque rhetoric that to this day sets the tone for the ceremonies that take place against its background.

Alexsander Deyneka, temporarily pushed aside from his position as the country's leading monumentalist artist, was asked to create 60 similar circular medallions in the Florentine mosaic style with profile portraits of peoples and the greatest scholars of all time to be placed on a frieze above the columns in the two foyers of the assembly hall. For the end part of the frieze, there were to be depictions of the greatest of the greats – Marx and Engels in one foyer and Lenin and Stalin in the other. Had it not been for the high fee paid for this commission, this job may have seemed humiliating, but Deyneka subsequently described this commission as one of the most serious

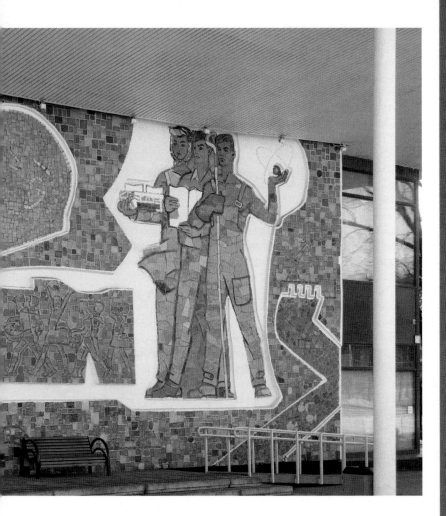

and fascinating in his life. He found it interesting to collaborate with the architect Lev Rudnev in finding proportions that made it possible to inscribe into circles of the same size profiles of beardless men with short haircuts, Lomonosov in a wig, as well as Leonardo da Vinci with his long beard.[17]

Mosaic has a conspicuous yet at the same time non-traditional role in the decoration of the All-Union Agricultural Exhibition. Inside the pavilions you can find all sorts of things – frescoes, plaster moulding, bronze and wooden sculpture and latticework, majolica – but no mosaics, neither of the smalt or Florentine variety. On the other hand, the largest and most symbolically significant elements on the exteriors of the pavilions are faced in smalt. The sculptures above the main entrance as well as the Mechanisation (Space), Ukrainian, and Belorussian pavilions and the emblems and

standards above the entrance to the Main Pavilion were radiant with golden smalt. The Construction Materials Pavilion (architects: G. I. Lutsky, L. I. Lopovok; sculptors: M. E. Yaroslavskaya, V. M. Solomonovich, A. N. Zagarbynin, A. I. Naroditsky) made the most unusual use of mosaic.

Evidently in order to underline the semitransparency of the cube made from blocks of construction glass with the exacting name 'Stalinite', the portal has, in addition to the traditional crest and standards, an abundance of luxuriant flowers, fruits, and vegetables – even cabbage, carrots, and aubergines covered in smalt of different colours. However, the most notable mosaic works at VSHV–VDNH are undoubtedly the fountains. Architect Konstantin Topuridze described how he had the idea of using mosaic for the Golden Ear of Wheat fountain, situated on a pond that is visible

from both the Beer and Main Restaurant pavilions: 'Originally, the Ear of Wheat fountain was to have been made from sheets of copper embossed using the dishing method. This technique would have made it necessary to patinate the surface of the ear of wheat, which would have given the entire fountain a gloomy appearance, or to paint it using gold paint. Both solutions seemed unsatisfactory, prompting the idea of making the fountain from coloured mosaic using golden-coloured canterelli (yellow canterelli overlaid on silver makes for a good golden colour with a variety of shades).'[18] Engineer B. Novikov and hydro-technician S. Strashkevich had to redesign the fountain's load-bearing structure using thin-walled elements of reinforced concrete, while sculptor Prokopy Dobrynin had to mould a new model.

The latter was then covered in smalt by specialists from the mosaic workshop at the USSR Academy of Arts, which had been summoned from Leningrad for this purpose. This bold approach turned out not to be long-lasting: the metal rusted due to the regular changes in humidity, the thin concrete envelope swelled up, and the smalt disintegrated to such an extent that it was not clear whether restorers could preserve the fountain or if it would be necessary to replace it with a new one. Large areas of smalt have also been lost on the Stone Flower fountain (also designed principally by Topuridze and Dobrynin), but for all the time that all the precious pieces of glass – taken from the same imperial reserves – were in place, the fountain had a truly fairy tale-like appearance.

Opened on 1 August 1954, the VSHV complex was an outstanding success. Its architecture was swiftly declared the apogee of the creativity of the entire Soviet people. Yet this success was extremely short-lived. Nikita Khrushchev, First Secretary of the Communist Party of the Soviet Union, made his fateful speech on 'superfluity' in construction on 7 December 1954.

What had previously been an object of pride all of a sudden turned into something that gave rise to feelings of awkwardness and indeed something that it was considered best to camouflage in some way. Both architecture and mosaic now had to look for new ways forward.

New paths and models

'Soviet architecture must be characterised by simplicity, austerity of form, and cost-saving solutions,' stated the resolution on 'eliminating superfluity'. However, no clarification was provided regarding how exactly architects were supposed to design their buildings, apart from the fact that they should remove all decoration from structures that had already been designed and continue to develop solutions in the field of large-panel house construction. Help came from an unexpected quarter: architecture was formally stripped of its status as an art (the Academy of Architecture was renamed the 'USSR Academy of Construction and Architecture' in August 1955 and architecture colleges were recategorised as technical colleges). Technology, unlike art, lies outside the bounds of ideology, so there was nothing objectionable in adopting appropriate technical solutions from developed capitalist countries. In any case, the iron curtain was coming down and the USSR was slightly opening up to the world. The World Festival of Youth and Students was held in Moscow in 1957 and this was followed by the Congress of the World Union of Architects in 1958. That same year, the USSR took part in the first post-war world expo in Brussels. In 1959 there was an exchange of national exhibitions between the USSR and the USA, leading to the creation of an American exhibition complex in Sokolniki, where, among other things, American contemporary art and photographs of American contemporary architecture were exhibited. There were also exhibitions of architecture from France, Italy, Finland, etc. The official responses to art and architecture differed. Artists who took a close interest in Western innovations were firmly and famously put down by Khrushchev at the '30th Anniversary of the Moscow Branch of the Union of Artists' exhibition at the Manezh in Moscow in 1961. Khrushchev had no reservations about declaring, 'As far as art is concerned, I am a Stalinist.' Architectural borrowing, on the other hand, was encouraged. Architects were sent abroad to gain experience and professors advised their students to look at western architecture magazines (which had been strictly forbidden until only recently).

Vladimirova, O. N., Zelenetsky, I. L., 'The Charms of Music', (1976)–1977.
Lyre Children's Music School, concert hall 108A

Both groups soon discovered that in other countries that had suffered in the war, construction had been conducted as if in compliance with the Communist Party's new instructions for several years already, with an emphasis on 'simplicity, austerity of form, and cost-saving solutions'; and furthermore that despite efforts to save on costs, simplicity and austerity of form often went hand in hand with monumental art.

Life in the post-war world, which was only just feeling its way towards an 'economic miracle', was relatively hard and society needed injections of optimism. It should be admitted that post-war buildings were in themselves usually fairly depressing. This is why municipalities, church communities, universities, supermarkets, and restaurants commissioned large-scale paintings, sgraffito, or mosaics wherever possible. It immediately became clear that modernist mosaics do not have to be made from precious materials or involve high levels of labour expenditure. Smalt can be inserted in large unworked pieces, to which the simplest stone or ceramics can be added. The demand for monumental art was so great and the gulf between clients' budgets and ambitions so large, the process involved both famous artists (such as Ben Nicholson and Eduardo Paolozzi in Great Britain, for example) as well as artists who were totally unknown and sometimes less skilled.

The USSR took the same path, but fittingly for a command economy, was more systematic about it. There was a need for a new language of monumental art together with a new language of architecture. There was a tried-and-tested instrument for this: the competition for the Palace of Soviets (1957–1958), which was now to be built on Lenin Hills. The winning project was by Aleksandr Vlasov and entirely modernist in style; it involved figurative coloured friezes at the top of the external walls of the oval meeting halls. Alexsander Deyneka, the most 'progressive' of the country's distinguished artists, was asked to produce sketches and mosaic samples. However, by this time, Deyneka had exhausted his fathomless talent. To be frank, the samples that have survived look pathetic. Deyneka was saved from complete disgrace by the cancellation of the entire Palace of Soviets project. Deyneka was given an honourable but relatively simple task in the Kremlin Palace of Congresses, which was built instead of the Palace of Soviets. He was to execute the barely visible symbols on the external wall piers of the banqueting hall and the mosaic frieze comprising emblems and standards above the staircase in the foyer. The elderly master coped with this satisfactorily enough. The traditional motifs are fused with the wall surface, without any reminiscence of their puffed-up precursors at VSHV.

The first real breakthrough was made with the support of the Central Committee of the All-Union Lenin Communist Youth Union, which was sometimes bolder than its 'adult' counterpart, the Central Committee of the Communist Party of the Soviet Union. In their unprecedentedly modernist project, the young authors of the Moscow Palace of Pioneers involved artists and designers who were just as bold: Evgeny Ablin, Andrey Vasnetsov, Aleksey Gubarev, Irina Derviz, Grigory Derviz, and Igor Pchelnikov (to mention only those who took part in creating the mosaics). The most important of these mosaics decorates the main entrance, which is hospitably wide and transparent in a decisive departure from the traditional entrance portal. Entirely recognisable and canonical images – a profile of Lenin, a group of Pioneers around a fire, children at play, a radiant sun – are presented in a manner that would have been inconceivable a few years earlier. An embedded relief frames patches of mosaic made from large blocks of orange smalt in various shades; and the contours are defined by strips of blue or yellow glass, which are likewise fairly large by traditional standards. On the palace's garden façade, the mosaics on the three identical side walls are made of tinted silicate brick and symbolise man's conquest of three elements – water, earth, and sky. This was of course a slap in the face for academic craftsmanship and should have led to public uproar, but on 1 June 1962, after examining the entire construction project in detail Khrushchev unexpectedly declared: 'I like architecture like this,' and thus gave his approval not just to architecture 'like this', but also to the art 'like this' that accompanied it. Socialist realism had not been abolished, but as far as works of monumental art were concerned, 'socialist content' was permitted to be international in form.

Meanwhile the new format of synthesis of the arts and the specific character of monumental as opposed to easel art was discussed at the Union of Artists. *Dekorativnoe iskusstvo SSSR* ('Decorative Art of the USSR'), a journal that had been established in 1957, published this type of article. In the June 1962 issue, as if it had been given the nod to do so, the magazine printed an article by Deyneka entitled 'Monumentalists: Go For It!'. In it Deyneka warned his colleagues – Vladimir Stozharov, Georgy Nissky, Andrey Vasnetsov – against excessive simplification and individualism in means of expression.[19] Young artists, however, paid more attention to another luminary: Vladimir Favorsky, a wonderful graphic artist who also had experience working in monumental art. His frescoes in the Museum of Protection of Maternity and Infancy (1933), which survived only in photographs, were highly regarded. A constant public presence until his death in 1964, Favorsky lectured, gave interviews, wrote articles, and tried to convey to the artistic community his understanding of the problem of the flatness of the monumental image and the special character of narrative in wall painting and mosaics – narrative that is entirely apt in these genres, although it very rarely leads to worthy results in easel painting. Artists turned to the original sources, studying available examples of old-Russian painting. The frescoes by Theophanes the Greek in the Church of our Saviour on Ilyina ulitsa in Novgorod, which had taken on a pinkish-brown colour as a result of a fire that had occurred in the distant past but had retained their distinctive flashes of white, made such an impression on Nikolay Andronov and Andrey Vasnetsov that they created almost monochrome mosaics for both the enormous box of the Oktyabr Cinema (1967) and the foyer of Izvestia's conference hall (1978). Vasnetsov took the same approach in the Museum of the History of Cosmonautics in Kaluga (1966–1967). The limited range of colours in many other important mosaics – such as 'The People and the Party are One' designed by Yury Korolev in the vestibule of the Central Museum of the Armed Forces in Moscow (1965) – may not have been the result of a desire for noble restraint, but rather a response to a banal shortage of materials: the pre-revolutionary supplies had already been exhausted and mosaic produced in the USSR could use only inexpensive chemical components, which made its bright colours difficult to harmonise with one another.

Another fairly exotic yet inspiring source was mosaics in Mexico, where this art form was currently undergoing its glorious heyday. Mexico was considered a friend of the

USSR, so information was officially available. In 1960 the Pushkin Museum of Fine Arts held an exhibition of Mexican art that included large, coloured photographs of the University of Mexico's library. The façades of the 11-storey book-storage facility were covered in continuous mosaic made from natural stone (Juan O'Gorman, 1952), and in 1962 the USSR Union of Artists held a viewing of slides of the most recent works by David Alfaro Siqueiros – paintings for the Castillo de Chapultepec. An exhibition entitled 'Mexican Painting and Graphic Art' was held in Leningrad in 1973 and showed work by Siqueiros, Orozco, and others. This knowledge of Mexican art helped liberate Soviet artists' imagination and demonstrated how it was possible to distort forms, including the forms of the human body, in order to achieve greater expressiveness. Even more importantly, it demonstrated how painting can work together with architecture, as opposed to merely being used to 'embellish' a building or camouflage construction deficiencies.

Heyday

Following Khrushchev's retirement in 1964, the policy of asceticism in construction was softened slightly. The first successes in industrial house building showed the danger of creating an excessively monotonous environment. Mosaics had returned to the metro by the 1970s. By this time, the metro lines built between the 1930s and 1950s were beginning to be seen as an important part of Moscow's identity and an object of pride. Events that were celebrated at national level – such as the 50th anniversary of the revolution (1967), the 100th anniversary of the birth of Lenin (1970), and the 1980 Olympic Games – required the creation of emblematic buildings that were invariably accompanied by monumental art. By the mid-1960s, a well-integrated system for creating monumental painting, including mosaics, had taken shape. Back in 1954, a department of monumental and decorative art had been set up separately from the painting department at the Moscow Union

Milyukov, B. P. 'Creation', (1969)–1971.
Moscow State Union Planning Institute . 077A

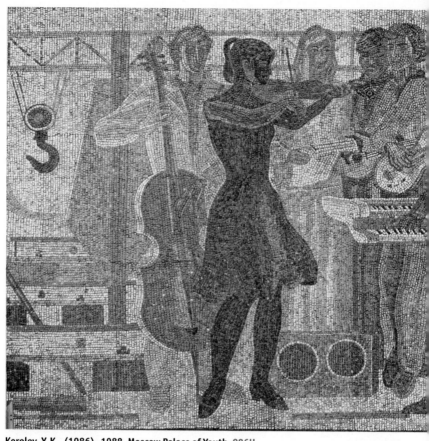

Korolev, Y. K., (1986)–1988. Moscow Palace of Youth. 086H

of Artists. Its members were artists who even at that time felt inhibited by the category of academic eclecticism that called itself 'socialist realism'. The department had its own production facility, and an integrated facility producing decorative art was set up at a later date. A fixed percentage from the budget began to be allocated for the construction of public, sports, educational, and manufacturing buildings, and subsequently residential micro-districts for 'tackling issues related to synthesis of the arts'. For artists, this meant very good compensation and resulted in closely contested competition for commissions.

Distribution of commissions and payment of artists' fees was officially the job of the Art Fund, but clients who were not particularly demanding or lacked influence were allocated artists who were simpler or cheaper, while more attention was paid to the desires of important people. The opinion of Viktor Elkonin, head of the department of monumental and decorative art, carried a great deal of weight. For example,

he favoured Nikolay Andronov, Andrey Goncharov, and Andrey Vasnetsov, helping them receive good commissions and sometimes acting as their co-author. The client's word could also be important. Directors of research institutes and rectors of higher education institutions usually advocated for their choice of artist. For example, Viktor Kirillov-Ugryumov, rector of the Moscow Engineering and Physics Institute, insisted that the monumental works of art for the institute's new building be made by Mikhail Shvartsman and Grigory Dauman, the artists who had been proposed by the architect Aleksandr Korotkov despite the fact that they were considered exoteric if not avant-garde. As a result, three relief compositions with mosaic inserts were created in 1963: 'The Taming of the Atom', 'Penetrating the Essence of the Atom', and an untitled panel in the reading room depicting a woman holding in gigantic arms what seems to be some kind of power unit. All this was much closer to symbolism than surrealism, but the rector was very satisfied

and took pride in his involvement in the creation of these 'hieratic' pieces until the end of his life. Of course, difficult figures such as Shvartsman and Dauman received commissions only rarely. Dauman executed only one other mosaic, also together with artists Eduard Kozubovsky and Anatoly Fedotov, who in this case created the relief for the mosaic. This was the mosaic in the vestibule of the Main Calculating Centre of Gosplan of the USSR, which was designed by Leonid Pavlov in 1970. Both artist and architect were enchanted by the thought of a world in which all problems could be resolved using electronic-calculating machines. Dauman filled three relief circles with unclear images of a laboratory, a space being studied by scientific mechanisms, and finally, a recipient of all the blessings that are to come: a magnificent woman, possibly an African or an alien ... The mosaic in the interior is intended to be viewed attentively from close up: the non-contrasting small stones and pieces of glass flow around the shape and coil in a spiral. The

computer programmers were supposed to be won over by the inclusion of binary code recording the year of execution – the digits 11110110010 laid out in silver mosaic. 'Macroworld and Microworld', a panel by Evgeny Kazaryants above the entrance to the House of Optics (1973), echoes to some extent the latter work by Dauman. The building's name hints at a shop, but this shop was not selling ordinary glasses, but rather microscopes, telescopes, and other intricate devices created by the S. I. Vavilov State Optical Institute. The additional capacities of sight given by optics made it possible for Kazaryants to play at surrealism, a style that was still forbidden. Recognisable reality occupies only the centre of the panel, where under the planet Earth we see a concentration of various lenses and prisms, while to the right and left is an imaginary world that can supposedly be seen under a microscope or through a telescope. Vaguely recognisable biomorphic forms echo one another and suggest a unity of everything that exists and at the same

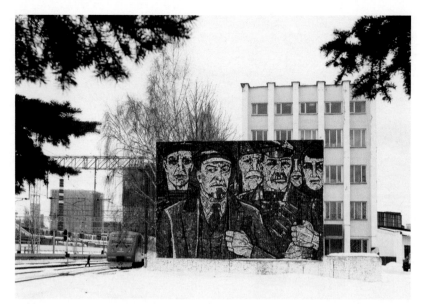

Dekhto, Y. A., (Arakelov, V. N., Ter-Grigoryan, S. L. (?)). 'Lenin and the Bolsheviks', 1960 (?).
Ilyich locomotive shed. 036B

time associations with Andrey Tarkovsky's 1972 film *Solaris*. Kazaryants employed the Roman (i.e., direct) technique of laying out mosaic, using pieces of smalt that were so small they are practically indistinguishable to the eye, which reacts only to the very delicate variations in colour and the glittering of the surface.

Undisguised abstraction, on the other hand, was permitted only for absolutely specific reasons, such as the decoration of the Council of Economic Cooperation (SEV) building.[20] The headquarters of this international organisation needed to exhibit freedom of thought, even if it brought together only countries with socialist regimes. It could almost be said that the SEV building is the best example of modernist architecture in Moscow. Its principal architect (at least nominally), Mikhail Posokhin was also chief architect of Moscow and could not allow the mandatory 'synthesis of the arts' to confuse this impression. The exterior wall of the circular conference hall was covered in a mosaic of textural concrete elements and wafers of fluorite (a mineral with a pronounced crystalline structure that takes on various shades from green to violet). The mosaic was made by Hungarian craftsmen to sketches by Grigory Opryshko – the same designer who had so convincingly glorified the well-being of the Belorussian and Ukrainian peoples at their respective

metro stations and also created the short-lived mosaic portrait of Stalin at Arbatskaya metro station on the Arbatsko-Pokrovskaya line. In the conference hall of the Council of Economic Cooperation, Opryshko changed his style as nimbly as the architects themselves. We should remember that 20 years before the SEV building, Mikhail Posokhin and Ashot Mndoyants had designed one of the seven 'Stalinist high-rises' – a building nearby on ploshchad Vosstaniya (now Kudrinskaya ploshchad). Using a little bit of imagination, you can make out the flashes of a fireworks display or revolutionary explosions on the grey mosaic: this was how they explained the mosaic to their dull-witted bosses, but it is in fact an abstract composition of course. Posokhin engaged Evgeny Ablin for the interior mosaic that covered an entire wall in the restaurant and dining room. Ablin had made his name by participating in the creation of the mosaics for the Palace of Pioneers. He created a mosaic from fluorite that had nothing whatsoever to do with figurative art: the energetic and very textural intersection of segments of curves, made from unworked pieces of fluorite and marble, could make us think only of the experiments in painting by the Russian avant-garde. Nevertheless, this work resulted in Ablin being awarded the diploma of the Moscow Union of Architects for 1967.

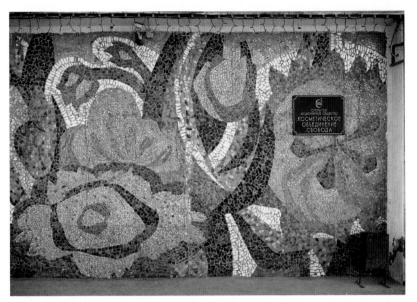

Unknown artist, 1967. Svoboda Factory. 067A

After this, Ablin created a non-figurative volumetric composition on the façade and in the interior of the shopping centre on ploshchad Yunosti in Zelenograd (1970). The only difficulty he encountered was finding the sufficient quantity of glittering shards of marble for a mosaic three storeys high. He subsequently continued to be successful in his career. Posokhin remembered him once more in 1978, inviting him to decorate the diving tower at the Olympic swimming pool with mosaic and to create a mosaic in the super-modern atrium of the World Trade Centre, a project involving collaboration with American partners.

Another architect, Leonid Pavlov, was not as influential as Posokhin, but he was very insistent and persuasive. He preferred to collaborate with Elenora Zharenova and Vladimir Vasiltsov. Alongside mosaics for the futuristic Automobile Service Station (STOA; the service station for Zhiguli cars on Varshavskoe shosse, 1966–1977; unfortunately, these mosaics have disappeared), this married couple created the famous 'ear' on the façade of the Central Economics and Mathematical Institute (1966–1978). The mathematicians who worked in the building refused outright to recognise the Moebius strip in the mosaic relief, but this does not prevent it from looking great as a plastic accent on the flat gridded façade. Nagatinskaya metro station, which opened

in 1983, is another collaboration by Pavlov, Zharenova, and Vasiltsov. As the artists recalled, the theme for these Florentine mosaics – the history of Moscow – was suggested by the location, which was the site of the old settlements of Nagatino, Nizhnie Kotly, and Kolomenskoye. 'This is on the route taken by the forces of Dmitry Donskoy on their way to Kulikovo Field; it's where the peasants' salt mutinies took place and Ivan Bolotnikov rose up in 1606. It was home to skilful craftsmen and folk craftsmen. In Kolomenskoye there was a wooden palace that was famous for its beauty and intricacy.'[21] Proposals were prepared, but it turned out to be difficult to secure approval. The client required 'natural' or 'chemical' motifs, but the drawings in warm shades of natural stone were as enchanting and imbued with as much love for the city as the words of the artists, so the bosses gave way in the end. History was already in fashion at the beginning of the 1980s.

After this, the door was opened for using historical subject matter at other metro stations. Florentine mosaics were created at Tsaritsyno station (1984; here Andrey Kuznetsov, did not refrain from using the beloved theme of the Revolution of 1917) and at Chekhovskaya station, with its idyllic images of the Russian country house (1987; Petr Shorchev, Lyudmila Shorcheva). Savelovskaya station has a smalt mosaic

entitled 'The History of Railway Transport'. Here, Nikolay Andronov and his colleagues were clearly looking back to the panels at Avtozavodskaya.

Among the Moscow monumentalist artists, of course there were also masters who practised a slightly updated but still utterly steadfast version of socialist realism until the very end of the Soviet regime. The leading monumentalist was Yury Korolev, who executed mosaics at the Central Museum of the Armed Forces (1961–1965), the mosaic decoration for Sviblovo (1978), and Ulitsa 1905 Goda (1976–1979) metro stations, and even the mosaics on the façade of the Palace of Youth. The latter were completed in 1990 when their author had already been director of the Tretyakov Gallery for seven years.

In the final period of Brezhnev's rule, supervision of art began to weaken and abstractionism and symbolism broke through at various times in unexpected, although usually not very conspicuous, spots. Sometimes this extended to things that not only Party functionaries, but ordinary people too would never have expected to see on the streets of the Soviet capital. The mosaic covering all four walls of the library of the 2nd Medical Institute takes passers-by completely by surprise. Terrible and distorted images follow one another in a pitiless rhythm on an enormous surface (12 × 45 metres). The mosaic is called 'Healing', but the artists have been extremely harsh in showing how much healing can cost in suffering and exertion (interestingly, Leonid Polishchuk said that the idea for the composition came to him when he was on the verge of committing suicide). There is no trace of handiwork in this mosaic: the square panels were filled with smalt at a factory using mechanical means – and the emphasis is on the interaction between the smooth surface of the wall and the very illusory distortions of the objects depicted. The effect is head-turning, but the wall – and the shape of the building – hold their own, retaining the fundamental dignity of monumental art.

The end: Its causes and consequences

Soviet mosaic was not such a unique phenomenon. Overall, it developed along the same path as monumental art in a large circle of countries, by no means all of them totalitarian regimes. Its defining qualities were, on the one hand, the large ratio of propaganda in its content and on the other, the fact that artists working in this field were very talented and would probably have found other uses for their talents had it been possible to work on private commissions. Alongside a large number of naïve and badly made mosaics whose only interest for us is as artefacts left behind by a vanished culture, we find first-class works surpassing in quality anything similar that was created in other countries across what was once the Soviet Union and indeed in the most concentrated form in Moscow. However, there is one period during which Soviet mosaics have no equivalents: during the post-war decade, Soviet art and architecture were prescribed a path that was the exact opposite of that chosen by both the USSR's defeated opponents and its former allies. Yet the mosaics created in the period when Soviet architecture drew close to international modernism – and pulled after it monumental art – possess no less value and originality.

In 1952 Aline Bernstein Louchheim, a columnist for the *New York Times* and the wife of the architect Eero Saarinen, wrote: 'It is simply shocking that contemporary architecture and mosaic decoration, which are naturally ideally suited to one another, do not yet have a long and productive marriage behind them. Because the beauty of contemporary architecture is in the expression of its structure and the underlining of the beauty of its materials. And mosaic, when it becomes an integral part of architectural elements, reinforces the impression that these elements make without overshadowing their functions.'[22] These sentiments can also be applied to Soviet architectural modernism, with the qualification that mosaics often had to 'overshadow' the quality of the materials used and the construction.

After returning to architecture at the end of the nineteenth century, mosaic left it, together with the modernist era, without waiting for the end of the twentieth. Recent architecture has been able to call on such an arsenal of devices that it has no need for support from other art forms. It is no less

important that the niche occupied by mosaic in the urban setting has been taken over by visual advertising, which due to its nature inevitably distracts attention from other types of images. Smalt, which is now produced in a quality and an array of colours that were previously unattainable, is used as a finishing material for bathrooms and, at best, for swimming pools.

Yet monumental mosaic has a natural refuge in which it can continue to live for a long time to come: the metro. The inevitable dampness and comprehensible desire to make being underground less depressing have resulted in the creation of more and more new mosaics – and not just in the metro system or just in Moscow, where the image of the 'underground palace' may be considered traditional. They have also been created in Stockholm, Naples, Paris, and even London and New York, where the underground railway has long been perceived as merely utilities infrastructure. We can hope that mosaic's water-resistance and strength, qualities which once led the Greeks and Romans to use it for decorating floors, will ensure it lives in the future.

Like other works of monumental art, mosaics created throughout the world in the twentieth century are gradually disappearing – simply because they have lost their relevance to the present day. For their part, protectors of heritage fight to save mosaics that have artistic or nostalgic value. In London, for example, a ceramic frieze entitled 'The History of the Old Kent Road' (by Adam Kossowski, 1965–1966) on the walls of North Peckham Civic Centre received listed status last year, while in Zelenograd, Ablin's haut relief on the shopping centre on ploshchad Yunosti was placed under state protection. At the same time, the mosaic bowl of the fountain on the latter square in Zelenograd was destroyed as part of a campaign to improve public amenities. The Twentieth-Century Society in the UK has launched a campaign to protect mosaics and other wall paintings from this period and is working on creating a database of these works. Information on mosaics in Russia is collected randomly by aficionados. It is possible to find numerous images on the internet, but as we worked on this book, we were faced with the problem that even the names of the authors of many of the mosaics are unknown. We hope that this book's publication will lead to the release of new information and promote scholarly study of an undervalued stratum of our artistic heritage.

1 Specifically, specialists from Frolov's workshop carried out the restoration of Lomonosov's 'Battle of Poltava' and its transfer to a new site and created the mosaic emblems of the USSR that covered up the heraldic symbols on the Bryansk (Kiev) Railway Station building in Moscow.

2 Cited from: Deyneka, Zhivopis (Moscow: 2009), p. 49.

3 See: 'On the Question of Monumental Art' in Iskusstvo, 1934, no. 4, p. 4.

4 Artist: Barry Faulkner; execution: Ravenna Mosaic Works.

5 Iofan, B. M, Gelfreykh, V. G., 'Certain Issues Relating to the Construction of the Palace of the Soviets' in Stroitel'stvo Moskvy, no. 9, p. 6.

6 See: Dushkina, N. O. (compiler), Aleksey Nikolaevich Dushkin. Arkhitektura 1930–1950x godov. Katalog vystavki, Moscow, 204, p. 169–170.

7 Deyneka, A. A., Iz moey rabochey praktiki (Moscow: 1961), p. 42.

8 Zelenin, M. A., 'The Finishing of Third-Phase Metro Stations' in Stroitel'stvo Moskvy, 1939, no. 2, p. 15.

9 Deyneka. Monumentalnoe iskusstvo. Skul'ptura, Moscow, 2011, p. 149.

10 Deyneka. Monumentalnoe iskusstvo. Skul'ptura, Moscow, 2011, p. 156.

11 See: Dushkina, N. O. (compiler), Aleksey Nikolaevich Dushkin, p. 169–170.

12 Cited from Frolov, V. A., 'The Language of Mosaic' in Frolov, V.A., Peterburgskaya mozaika. Gorod – dinastiya – kul'tura. Izbrannye statyi, (St Petersburg: 2006), p. 130.

13 Munts, E. V., 'On Malaysian Ancestors, Monumentalist Artists, and the Monument to Osip Mandelshtam' in Ustnaya istoriya. <http://oralhistory.ru/talks/orh-1777/text>

14 Zelenin, M. A., 'The Finishing of Third-Phase Metro Stations' in Stroitel'stvo Moskvy, 1939, oo. 2, p. 14.

15 Advertisement on the inside page of the back cover of Stroitel'stvo Moskvy (1939, nos. 23–24 and 9–10).

16 Zelenin, M. A., 'The Finishing of Third-Phase Metro Stations' in Stroitel'stvo Moskvy, 1939, no. 2, p. 13–15.

17 Deyneka. Monumental'noe iskusstvo. Skul'ptura, Moscow, 2011, p. 115.

18 Topuridze, K., 'The Fountains at the All-Union Agricultural Exhibition' in Arkhitektura SSSR, 1954, no. 7, p. 19.

19 Deyneka, A., 'Monumentalists: Go For It!' in Dekorativnoe iskusstvo, 1962, no. 6, p. 1–3.

20 This building is currently occupied by Moscow's city hall.

21 Vasiltsov, V. K., Zharenova, E. A., 'On Our Work on Nagatinskaya Metro Station' in Kostina, O. V., Arkhitektura moskovskogo metro. 1935–1980-e gody, Moscow, 209, p. 194.

22 Louchheim, Aline B., 'An Ancient Medium in Modern Use: Mosaic Craft Adds Color To Our Architecture And Ocean Liners', New York Times, 5 October 1952, p. X9.

Art Deco

1

Art Deco

The art deco style, which was named after the Paris World Expo of 1925 (*Exposition Internationale des Arts Décoratifs et Industriels Modernes*), expressed the moods of the 'roaring 20s' and the happy period between the First World War and the Great Depression. The striving for luxury and the fascination with contrasting colours, precise geometry, and motifs and ornaments from non-European civilisations created a unique fusion of images and compositions. In Soviet monumental and decorative art, features of art deco (with respect to architecture, people usually talk of 'postconstructivism' and the 'Style of 1935') made their appearance during the period of the New Economic Policy (NEP) in the 1920s and persisted even in the post-war years. In the 1930s the task of monumental art was to promote the new policy of the young country, replace the attributes of monarchical authority with new symbols of the state, persuade people to perform heroic feats of labour, and glorify the victory won in the revolution. The abundance of food, successes in industrialisation, and attainments in agriculture were declared fruits of joyful labour by healthy and happy citizens.

The collaboration between Aleksandr Deyneka and Metrostroy, the organisation responsible for building the Moscow metro, was a unique instance in the history of both architecture and art. Deyneka created oval mosaic panels for Mayakovskaya station, which is in the art deco style. By the end of the 1930s, Deyneka, a graduate of Kharkov Art School and Vkhutemas in Moscow, had managed to create designs for decoration of propaganda trains, sketches for panels for international exhibitions in Paris, and the 'monumental historical-revolutionary picture "The Defence of Petrograd"'. He drew posters, worked for the theatre, and painted lyrical landscapes, aviators, and sports players. Deyneka's mosaics at Mayakovskaya and Novokuznetskaya stations represent the happy period in Soviet art when themes and a set of subjects had been defined, but the figurative canon of 'socialist realism' was only just beginning to take shape. For the first time in history, the ancient genre of the mosaic was being used to depict modern industrial subjects; smalt was being arranged in patterns that represented cranes, tractors, trains, and airplanes.

Deyneka, A. A., 'Playing Ball' from the series 'A Day in the Life of the Country of the Soviets', 1938. Mayakovskaya metro station, underground hall. 001B

Mayakovskaya metro station, underground hall
architect: Dushkin, A. N.

001 B

Deyneka, A. A., workshop of Frolov, V. A.
'A Day in the Life of the Country of the Soviets' (34 panels)
1938

One of the most beautiful stations in the Moscow metro (the Soviet state's emblematic project for giving the proletariat palaces of its own), Mayakovskaya metro station was built by Aleksey Dushkin (1903–1977), an engineer and architect from Kharkov. Arches of polished stainless steel divide the underground hall into 35 sections and Dushkin designed mosaic panels for each of their oval vault-like domes. The hereditary mosaicist and academician Vladimir Frolov (1874–1942) recommended the artist Alexsander Deyneka

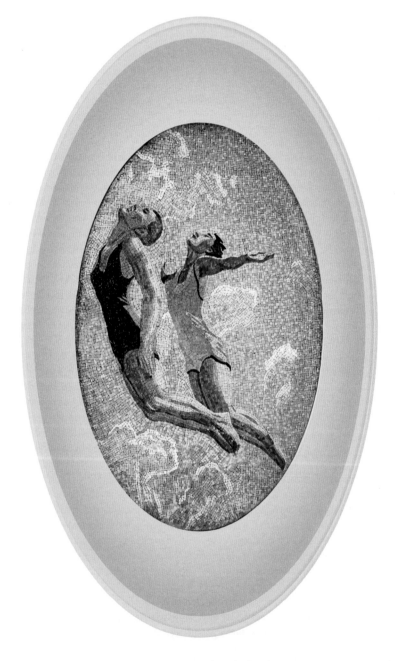

(1899–1969) to Dushkin. It was Deyneka's idea to display an entire suite of mosaics: 'A series of pictures in succession – construction projects, tractors and combines traversing enormous kolkhoz fields, gardens in blossom, ripening fruit, skies busy with airplanes day and night, young people labouring heroically and then having a wonderfully good time, or getting ready to work or defend the country. The life of the USSR pulsing with vitality 24 hours a day.' Although Deyneka later complained that Dushkin had fragmented the space and put the mosaics up too high, close to the ceiling, the use of 16 sconces to illuminate each mosaic oval was an indubitable success. No other mosaic in Moscow has achieved such striking brightness of colour and radiance. Mayakovskaya metro station, with its columns decorated with semiprecious stone (rhodonite), floors laid with suprematist black squares, and Soviet citizens at work and leisure against the background of the sky in its domes, was awarded the Grand Prize at the World Exhibition in New York in 1939.

1

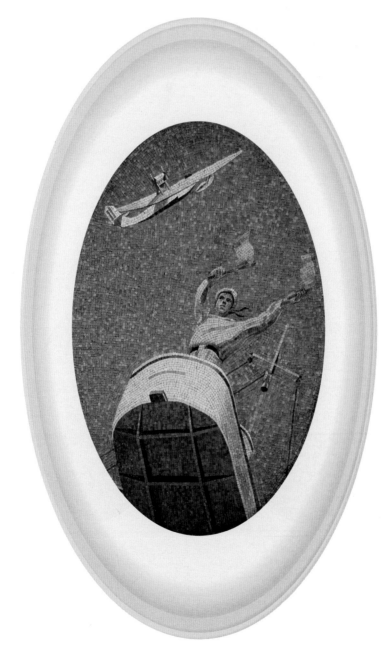

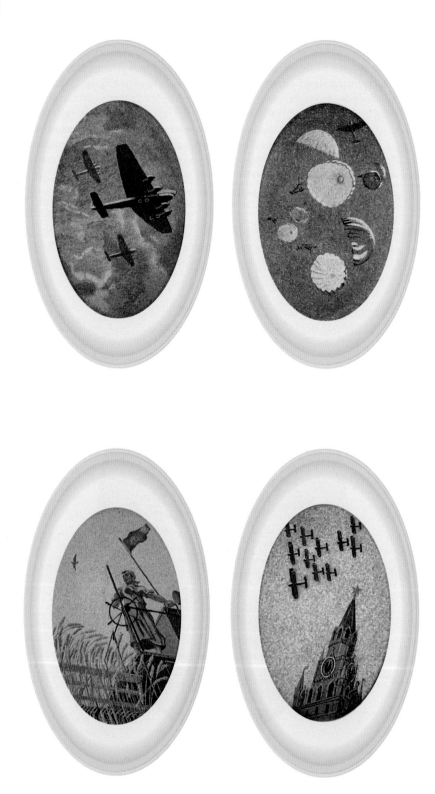

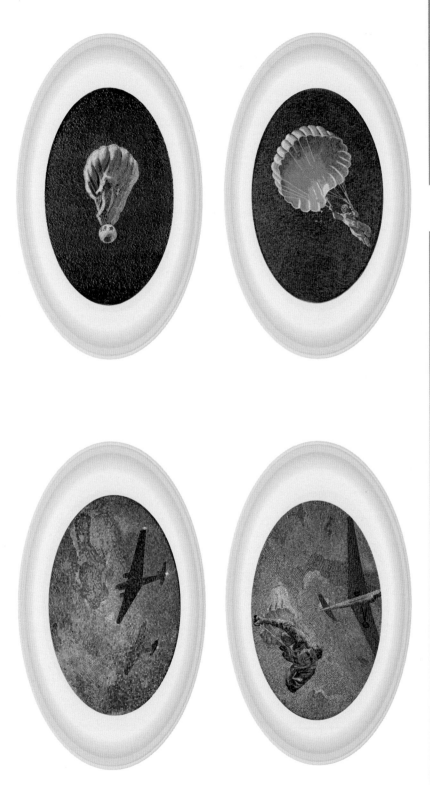

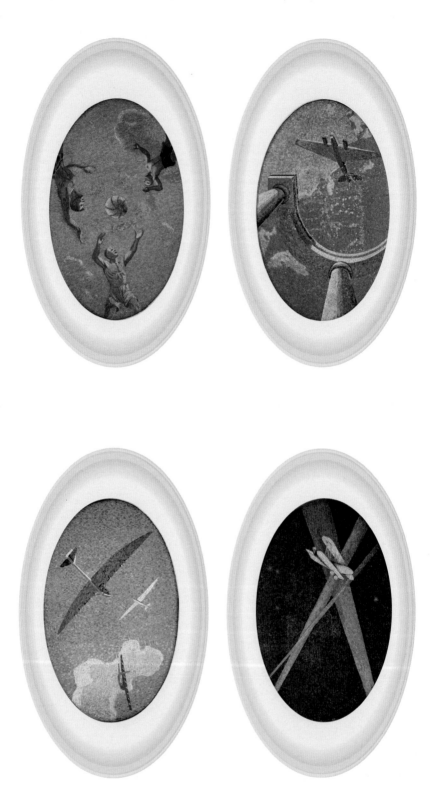

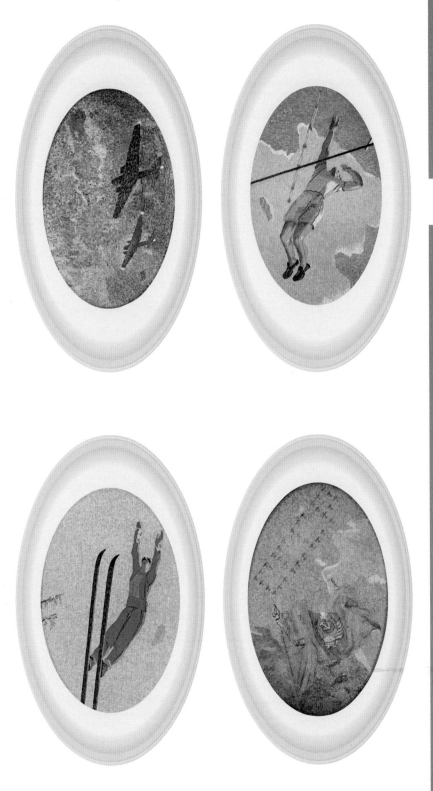

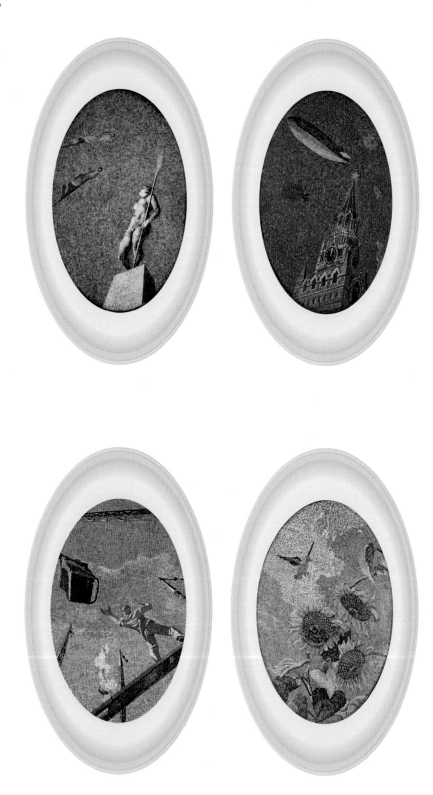

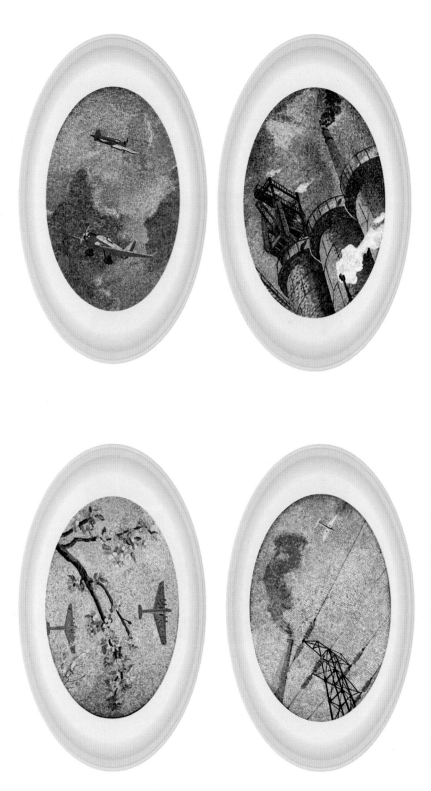

1

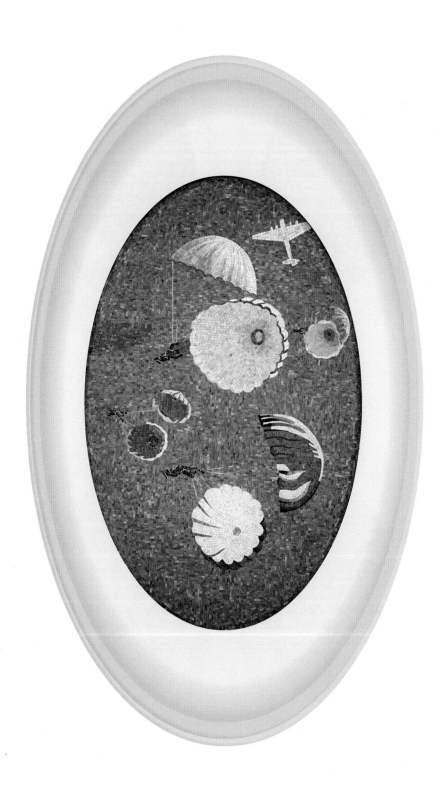

1

**Novokuznetskaya
metro station,
vestibule,
underground hall**
architects: Taranov, I.G.,
Bykova, N.A.

002 G

Deyneka, A.A., workshop of Frolov, V.A.
'Gardeners', 'Steelworkers', 'Machine
Builders', 'Builders', 'Aviators', 'Skiers',
'Parade of Gymnasts'
1943

Another work by Deyneka in the Moscow
metro is a series of 14 octagons concern-
ing the Moscow–Donbass railway line.
This was intended for Paveletsky vokzal
(or Donbasskaya) metro stations, which
were designed by the constructivist ar-
chitects Viktor and Aleksandr Vesnin. In
the end, half of these mosaics were in-
stalled at neoclassical Novokuznetskaya
station, whose vaulting is much lower
than the Vesnins' station for which they
had originally been designed. Poster-like

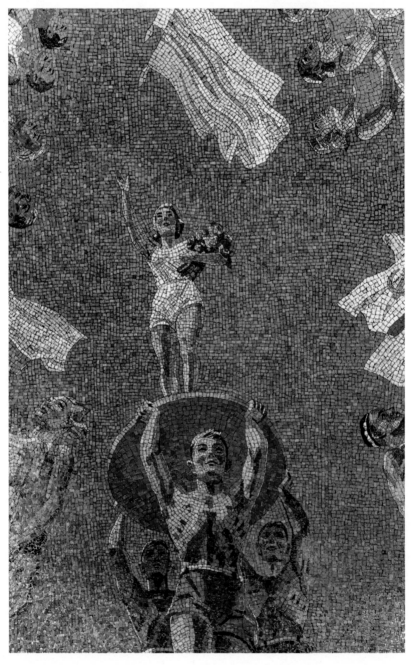

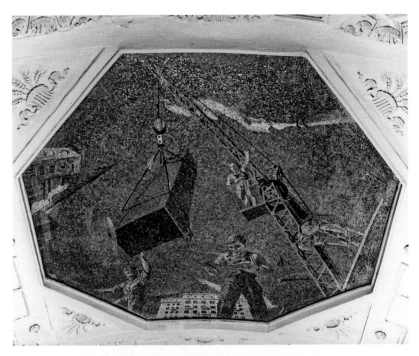

1

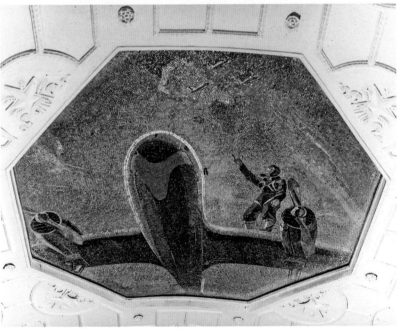

foreshortening and the large area to be covered allowed Deyneka to construct complex scenes with large numbers of figures. Metro passengers found themselves on a construction site, in the workshop of a metal factory, or under a bridge with a train passing overhead. Successes in industrialisation in the USSR were illustrated by a mosaic airplane, tractor, and crane. These ceiling pieces can be viewed and admired as you move through the station in any direction. The underground halls at Novokuznetskaya feature six octagons; a further octagon depicting a parade of gymnasts was placed in the station's above-ground vestibule. Critics of the time accused Deyneka – 'one of our typical monumentalists' – of having a 'poster-like graphic style' that needed to be suppressed.

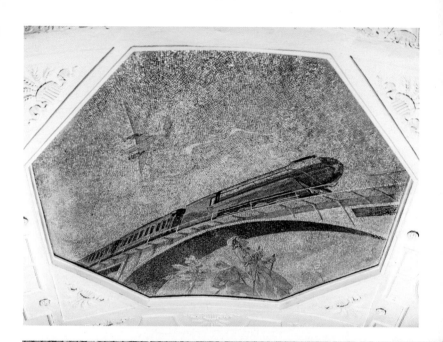

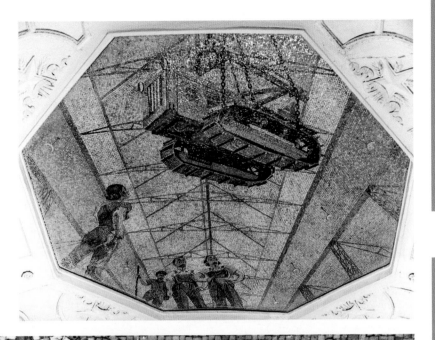

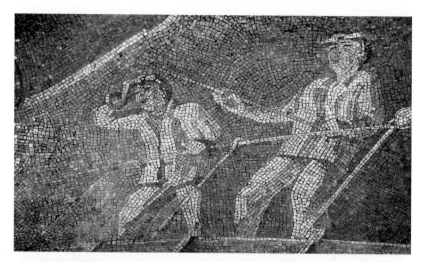

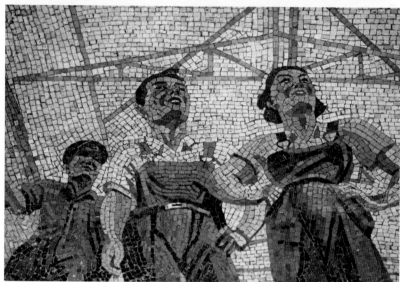

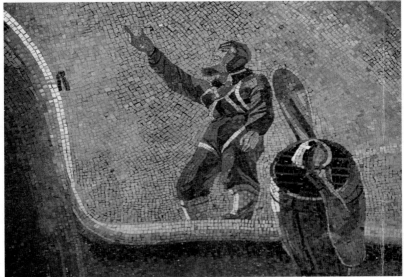

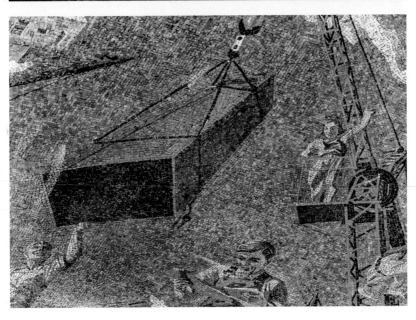

**Avtozavodskaya
metro station, vestibule**
architect: Dushkin, A. N.

003 **I**

Zavod imeni Stalina (Avtozavodskaya since 1956) metro station was designed by Aleksey Dushkin, the chief architect at Metrostroy, and opened during the war. Dushkin also designed the station's southern vestibule, which is decorated using mosaics by Vasily Bordichenko and Boris Pokrovsky. The sketches for the mosaics were discussed with Evgeny Lansere, an academician and member of Mir iskusstva. By all appearances, it was Lansere who suggested using the image of the *bogatyr* (epic hero): the latter's pointed helmet and spear reinforce the rhythm of the towers of the Kremlin. The entire

*Bordichenko, V. F., Lekht, F. K.,
Pokrovsky, B. V*
'Heroes' ('Parade on Red Square')
(1940)–1943

epic/decorative and centred composition is far removed from the socialist realism of the mosaics by the same authors on the station's underground hall. It depicts a real event: the parade in Red Square on 7 November 1941 in honour of the 24th anniversary of the October Revolution. The new model KV-1 (centre) and model T-35 (sides) tanks that took part were dispatched to the front soon afterwards. The parade took place as German troops were on the approaches to the city but was strategically important in demonstrating the successes of Soviet military factories and the army's readiness for battle.

1

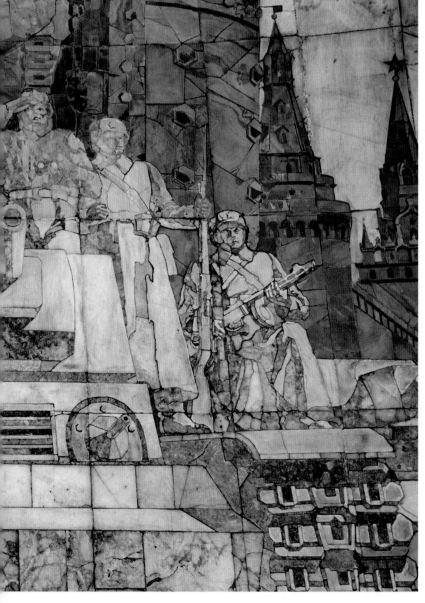

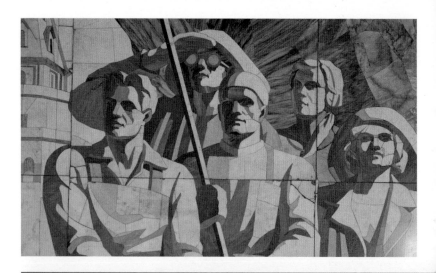

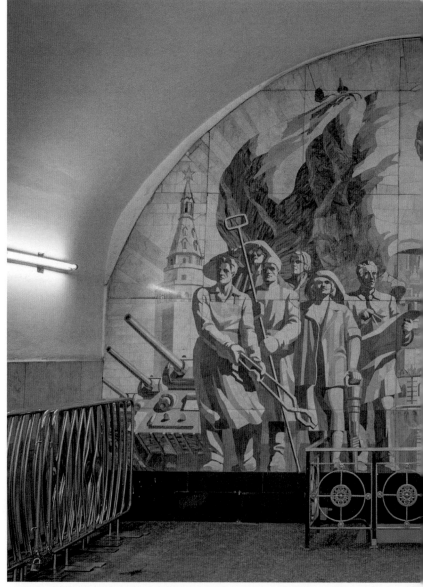

Novokuznetskaya metro station, end wall of the underground hall
architects: Taranov, I. G., Bykova, N. A.

Pokrovsky, B. V.
'The Front and Rear in the Fight Against the German Occupiers'
(1940)–1943

This Florentine mosaic of white/yellow and grey marble depicts Soviet soldiers and workers at an arrow-slit tower at the Moscow Kremlin. A flag flutters between the 'rear' and the 'front'. The centre once featured a portrait of Joseph Stalin, but this was replaced in the 1960s with the head of Lenin. Among the rear personnel, miners, and metal workers are the station's architects: Ivan Taranov carrying technical drawings and compasses and Nadezhda Bykova, a 'female metro construction worker' with a jackhammer. The central underground hall was extended in 1970 and the panel 'moved' to part of the cross-over passage.

1

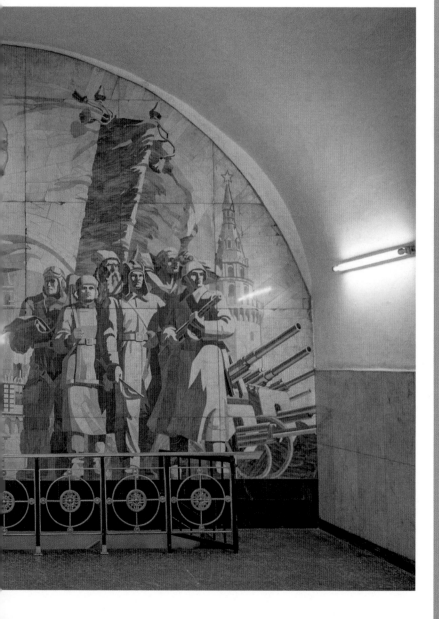

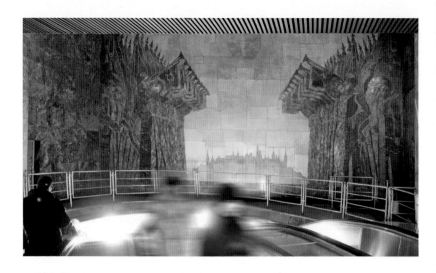

Paveletskaya metro station on the Zamoskvoretskaya Line, vestibule

Bordichenko, V. F., Mashkovtseva, E. D.
'Fanfare in Honour of the People and its Leader, I. V. Stalin'
('Fanfare Players Announcing Victory')
1943

After Stalin's personality cult was debunked, the marble panel in shades of red and grey decorating the wall behind the escalator in the above-ground pavilion of Paveletskaya metro station lost the profile of Stalin that had occupied the centre of the composition, above outlines of the ensemble of buildings in the Kremlin (traces of the portrait are visible to this day). The Red Army, established immediately after the revolution, was renamed 'the Soviet Army' after 1946. The red body of fanfare players standing in profile is articulated by the rhythm of hands holding trumpets and the wooden flagpoles of the red standards. The melting light-grey silhouette of the Kremlin gives the composition a romantic resonance.

Baumanskaya metro station, end of the underground hall
architect: Iofan, B.M.

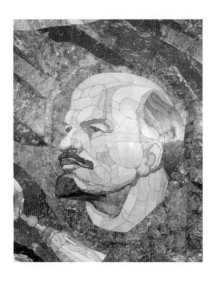

Bordichenko, V. F., Pokrovsky, B. V.
(Ivanov, A. T.)
(1940)–1945

1

Judging by the appended dates, the three mosaic red flags at the end of the underground hall of Baumanskaya metro station represent liberation movements: the revolutions of 1905 and 1917 and the Great Patriotic War, during which the station opened in 1944. The centre of the scarlet banner once featured profiles of Lenin and Stalin. The mosaic was rearranged in 1963 by the artist Aleksandr Ivanov, who also worked on the panels for Kievskaya metro station on the Circle Line. Since then, only Lenin observes departing trains from the flag in the station's middle nave. Beneath the standards is a decorative composition with a five-pointed star, the year 1945, barrels of weapons, and a laurel wreath, all laid out in grey marble. The red marble of the mosaic beautifully fits the architecture of the station, which was named after the prominent Russian revolutionary Nikolay Bauman and designed by Boris Iofan in quartzite, granite, and ceramic tiles in shades of red. The station was supposed to be dedicated to the Spartacist uprising, but the niches contain sculptures of Red Army soldiers, partisans and metro builders rather than gladiators.

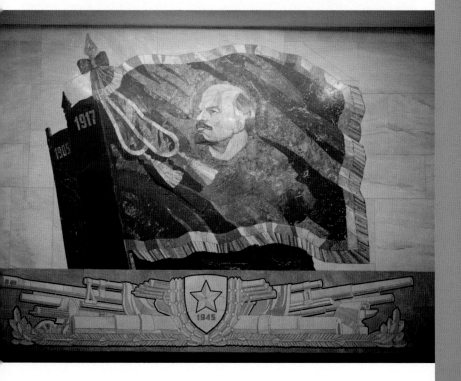

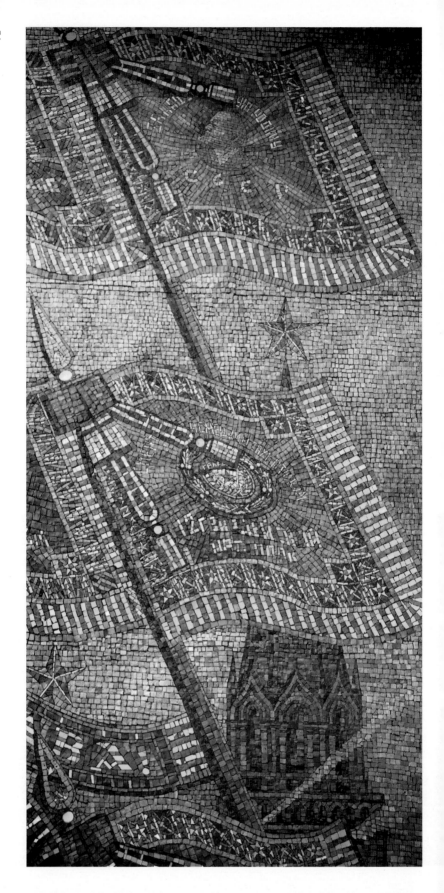

Baumanskaya metro station, vestibule

1

Rabinovich, I. M.
'Flags of Victory'
1947

The escalator tunnel leading down to the underground hall of Baumanskaya metro station was designed by the theatre designer Isaak Rabinovich in the style of a triumphal arch. The central inscription on the scarlet ribbon reads 'Glory to the Soviet Army'. It is topped by the Order of Victory, the USSR's highest military decoration, and it is possible to make out the mausoleum and the Spasskaya Tower in the Kremlin inside its five-pointed star. The Kremlin's towers also stand at either side of the entire composition of 16 standards of guards regiments (16 to match the number of Soviet republics, including the Karelo-Finnish Soviet Socialist Republic). The use of a combination of red and golden smalt throughout the essentially decorative composition of flags and ribbons gives the frieze a resemblance to a theatre curtain. Stalin's words – 'Our battlefront and rear are a single, inseparable military camp' – were removed from the panel following the Party's twentieth congress in 1956 and the debunking of the personality cult by Nikita Khrushchev.

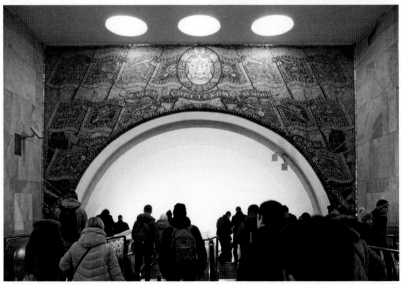

Baumanskaya metro station, end of the underground hall

Ploshchad Revolyutsii metro station, eastern vestibule

architects: Zenkevich, Y. P., Dushkin, A. N., Demchinsky, N. I.

Bordichenko, V. F.
'15 Soviet Republics'
(1940)–1947

The Florentine-mosaic composition on the wall of the semi-circular hall faced in light-coloured marble is dedicated to the 30th anniversary of the October Revolution. Scarlet banners bear the dates 1917 and 1947 framed in oak leaves. A shield with the hammer and sickle is in the centre of 18 standards. To the left and right of the state symbols, the first and last couplets of the first version of the hymn of the USSR (1943) are shown in bronzed letters. The quote ends with the words: 'Soviet flag, people's flag / May it lead us from victory to victory!' These words were removed from the hymn in 1977. The policy of de-Stalinisation resulted in the word 'flag' being replaced with 'Party of Lenin' and 'victories' with 'the triumph of Communism'.

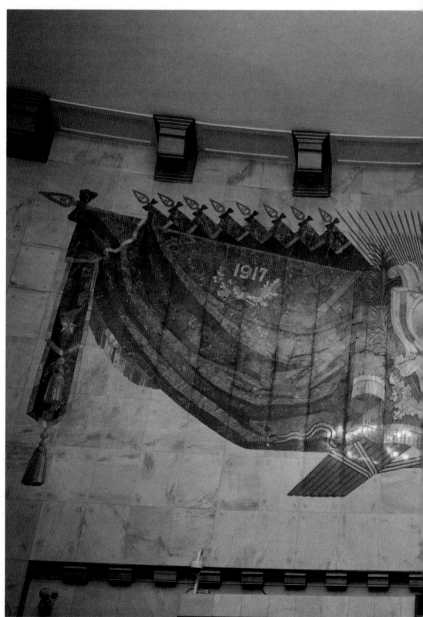

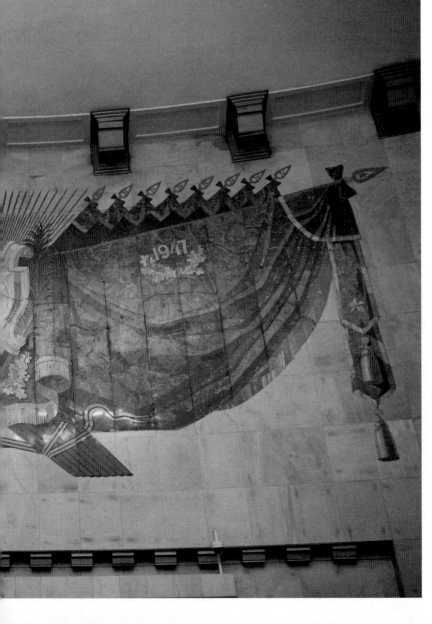

Paveletskaya metro station on the Circle Line, vestibule

009 **I**

Rabinovich, I. M.
'Stalin's Plan for Transforming Nature'
1950

The dome of the vestibule of Paveletskaya metro station on the Circle Line is decorated with a frieze consisting of marble mosaic, coloured and golden smalt, and wrought-iron details. The words of the 'Hymn about the Forest' by an unknown author are a reference to Stalin's plan to transform nature by planting forests after the drought and famine of the mid-1940s. Isaak Rabinovich arranged the marble letters of the hymn directly on the standards: 'We shall clothe the Fatherland in forests and gardens / We shall make war on the deserts / We shall put an end to drought forever / The face of our native earth will change!' This plan was abandoned after Stalin's death in 1953. Many belts of woodland were cut down, and the profiles of the general secretary in the centre were replaced with five-pointed stars. In this relatively narrow frieze, Rabinovich managed to convey in allegorical form the planting of trees as a means of protecting agriculture: bundles of ripe ears of corn surge behind the garlands of oak and other leaves. The frieze at Paveletskaya station is remote from the aesthetic of socialist realism, being more reminiscent of mannerist graphic vignettes from the turn of the twentieth century.

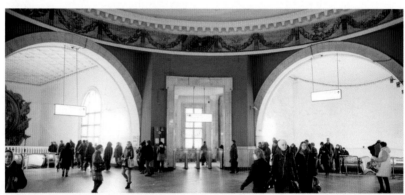

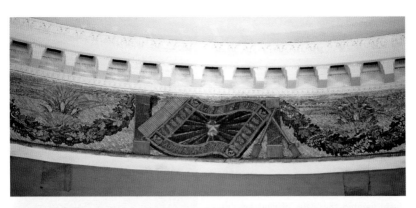

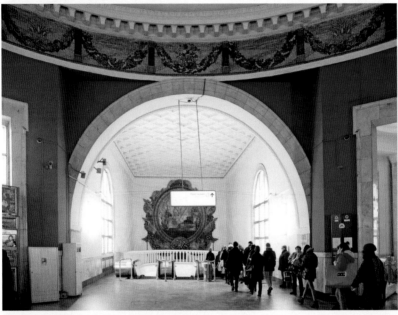

1

Novoslobodskaya metro station, end wall of the underground hall
architect: Dushkin, A. N.

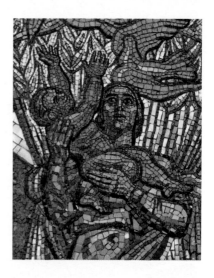

Korin, P. D., Bordichenko, V. F., Pokrovsky, B. V.
'Peace Throughout the World'
1952

The monumentalist artist Pavel Korin, a hereditary icon-painter who had previously painted the walls of churches, devised for Novoslobodskaya metro station stained-glass panels with ornamentation based on patterns of fabrics used in church vestments in pre-revolutionary Russia. He also decorated the end wall of the central hall with a large panel. This mosaic of stone and coloured and gold smalt combines a gigantic depiction of the emblems of the USSR (a five-pointed star and a hammer and sickle) and symbols of prosperity (a golden sheaf of wheat, fruit trees) with a figure of a woman and a child. Korin's model was the wife of Aleksey Dushkin, the architect of Novoslobodskaya station. Korin's 'Soviet Madonna', placed as if in the apse of an underground church, is reminiscent of Raphael's Sistine Madonna in both its pose and red-blue clothing. The figure's bare feet were 'shod' in sandals following orders from Khrushchev himself. His next order was to dismantle the mosaic, but this was not carried out. Following Khrushchev's removal from power, the wall concealing Korin's panel was demolished, the sandals were removed, and Korin himself replaced Stalin's profile in the centre of the composition with doves, an olive branch, and a ribbon with the inscription *МИР* ('Peace').

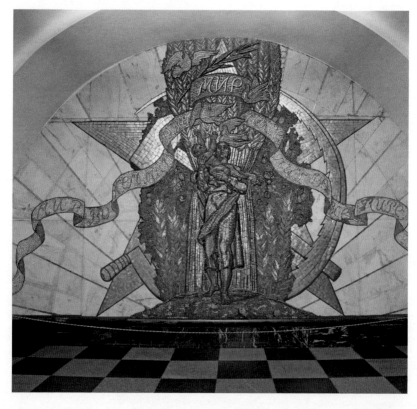

1

Medical emblem
Novopeschanaya ulitsa, 8/2

Unknown artist
1980s

The composition in a moulded-plaster frame on an entrance to a Stalinist residential building was probably executed by an amateur artist. Diverging rays decorate the background of the mosaic with a medical emblem: the Bowl of Hygeia.

The motif of the rising sun, characteristic of art deco, was often encountered during the Soviet era in heraldry, window grilles, and prison tattoos. Another mosaic composition appeared on the same building in 1997 on the eve of the 850th anniversary of Moscow. The silhouette of Pokrovsky Cathedral – the church 'named' by ordinary people in honour of Vasily the Blessed, a well-known holy fool from the time of Ivan the Terrible – soars against a background of a festive fireworks display.

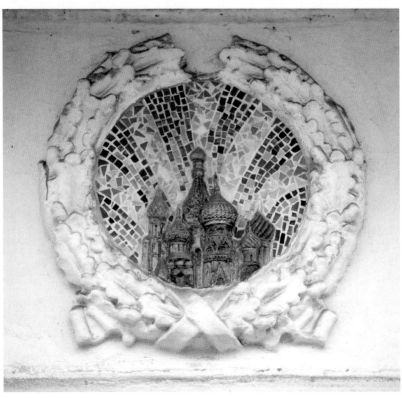

TsSKA
swimming pool

architects:
Averintsev, B.I.,
Gaygarov, N.I.
Leningradsky prospekt, 39, bldg. 9

Favorsky, V.A.
1954

012 A

The swimming pool building was erected at the initiative of Joseph Stalin's younger son. Vasily Stalin was a military pilot and became the commander of the air force of the Moscow Military District following the end of the Second World War. He played an active role in promoting the development of physical culture and sport. After his father's death, Vasily Stalin was arrested on charges of misuse of funds and anti-Soviet activity. The 50-metre Olympic swimming pool was completed without his patronage or supervision. Situated next to an airfield, the swimming pool has an aircraft hangar as its roof. The load-bearing structure is camouflaged by a succession of columns, mouldings, and mosaics. The main thematic motif in the decoration of the building's façade is a Renaissance 'superfluity': the shell. The central part under

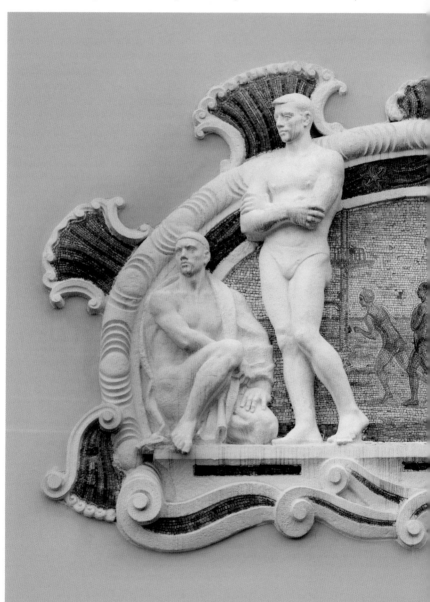

the arched vault features a composition involving sculpture and mosaic. The originality and slight absurdity of this panel is because of its combination of plaster figures of swimmers and a female swimmer in the foreground with a smalt composition inside a cartouche. The composition depicts a group of people launching themselves from a diving tower on a sandy beach. Nikolay Gaygarov, one of the pool's architects, would later collaborate in designing the Museum of Armed Forces of the USSR, a modernist building that featured an interior decorated with a large mosaic.

1

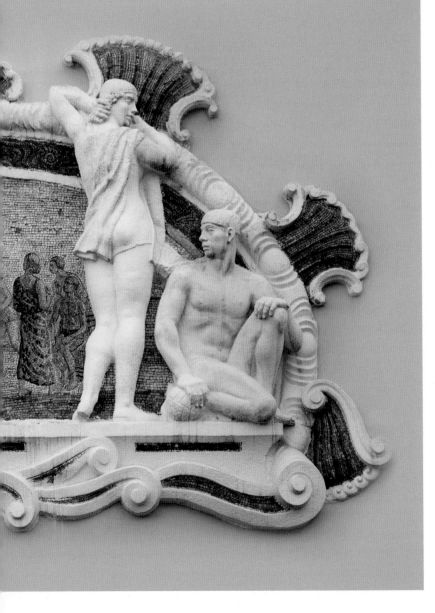

Armenia (shop)
Tverskoy bulvar, 28

013 C

Vartanyan, A. V.
'Sunny Armenia'
1952

1

Visitors to this well-known Moscow shop and café are met by an Armenian girl with a basket of fruit on her shoulder and glimpses of Mount Ararat in the background. The grapevines in the mosaic are continued in the moulded frame. The panel's author is Armen Vartanyan (1923–1985), who received his early art education in the workshops of the Yerevan Art School in the 1940s. He also worked as a muralist on the construction of the Palace of Soviets in Moscow, assisted Pavel Korin, and attended classes at the Moscow Institute of Applied and Decorative Art. From the late 1940s to mid-1950s he was a head of the monumental workshop of the Moscow Union of Artists. The 'Sunny Armenia' mosaic was made of smalt and semiprecious stones: jasper, malachite, pink rhodonite. Members of the artistic council considered the panel to be 'the first monumental mosaic work in the history of Armenian art during the Soviet period'.

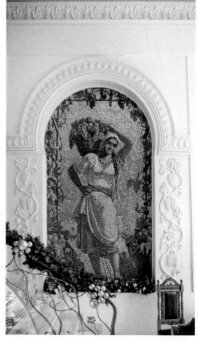

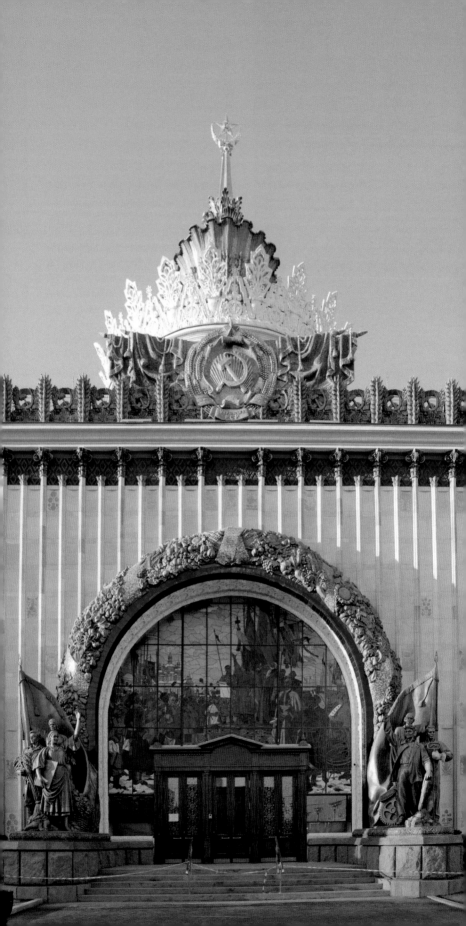

Pavilion of the Ukrainian Soviet Socialist Republic (No. 58, 'Agriculture')
architects: Tatsy, A. A., Chuprina, V. I.
VNDH
Prospekt Mira, 119

014 A

Orlov S. M., Antropov, A. P., Slonim, I. L., Rabinovich, S. D., Shtamm, N. L.
'Maidens with Laurel Wreaths'

Ryleeva Z. V.
'Emblem of the Ukrainian SSR'
1954

Pavilion No. 58 was one of the largest and most conspicuous pavilions at the All-Union Agricultural Exhibition (VSHV, now VDNH; the Exhibition of Achievements of the National Economy). The pavilion was built in 1939 according to a design by the Ukrainian architects Aleksey Tatsy and Valentina Chuprina. It was reconstructed in 1954 and given new and opulent decoration. The rectangular building is faced in ceramic tiles with relief images of symbols of the wealth of Ukraine, the 'granary of the USSR'. These symbols include sunflowers, sheaves of wheat, ox heads, bees, honeycombs, and even fish. The centre of the façade features a relief emblem of Ukraine, faced in smalt, with flags. The rotunda is topped with a 'golden' mosaic sheaf, while the corners of the buildings have gigantic maidens, also of 'gold', and known as Glories. Each Glory has a laurel wreath in her hand and a wreath of flowers on her head, a detail from Ukrainian folk dress. Mosaic fragments (a wreath symbolising 'Abundance') also decorate the ceramic flower-and-fruits archivolt of the arch of the pavilion's main entrance. The internal space of the arch is occupied by a stained-glass panel based on motifs from Mikhail Khmelko's *The Pereyaslavl Rada of 1654*, which marked the 300th anniversary of the reunification of Ukraine and Russia. The Ukrainian SSR Pavilion was renamed 'Agriculture' in 1964, which gave the maidens covered in golden smalt on its roof additional allegorical meaning.

1

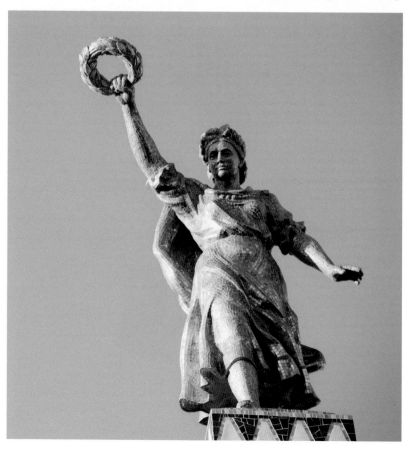

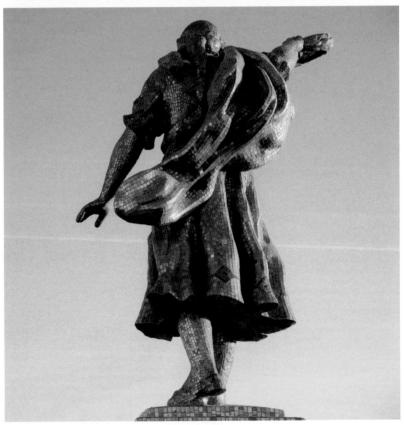

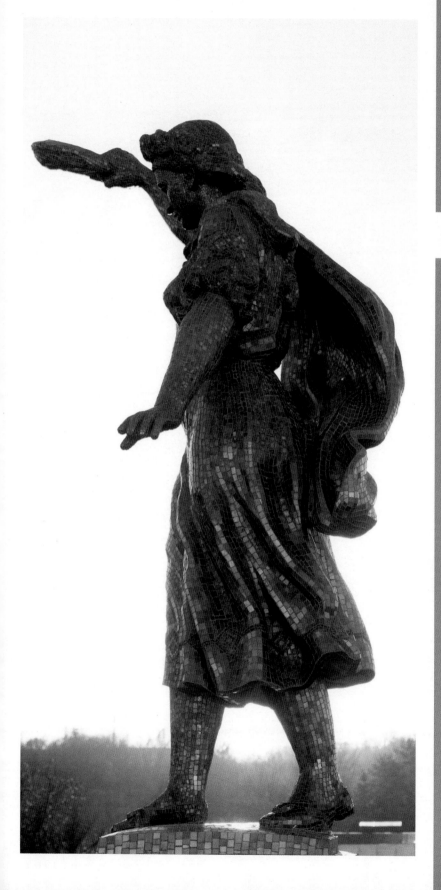

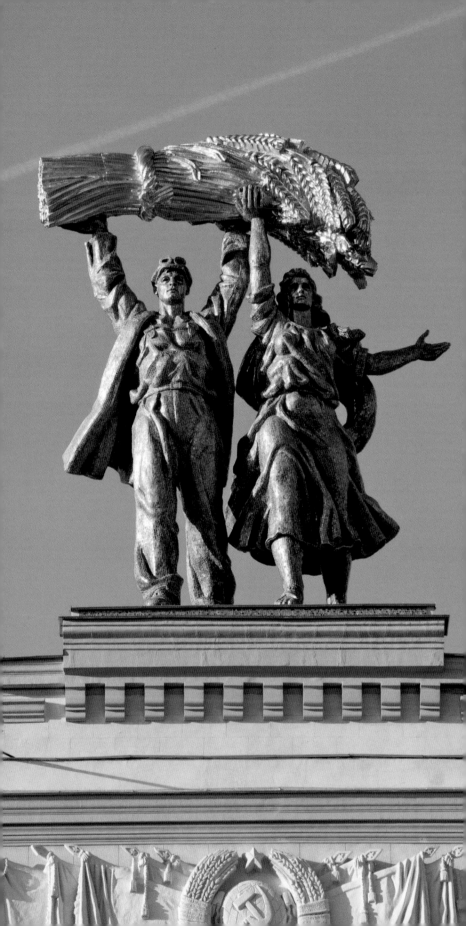

Arch
of the main
entrance
architect: Melchakov, I. D.
VNDH
Prospekt Mira, 119

Orlov S. M., Antropov, A. P., Slonim, I. L.,
Rabinovich, S. D., Shtamm, N. L.
'Tractor Driver and Kolkhoz Woman'
1954

The concrete, gold-covered figures of the tractor driver and kolkhoz woman holding aloft a brass sheaf together in their extended hands stand at the top of the main entrance to the VDNH, simultaneously serving as an emblem of the entire exhibition. In terms of plasticity, the sculpture is inferior to its prototype – Vera Mukhina's *Worker and Kolkhoz Woman*, which was assembled from sheets of steel for the USSR pavilion at the 1937 Paris exhibition and now stands nearby. Innokenty Melchakov, the architect of the post-war entrance to the VDNH, was selected following a competition. He took part in designing the USSR pavilion at the World's Fair in New York in 1939.

1

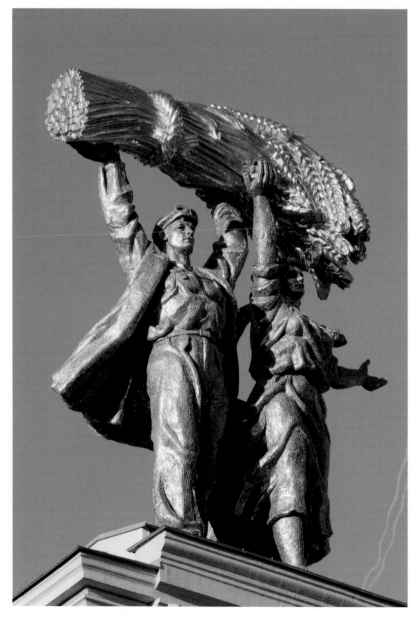

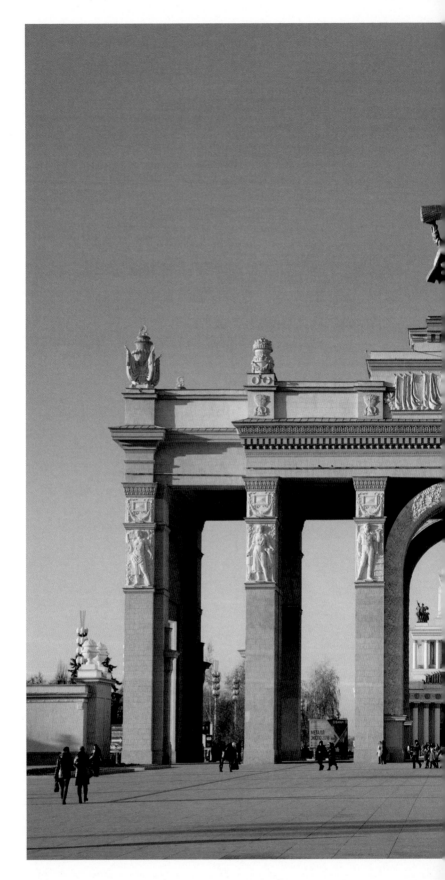

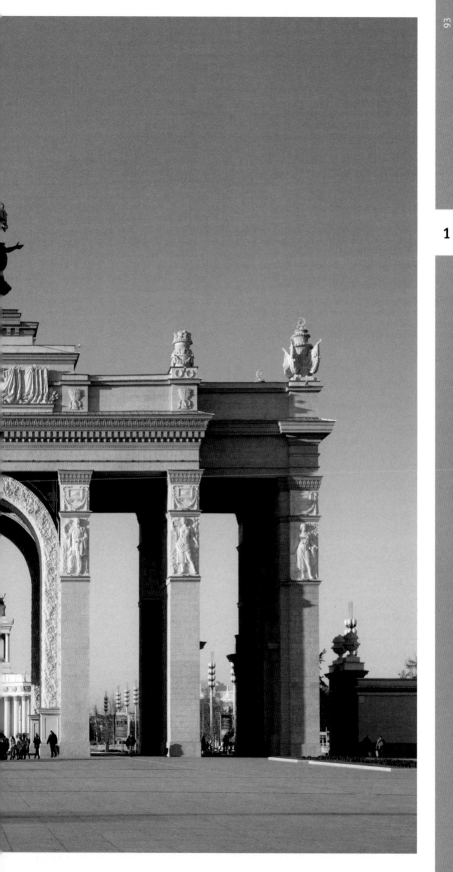

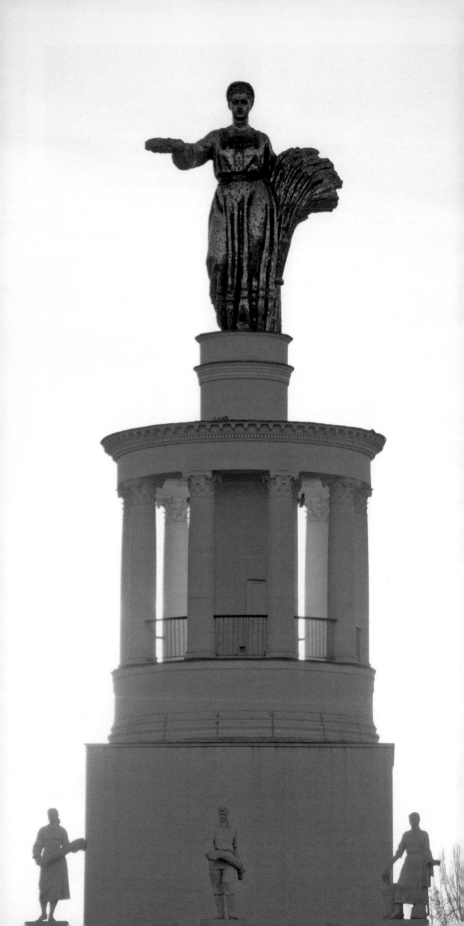

Pavilion of the Belorussian SSR (Pavilion No. 18, 'Electric Equipment', 'Republic of Belarus')

016 A

architects: Zakharov, G. A.,
Chernysheva, Z. S.
VNDH, Prospekt Mira, 119

Bembel, A. O. 'Motherland'
1954

The female figure standing on the rotunda refers in its architectural composition to both the 'Civic Glory' of the famous City Hall building in Manhattan in New York and the ballerina (now dismantled) of the 'House Under a Skirt' on the corner of Tverskaya ulitsa and Tverskoy bulvar in Moscow. 'Motherland' by sculptor Andrey Bembel (1905–1906), a People's Artist of the Belorussian SSR (1955), holds the laurel wreath of glory in her right hand and a sheaf in her left. Under the rotunda there are five figures of no great size relative to the allegorical Motherland; these figures are the 'Labourers of Belorussia'.

1

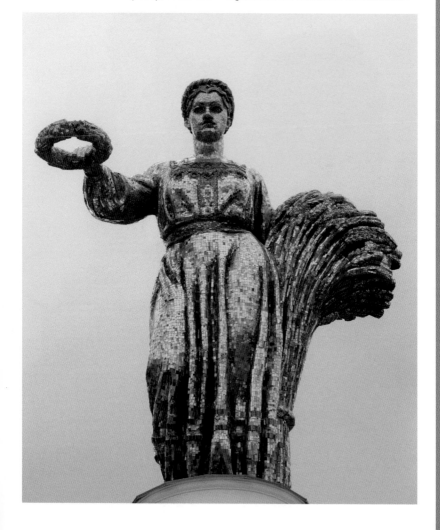

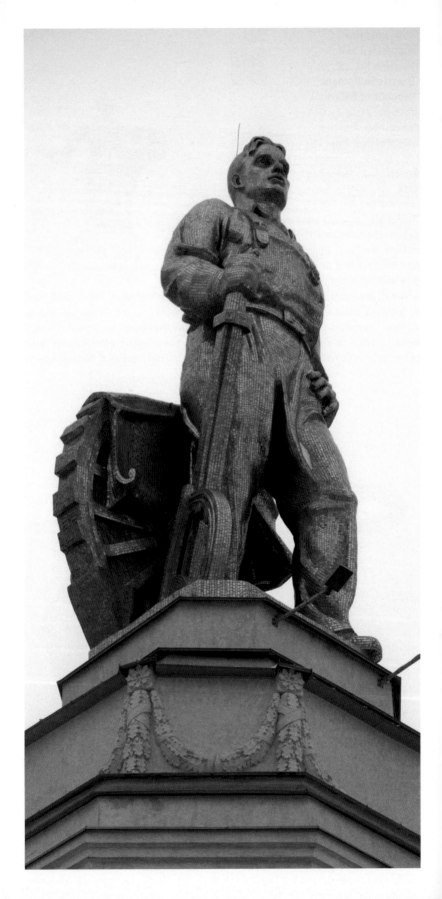

**Mechanisation Pavilion
(No. 34, 'Mechanisation
and Electrification
of Soviet Agriculture',
'Machine Building',
'Urban Planning', 'Space')**
architects: Andreev, V. S., Taranov, I. G.,
Bykova, N. A.
VDNH

017 A

*Orlov, S. M., Antropov, A. P., Slonim, I. L.,
Rabinovich, S. D., Shtamm, N. L,
Dobrynin P. I.*
'Machine Operator'
and 'Female Tractor Driver'
Prospekt Mira, 119
1954

The Mechanisation Pavilion designed by
Vyacheslav Oltarzhevsky, principal ar-
chitect of the VSHV, initially resembled a
'wooden skyscraper' and was ill suited to
demonstrating agricultural equipment.
Oltarzhevsky was arrested and sent to a
prison camp in 1938. The pavilion was dis-
mantled and rebuilt in 1939 in the form of
an enormous hangar that was open on two
sides and functioned only during the sum-
mer. An enormous glass dome and a main
façade with two towers were built onto it

in 1954. The towers were topped with fig-
ures of a machine operator and a female
kolkhoz combine driver covered with
golden smalt. Leading Soviet sculptors
Vera Mukhina and Ivan Shadr were invit-
ed to execute the sculptural decoration of
the Mechanisation Pavilion, but declined
due to the tight deadline. Work on creat-
ing the reliefs was supervised by Sergey
Merkurov. The female tractor driver at the
wheel and the machine operator were cast
in concrete and covered in golden smalt.
They were the responsibility of sculp-
tor Sergey Orlov (1911–1971), author
of 'Maidens with Laurel Wreaths' at the
Ukraine Pavilion and 'Tractor Driver and
Kolkhoz Woman' at the main entrance to
the VDNH. Orlov also assisted in creating
the equestrian statue of Yury Dolgoruky
at Moscow City Council on ulitsa Gorkogo
(now Tverskaya ulitsa) in 1954. Pavilion
No. 34 was renamed 'Space' in 1967 to
mark the 50th anniversary of the October
Revolution. Its halls contained an exhibi-
tion dedicated to the USSR's successes in
space. The golden kolkhoz female machin-
ery operators standing against the back-
ground of the glass dome are now neigh-
boured by the Vostok carrier rocket: they
look utterly surrealistic.

1

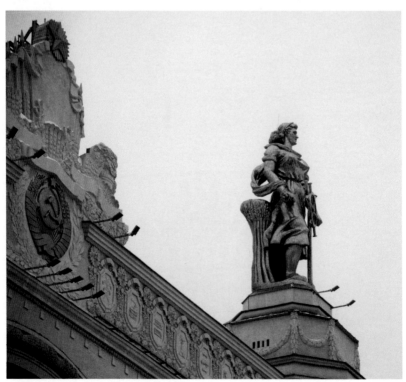

'Stone Flower' (fountain)
VDNH

018 A

architect: Topuridze, K.T.;
sculptor: Dobrynin, P.I.
Prospekt Mira, 119
1954

A fountain with two gigantic cornucopias stood in front of the Ukraine Pavilion at the 1939 exhibition. Konstantin Topuridze and Prokopy Dobrynin designed a fountain for this spot at the beginning of the 1950s. Called 'Golden Sheaf', it featured female figures that are allegorical representations of the Soviet Union's republics. The entire composition subsequently moved closer to the central entrance of the VNDH, coming to rest immediately behind the main pavilion where it became known as 'Friendship of Peoples'. Another fountain then appeared next to the Ukrainian pavilion. It was called 'Stone Flower' after the intoxicating flower that grew inside the malachite mountain in the story by Pavel Bazhov. If you believe Bazhov, the flower did not bring anything good to those who encountered it ('whoever casts eye on it will find no favour in the whole wide world'). The concrete petals of the green 'malachite' flower that open on the 'crystals' and 'semi-precious stones' were faced in multi-hued smalt by craftsmen at the Academy of Arts of the USSR. The stepped and circular composition of the fountain refers to Latona – the fountains at Versailles in France and Bavaria's Schloss Herrenchiemsee (Leto or Latona, beloved of Zeus and pursued by Hero, the goddess of the Earth, gave birth to the twins Apollo and Artemis on an island in the sea). Imitating palace complexes and royal residences and intended to demonstrate the prosperity of the new empire, the ensemble of buildings at the Soviet Union's principal exhibition constitutes an amazing fusion of Greek mythology, classical tradition, and the folklore of the Soviet peoples, whose images are sometimes in direct contradiction with one another. Restoration of the fountain was completed in the spring of 2019. It no longer even vaguely recalls a stone flower: even when obscured by torrents of water, the new smalt blinds onlookers with bright plastic colours.

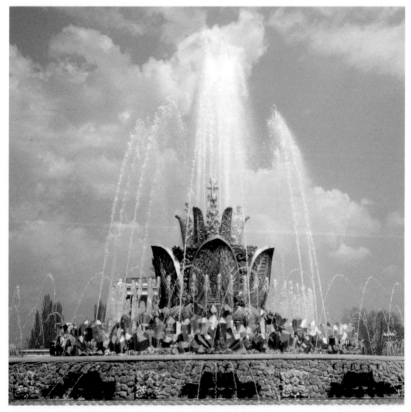

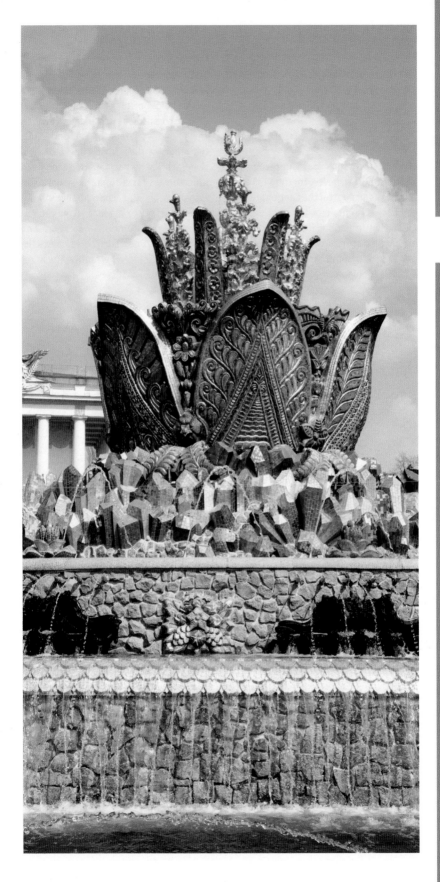

'Golden Ear' (fountain)
VDNH

019 A

architects: Topuridze, K. T.,
Konstantinovsky, G. D.;
sculptors: Dobrynin, P. I., Petrov, I. M.
Prospekt Mira, 119
1954

The first 'ear of corn' fountain designed by Vyacheslav Otarzhevsky for the 1939 exhibition was made after the deep impression the Cactus Fountain at the 1931 Colonial Exhibition in Paris made on him. It was an elegant structure consisting of copper sheets, a spiral, and a small sphere. The new 'Golden Ear' (1954), standing on a granite base in the middle of a pond, was designed in reinforced concrete by the authors of the 'Friendship of Peoples' and 'Stone Flower' fountains. Clad in gold and red smalt, the cone-like ear stretches to a height of 16 metres and grows out of four cornucopias spilling forth fruits. The fountain's jets spring directly from the grains of the ear, forming a distinctive 'rachis'. The naturalistic second ear, which breaks forth from the smooth surface of the pond, is considerably inferior in its plasticity to the first, while the surrealism of this situation – wheat growing in water – does not impart elegance to the sculptural design. The fountain was restored in 2017–2018.

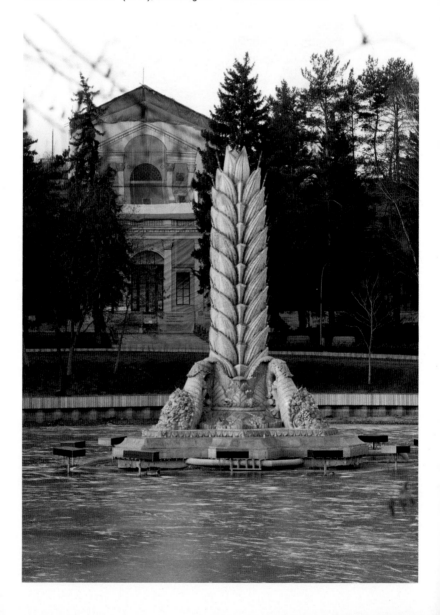

Lomonosov Moscow State University (MGU) Principal building, vestibule

Vorobievy gory, 1

020 H

Deyneka, A. A., Arakelov, V. N.
'Portraits of Great Scholars'
1950

Lev Rudnev, the principal architect of the Moscow University high-rise, initially planned to decorate the building's vestibule with bas reliefs of scholars. There was subsequently a plan to place mosaic images of Marx, Lenin, and Stalin alongside the portraits of figures from academia. In the end the foyer of the assembly hall was decorated with marble medallions with shoulder-length 'right-to-left' profiles of 60 'great scholars'. The list of subjects was approved by Stalin himself (the names of Mendeleev and Michurin, among others, were excluded at the last moment). Deyneka encountered difficulties drawing the portraits, as there were no profile images for many of the scholars and even photographs of contemporary academics were incidental and of poor quality. The Florentine compositions in light-coloured marble against red backgrounds in medallions with a white edge and laurel wreaths of glory represent heroes of Russian science (Gubkin, Yablochkov, Przhevalsky, Sklodovskaya-Kyuri, Timiryazev, Vernadsky) and figures from different periods and countries (Zu Chongzhi, Ulug-bek, Leonardo da Vinci, Archimedes, Avicenna, etc.). The portraits are mounted in chronological order but positioned so high above the cornice that they are very difficult to make out.

1

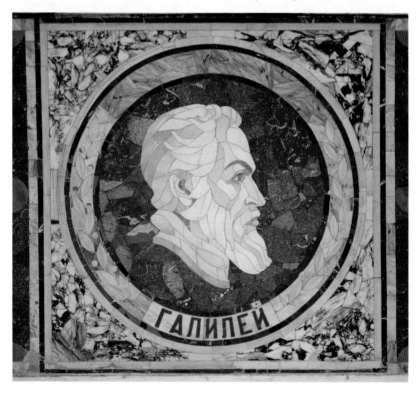

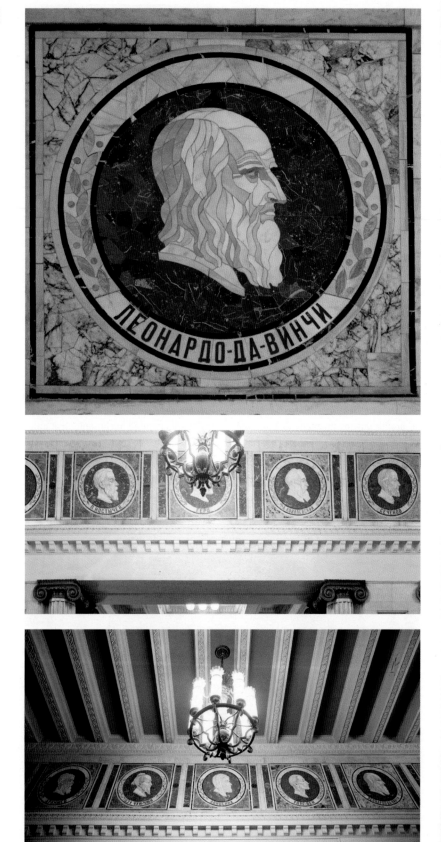

Lomonosov Moscow State University (MGU). Principal building, conference hall, stage
Vorobievy gory, 1

021 **H**

Korin, P. D.
(1951)–1953

The post-war reconstruction plan for Moscow involved the construction of eight multi-storey buildings intended to be high-rise landmarks in the urban landscape. It was decided to accommodate the faculties of Lomonosov Moscow State University in one of these high-rise buildings. The original plan was to place a marble statue of Stalin behind the presidium on the stage of the 1500-seat assembly hall, but this idea was subsequently dropped, and Pavel Korin's smalt mosaic was completed in the year of the generalissimo's death in 1953. The years 1755 (the foundation of MGU) and 1953 symbolise the continuity of scientific tradition and are arranged in mosaic on the panel itself. The imitation of fabric in the composition consisting of scarlet banners in a dawn golden sky is slightly reminiscent of a theatre curtain and harmonises beautifully with the strips of carpeting in the hall. Against the red background and between the architectural volutes and spheres, there are symbols and emblems of science and knowledge: a flaming brand, a glove, an open book, scrolls, a pen, and compasses. The bottom part of the composition is completed by a laurel garland tied with a ribbon. The rhythm of the slender poles of the 'victory standards' in Korin's mosaics is interrupted by the white marble of the four massive columns. Here architecture has prevailed over artistic design, despite the fact that the latter is so monumental here.

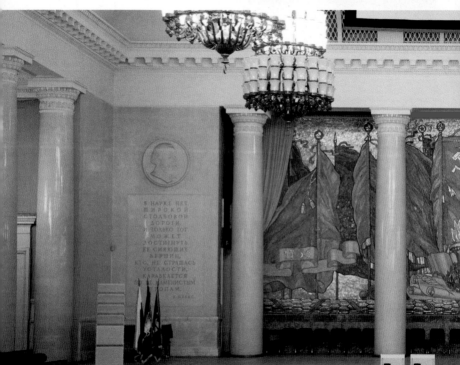

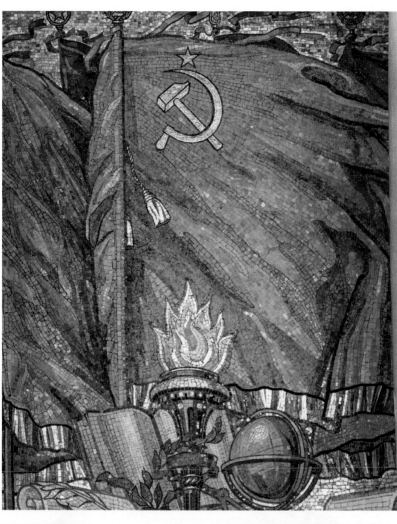

1

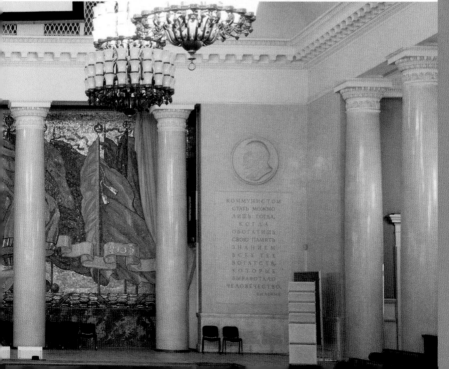

Belorusskaya metro station on the Circle Line, underground hall

022 B

architects: Taranov, I. G.,
Bykova, N. A.

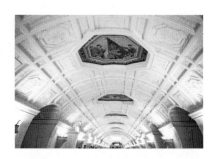

Opryshko, G. I.
'The Flowering of Soviet Belorussia'
1951

The Circle Line, which was built as a kind of memorial to the USSR's victory in the Second World War, became the richest of Moscow's metro lines in terms of decorative design. At Belorusskaya station, Ivan Taranov and Nadezhda Bykova, who also designed Novokuznetskaya station on the Zamoskvoretskaya Line, placed octagonal panels identical in shape on the vaulting of the central hall with its plaster mouldings. The individual pieces on the theme of the flowering economy and culture of Belorussia are all strictly oriented in the same direction and framed with national Belorussian ornaments. This was a time of increasingly energetic promotion of the idea of 'friendship of the peoples' in the USSR. Creative work by artists from the Soviet republics expanded the range of decorative motifs available in the art deco style. Here the mosaics assembled from pieces of marble of different colours with inserts of golden smalt are wonderfully 'legible' on the high ceiling without any need for additional lighting. Although the slightly static compositions with builders, embroiderers, arable farmers, cattle breeders, military personnel, and schoolchildren refer to socialist realism, the station's overall design represents the art deco style with its floor tiles in a Belorussian national pattern and 'pictures' formed from large fragments of marble.

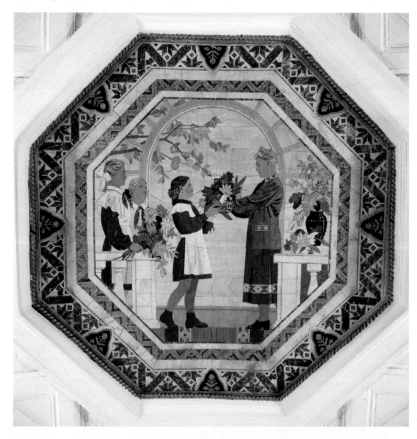

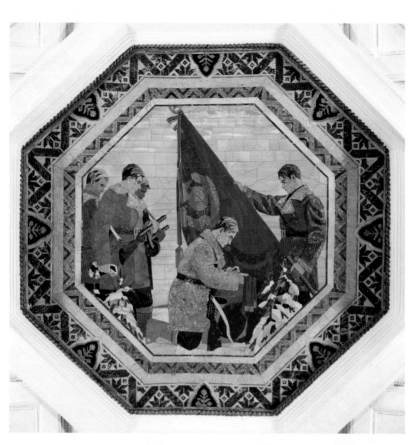

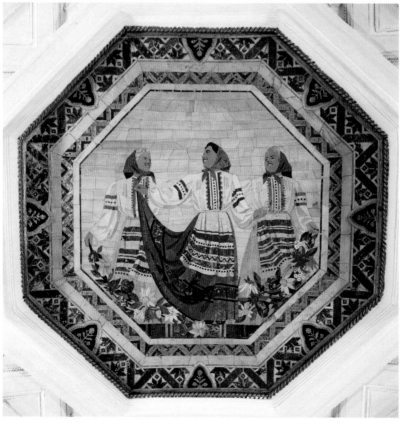

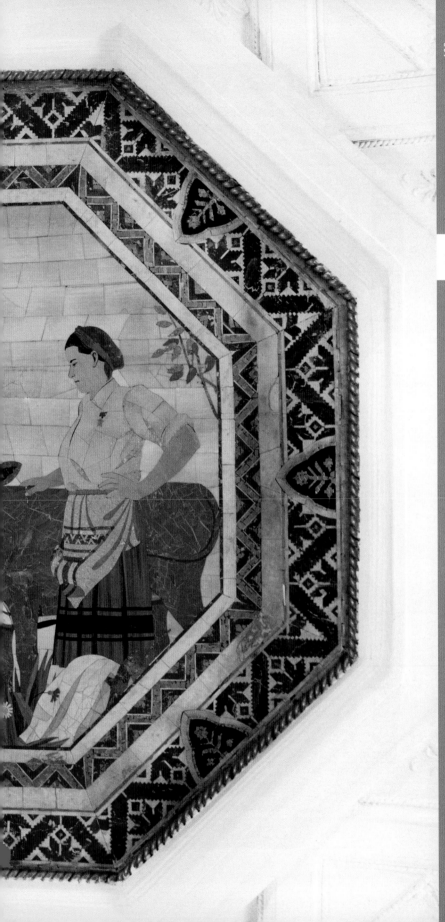

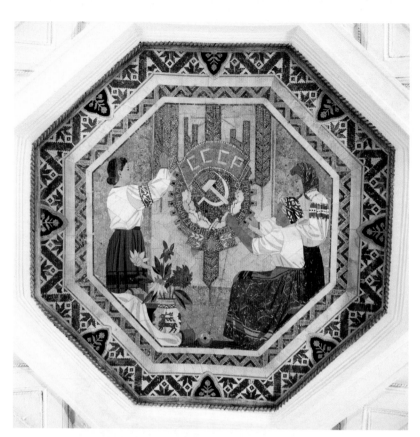

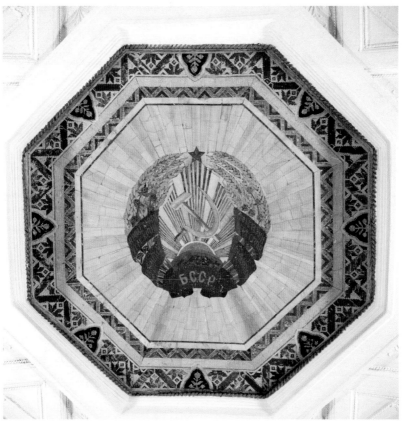

1

**Kievskaya metro station,
ground vestibule**

Opryshko, G. I.
'The Triumph of the Labour of
the People of Soviet Ukraine'
(1952)–1953

Florentine mosaic decorates the frieze behind the columns in the ground vestibule of Kievskaya metro station. The artist Grigory Opryshko depicts typical Ukrainians, many in national dress, as they walk towards the emblem of Soviet Ukraine. This circular procession of representatives of various professions and occupations faces the viewer and is seen in profile in the manner of Egyptian gods and heroes. It is, notwithstanding the relative surrealism of the composition, decorated with a line of national ornamentation and a background of golden smalt. Human concerns and qualities are thereby subordinated to the state: the focus is on the composition of red standards and the state emblem in a moulded cartouche.

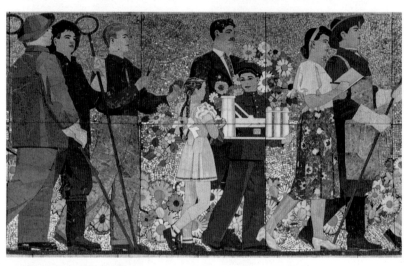

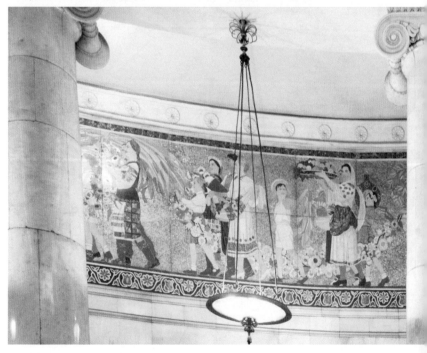

1

**Smolenskaya
metro station
on the Arbatsko-Pokrovskaya
Line, vestibule**

024 F

*Korin, P. D.,
Ryabov, L. M.*
1953

The subject of the frieze in the circular hall of the above-ground pavilion of Smolenskaya station is the victories in the two great patriotic wars in 1812 and 1945. Above the escalator tunnel is a Victory Order against the background of scarlet standards, a laurel wreath, oak branches, and the Ribbon of St George. Military attributes from earlier epochs – a metal helmet, a sword, a quiver with arrows – are also tied with a black-and-orange ribbon. This striped symbol is part of the Order of St George, which was instituted by Catherine II during the Russo-Turkish War of 1768–1774 and also used during the Second World War to decorate divisions, units, and

ships that had shown exceptional courage and heroism. Korin chose imperial acanthus leaves as the background for his Florentine mosaic frieze. The space between them is decorated with golden smalt.

Biblioteka imeni V. I. Lenina metro station, end wall of the underground hall

025 F

Opryshko, G. I.
'V. I. Lenin'
1957 (1955?)

The history of Soviet mosaic began with the decoration of the interior of the Lenin Mausoleum with red marble banners (today it is not permitted to take photographs inside the mausoleum). Soviet 'Leniniana' – the presentation of the image of the 'leader of the revolution' in literature and fine art – is extremely extensive and continues to be created to this day in contemporary Russian art. Following the debunking of Stalin's personality cult, representations of Stalin were dismantled everywhere. Profile portraits of Lenin, on the other hand, were not under any threat apparently. On the contrary, the figure of Lenin rode a new wave of popularity in Soviet modernism. The Russian V. I. Ulyanov (Lenin) Public Library, which was established in 1924 at what was previously the State Rumyantsev Museum, was renamed the State V. I. Lenin Library in 1925 before becoming the Russian State Library in 1992. The name of the metro station next to the library retained its dedication to the first Soviet leader and the metro as a whole continues to bear the full name it had in Soviet times: the Moscow V. I. Lenin Metropolitan Railway of the Order of Lenin and the Order of the Red Labour Standard.

1

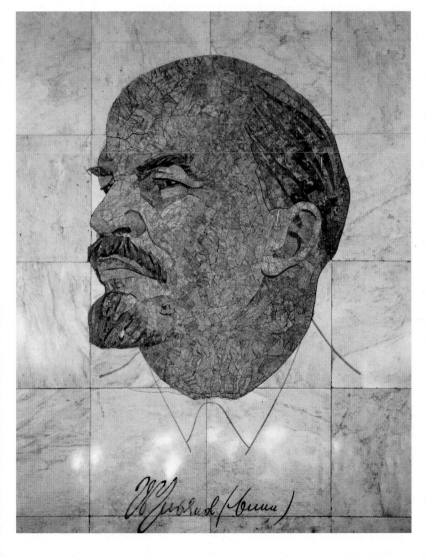

Socialist Realism

2

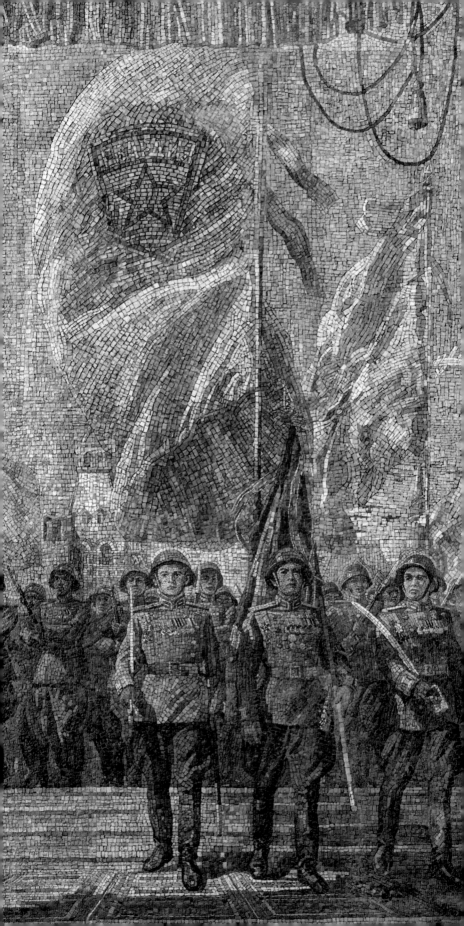

Socialist Realism

2

'With socialist realism being the main method used by Soviet artistic literature and literary criticism, it requires the artist to historically-specifically and truthfully depict reality in its revolutionary development. Truthfulness and historical specificity of artistic depiction of reality must be combined with the objective of ideological remoulding and education in the spirit of socialism.' This was how socialist realism was defined in the Charter of the Union of Writers of the USSR, which was established following the governmental resolution of 23 April 'On the Reorganisation of Literary and Artistic Organisations'. All independent creative associations and organisations were merged to form single unions of writers, artists, architects, and film-makers. Realism nevertheless contained substantial traits of romanticism and idealism. Nature had to be depicted mimetically, with verisimilitude, but also with a heroic grandiloquence and without any hint of criticism. This was the 'social mandate' that monumentalist artists were called on to fulfil. Art that was comprehensible to the broad masses, so-called 'populist realism', turned many works into didactic teaching aids that were highly literary and predictable in their scenes and poses. Happy work in the countryside and in the factories, victories in the revolutionary fight and Second World War, scenes from history, the cult of the leaders of the revolution, the emergence of the 'new woman', and sports parades, processions, and demonstrations became the main themes for artists and writers. Critic and dissident Andrey Sinyavsky defined socialist realism as 'classicism with admixtures of romanticism'. Art historians Ekaterina Degot and Boris Groys regard it as a 'second avant-garde', while Nadya Plungyan places this movement in the context of the grand modernist project.

Rublev, G. I., Iordansky, B. V. 'Victory Day Parade', 1951
Dobryninskaya metro station, vestibule. 028I

**Paveletskaya metro station
on the Circle Line,
vestibule**

Rabinovich, I. M.
'Red Square'
1950

Passengers on the escalator tunnel in the vestibule of Paveletskaya metro station will encounter a 'picture' sitting in a lavish frame. A scarlet banner streams above Red Square and Lenin's Mausoleum, the Spasskaya Tower in the Kremlin, the Monument to Minin and Pozharsky, and the Cathedral of Vasily the Blessed. The plaster sculptural frame is coloured to look bronze and consists of flags and the fruits of southern lands. The ribbons display the names of cities from which visitors to Moscow might arrive at Paveletsky Station: Saratov, Astrakhan, Kamensk, Penza, Voronezh, Stalingrad, Kamyshin, Belgorod …

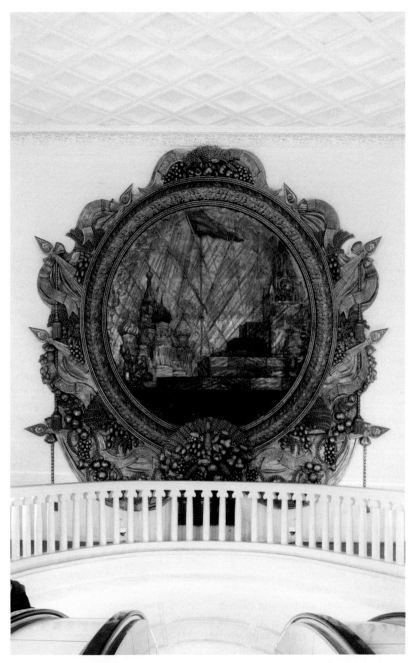

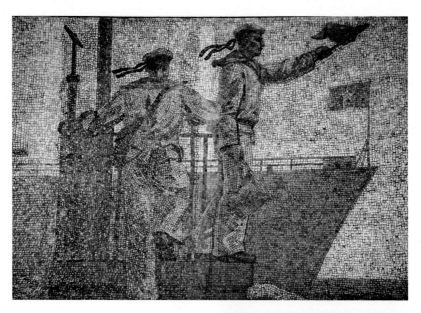

2

Avtozavodskaya metro station
architect: Dushkin, A. N.

027 I

Bordichenko, V. F., Pokrovsky, B. V., Lekht, F. K., workshop of Frolov, V. A.
'The Soviet People During the Years of the Great Fatherland War'
(1940)–1943

Zavod imeni Stalina station was designed by Aleksey Dushkin, who had already designed Mayakovskaya station (with mosaics by Deyneka). The mosaic panels sit almost beneath the station's ceiling and have no special lighting. They depict scenes of Soviet citizens at work during the war years. The eastern wall shows operations at the Stalin Automobile Factory (ZIS), including the foundry, forge workshops, machine-assembly, and a workshop assembling caterpillars for tanks. The western wall displays bombs being loaded, tractors busy harvesting, fishermen, and naval cruisers. The eight panoramic mosaic panels are in an absolutely realistic style: their tranquil figures are frozen in familiar poses against a background of manufacturing landscapes. They were assembled in besieged Leningrad at the workshop of Vladimir Frolov and delivered to Moscow via Lake Ladoga. In 1956, after Stalin's death and the campaign against his cult of personality, the factory was renamed after one of its directors, Ivan Likhachev, and became ZIL (formerly ZIS). The metro station was also renamed 'Avtozavodskaya' in the same year.

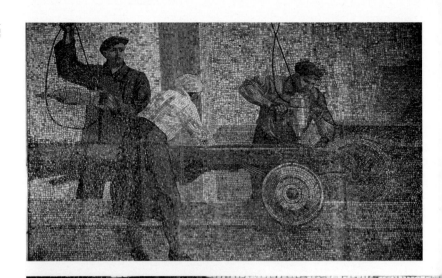

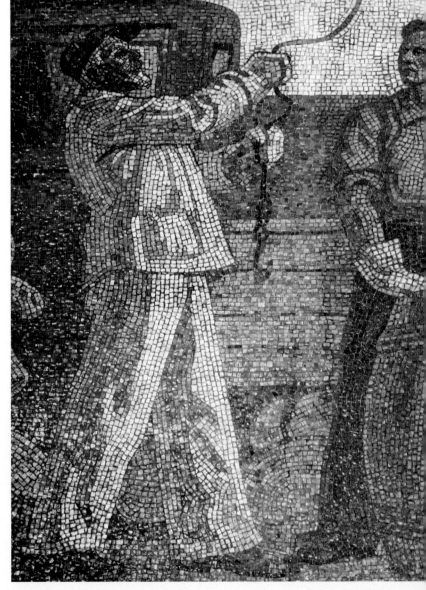

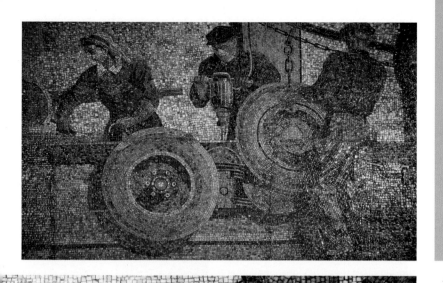

2

Dobryninskaya metro station, vestibule

architects: Pavlov, L. N.,
Tatarzhinskaya, Y. V.

028 I

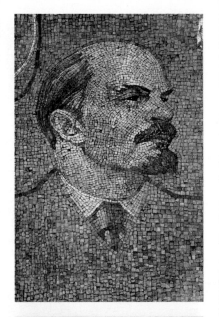

Rublev, G. I., Iordansky, B. V.
'Lenin on the Background of the Emblems
of the Soviet Republics', 'Workers Parade',
'Victory Day Parade'
1951

The most notable element in the archi-
tectural design of the underground hall
of Dobryninskaya metro station is arches.
Architect Leonid Pavlov took this motif
from the tradition of Old Russian architec-
ture but fitted the arches into one another
in a way that is entirely modernist. Simi-
lar 'stepped' arches can be found between
the three mosaic panels inside the sta-
tion's above-ground pavilion. The central
panel is absolutely decorative (a profile
of Lenin against a red background, sur-
rounded by the emblems of the 16 Soviet
republics), while on the two side panels,
the socialist-realist canon in a depiction
of people marching with flags continues
to allude to the poster-type aesthetic of
Deyneka's mosaics. The profiles of Lenin
and Stalin on the left were later replaced
with the *Gvardiya* ('Guards') sign, while
Stalin's portrait in the hands of athletes
on the right mosaic was replaced with one
of Yuri Gagarin.

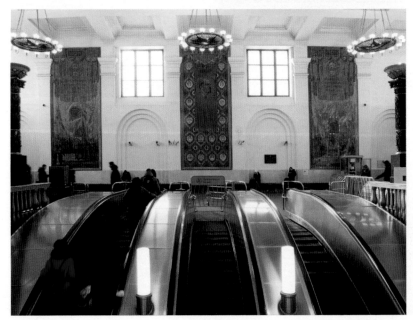

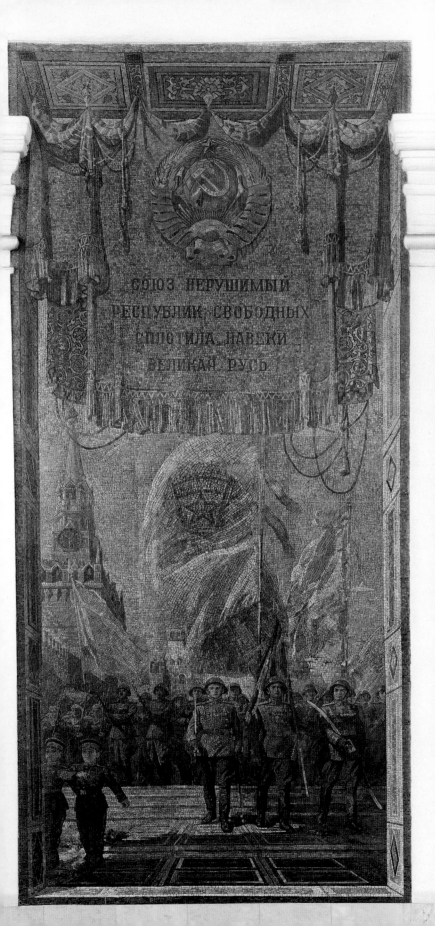

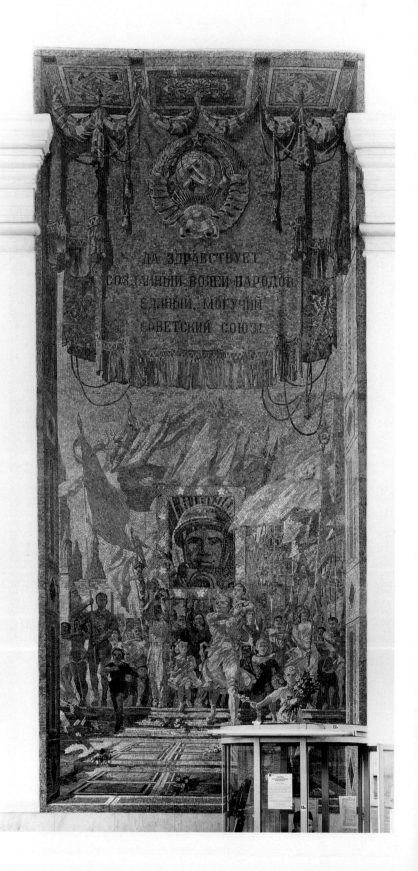

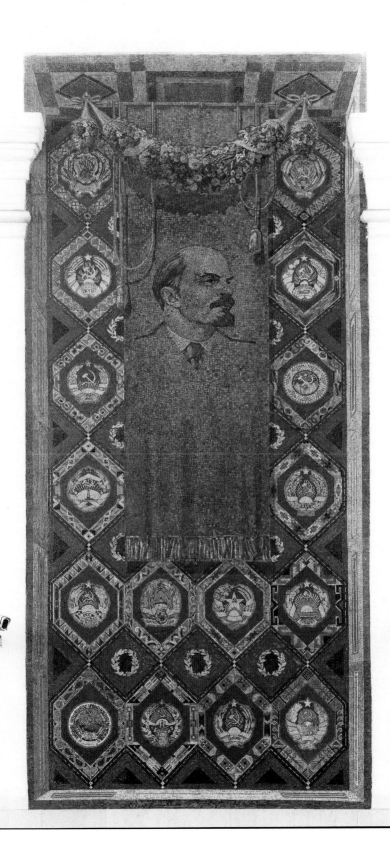

Komsomolskaya metro station on the Circle Line, underground hall
architect: Shchusev, A. V.

029 D

Bordichenko, V. F., Pokrovsky, B. V., Fuks, V. I., Chernyshev, B. P., Kornoukhova, A. F., Ryabov, L. M., Shilovskaya, T. A., and others, supervised by and using the drawings of Korin, P. D.
'Aleksandr Nevsky', 'Dmitry Donskoy', 'Minin and Pozharsky', 'Aleksandr Suvorov', 'Mikhail Kutuzov', 'Soviet Soldiers and Officers by the Walls of the Reichstag', 'Speech by V. I. Lenin', 'Mother Motherland', 'The Order of Victory'

Kazakov, S. M., Sergeev, A. M.
'Russian Weapons'
(1951)–1954

The theme of victory is common across all Circle Line stations, but it reaches its apotheosis at Komsomolskaya metro station. This station is higher and wider (9 by 12 metres, as opposed to the usual 5.3 by 7.3 metres) and was decorated with special luxury. Aleksey Shchusev, designer of the interiors of Kazan Station (the railway station above Komsomolskaya) in the Moscow baroque style, continued to develop his approach in the hall of this station. Moulded frames on the vaulting of the underground hall contain depictions of heroes of battles and wars mentioned by Stalin at the parade on Red Square in 1941. 'The courageous image of our great ancestors' is represented by Aleksandr Nevsky, Dmitry Donskoy, Kuzma Minin and Dmitry Pozharsky, Aleksandr Suvorov, and Mikhail Kutuzov. Two panels ('The Handing Over of the Guards Flag' and 'Victory Parade') that depicted Stalin were replaced by Korin with 'A Speech by V. I. Lenin' and 'Mother Motherland' during the de-Stalinisation process. All eight panels show historical scenes against a golden icon painting background. All of the panels are oriented in the same direction and, unlike Deyneka's ceiling pieces, take no account of spatial perspectives: these are not ceiling panels, but rather pictures on the ceiling.

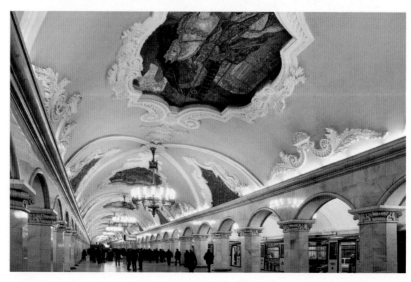

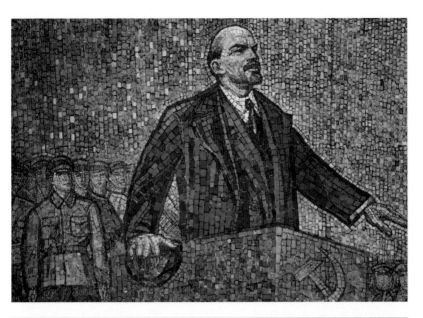

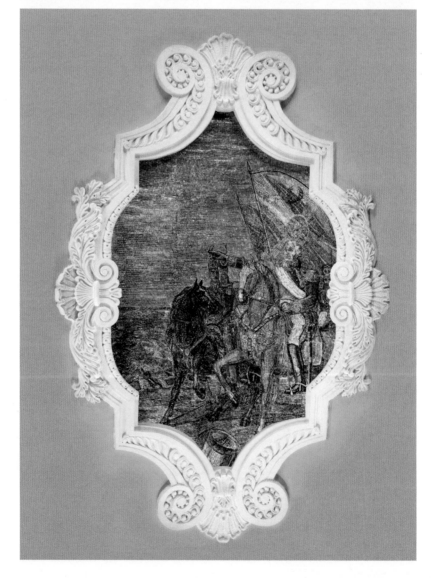

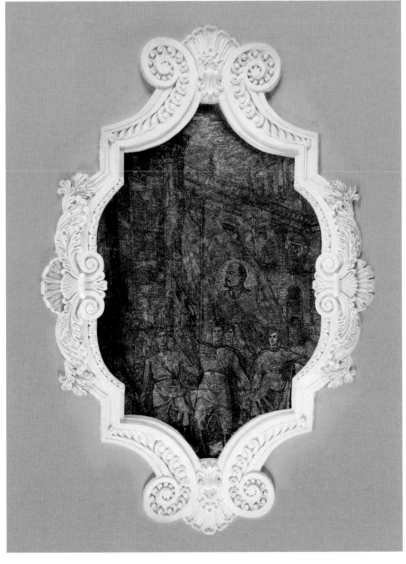

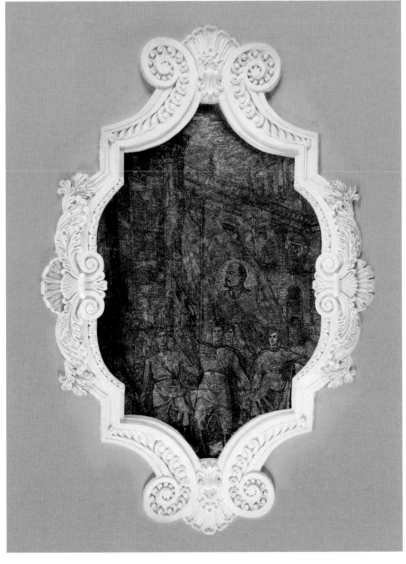

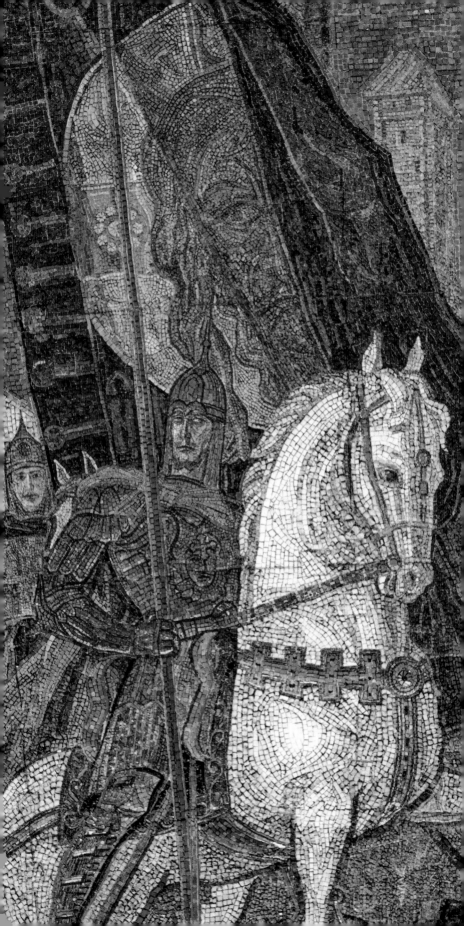

2

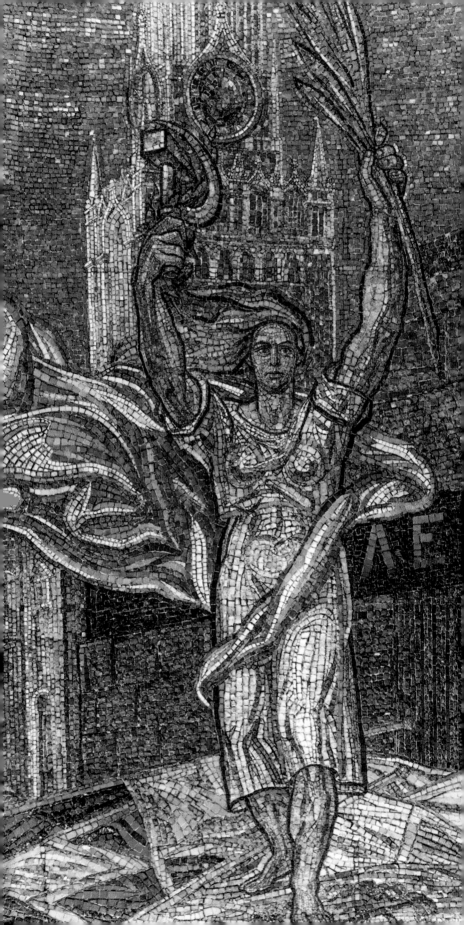

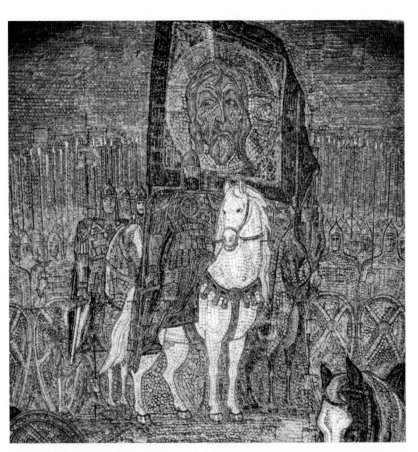

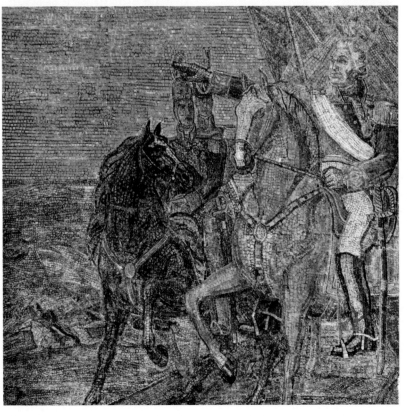

2

Kievskaya metro station on the Circle Line, underground hall
030 E
architects: Katonin, E. I.,
Skugarev, V. K., Golubev, G. E.

*Myzin, A. V. and Ivanov, A. T.,
with the assistance of
Anikanov, M., Akhmarov, C. G.,
Boguslavskaya, O., Bykova, G. Z.,
Vasilieva, L., Vatutin, N.,
Dorofeev, A., Zakharov, V. M.,
Kalmykova, G., Kirova, I.,
Kornoukhova, A. F., Kozhanov, E. G.,
Konov, F., Korin, B. A., Lobanikhin, B.,
Lukashevker, A. D., Lukovtsev, B.,
Permyakov, Y. P., Rozova, L. A.,
Rybalchenko, V., Ryabov, L. M.,
Sekretarev, I. V., Semenov, V.,
Sidorov, M., Sorochenko, K. K.,
Surskaya, R., Sukhov, V.,
Fedyushkin, B., Filatov, V.,
Fuks, V. I., Khayutina, L. E.,
Khryashchev, V., Cherepanova,
Sheremetev, V., Shilovskaya, T. A.*

*Velizheva, M. A.
Orlovsky, A. L.*
'First Tractor Team'
1953

'The Rada at Pereyaslavl.
8/18 January 1654',
'Battle of Poltava',
'Pushkin in the Ukraine',
'Chernyshevsky, Dobrolyubov,
Nekrasov, and Shevchenko
in St Petersburg', 'Lenin's Iskra',
'1905 in Donbass', 'Soviet Rule is
Proclaimed by V. I. Lenin. October 1917',
'M. I. Kalinin and G. K. Ordzhonikidze
at the Opening of Dnieper
Hydroelectric Station. 1932',
'Public Festivities in Kiev',
'The Reunification of the Entire Ukrainian
People in a Single Ukrainian Soviet State',
'The Liberation of Kiev by the Soviet
Army. 1943', 'Victory Firework Display
in Moscow, 9 May 1945',
'Friendship Between Russian and
Ukrainian Kolkhoz Workers',
'Socialist Competition Between
Metalworkers in the Urals and Donbass',
'Commonwealth of the Peoples
is the Source of the Socialist
Motherland's Prosperity',
'Decorated with Orders, Flourishes Ukraine,
Republic of Workers and Peasants'

Kievskaya metro station is perhaps the richest station on the Circle Line when it comes to mosaic decoration. 18 panels in moulded frames on both sides of the central underground hall illustrate the friendship between the Russian and Ukrainian people. While scenes depicting events throughout the twentieth century ('The Liberation of Kiev by the Soviet Army. 1943', 'Lenin's Iskra') are shown in a more or less realistic manner, others such as 'Pushkin in the Ukraine' or 'The Battle of Poltava' look almost like caricatures. Each of the mosaic 'pictures' is clearly visible to passengers and features an inscription indicating a date on a marble 'scroll'. The 'clients'' desire to present both history and modernity in the same space, in a staged manner, and with optimism is realised here in a series of slightly tortured panels orchestrated with widely varying degrees of success. One of the 'pictures' ('First Tractor Team') was designed by the artist Mirriel Velizheva, who was a graduate of Stroganovka (Stroganov Moscow Higher School of Applied Art).

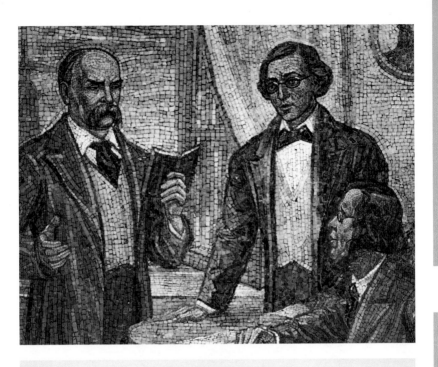

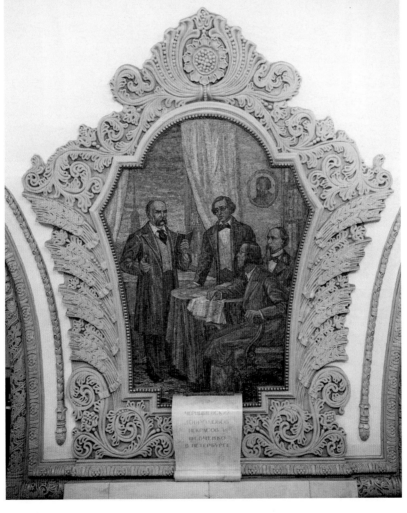

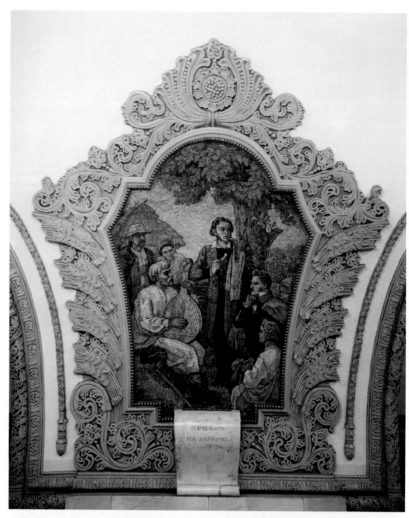

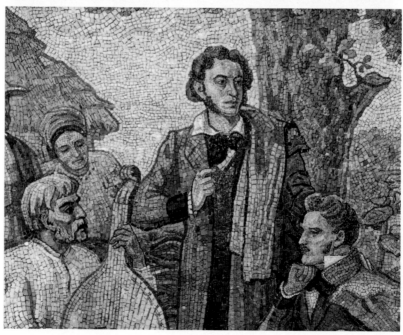

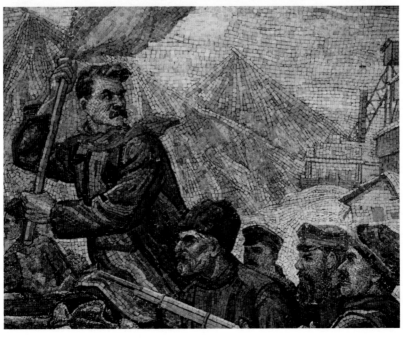

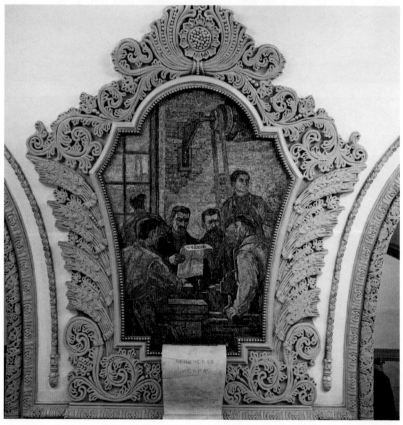

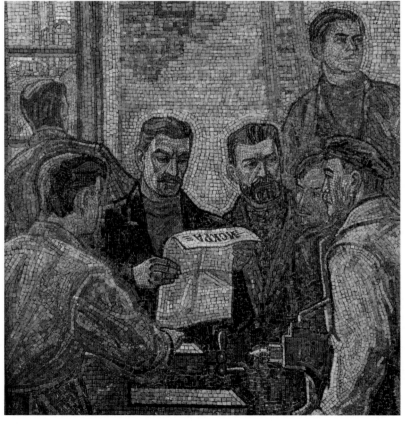

2

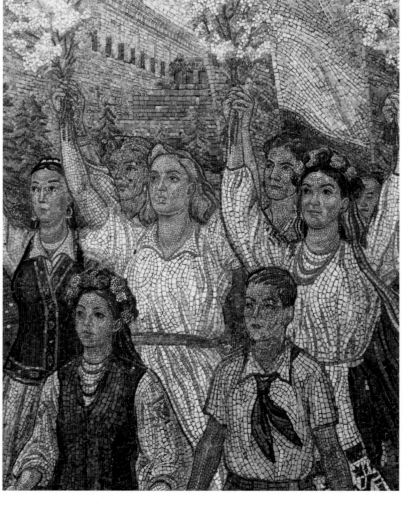

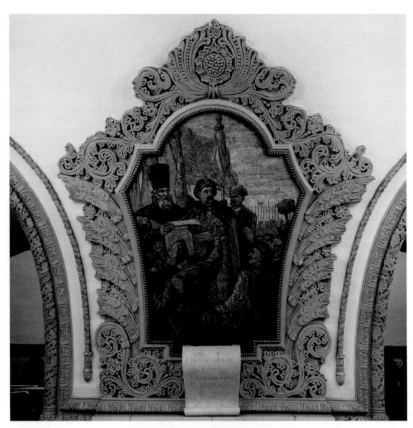

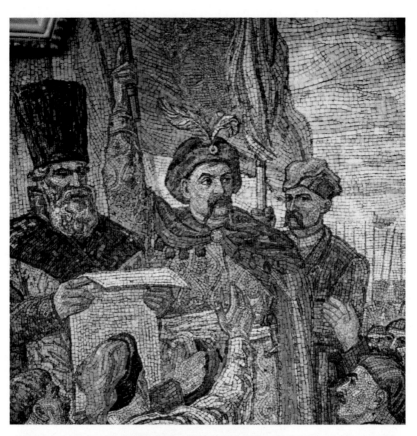

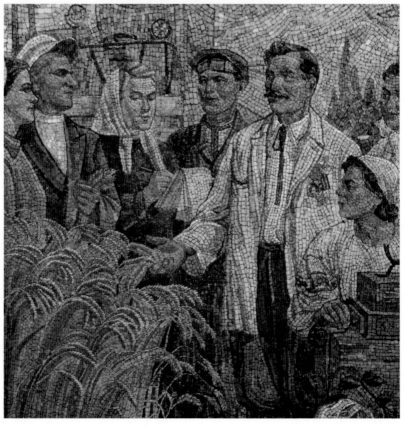

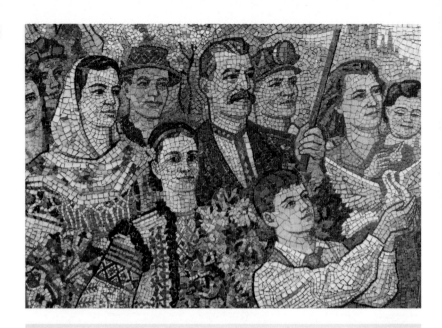

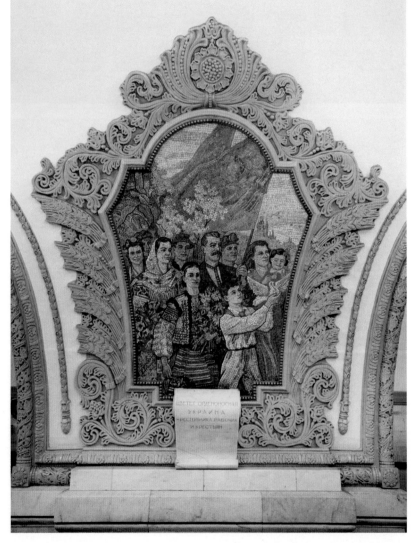

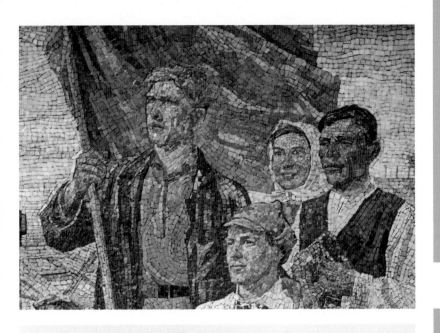

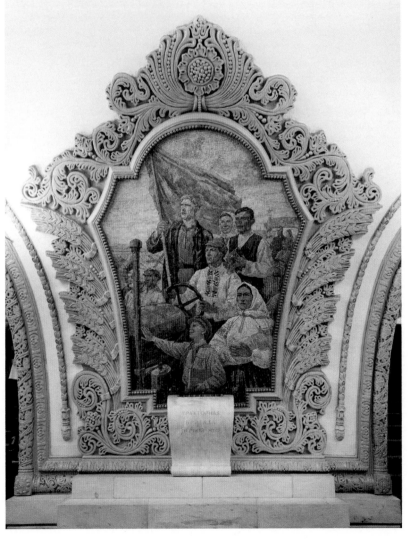

Modernism

154

3

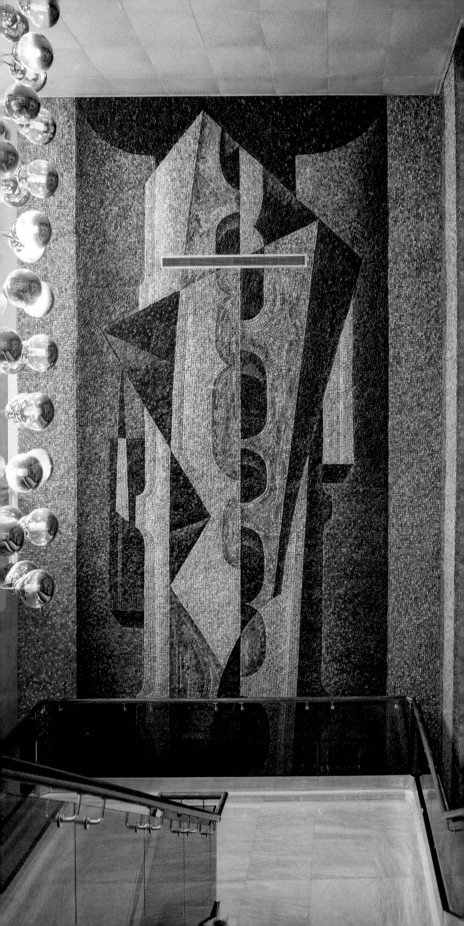

Modernism

Soviet modernism, which simultaneously put an end to Stalinist neoclassicism and 'architecture as art', brought new ideals: cost-saving, rationalism, and accessibility. The concrete and brick boxes now being built owed their individuality largely to monumentalist artists. Sgraffito, brickwork, and mosaics decorated the end walls of residential buildings and schools as well as the interiors of research institutes. The sketches for many mosaic panels were executed by masters of easel painting and graphic art who also worked in the 'severe style'. The new ideal of the 'Soviet Reformation', to use the term coined by Aleksey Bobrikov, with its serious and responsible heroes, was embodied in large figures taken from the working professions. What's more, the aesthetic of the Khrushchevian Thaw brought a light plasticity, a lyrical mood, and a typically modernist range of colours.

The patterns of the mosaics often tended towards abstraction and used a range of two or three colours. Human figures of different scales were combined on the same plane, as in book illustrations. Between individual compositions there often lies an almost sculptural outline, and the grout lines between pieces of mosaic become overt and wide. It was in the 1960s that natural stone and ceramic tiles made their appearance in Soviet mosaic. The floors of many institutions were decorated with figures made from the remnants of marble facing. 'Simple' and 'primitive' genres of mosaic such as the portrait (usually just a head) and still life became common. This was also a period that saw the thinking develop in terms of architectural ensembles. The space of architecture – of buildings consisting of several blocks – was fitted into the landscape in such a way as to produce a unified artistic design.

Ablin, E. M. Sovintsentr (World Trade Centre), congress centre, atrium, 1980. 057E

**The Green Theatre
at Gorky Central Park of
Culture and Leisure**
Krymsky val ulitsa, 9/33

031 H

*Chernyshev, B. P., assisted by students at
Moscow Architecture Institute (MARKHI)*
'Maiden from the Fiery Earth', 'Youth from
the Marquises Islands' in the 'Festival
Guests' series
1957

The Green Theatre was established in
Neskuchny (Merry) Garden on the bank of
the River Moskva in 1830. A theatre build-
ing was built by Lazar Cherikover in the
postconstructivist style from 1928-1933.
It was reconstructed by architect Yury
Sheverdyaev in 1957 for the World Festival
of Youth and Students. Sheverdyaev had
studied at the avant-garde Vkhutein. Be-
fore the war he worked at the workshop of
the academician and neoclassical archi-
tect Ivan Zholtovsky, and from the 1960s
to 1980s designed emblematic modernist
buildings (including the Rossiya Cinema,
the Central House of Artists, the Izvestia
building, and the Hotel Intourist) in the
Soviet capital. The two classical niches in
the side façade of the Green Theatre are
decorated with mosaics on the theme of
friendship between peoples. Next to a fe-
male and a male figure in ceramic, smalt,
and natural stone soars a dove – a sym-
bol of peace devised by Pablo Picasso in
1949 for the World Congress of Supporters
of Peace that became the emblem of the
pacifist movement. Next to the niches on
individual stones, we can clearly make
out the relief emblem of the 6th Festival
of Youth and Students: a terrestrial globe
with five blossom-like continents.

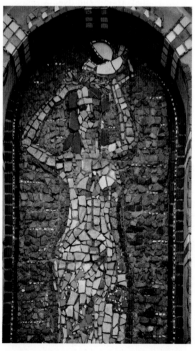

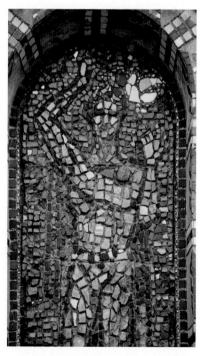

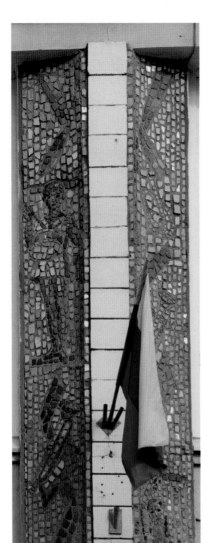

Palace of Pioneers (Palace of Creativity of Children and Young People on Miussy)

Aleksandra Nevskogo ulitsa, 4

Chernyshev, B. P., Shilovskaya, T. A., Gridin, V. A., Lukashevker, A. D., 'Pioneria' *1960*

The Pioneers were established in the USSR in 1922 as an organisation based on the pre-revolutionary Scout movement. The first House of Pioneers opened in 1923. The Palace of Pioneers on Miussy was built on the site of the demolished Cathedral of Aleksandr Nevsky according to a design by architects Yury Sheverdyaev and Karo Shekhoyan and following Khrushchev's resolution regarding the 'elimination of superfluity' in architecture. The austere architectural shape was decorated with reliefs and mosaic panels between the windows of the first and second storeys of the main entrance. The compositions are relatively artificial: the pioneer figures 'float' in the air and are linked by twisted ribbons and bugles. One of the panel designers, Boris Chernyshev (1906-1969), a pupil of Kuzma Petrov-Vodkin, is known for using natural stone in his smalt mosaicwork. The grout lines between the coloured stones are extremely wide, making the building's façade even more graphic.

3

**Moscow Palace
of Pioneers
on Vorobievy gory**
Kosygina ulitsa, 17

033 **H**

architects: Yegerev, V.S.,
Kubasov, V.S., Novikov, F.A.,
Paluy, B.V., Pokrovsky, I.A.,
Khazhakyan, M.N.
engineer: Ionov, Y.I.

*Ablin, E.M., Gubarev, A.A.,
Lavrova-Derviz, I.I.,
Derviz, G.G., Drobyshev, I.,
Pchelnikov, I.V.*
'Young Followers of Lenin',
Panels on the end wall
of the theatre building
(1959)–1962

One of the iconic works of Soviet modern-
ist architecture was designed by a team of
young architects led by Igor Pokrovsky,
who engaged other young artists. Mo-
saics decorate the four end walls of the
blocks, the way to the pool, and the main
entrance (there is a granite-mosaic con-
stellation of Cancer inside on the floor of
the block containing the observatory).

Innovative methods of laying the mosa-
ic and the use of coloured brick, reliefs, a
mosaic line on a brick wall, as well as large
pieces of coloured glass make the decora-
tion of the Palace of Pioneers unique. The
composition with buglers, a Pioneer's fire,
and a gigantic profile of Lenin above the
main entrance is completed by a group of
young people: one holds a peaceful at-
om in his hand, another a book, and the
lady carries a model of the palace. These

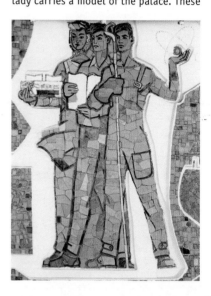

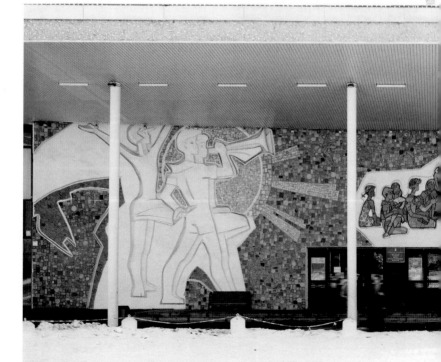

figures paradoxically recall Christian images of saints holding churches in their palms. Only the mosaic of the central portal is in a good state of preservation today. It is covered by a portico. The colours of the end walls have changed from rain, snow, and light, and the way to the pool is currently undergoing restoration. It is doubtful whether the colour and texture of the coloured glass that was made specially for this building can be recreated.

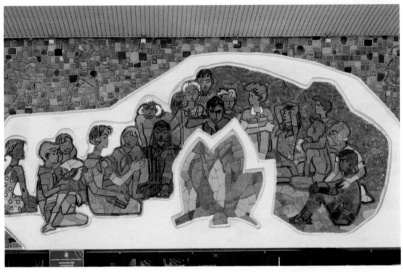

3

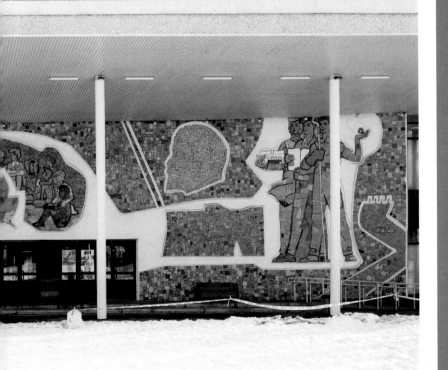

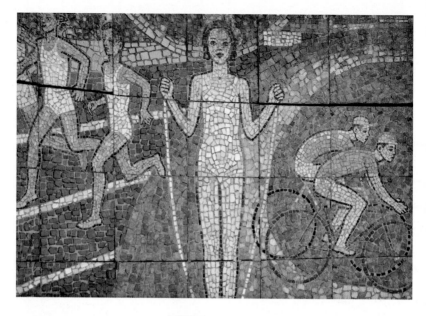

Stadium of Young Pioneers (Tsarskaya ploshchad residential complex)

034 B

Leningradsky prospekt, 31

Zhernosek, E. P. 'Sport'
Potikyan, M. L. 'Sport and Children'
Transferred
1964

Yury (Georgy) Shchuko designed the railings of the Stadium of Young Pioneers immediately after the war in 1946. In 1964 the curving masonry niches were decorated with mosaics involving the use of natural stone and even fragments of brick (the stamps on the bricks are visible). The 'Sport' panel depicts runners, cyclists, and a girl with a skipping rope and was designed by Elvira Zhernosek. The 'Sport and Children' mosaic panel bears the signature 'Potikyan 64' on the bottom right corner. The two mosaics are amazingly alike – compositions with a multitude of figures drawn in an austere and slightly naïve hand and laid out in stone of natural colours with wide grout lines. The stadium railings were taken down in 2017. The mosaics, which were recognised as 'items with traits of cultural heritage' in 2016, were dismantled. Today, they are placed on the territory of a residential complex.

Memorial stele in memory of F. E. Dzerzhinsky

035 A

Public garden
beside house 112, Prospekt Mira

Ter-Grigoryan, S. L.;
architect: Andreev, V. S.
1977

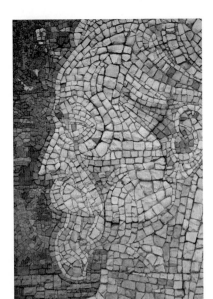

Feliks Dzerzhinsky (1877–1926) founded the All-Russian Extraordinary Committee for Combating Counter-Revolution and Sabotage (VChK) and was the head of the State Political Directorate at the People's Commissariat for Internal Affairs. He was 'the revolution's sword' and 'red terrorist no. 1'. Sculptor Evgeny Vuchetich designed the monument to 'Iron Feliks' in the Khrushchev era for Lubyanskaya ploshchad. It was dismantled in 1991. The memorial stele on the corner of prospekt Mira and Novoalekseevskaya ulitsa was erected during the Brezhnev era to mark the 100th anniversary of Dzerzhinsky's birth. It was part of the 'Board of Honour of Top Workers in Dzerzhinsky District', which was subsequently dismantled in the 1990s. Today the natural stone mosaic designed by Sergey Ter-Grigoryan (born 1929) remains in place as a memorial to a time when it was still the practice for the cult of leaders to be embodied in gigantic portraits.

3

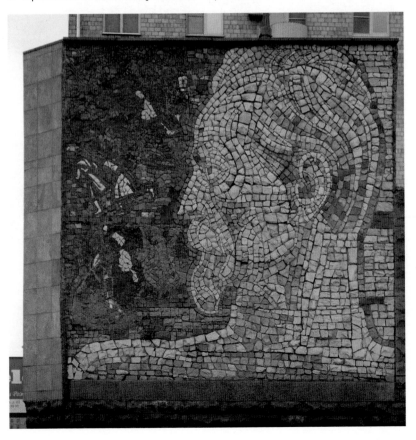

**Ilyich
locomotive
shed**
Nizhnyaya ulitsa, 17/1

036 B

*Dekhto, Y. A. (Arakelov, V. N.,
Ter-Grigoryan, S. L. (?))*
'Lenin and the Bolsheviks'
1960 (?)

The six enormous head and chest por-
traits on a free-standing stele were made
from natural stone. The serious faces – of

Lenin, a sailor, soldiers, a partisan, and
a woman in a shawl – embody the ener-
gy of the revolution and fit precisely with
the emotional charge and plasticity of the
'severe style'. The strong-willed Soviet
heroes are depicted in a generalised and
understated manner. The planes of col-
our are outlined with powerful contours.
Preference is given to the genre of por-
trait – even if generalised and referring to
the medieval composition of the interces-
sion as opposed to the thematic socialist-
realist picture.

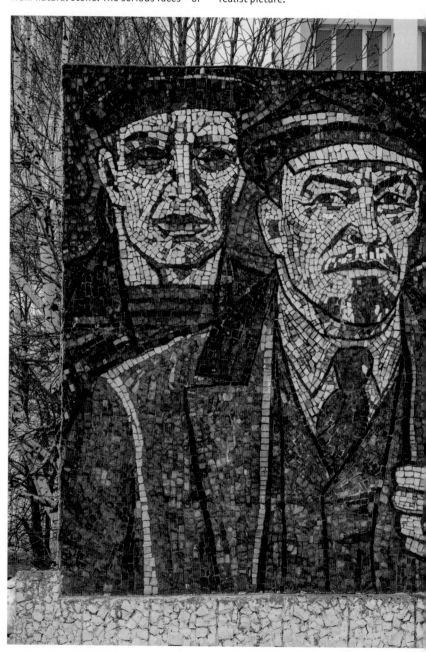

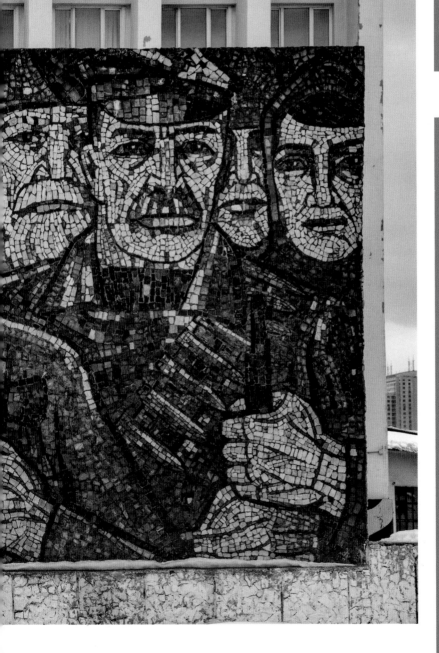

3

State Kremlin Palace, Moscow Kremlin.

037 F

architects: Posokhin, M.V.,
Mndoyants, A.A., Stamo, E.N.,
Shteller, P.P.,
Shchepetilnikov, N.M.

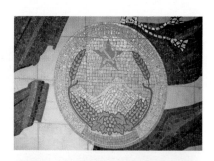

*Deyneka, A.A, the mosaic workshop
at the Academy of Arts of the USSR under
the supervision of Ryabyshev, V.I.*
'Emblems of the Soviet Republics'
1960–1961

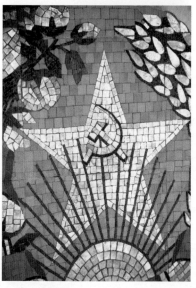

The building intended to serve as a venue
for party congresses was built at the initi-
ative of Nikita Khrushchev on the site of
the Armoury Chamber, a structure dating
to the beginning of the nineteenth cen-
tury that had been demolished specifical-
ly for this purpose. This modernist white
cube with its precise rhythmic façade ar-
ticulation was erected under the supervi-
sion of Mikhail Posokhin, Chief Architect
of Moscow, in a record short 16-month pe-
riod. The artist Alexsander Deyneka, who
had been devising décor for the Palace
of Soviets (the country's principal build-
ing, which was replaced by the Palace of

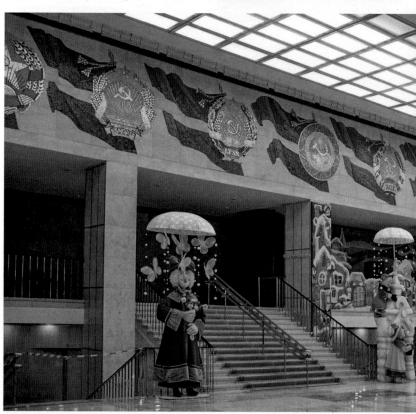

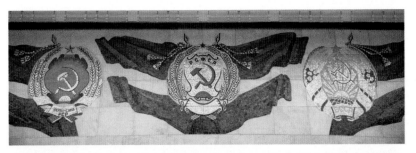

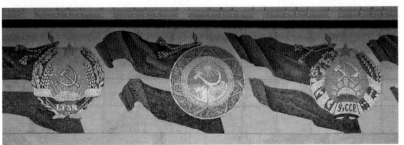

Congresses in the end) since the 1930s, was invited to decorate the 'foyer for delegates'. After executing a frieze of the emblems of the Soviet republics made from smalt, ceramics, and marble, Deyneka also took part in designing the palace's exterior. The banquet hall was originally intended to occupy a free-standing structure in the Kremlin but was subsequently accommodated above the main hall for delegates. Deyneka decorated its 16 external pylons with emblems of the USSR (the star and hammer and sickle), but placed so high, these mosaics of smalt and smoothed marble are invisible without the use of special optical equipment.

3

'The Battle of Borodino', museum panorama
Kutuzovsky prospekt, 38

038 A

Talberg, B. A., the mosaic workshop of the Academy of Arts of the USSR under the supervision of Ryabyshev, V. I.
'1812': 'The People's Militia and the Fire of Moscow', 'The Victory of the Russian Army and the Expulsion of Napoleon'
1962

The war of 1812 is the subject of the smalt mosaic by Boris Talberg that was recognised as an 'item of cultural heritage of regional importance' in 2015. The museum itself with its glass-clad rotunda was built for the 150th anniversary of the Battle of Borodino in order to accommodate the panoramic picture created by Franz Roubaud for the centenary of the legendary battle. The mosaic was restored for the battle's bicentenary. While it possesses a relatively austere and understated colour range, the mosaic panels, each of 75 square metres, represent curious allegories and symbols: a flaming key signifies the surrender of burning Moscow to the French; a woman flying without wings but with a heavy weapon symbolises 'victory with the sword of vengeance'; and George the Victorious from Moscow's crest defeats a snake in clouds inside the initials of Alexander I. Two imperial ciphers are also shown beside an enormous profile of Mikhail Kutuzov. The entire mosaic – assembled from square tiles with open grout lines – is placed in fragments in the space of the façade walls. This further reinforces the modernist artificiality as a counterbalance to the 'verisimilitude' of Roubaud's panorama inside the museum.

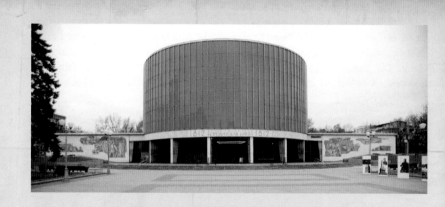

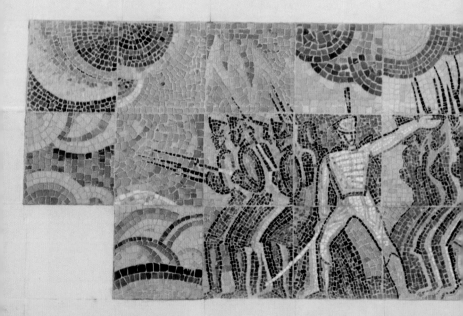

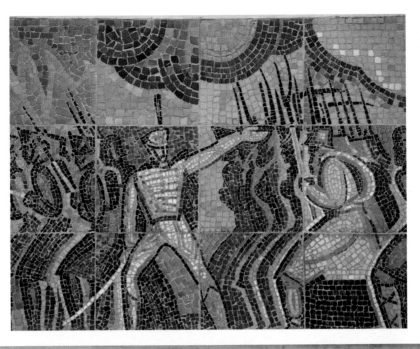

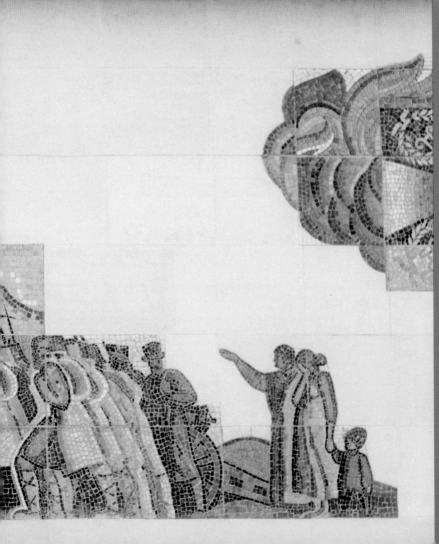

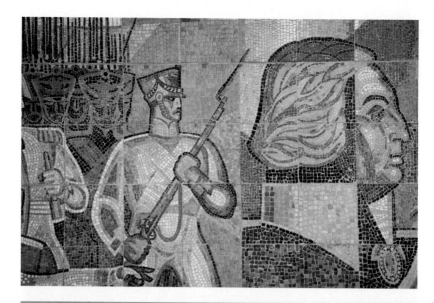
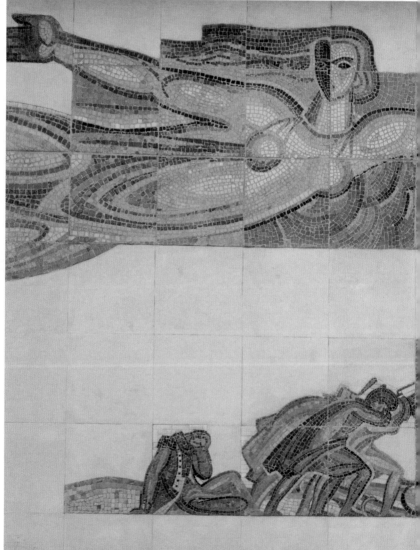

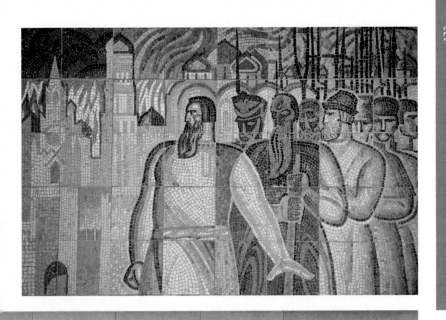

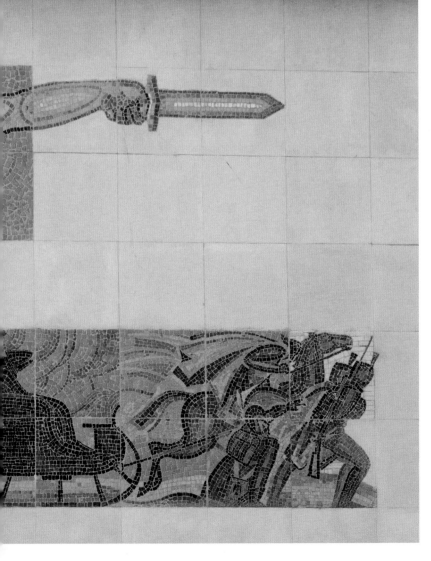

3

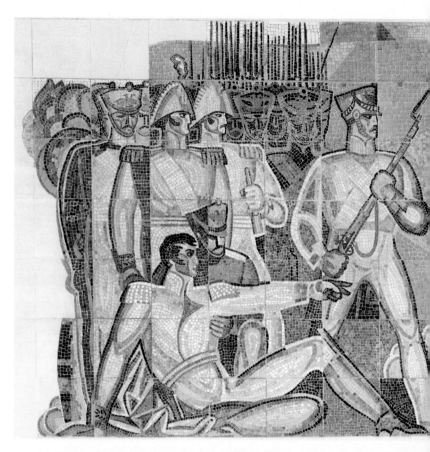

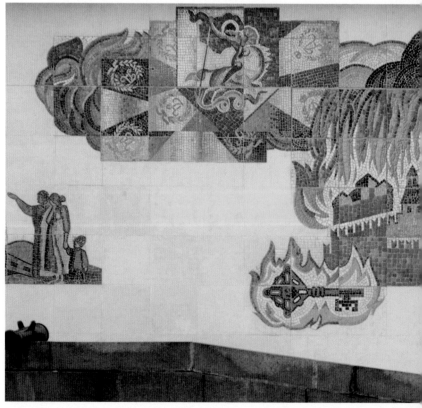

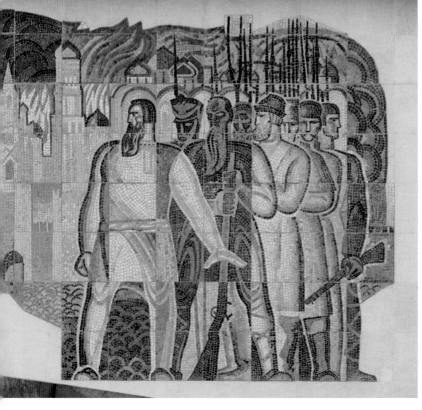

**Central Museum
of the Armed Forces
of the Russian Federation**
Sovetskoy Armii ulitsa, 2/1

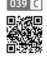
039 C

The new building for the Museum of the Armed Forces of the USSR, which was established in 1919, was designed by Boris Barkhin and Nikolay Gaygarov and completed for the 20th anniversary of the victory in the Second World War. The entrance hall's extensive wall is decorated with a mosaic in shades of red (representing the Red Army and the Navy) and depicts gigantic figures of sailors, infantrymen,

Korolev, Y. K.
'The People and the Army are One'
(1961)–1965

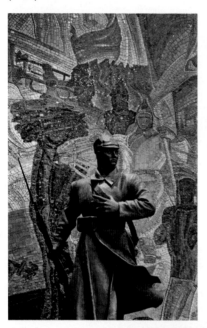

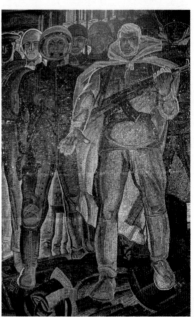

tank operators, cosmonauts, a woman with a child, and Mother Motherland. The left part of the composition portrays military history: Russian volunteer soldiers with shields and swords, grenadiers fighting under Suvorov or Kutuzov, and revolutionary soldiers. Originally planned as a background for a bust of Lenin, the mosaic turned out to be more expressive and interesting than the sculpture. The designer

Yury Korolev (1929-1992) studied under Aleksandr Deyneka in Moscow and under Georgy Rublev at the V.I. Mukhina School of Decorative and Applied Art in Leningrad. The author of numerous works of monumental art (frescoes, mosaics, stained glass) as well as easel paintings and graphic art, Korolev was head of a workshop at the Surikov Institute and director of the Tretyakov Gallery for 12 years.

3

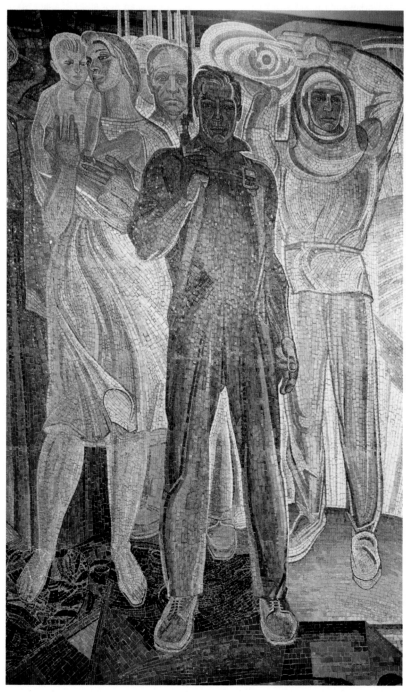

**Paveletskaya
metro station on
the Circle Line,
end wall of the
underground hall**

040 I

Korin, P. D.
'The Worker and the Kolkhoz Woman'
1963 (?)

'The Worker and the Kolkhoz Woman' mosaic panel at the end of the central hall of Paveletskaya-Ring station (1950) was installed at the beginning of the 1960s, replacing a medallion with portraits of Lenin and Stalin by the sculptor Matvey Manizer. Pavel Korin's design of this composition on the popular theme of the unity of the working class and the peasantry is relatively simple: a bare-chested worker carrying a hammer holds the hand of a peasant woman in a short summer dress and heeled shoes carrying a sickle. Between the two figures is the crest of the USSR, while the background is densely filled with a vegetative empire-style ornament. This 'picture' executed in relief/mosaic is utterly discordant with the underground hall, which is in the style of a Florentine renaissance cathedral with marble incrustations, ceiling rosettes, and columns with Corinthian capitals.

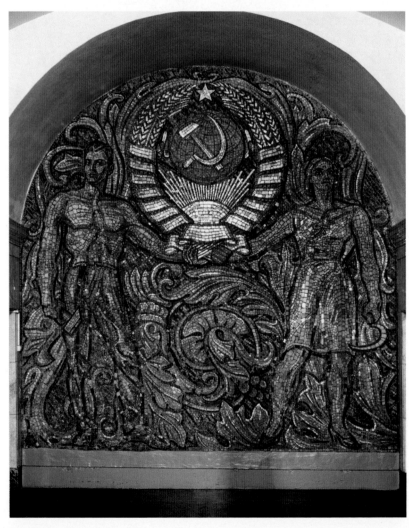

Okhotny Ryad metro station, eastern pavilion

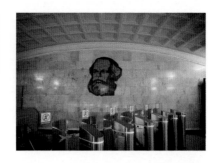

Reykhtsaum, E. E.
'K. Marx'
1964

Okhotny Ryad, the metro station closest to Red Square, opened in 1935 and has undergone several name changes since then. The station was originally christened after the street and square on which it stands, where hunters once sold game. It later bore the name of Lazar Kaganovich, who was in charge of construction of the Moscow metro system. In 1961 the station was renamed 'Prospekt Marksa' after the new avenue linking three streets in the centre of Moscow: Teatralny proezd, Okhotny Ryad, and Mokhovaya ulitsa. A 'Florentine' marble portrait of Karl Marx, author of *Das Kapital* and the *Communist Party Manifesto,* was installed in the station's foyer in 1964. The station finally reverted back to its original name in 1990. Meanwhile the face of the memorialised German philosopher and economist continues to observe perplexed passengers to this day.

3

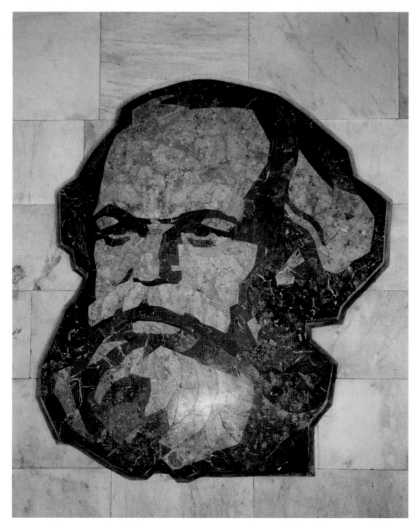

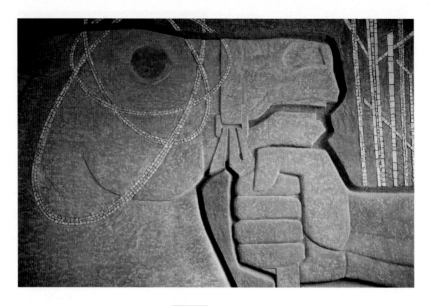

Moscow Institute of Engineering and Physics, vestibule of the principal building, library

Kashirskoe shosse, 31

042 A

Dauman, G. A.,
Shvartsman, M. M.
'The Taming of Atomic Energy'.
'Penetration of the Essence of the Atom',
'Untitled'
1962

The vestibule of the Moscow Institute of Engineering and Physics features two allegorical cement reliefs with mosaic inserts: a man's hand tames an atomic steed, and an eye in dark-blue smalt 'penetrates the essence of the atom'. The vertical panel in the reading room is almost entirely made of smalt and stone. Here a gigantic female figure – the embodiment of science – holds a nuclear power station in her hands, while on either side of her the moon and the sun hang suspended, a rocket flies, and trees grow. A series of digits made up of 0s and 1s indicates the year the panel was created – 1963. The panel's designer, Mikhail Shvartsman, was a connoisseur of icons and frescos and managed to impart a human and cosmic dimension to formulae and phenomena from physics. The horse with the eye/atom became the emblem of the National Nuclear Research Institute (MIFI).

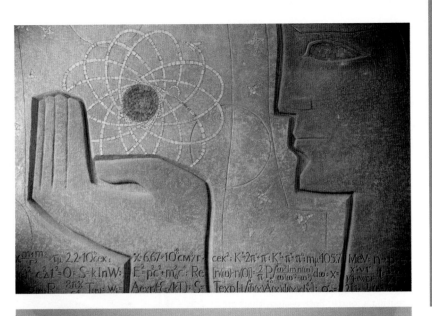

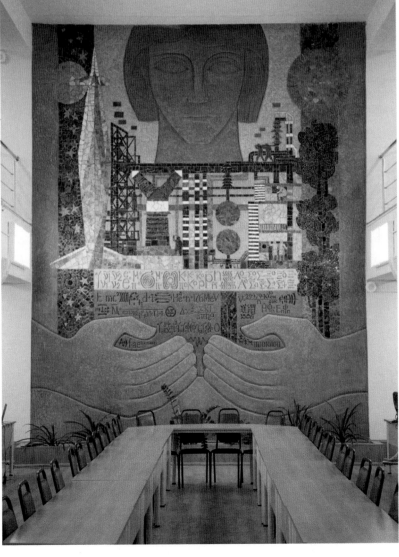

3

Principal directorate of the USSR Hydrometeorological Service

043 E

Bolshoy Predtechensky pereulok, 11–13

Unknown artist
1965

Two horizontal spaces between windows on the Hydrometeorological Service brick building are decorated with a relief and a mosaic on the most popular theme of the 1960s: space. One of the panels shows a flying cosmonaut holding a green branch, while the other depicts three cosmonauts greeting a fourth. Both compositions are executed in a mixture of smalt, ceramic tiles of various sizes, and fragments of tiles. Parts of the composition – the faces, hands, sun, and a star – have been left in cement, which adds realism to the slightly surrealistic and decorative compositions designed by an author whose identity remains unknown.

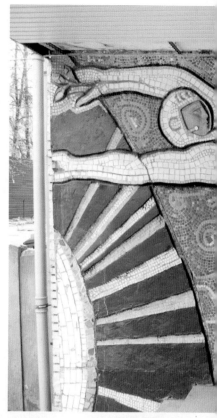

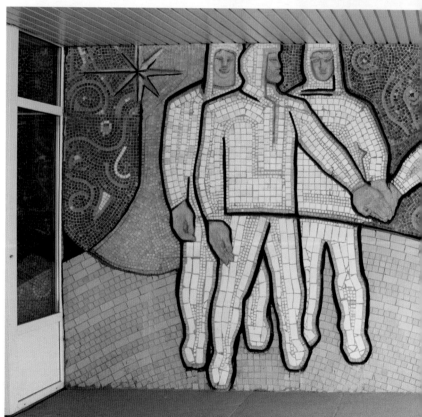

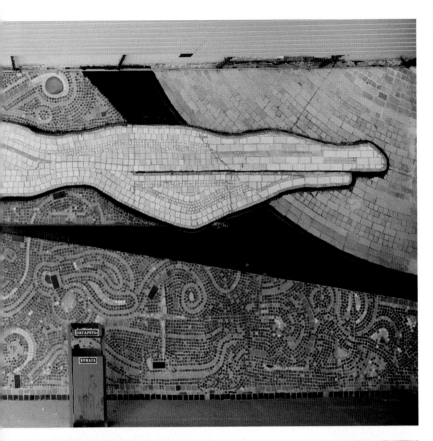

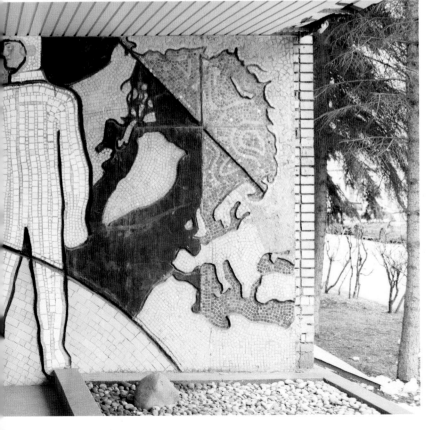

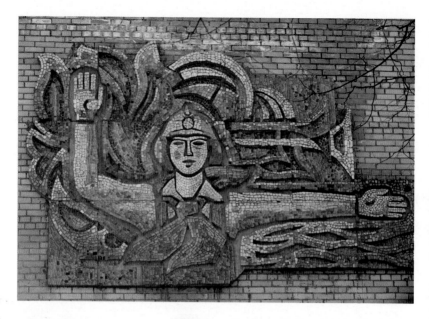

Headquarters
of the youth volunteer
fire brigade
Moskovsky prospekt, 4

044 A

Zernova, E. S. (?)
1972

Established to provide firefighting train-
ing to schoolchildren, brigades of youth
firefighters still exist in Russia today. The
coarsely executed relief and mosaic show
a half-figure portrait of a schoolchild in a
protective hat with a raised and extend-
ed arm regulating traffic and pointing to
a safe route. Behind him we see a fire and
horns sounding the alarm. There is run-
ning water under the Pioneer's extended

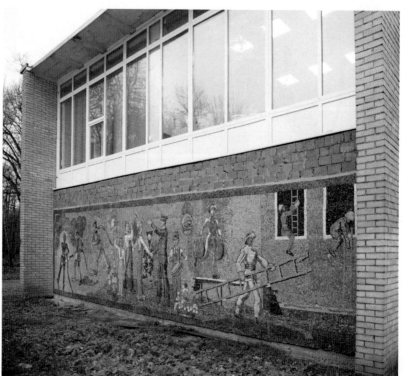

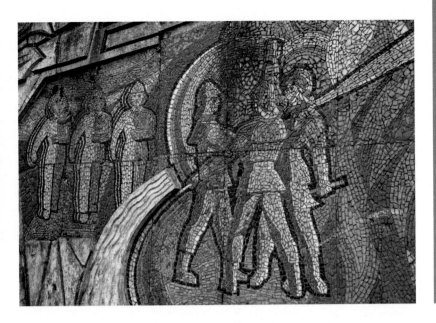

hand. The composition on the stele beside the building is much more interesting. This monochrome relief depicts figures of children with fire horns, seen in profile. Three mosaic boys in blue uniforms direct a hose with a relief jet of water at a fire, while a detachment of schoolchildren in Pioneer's ties march in three lines nearby. A further panel showing children with a hose, the awarding of an ensign, and a training session involving ladders decorates the headquarters building of the volunteer fire brigade. It is possible that Ekaterina Zernova was one of the authors of these mosaics (the initials 'E. Z.' are visible in the corner of the latter panel). Zernova worked with red, blue, and white smalt and used a black outline and contrasting shadows in her depictions of human figures.

3

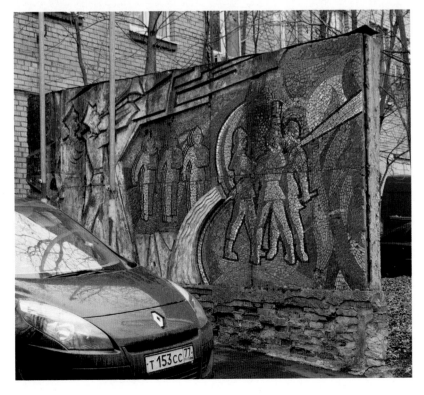

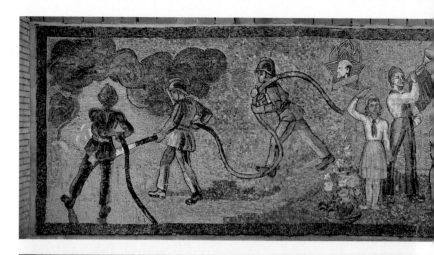

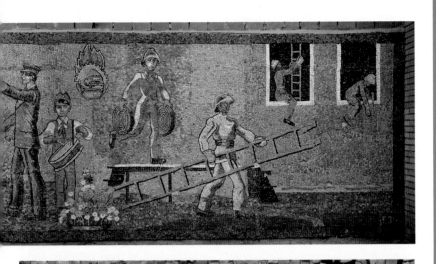

3

Principal Directorate of the Fire Service for the City of Moscow (now Principal Directorate of the Russian Ministry for Extraordinary Situations for the City of Moscow)
Prechistenka ulitsa, 22/2

Vasiltsov, V. K., Zharenova, E. A.
'The History of Great Fires in Moscow'
1994

Spouses Vladimir Vasiltsov and Eleonora Zharenova, graduates of Deineka's workshop at the V. I. Surikov Moscow State Art Institute, decorated the wall of a mansion from the 1760s on Prechistenka. During reconstruction after the fire of 1812, it was adapted for use as a fire station and a wooden fire-observation tower was added in 1843. It now houses the Fire Service Directorate and the wall shows a mosaic of two fires: the Bolshoi Theatre in 1853 and the Hotel Rossiya in 1977. Unflappable firemen hold hoses against a background of large buildings. Hotel Rossiya, which was designed by Dmitry Chechulin and located in Zaryadye beside the Kremlin, was demolished along with the mosaics in its inner courtyard in 2006–2010.

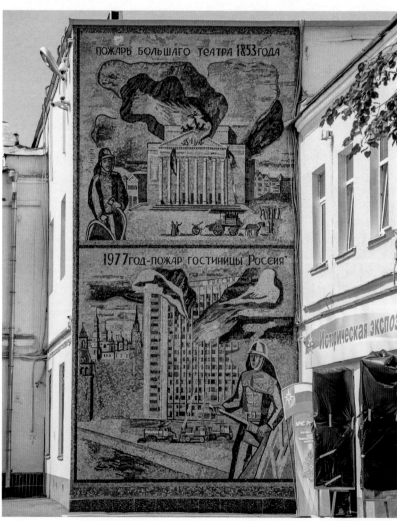

All-Russian Voluntary Fire Society
Gilyarovskogo ulitsa, 29

Unknown artist
1970s

Erected in 1917, this building features a relief on its end wall and was decorated with Roman mosaic in the 1970s. Firemen in safety helmets pour water from hoses and scramble up ladders. A female controller takes calls for help. Jets of water, clouds of steam, and columns of fire impart geometrical plasticity to this figurative composition and dramatism to the whole narrative.

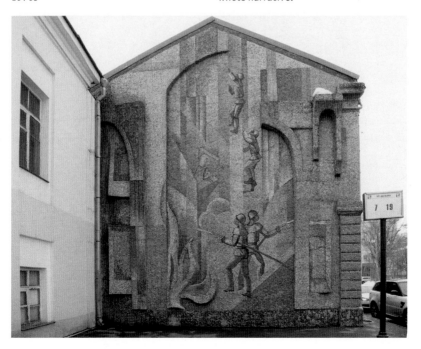

'Runners'
Beskudnikovsky bulvar, 12

047 A

Fuks, V.I. (?), (Tutevol, K.A. (?))
1966

This brick building with large windows contains a sports school and a swimming pool. 'Runners', the mosaic panel on its façade, may have been designed by Vladilen Fuks (1926–1986). Fuks also created mosaics for buildings in the districts of Medvedkovo, Degunino, and Beskudnikovo in the north of Moscow in the mid-1960s.

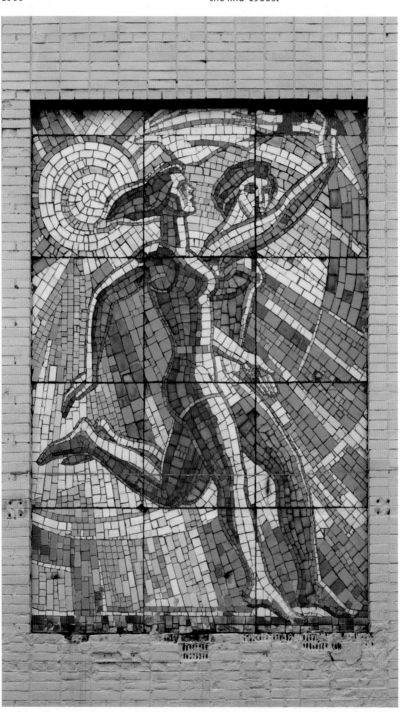

Moscow Factory for Thermal Automation (MZTA)

Mironovskaya ulitsa, 33

Unknown artist
1964

Founded in 1926, the factory made shells and parts for Katyusha rocket-launchers in the Second World War and boiler equipment in the 1950s. The brick entrance checkpoint building features a brutal mosaic relief. A male and a female look one another in the eyes. The pieces of equipment between and around them have become abstract figures. The piece is made even more surrealistic by a half-sphere between the two foreheads. The romanticism of the 1960s is boosted by the manufacturing aesthetic; technology takes on an anthropometric dimension.

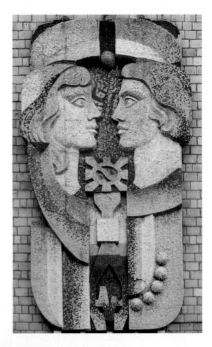

3

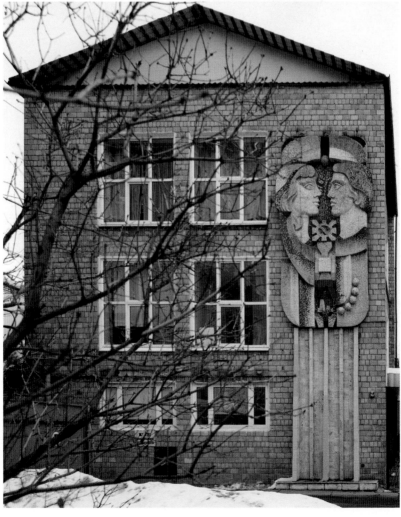

**Palace of Marriage
(now Ryazansky ZAGS)**
1st Novokuzminskaya ulitsa, 3

 049 A

Zhernosek, E. P.
'Youth. Spring. Love'
1966

This composition in the spirit of romantic 'naïve modernism' with young women, churches, and white doves is deliberately 'primitive'. The vertical strips in grey, brown, and green set a rhythm for the stretched-out architectural volumes and long women's dresses.

3

**Seasons of the Year
Restaurant
(now the Garage Museum of
Contemporary Art),
Gorky Central Park
of Culture and Leisure**
Krymsky Val ulitsa, 9/32

Unknown artist
'Autumn'
(1968)–1972

Gorky Park – a cult place in Moscow – was laid out on the site of the legendary All-Russian Agricultural and Crafts Exhibition of 1923, which in turn had replaced a rubbish tip on the bank of the River Moskva. The Seasons of the Year restaurant was built in the 1960s with extensive glazing to allow people to enjoy views of nature. The central wall in the restaurant's vestibule was decorated with a ceramic mosaic likely laid out to designs by students of the Stroganov School of Applied Art or another art institution. The composition recalls Botticelli's *The Birth of Venus,* but the long-haired maiden has a 'creating' right palm taken from Michelangelo's *The Creation of Adam.* An ear of wheat, the sun, and a dove are also visible floating in the mosaic. The mosaic was conserved along with the losses it had incurred following the closure of the restaurant. This was decided by architect Rem Koolhaas, who adapted the building to be used as an exhibition space by the Garage Museum of Contemporary Art when it moved to Gorky Park from Bakhmetievsky Garage (built to a design by Konstantin Melnikov and Vladimir Shukhov in 1927).

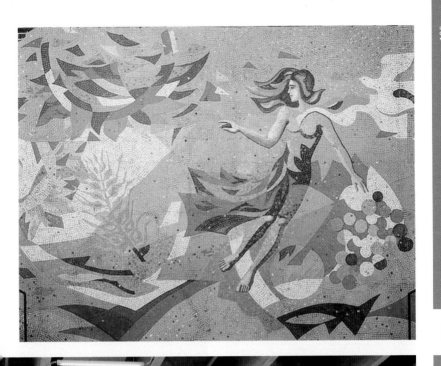

F. E. Dzerzhinsky
Trekhgornaya
manufaktura
Rochdelskaya ulitsa, 15/1

051 E

The new blocks erected at Trekhgornaya manufaktura, a textile factory established at the end of the eighteenth century, were decorated with a mosaic wall. Valentin Ivanov (born 1946), a graduate of the V. I. Surikov Art Institute and a pupil of Klavdia Tutevol, employed three female images to convey the location's historical name – *Trekhgorka* ('Three Hills'). The relief faces with a plasticity of outline that resembles Picasso are accompanied by circular breasts and 'fluidly' transition into abstraction.

Ivanov, V. V.
1976

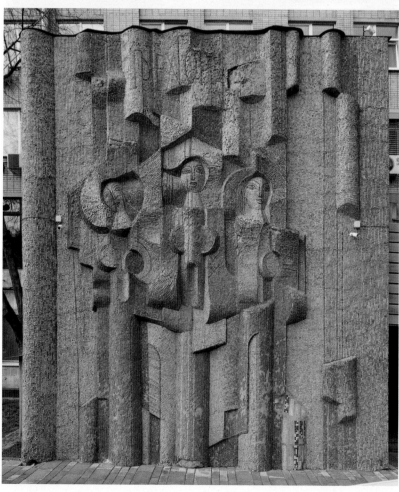

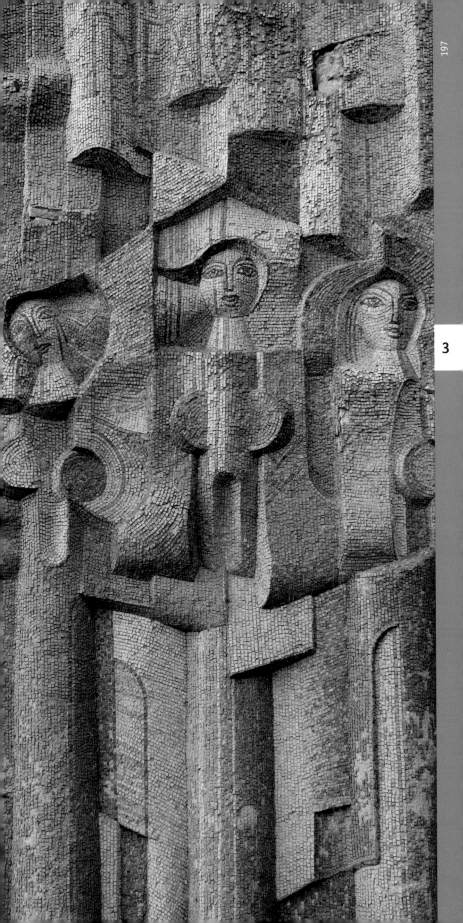

**M. V. Frunze
Moscow cotton
factory**
Varshavskoe shosse, 9,
bldg. 1B, KNOP block

052 A

Unknown artist
1960s (?)

One of the walls in the interior of this old
textile factory is decorated with a mosaic.
Three female figures wearing long, light-
coloured 'ancient-classical' vestments
'plait the thread of life'. The resemblance
to ancient parks and fates is reinforced
by the solar discs in the middle ground,
which evidently symbolise textile-making
machinery. The complex of buildings at
the Danilovskaya manufaktura has been
turned into lofts.

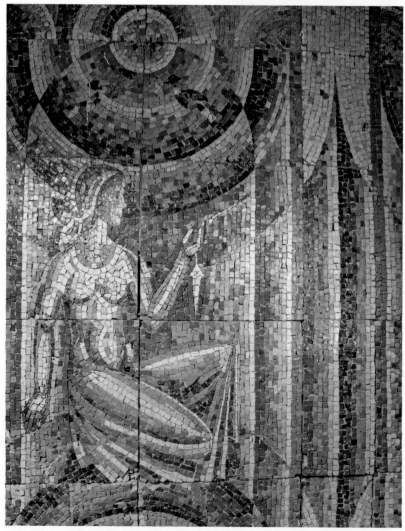

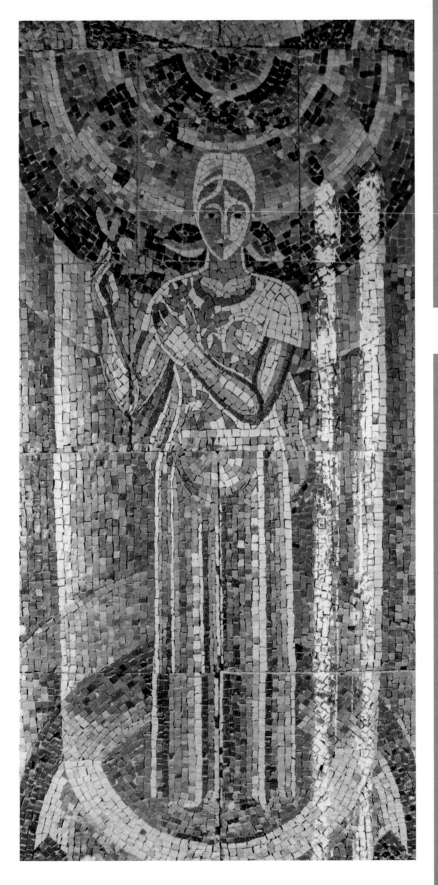

3

Institute for Research Sapfir, (now the Sapfir Scientific-Manufacturing Enterprise)
Shcherbakovskaya ulitsa, 53/2

Gulov, V. I., Kazakov, B. I., Skripkov, Y. N.
Ter-Grigoryan, S. L.
'Science'
1967

An allegory of science – a gigantic maiden – looms like the nymph Calypso above a hydroelectric station. A pentagon containing the USSR crest is visible in her raised right hand. The female figure links three horizontal panels. The first of these panels is dedicated to space, clouds, and satellites; the second portrays earth, water, and technical structures; and the third depicts people from the scientific professions – cosmonauts, engineers, and scientists.

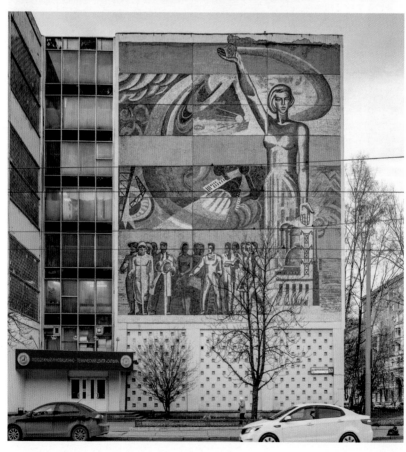

'Gas Industry' Pavilion (Pavilion No. 21)
VDNH
Prospekt Mira, 119

Unknown artist
1967

Pavilion No. 21 at VDNH was built in the Stalinist neoclassical style in the first half of the 1950s. The pavilion was originally named 'Potatoes and Vegetables', but this was later changed to 'Sugar and Confectionery Industry'. In 1967 the pavilion's rotunda was fundamentally reconstructed in the modernist style by Elena Antsuta and Vladislav Kuznetsov. Its originally designed concave portico rests on a trapeziform support whose outline is repeated by a buttress decorated with an abstract mosaic. The panel's pattern and dark blue colours evidently symbolise the burning of gas. Pavilion No. 21 is currently closed.

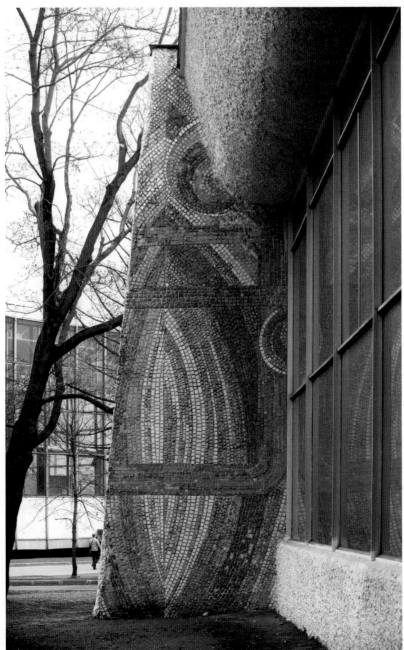

Oktyabr Cinema
Novy Arbat ulitsa, 24

Andronov, N. I., Vasnetsov, A. V., Elkonin, V. B., Syrkin, L. Z., Osin, O. I.
'October's Conquests'
1967

Oktyabr Cinema was built by Mikhail Posokhin and Ashot Mndoyants, the architects who designed this entire modernist avenue, which was originally named after the revolutionary Mikhail Kalinin. The monumentalist artists here used natural stone mosaic to decorate the square

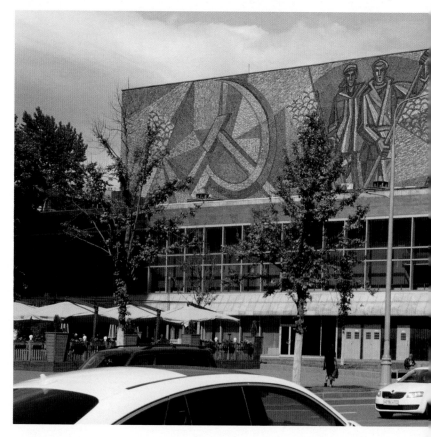

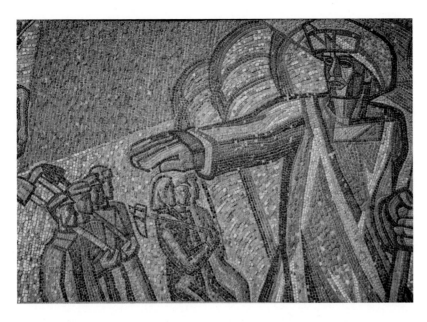

perimeter of the upper part of the cinema building. The division of the planes into geometrical figures in various colours, many of which are 'embellished' with a cobblestone pattern, imparts a dynamic quality to the even surface. The figures of members of the Red Army and the Red Navy, miners, metalworkers, soldiers, and workers are depicted in a great variety of scales and in a severe style. All are portrayed walking along the perimeter of the square, returning to one of the centres of the entire composition: the gigantic emblem of the hammer and sickle.

3

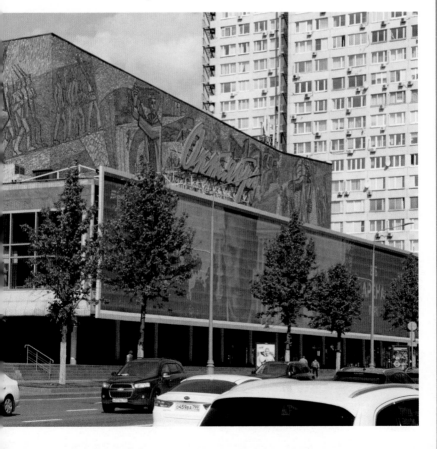

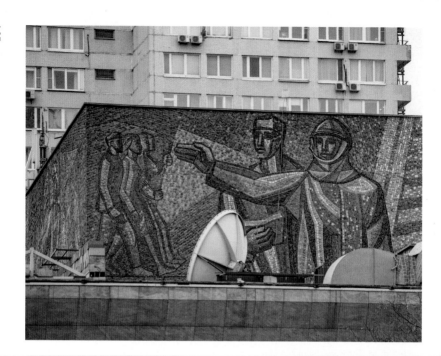

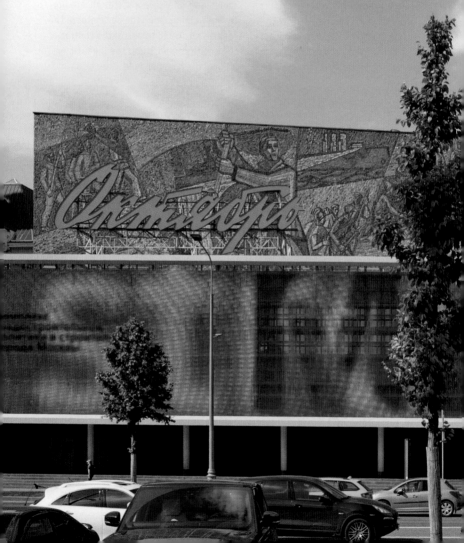

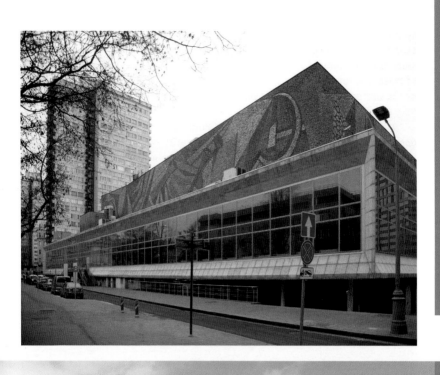

Council for Mutual Economic Assistance (now the Government of Moscow), façade of the conference hall, interior wall
Novy Arbat ulitsa, 36

056 E

Opryshko, G. I.
'The Riches Inside the Earth'
1966–1967

Mikhail Posokhin, the Chief Architect of Moscow and planner of prospekt Kalinina (now Novy Arbat), selected the site for the Secretariat of the Council for Mutual Economic Assistance – the organisation facilitating economic development in socialist bloc countries. Posokhin headed the team that designed the high-rise for the administration, the cube of Hotel Mir, and the rotunda of the conference hall, which all share a plinth. The external abstract mosaic 'The Riches Inside the Earth' was designed by Grigory Opryshko and made by Hungarian craftsmen from relief concrete tiles and natural stone. A similar 'firework display' made from marble, evidently by the same author, adorns an inside wall of the conference hall. Posokhin supported Evgeny Ablin in securing approval for minimalist sketches for the restaurant and canteen in the mid-1960s when abstraction was forbidden and Khrushchev denounced creators of non-figurative art as 'abstractists'. Ablin had the fluorite for his mosaic prepared in Tajikistan and personally chose the colours.

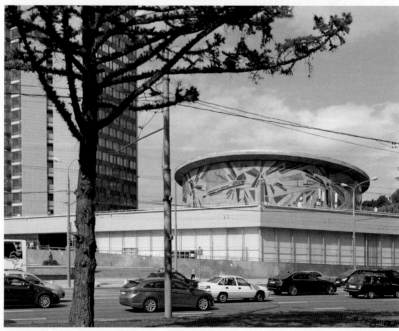

Sovintsentr (World Trade Centre), congress centre, atrium

Krasnopresnenskaya naberezhnaya, 12

057 E

Ablin, E. M.
1980

The Sovintsentr, an iconic work of late-Soviet modernist architecture, was built with financial support from American businessman Armand Hammer in order to accommodate the representative offices of foreign companies. Here, architects Mikhail Posokhin, Vladimir Kubasov, and Petr Skokan designed an original volume with a stepped wall and an interesting interior space. From the atrium with its famous wooden clock with a cock, the visitor can ascend a staircase whose walls are decorated with mosaic. The abstract compositions by Evgeny Ablin, with their rhythmical contrasting patterns, echo the original lamps and abut a pool with a fountain on the ground floor.

3

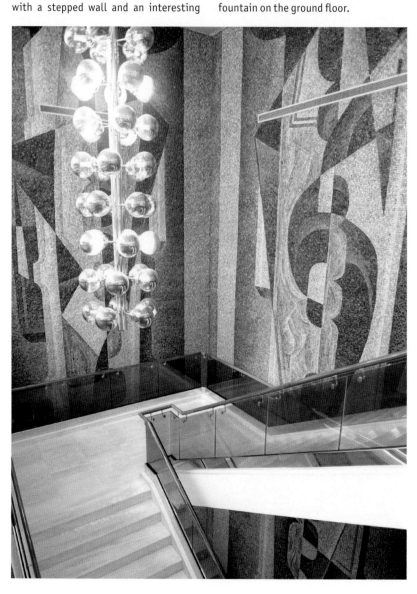

Olympiysky Sports Complex.
Swimming pool, diving pool
Olimpiysky prospekt, 16/1

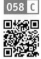

058 C

Ablin, E. M.
Diving tower
Dismantled
1980

The diving tower at the pool of the sports complex designed by architects Mikhail Posokhin, Boris Tkhor, and Leonas Aranauskas for the 1980 Olympic Games was decorated with smalt by the artist Evgeny Ablin. This mosaic's fluid sculptural forms and blue chromatic transitions turn the training structure into a gigantic underwater tree. The Olimpiysky Sports Complex has been closed for reconstruction since 1 January 2019. The swimming pool and the diving tower have both been demolished.

Auto-tractor Electric Equipment Factory
Elektrozavodskaya ulitsa, 21/41

059 A

3

Unknown artist
1965

The concrete relief laid out in a mosaic of natural stone still has some way to go before it becomes pure abstraction, but it is an organic fit with the industrial architecture. It is works like this that are most often lost. Their artistic value fails to be recognised, either by those who own the real estate or by the cultural environment. At the same time, this is a curious and rare example of sculptural and architectural generalisation of equipment from the 1960s.

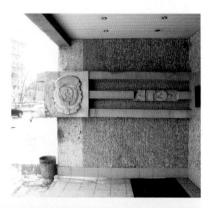

Novoe Donskoe Cemetery, columbarium no. 20

060 I

Ordzhonikidze ulitsa, 4

Neizvestny, E. I.
1966

Ernst Neizvestny's symbolist-lyrical re-
lief with a tree sprouting from a dead
body decorates the columbarium built
in 1960 at Novoe Donskoe Cemetery. The
side walls, corners, and parts of the walls
of columbarium no. 20 were covered with
mosaic according to designs drawn up by
Neizvestny in the mid-1960s. These are
generalised images of human figures in
mourning; bowls containing fire; branch-
es of laurel, oak, and dog rose; doves, and
even weeping children and infants. The
reliefs are of austere simplicity and dec-
orated with yellow, red, dark blue, and
black smalt. The columbarium walls are
currently under threat of demolition.

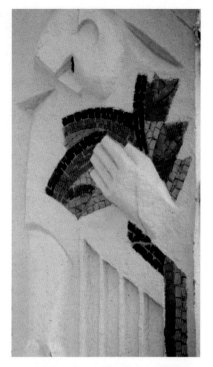

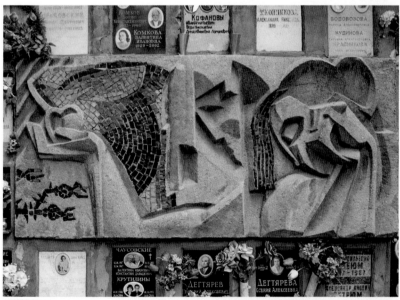

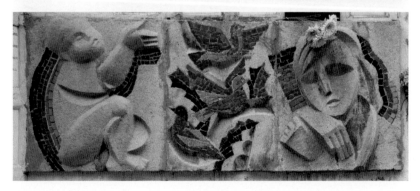

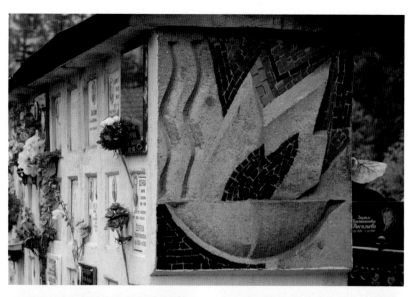

Urban clinical hospital no. 68 (Demikhov GBK)

061 A

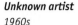

Shkuleva ulitsa, 4, bldgs. 8 and 10

Unknown artist
1960s

A simple elongated volume, the hospital building was built in 1958. The mosaic on its narrow side walls was evidently executed at the same time or slightly later. One of the panels depicts preparations for an operation. In spite of the generalised character of the figures in medical uniform, the artist has reproduced the water tap, syringe, and medical instruments in recognisable forms. Vases containing flowers 'standing' on the wall are visible around the corner from this panel. The second mosaic shows patients being looked after in two scenes: a patient on a bed and tests being conducted in the outpatient department. There are more flowers of the same kind around the corner. Two medical emblems – a red cross and crescent – have been placed on two separate walls. Interestingly, the mosaic assembled from small fragments of natural stone forms coloured frames around the hospital windows. It has been clad in siding following repairs to the building. The mosaic has been preserved, but the building has been stripped of its coherent architectural and artistic appearance.

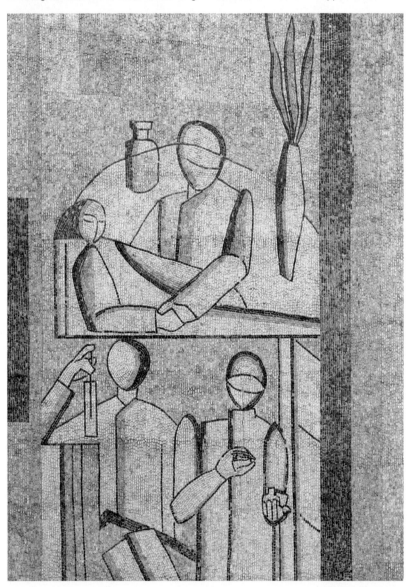

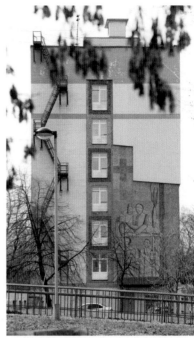

3

School No. 208 (A. S. Makarenko Intermediate School No. 656)

062 A

Beskudnikovsky pereulok, 4A

Unknown artist
1967

One of the end walls of the school blocks is 'embellished' with a mosaic made from smalt and natural stone. Schoolchildren here were evidently prepared for jobs as skilled workers. The figures of a metal-worker with a red-hot instrument of red smalt and a smiling young woman are shown against the background of a found-ry bucket. The identity of the author of this typical example of mosaic used to im-part individuality to a standard building remains unknown. The brutal aesthetic of natural stone and the romanticism of work are unlikely to be able to persuade today's Moscow schoolchildren to go into metal-lurgy but are still capable of stimulating interest in Soviet heritage.

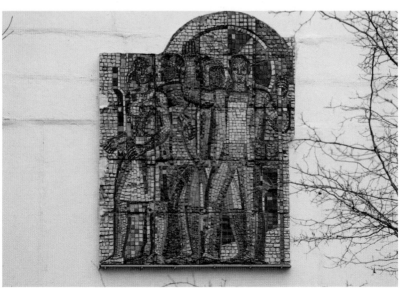

**Volga Cinema,
foyer**
Dmitrovskoe shosse, 133

*Chernyshev B. P., Shilovskaya, T. A.,
Lukashevker, A. D., Gridin, V. A.,
Slepyshev, A. S.*
'Volga', 'Cities on the Volga'
1968

Artist and sculptor Boris Chernyshev (1906–1969) introduced natural stone into Soviet mosaic, often in the form of pebbles, and used wide and open grout lines. This kind of deliberate primitivism, which has its roots in the Soviet avant-garde in the works of Pirosmani and was legitimised as a style 'of the people' in the paintings of Samuil Adlivankin and Georgy Rublev, took on a programmatic, naturalistic significance in the work of Boris Chernyshev. Chernyshev often collaborated with Tamara Shilovskaya (1916–2001), who helped Pavel Korin create mosaics at Komsomolskaya metro station and MGU. The artists decorated the foyer of the Volga Cinema, which is currently inaccessible to Muscovites (the building is under repair), with smalt in light and dark blue and natural stone. Five young women emerge from the water of the river. It is also possible to discern the outline of Kalyazinskaya belltower, the only part of St Nicholas' Cathedral to survive following the construction of the Uglich reservoir.

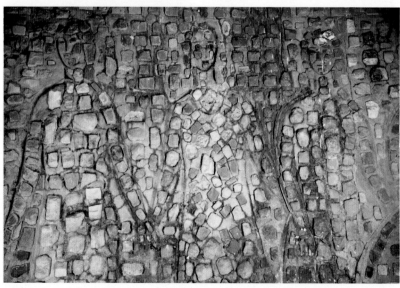

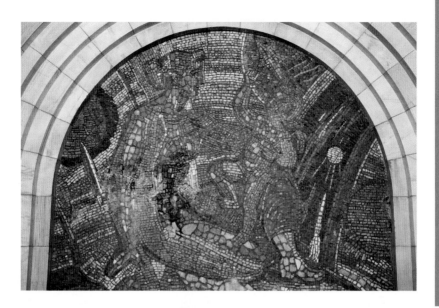

Dobryninskaya
metro station,
end wall
in the underground hall

064 I

Pavlovsky, S. A.
'Morning of the Space Age'
1967

The artist Serafim Pavlovsky created this panel from natural stone and smalt to replace a marble composition – a profile of Stalin surrounded by flags – by the famous sculptor Elena Yanson-Manizer. The female figure with a child playing with stars and planets imparts even more mysticism to the station designed by Leonid Pavlov with allusions to the stepped portals of the Church of the Intercession on the Nerl. This church-like station's principal 'nave' has thus acquired a 'Virgin Mary with child', another 'Soviet Madonna' – precisely as in Pavel Korin's composition at Novoslobodskaya.

3

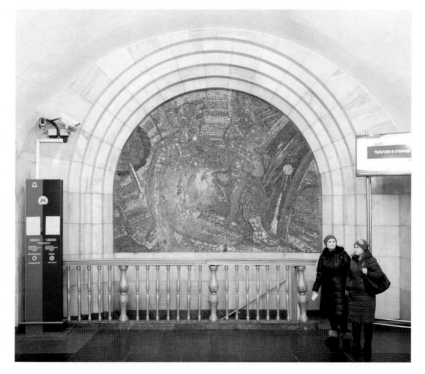

Residential buildings

065 A

Chernyshev, B. P.,
Shilovskaya, T. A.,
Lukashevker, A. D.
'Choristers'
Usievicha ulitsa, 15/2
1959–1960

Chernyshev, B. P.
'Tamara'
Usievicha ulitsa, 15
1961

Chernyshev, B. P.
'Moscow'
Leningradsky prospekt, 43/2
1966

The six-storey brick house at Usievicha ulitsa, 15 was built in 1961 and decorated with mosaics made from smalt and natural stone. Two of the mosaic panels have since been lost. The surviving panels are 'Tamara', which is positioned on the wall of the house and named after the poem by Mikhail Lermontov about the cunning and malicious demon who destroys his lovers, and 'Art' ('Choristers'), which is placed on the electricity transformer station in the courtyard of the building. The female images arranged in stone, ceramic tile, and glass feature broad grout lines and are simultaneously romantic and severe in their plasticity. Chernyshev started using the direct mosaic technique with large pieces of mosaic after work on his panel with the figure of Mikhail Kutuzov – one of the 'pictures' by Pavel Korin on the underground vaulting of Komsomolskaya metro station on the Circle Line. The mosaic/

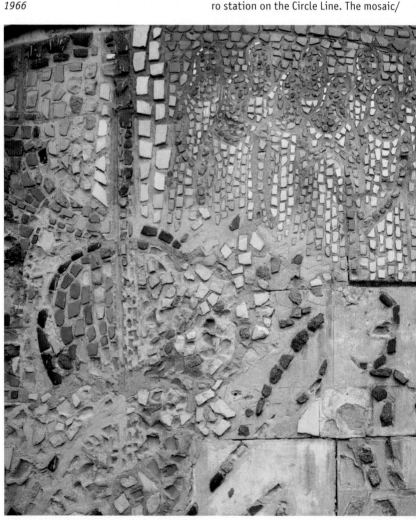

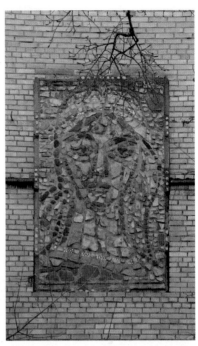

3

fresco/sculptural panel 'Art' was made by Chernyshev in 1959–1960 for the pediment of the Culture Pavilion at VDNH. He created 'Tamara' while undertaking work on the monument to Mikhail Lermontov a year later in 1961. 'Moscow' on house 43 on Leningradsky prospekt has an allegorical significance: the female face is an embodiment of the city.

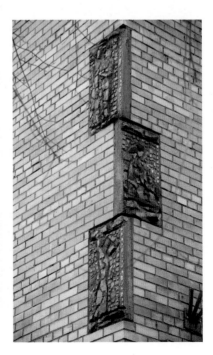

Moskvich Leninsky Komsomol Automobile Factory (now the Techno Hall shopping centre)
Volgogradsky prospekt, 32/8

066 A

Unknown artist
'Assembling Moskvich Automobiles'
1968

Four large strips of ceramic mosaics depicting automobiles, spanners, jacks, smoking chimneys, and pollarded trees wrap around the corner of the brick building here. The factory's emblems (invariably displaying the Spasskaya Tower in the Kremlin) are clearly visible once the observer moves around this corner. They are the emblems of the ZMA (Small-Engine Automobiles Factory), MZMA (Moscow Small-Engine Automobile Factory), and AZLK (Leninsky Komsomol Automobile Factory). The factory, which once manufactured the cult 'Moskvich' cars, was declared bankrupt in 2006.

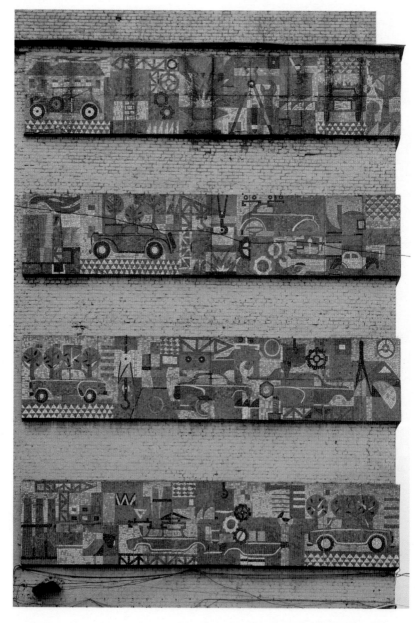

Svoboda Factory (now Kosmeticheskoe obiedinenie 'Svoboda')

067 A

Vyatskaya ulitsa, 47/4

Unknown artist
1967

The ensemble of style moderne brick buildings designed by the French architect Oscar-Jean Didiot was built specially for the A. Rallais et Co. perfume factory, which opened in Moscow in 1843. A relief of a female head with a tulip is mounted on the principal façade of one of the blocks. The factory manufactured the popular scents 'Lily of the Nile', 'Russian Violet', and 'Silver Lily-of-the-Valley'. In the 1860s its owners laid out plantations in the south of Russia to grow plants for making essential oils. After the revolution, the factory was renamed 'State Soap-Making Factory No. 4' and subsequently 'Svoboda'. It is currently owned by the financial and industrial group Buket. The clock-house leading through to the factory block was added on in 1967. Its windowless wall is decorated with a mosaic of ceramic and smalt with fantastical dark-blue and green colours.

3

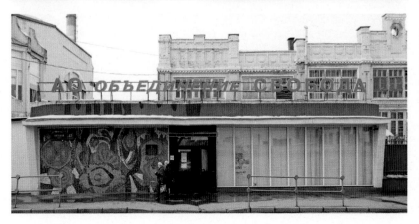

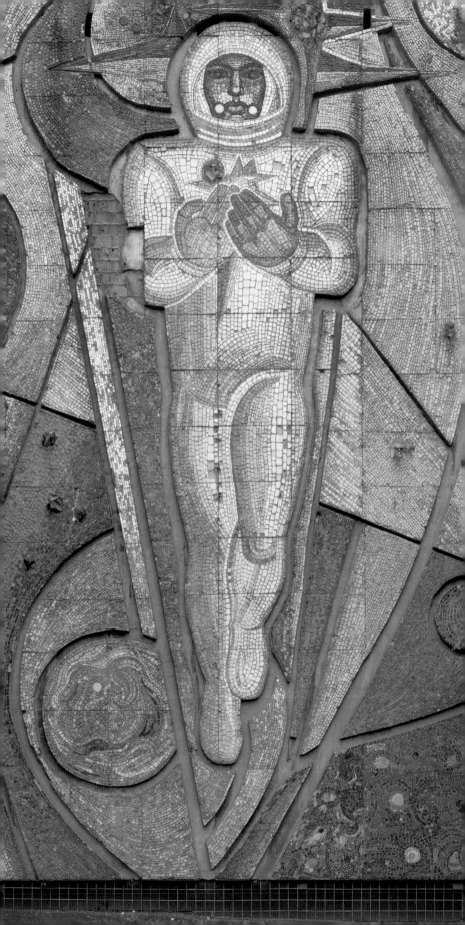

**Intermediate
School No. 548
(now School No. 630)**
Varshavskoe shosse, 12

068 A

Korolev, Y. K.
'Space'
(1965)–1969

On a wall specially built onto the end wall of this intermediate school, Yury Korolev depicted a gigantic, three-storey-high, cosmonaut in a spacesuit moving through space. The cosmonaut holds a 'stellar structure symbolising atomic energy, the world of the microcosm' and planet Earth floats beneath his feet. The entire panel, which consists of tiles of coloured glass, gold smalt, and natural stone, has a clearly expressed relief. The mosaic projects outwards, while there are white 'depressions' made by the outlines between the gradations of form and colour. There were three-dimensional stones inserted in places, though many of these have been lost over the years.

3

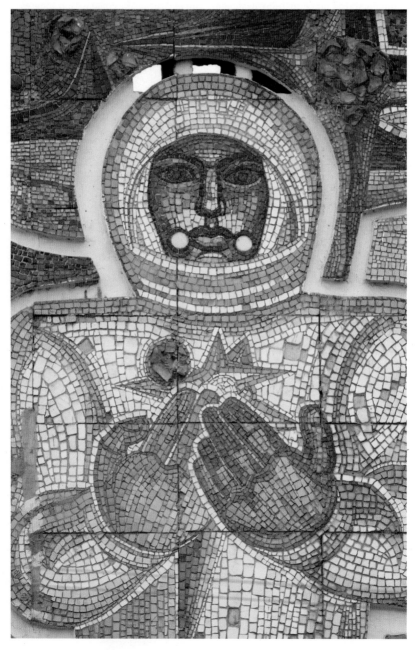

**Central House
of Film-Makers,
restaurant**
Vasilievskaya ulitsa, 13/1

069 B

Merpert, D. M.
'The Art of Film'
1969

The first Moscow House of Film opened on ulitsa Vasilievskaya in 1934. After several moves, the House of Film was given its own new and separate building – an understated modernist box designed by architects Evgeny Stamo and Andrey

Gozak and featuring a massive relief on its façade depicting a dove with a reel of film. One of the walls at the House of Film was designed by Dmitry Merpert (1924–2008), author of the 'Builders of Communism' mosaic panel (which became a well-known postage stamp) and the stele at Artek, the country's principal Pioneers camp. At the House of Film, Merpert depicted folk dancers, musicians, and drama performers in historical costume against abstract backgrounds. The human figures are suspended in the air and the entire composition adheres to a grey-yellow-light blue colour scheme.

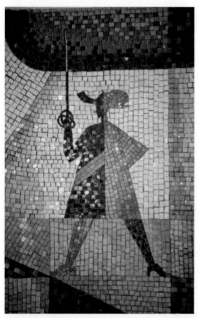

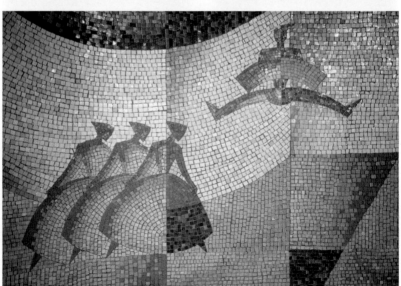

Park Kultury
metro station
on the Sokolnicheskaya Line,
vestibule

070 H

Ryabov, L. M.
'Maxim Gorky'
Late 1960s

The Central Park of Culture and Leisure (TsPKiO) was named after Maxim Gorky in 1932 when the Soviet writer was still alive. Gorky was the first chairman of the Union of Writers of the USSR and a proponent of socialist realism. His ashes were immured in the Kremlin wall. Nevertheless, the portrait of the 'realist' Gorky with his striking moustache à la German philosopher Friedrich Nietzsche was executed by Lev Ryabov in the modernist style in marble mosaic. The portrait was placed in the postconstructivist rotunda that was built according to a design by the architects Nikolay Koli and Sergey Andrievsky in 1935. This is how the first phase of the Moscow metro system, which had been purely architectural in its original design, was 'enriched' to include mosaics in the 1960s.

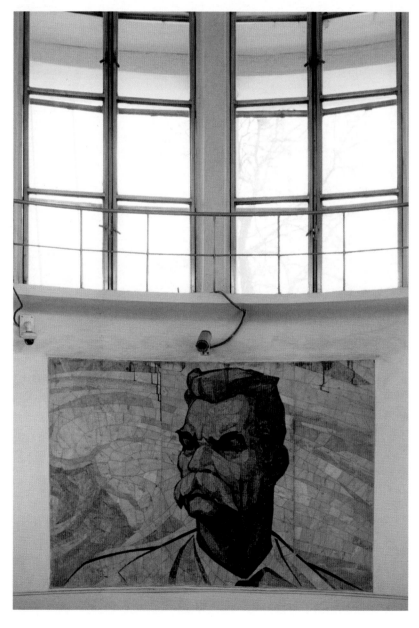

**Trolleybus
Depot No. 5**
Khodynskaya ulitsa, 5/2

Unknown artist
'All Power to the Soviets!'
1960s (?)

The history of Trolleybus Depot No. 5 dates back to before the revolution. Uvarovsky Depot, with its coaches for horse-drawn and electric trams, was situated in the centre of Moscow on Devichie pole. In 1922 the tram and trolleybus depot was named Ivan Artamonov after a worker who perished during the Civil War. It received the number '5' in 1963. Although we find the Russian initials 'O' and 'Shch' on the mosaic panel made from tiles on the end wall of the brick building, the author of this work remains unknown. The 'picture' is designed in the naïve modernist style and depicts events on Krasnaya Presnya during the revolution.

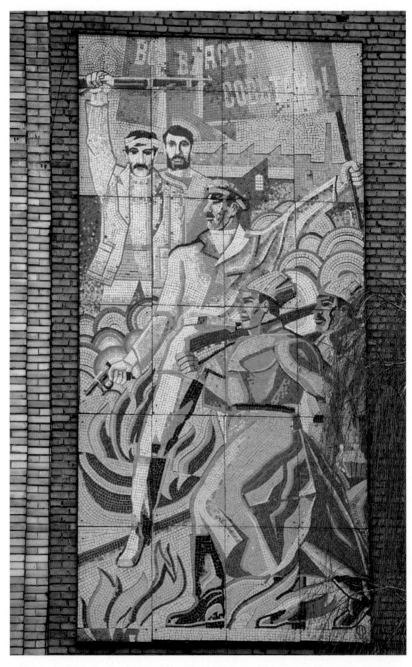

Prospekt Mira metro station on the Circle Line, vestibule

072 C

Kuznetsov, A. N.
'Mothers of the World'
1967

3

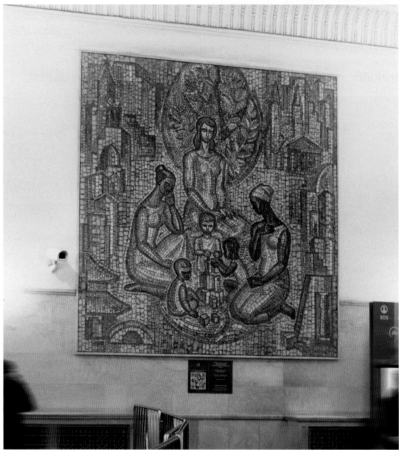

Botanichesky Sad (Botanical Garden) metro station was renamed Prospekt Mira ('Avenue of Peace') in 1967 after the main road that was given the name 'in 1957 in honour of the international peace movement and in connection with the 6th World Festival of Youth and Students that was held in Moscow'. The panel by Andrey Kuznetsov (1930–2010), one of the leading monumentalist artists in Moscow, depicts young women from three continents (Europe, Asia, and Africa) watching children erect a tower from building blocks. There are outlines of architectural structures from different epochs and cultures on either side of the composition, including a pagoda, an Egyptian temple, a classical portico, a mosque, a Gothic cathedral, a kremlin, and skyscrapers. This small panel was created by Kuznetsov to mark the 'Soviet Russia' republican anniversary exhibition. It was only later that it was installed at Prospekt Mira station to replace a bas relief with a profile of Stalin.

Krasnoselskaya metro station, vestibule

073 D

Kuznetsov, A. N.
'Red Drummer'
1969

A graduate of the Mukhina Higher School of Applied Art, Andrey Kuznetsov produced many works for the metro, including reliefs at Shosse Entuziastov station, stained-glass panels at Shabolovskaya and Cherkizovskaya, and a Florentine mosaic at Tsaritsyno. Krasnoselskaya station belongs to the first phase of Moscow's metro. It was designed in the art deco style without decorative 'superfluity' of any kind. It was 'enriched' with a mosaic made from natural stone and smalt in the vestibule in the 1960s. A much larger panel with a ripped, 'stellar' edge was installed on the end wall of the Palace of Pioneers in Tolyatti in 1969. Arkady Gaydar's short story *The Drummer's Fate* about Serezha, a schoolboy who uncovers a conspiracy by spies from the White Guards, was published in 1939 and enjoyed lasting popularity in the Soviet Union. The drummer boy on the panel comes across as a guarantor of peace and progress. Behind him, Red Army soldiers fight the enemy, cosmonauts and academics are busy at work, and builders erect multi-storey buildings (a new development in the architecture of the USSR).

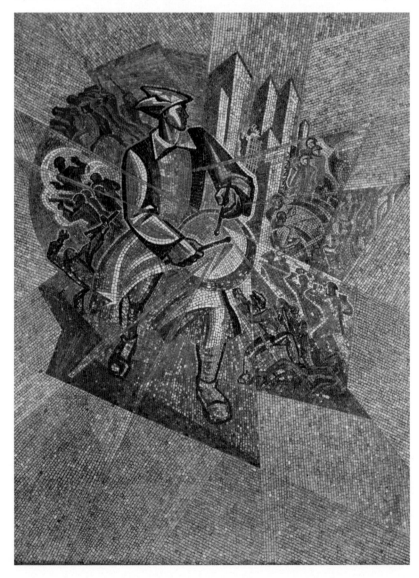

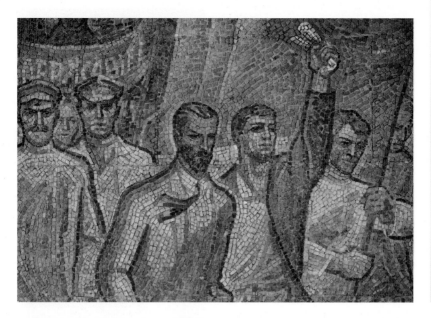

Moscow Bauman Higher School of Technology (now Moscow State Technical University), library, main building, auditorium 345
2nd Baumanskaya ulitsa, 5/1

074 D

Titov, V. A.
'Bauman'
1969

Nikolay Bauman was killed on 18 October 1905. Streets in cities across Russia were named after him. His name was also given to a metro station in Moscow, a university, and Kazan's State Academy of Veterinary Medicine. Bauman studied at the latter, which is near the main building of Imperial Moscow School of Technology (now known as 'Baumanka') and the spot where he was killed. Artist Viktor Titov (1922–2003) used this mosaic to depict a demonstration. It features cobblestones in the foreground and a 'Down with Autocracy!' sign at the back. Bauman was shouting these words from a horse-drawn cab travelling along Nemetskaya (now Baumanskaya) ulitsa when Nikolay Makhalin came running towards him and killed him with a piece of metal pipe as Bauman himself was taking aim with his Browning.

3

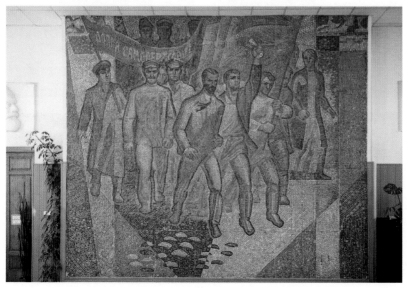

Main Calculating Centre of USSR Gosplan (now the Analytical Centre at the Government of the Russian Federation)

075 C

Prospekt Akademika Sakharova, 12

Dauman, G. A., Kozubovsky, E., Fedotov, A.
1970

The Gosplan Calculating Centre is a modernist cube on legs designed by Leonid Pavlov. It is decorated with original mosaic reliefs. The three circles depict industry, space, and agriculture: steelworkers and welders, cosmonauts in a spacecraft, and a woman with a child symbolically signify the three most important sectors of the Soviet planned economy. The mosaic inserts executed by artist Grigory Dauman (1924–2007) were made using very small pieces of natural stone and smalt. The two tiny welders in protective helmets are especially fine.

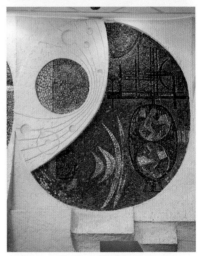

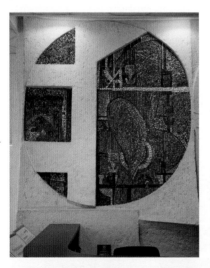

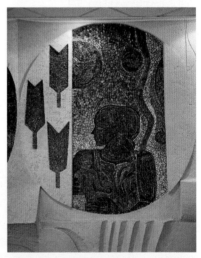

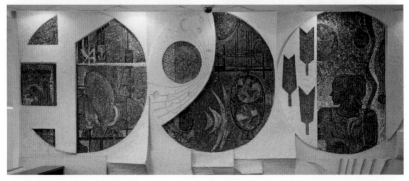

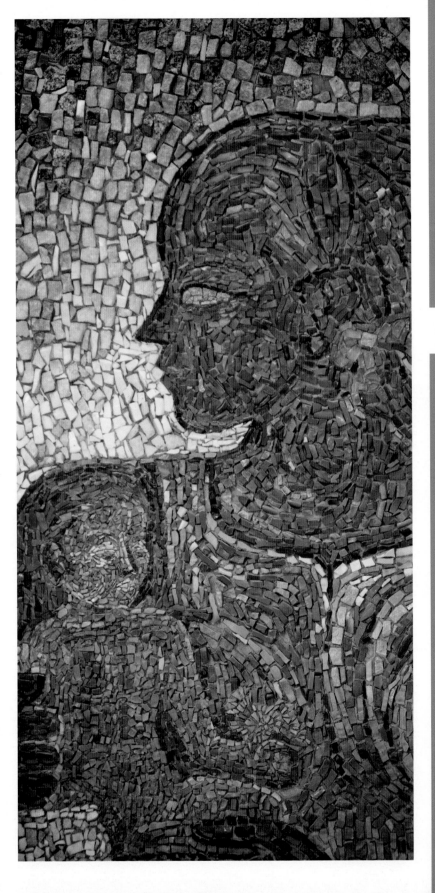

Moscow Central Bus Station
Shchelkovskoe shosse, 75

Korolev, Y. K.
'My Motherland' ('Russia')
(1966)–1971

The relief dividing the wall of the second-storey hall of the bus station was structured by Yury Korolev in the style of Dutch painter Piet Mondrian. The system of rectangles in different colours had figurative inserts in the manner of the marginal images on various subjects that are found in icons. Generic scenes in the large marginal images are combined with still lifes and images of animals and birds in the smaller 'rectangles'. The composition's original title – 'Russia and her Mothers' – is reflected in the largest panel, which depicts two women of different ages and two children. Also portrayed are a cosmonaut in a spacesuit floating in open space among the planets and a Second World War soldier coming out to meet the passengers. Here too is a reference to the carved stone lion at the Cathedral of St Dmitry in Vladimir and the Church of our Saviour in Nereditsa in Novgorod (the buses departing from this station served destinations in the north). Built in 1971, the bus station was demolished in 2017. The restored artwork is now located in the new building of the transport hub.

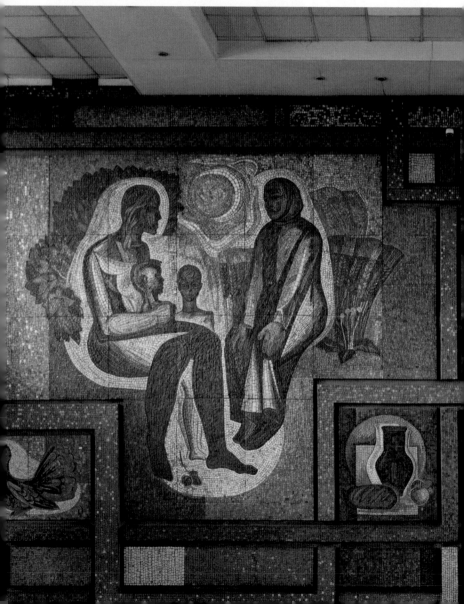

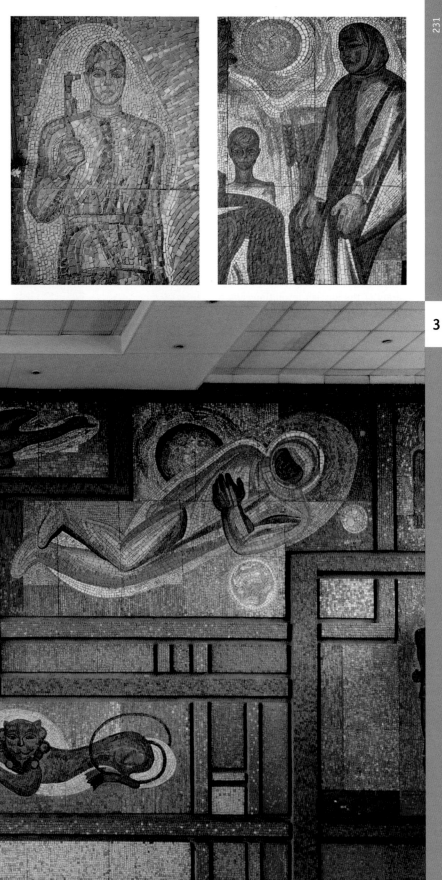

Moscow State Union Planning Institute (now Moselektronproekt)

077 A

Kosmonavta Volkova ulitsa, 12

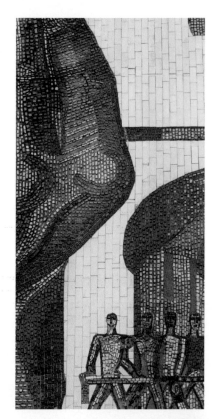

Milyukov, B. P.
'Creation'
(1969)–1971

This composition by monumentalist artist Boris Milyukov (1917–1998) consists of three gigantic right hands, figures of builders, and stylised lines and cables. It is made of natural stone, smalt, and rectangular white tiles. Milyukov earned the title 'Soviet formalist' and was a contemporary of the Russian revolutions and a fan of Picasso. He made this monumental panel on the façade of the Moscow State Union Planning Institute, which 'designed industrial, public, and residential buildings of varying degrees of complexity' and supervised the construction of enterprises in the electronic and atomic sectors.

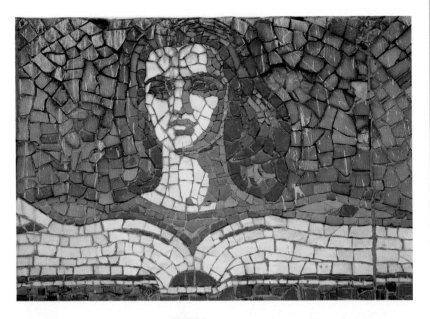

Building
on Donskaya ulitsa
Donskaya ulitsa, 39/4

 078 **I**

Zernova, E. S.
'Books are Mankind's Memory'
1960s

The mosaic on the wall of this brick residential building erected in 1932 was evidently installed in the 1960s. The sketch in tempera on canvas for this panel was executed by Ekaterina Zernova (1900–1995) in 1964. Five panels of masterfully composed yellow, dark-blue, and red smalt are arranged in a horizontal composition. A woman with a dark-blue face sits at an open book and holds a crystal in one hand. A red sun rises behind her, and we see a hammer and sickle on the left and flasks or retorts on the right. The building on ulitsa Donskaya is currently occupied by Moscow State University of Design and Technology. Zernova, who studied under Ilya Mashkov, worked with Yury Pimenov and Alexsander Deyneka. She produced a number of sketches for mosaic panels for the Institute of Oceanology at the Russian Academy of Sciences in the late 1960s and early 1970s. These sketches remained on the drawing board. One fairly small panel, hardly larger than an easel painting, currently hangs in a room at the institute: this is 'Bathyscaph' (1968).

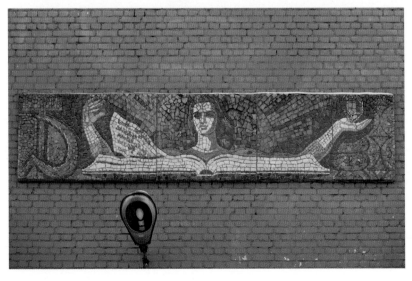

'Children's Book'
Sushchevsky val ulitsa, 49

Berezhnoy, I. G.
1979

The façade of Detskaya kniga ('Children's Book') factory, a publishing and printing house, features a mosaic assembled from pre-prepared tiles. The complex figurative composition of a female teacher, five pupils, a Red Army soldier in a greatcoat, and the head of a cosmonaut is positioned under a rainbow against a background of Kremlin buildings, a train crossing a bridge, a helicopter in flight, and a building under construction. Below these symbols is a quote from Lenin: 'Bringing up, educating, and training young people should be entirely about cultivating the Communist morality in them.' The factory has been demolished, but the authorities promised to re-install the mosaic on the new building set to be erected in its place.

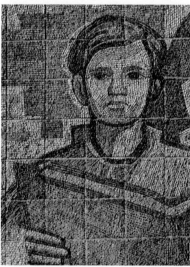

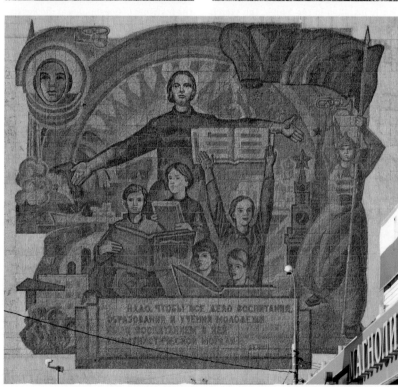

3

Institute
of Glass
Dushinskaya ulitsa, 7/1

080 A

Kuliev, A. A.
'The Birth of Glass'
1973

The Institute of Glass is housed an understated modernist box erected on the grounds of what was once a glassmaking factory. The main entrance is decorated with a monumental mosaic. It is possible to make out crystals and laminae of transparent glass in this almost abstract composition designed by artist Abdulla Kuliev, a graduate of Moscow Higher School of Applied Art (now the Stroganovsky Institute). The originality of this work is derived from the chromatic transitions inside the geometric figures. The entire composition was assembled on a windowless wall of the building using pre-prepared square tiles. The signatures of the architect and artist who designed it are visible in the lower part of the panel: 'Arch. Tyukov S. P. Art. Kuliev A. A. 1973.'

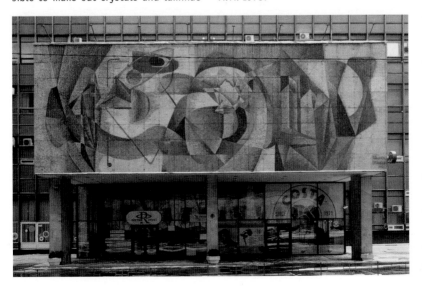

**Fili (now Konstruktor)
sports complex**
Bolshaya Filevskaya ulitsa, 32

081 A

Ivanov, S. I, Kolesnikov, V. V.
'Champions', 'Football', 'Sporting
Gymnastics', 'Snorkellers'
1973

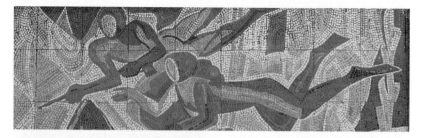

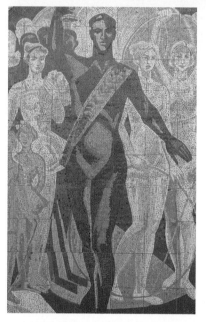

A mosaic panel entitled 'Big Sport' stands out in this series designed in an original red-brick/light-blue range of colours on the brick building of this sports complex. The centre features a young man triumphantly holding a winner's cup in his extended right hand. This figure was originally supposed to have been a young woman, as is clear from its jutting hips and the overall feminine proportions. The small horizontal panels between the windows of the first and second storeys are in a graphic style: the generalised plasticity of the figures of the horizontally diving goalkeepers and swimming scuba divers in flippers allude to the poster-like aesthetic of Alexsander Deyneka. And yet the seemingly tired figures of the sportsmen and their sad faces bear witness to the onset of the age of postmodernism.

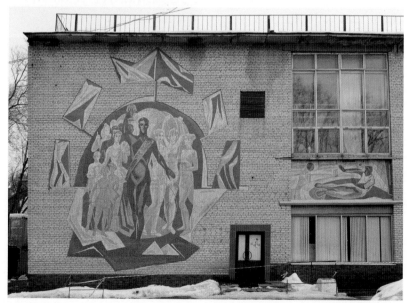

V. I. Lenin Institute of Physical Culture and Sport (Sports Research Institute at the State University of Physical Culture, Sport, Young People, and Tourism). Training block

082 A

Sirenevy bulvar, 4

Tutevol, K. A.
'Relay'
1972–1973

Sport was energetically promoted in the USSR. Many stadiums were built; 'industrial gymnastics' were held at factories and businesses; schoolchildren took tests in GTO ('Ready for Labour and Defence'); and the radio broadcast 'morning exercises'... The panel above the main entrance to the Institute of Physical Culture and Sport, which was founded immediately after the revolution in 1918, depicts a young woman running with the Olympic torch in her hand in front of two track athletes handing over a relay baton. The panel's author is Klavdia Tutevol (1917–1980), who studied under the avant-garde artists Aristarkh Lentulov and Alexsander Deyneka at the Surikov Institute and later worked at the workshops for the Palace of Soviets and at the Moscow Combine of Decorative Art and Design. The symmetrical composition of figures of powerful athletes unfolds against a semi-abstract background. The green oval of a stadium is in the centre, while the running tracks around it have become strips in different colours. A white dove flies in front of the athletes, while a flame of white smoke curls behind them. The USSR failed in its bid to host the 1976 Summer Olympics, but later succeeded in hosting the 1980 Summer Olympics.

3

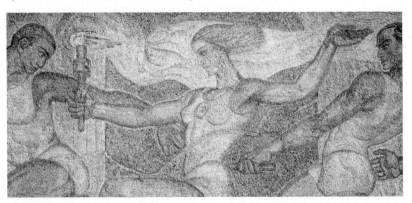

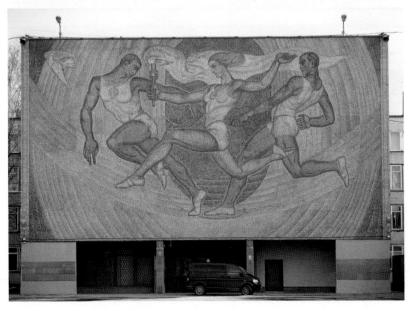

Pravda sports complex (now X-Fit fitness club), swimming pool

Pravdy ulitsa, 21/2

083 A

Kuliev, A. A.
'Sport'
1969

Mosaics portraying sports can also be found inside buildings. Entire walls of the Pravda sports complex were decorated by Abdulla Kuliev using natural stone in an austere range of colours. A grey female swimmer, a male pole vaulter, grey track athletes, and a grey diver against the background of the five Olympic rings are depicted in a slightly primitivist style whose coarse and chopped forms suit the brutalism of late Soviet modernism.

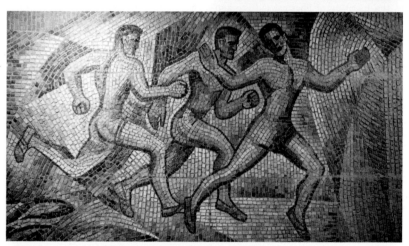

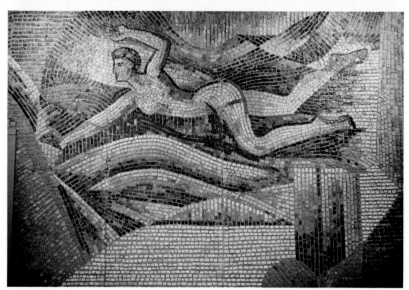

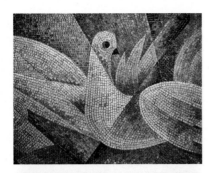

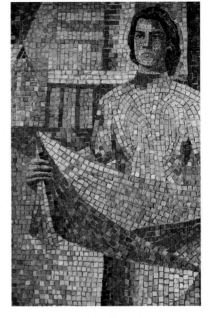

3

**Palace of Culture
of the First State
Ball-Bearing Factory
(now Theatre Centre
on Dubrovka, Aquamarine
Circus of Dancing Fountains)**
Melnikova ulitsa, 7/1

084 I

This large work by Kuliev on the walls of the Palace of Culture was not assembled from tiles, but rather laid directly on site. On the theme of 'Art', it turned out to be a severe challenge for visitors to the building, which is now mainly a venue for entertainment events. The female, male, and child figures are in natural stone in shades of red, grey, and light blue. They are presented in a consciously simplified and naïve style. The background behind these Soviet people is an industrial landscape with new residential districts and cranes as well as abstract figures formed from stone in subtle variations of colour.

Kuliev, A. A.
'Art'
1974

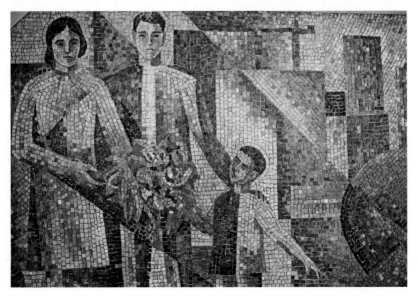

Sports pavilion at the stadium of Moscow Electric Lamp Factory (MELZ)

085 A

Gorodok imeni Baumana ulitsa, 1/38

Unknown artist
1980

The task of designing the interiors of the sports pavilion was apparently given to students studying monumental art. The panels with precise outlines and figures of different sizes represent various sports: rhythmic gymnastics, light athletics (running), tennis, and basketball. The slightly primitive backgrounds consisting of geometrical figures drawn à la Mondrian with black outlines push the athletes and sports players out towards the viewer. The building is currently undergoing renovations.

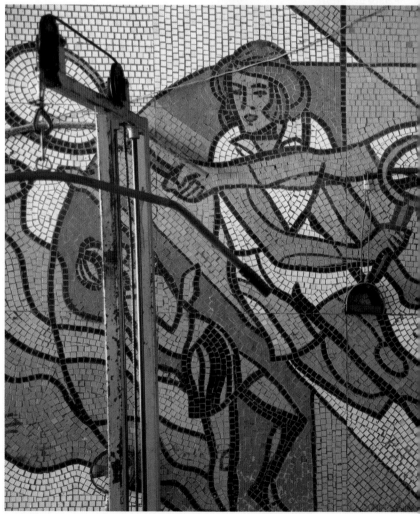

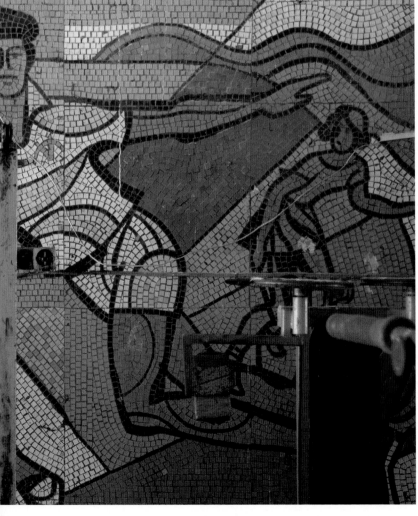

Postmodernism

4

Postmodernism

4

Postmodernism's conquest of the world in the 1970s was accompanied by gigantism and an ambitiousness of scale in Soviet architecture that had not been seen before and has not been seen since. Institutes, universities, palaces of culture and sport, restaurants, and metro stations were decorated with mosaics that now covered entire walls. The compositions were complex and had multiple subjects. Historical themes became more common. The 1980 Summer Olympics and the establishment of trade relations with the West led to the creation of panels on themes taken from world history and culture. Attention was increasing paid to 'setting'. Architects and monumentalist artists began to take cities' historical buildings into account. Abstraction was absolutely 'legalised'. However, there were clear signs of fatigue in both the genre of the mosaic itself and the monumental 'heroes' (including athletes) depicted in the mosaics. All the enthusiasm and joy of the 1960s gave way to a sense of disappointment: energetic gestures gave way to tranquil and slightly affected poses. Many works were executed by art students and therefore not signed. Mosaics became affordable, even 'standard', and its costs decreased. Mosaic work using natural stone and broken ceramic tiles was increasingly executed on small panels assembled on site. The disintegration of the USSR in 1991 brought with it the collapse of the entire system of state commissions and monumental art. Mosaics now embellish the walls of Russian Orthodox churches and some metro stations, but there has been a conspicuous decline in the quality of the design and execution. The heroic stage of this monumental art is now firmly in the past, but there is still time to preserve beautiful instances of it.

Bobyl, Y. P., Litvinova, L. V. 'Festivity', 1977.
Palace of Culture of the '50th Anniversary of the USSR' Automatic Lines Factory
(now R-studios, film production complex), foyer. 109A

**Moscow Palace
of Youth**
architects:
Belopolsky, Y. B.,
Belenya, M. E.,
Posokhin, M. M., Khavin, V. I.
Komsomolsky prospekt, 28

086 H

Korolev, Y. K.
(1986)–1988

Moscow Palace of Youth on Komsomolsky prospekt is a cult example of monumental modernism. The mosaic frieze on two of its walls is 'hidden' behind the austere colonnade supporting the roof. Alluding to a Greek prototype – the frieze inside the Parthenon – Yury Korolev's composition links times and epochs, professions, and peoples. Executed in pale and tranquil colours, the 'line' depicts both those who fought for the revolution and those who fought for 'peace throughout the world'. The postmodernist parade of professions places skilled workers – metalworkers, miners, builders – next to cosmonauts, architects, firemen, athletes, and academics. Here too we see creative teams, peoples of the USSR, and countries allied with the USSR (India, for example). The energetic youths concealed behind the shadows of the columns and raised to a height that cannot be seen by ordinary people are visible only to very attentive observers. To preserve it, the architects Yakov Belopolsky and Mikhail Posokhin covered the mosaic frieze with a roof and obscured it with the shade cast by the colonnade. This palace/temple of the Soviet youth is now a commercial building. The ideals of the twentieth century belong to history. Today's young people spend their leisure time very differently and leisure is not something that is organised at a national level. Many palaces of sport, film, the Komsomol officers, etc. are a thing of the past.

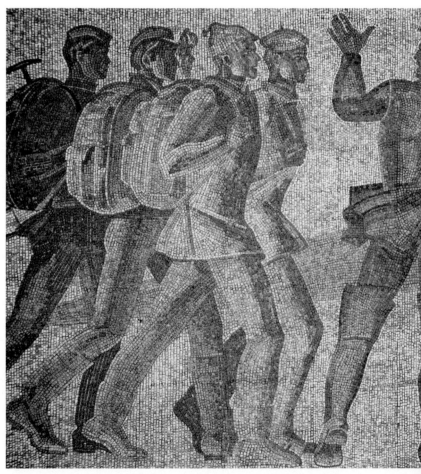

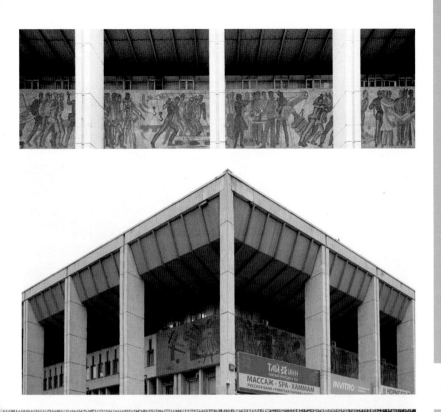

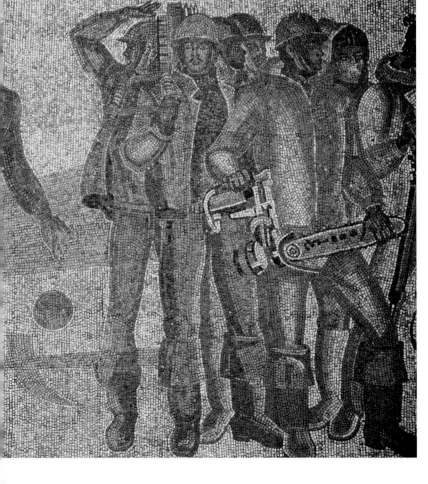

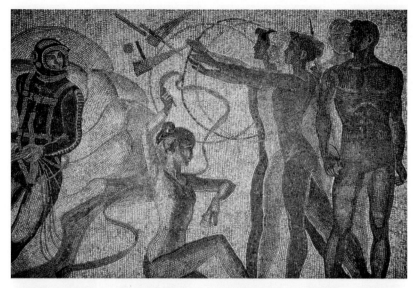

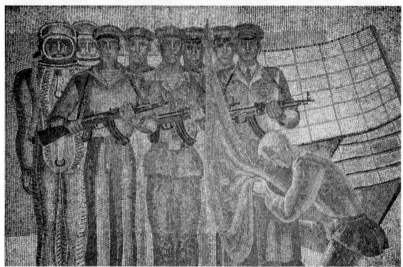

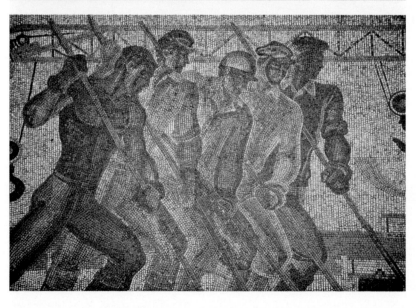

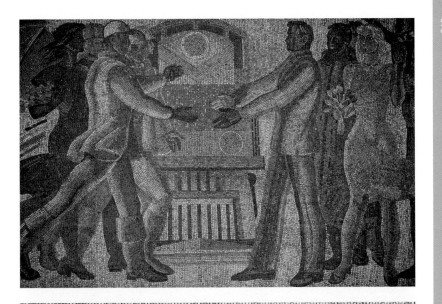

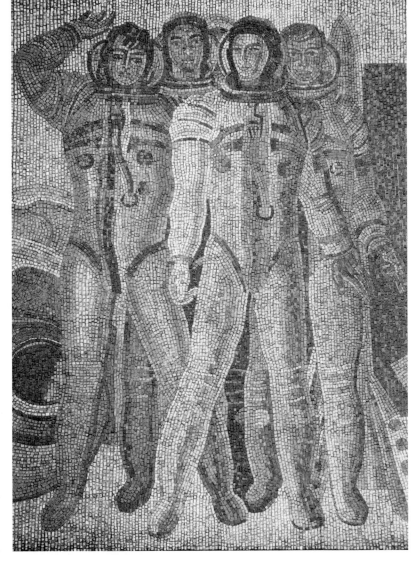

4

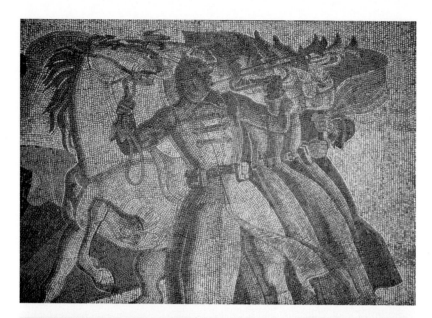

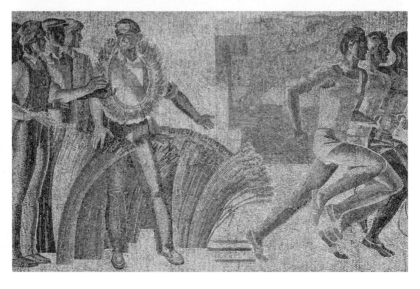

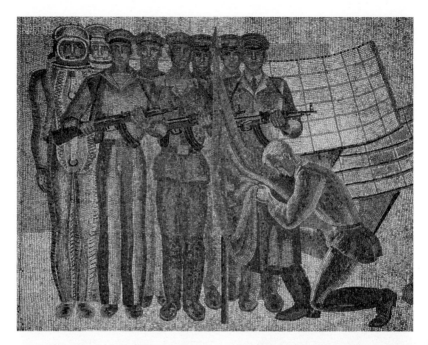

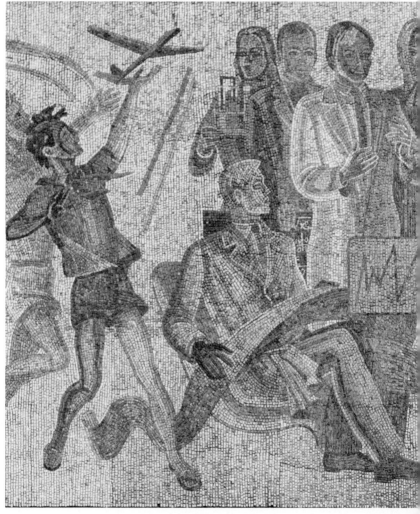

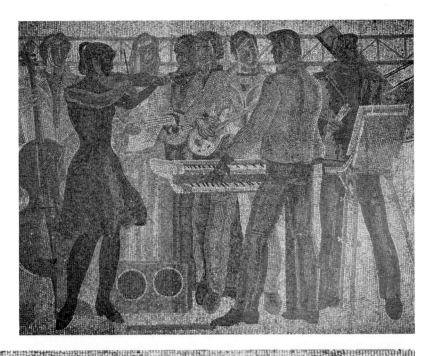

4

The Cultural Centre at the Olympic Village (now Philharmonia 2, S. V. Rakhmaninov Concert Hall), foyer of the Great Hall
Michurinsky prospekt,
Olimpiyskaya derevnya, 1

087 A

Zamkov, V. K.
'Culture, Art, Theatre'
1980

The interconnecting internal spaces, stairs, and foyers of the Cultural Centre were decorated with specially designed lamps and sculptures for the Olympic Games, but the centre's principal artistic work is a Florentine mosaic by Vladimir Zamkov. This polyphonic picture greeted visitors to the Olympics coming from countries all over the world. It incorporates a multitude of subjects taken from world culture. An area measuring 36 × 6 metres (with 6-metre turns extending around the corners) depicts: a succession of scenes from the history of Ancient Greece, the birthplace of the Olympic Games (including the Parthenon, the Charioteer, Nike of Samothrace, Venus of Milos ...); scenes taken from Shakespeare's plays as well as Pushkin's *Boris Godunov*; and the legendary St George on a horse next to an array of cultural symbols (theatre masks, an Ionic capital, and a laurel wreath). There are also canonical subjects involving the revolutionary struggle and friendship between peoples. The centre of the composition shows a woman with a torch in her outstretched hand and a 'blacksmith forging happiness', as well as a worker wearing overalls standing next to a Japanese woman and a black girl. Part of the panel with a marching revolutionary, a soldier, and a blacksmith became a separate panel embellishing the staircase of the Museum of Revolution in Moscow for a long time. It is now in the reserve collection of the Museum of Modern History of Russia.

4

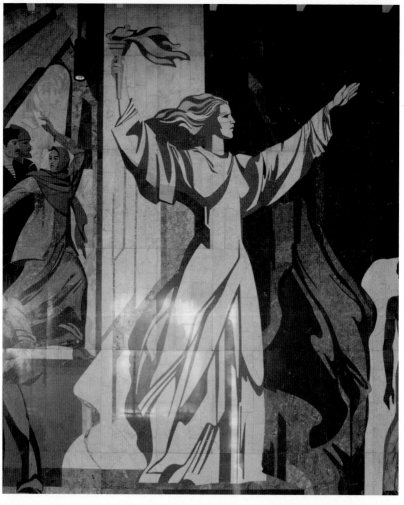

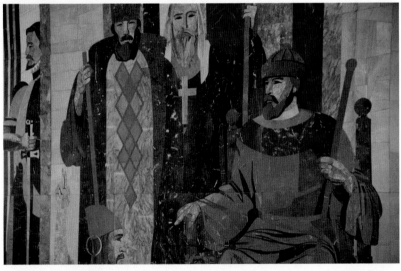

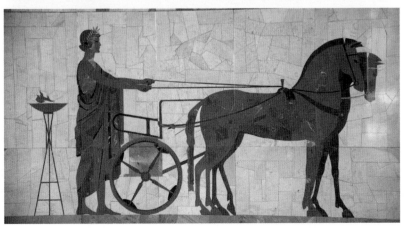

The Cultural Centre of the Olympic Village (now Philharmonia 2, S. V. Rakhmaninov Concert Hall), foyer of the Small Hall

088 A

Michurinsky prospekt,
Olimpiyskaya derevnya, 1

Talberg, B. A.
'Hospitality'
1979

The cultural centre with three halls and a restaurant was erected in the centre of the Olympic Village, a residential micro-district western Moscow built for the 1980 Olympics. One of the walls of the foyer was decorated by Boris Talberg, one of the subtlest and most lyrical monumentalist artists in the USSR. Surrounded by frames and rowan, oak, laurel, and vine leaves, a sad woman carrying a branch swims towards the observer. Her image is intended to symbolise hospitality. The chromatic transitions of the fluidly shaped surfaces are broken up by rectangles, giving the background of this composition a special plasticity. The architects (O. Kedrenovsky, E. Stamo, G. Mironov, V. Nesterov) and artists (V. Zamkov, B. Talberg) who worked on the Olympic Village were awarded the USSR State Prize in 1981.

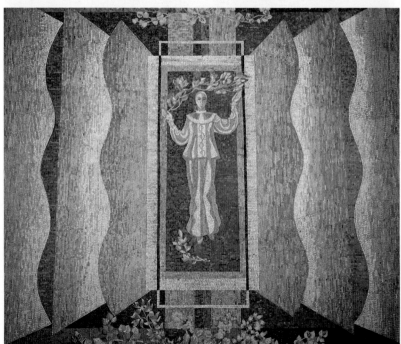

Sovintsentr (World Trade Centre), staircase No. 6

Krasnopresnenskaya naberezhnaya, 12

Talberg, B. A., artists executors:
Andreev, V. V., Zakharov, V. M.,
Korin, B. A., Sekretarev, I. V.
'Architectural Landscapes'
1981

This smalt mosaic was executed according to designs by Boris Talberg and is positioned on a marble-clad wall in the vestibule of the World Trade Centre. The central panel shows a Gothic bridge at Tsaritsyno Palace, which was founded by the order of Empress Catherine the Great and designed by Vasily Bazhenov. The two side panels depict Pashkov House, a mansion in direct proximity to the Kremlin and supposedly also designed by Bazhenov, and the hipped sixteenth century Church of the Ascension in Kolomenskoye. Talberg romanticised these banal architectural views with vases and thinly-leaved tree branches. The bottom right corner of the central composition has a mosaic list of the artists who created it: B. Talberg, B. Zakharov, B. Korin, and I. Sekretarev.

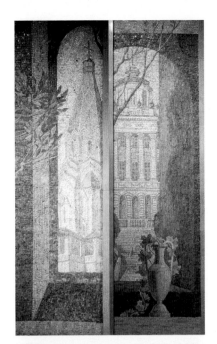

4

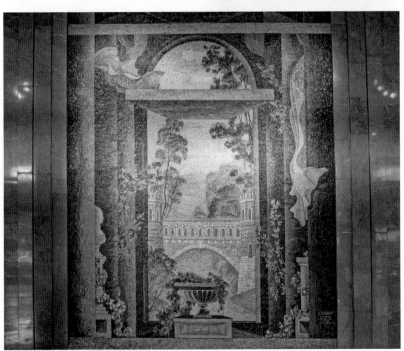

Library of the 2nd Medical Institute (N. I. Pirogov Russian National Research Medical University)

Ostrovityanova ulitsa, 1/5

A

Polishchuk, L. G., Shcherbinina, S. I.
'Human Healing'
(1973)–1979

The epic artwork covering all four façades of the medical institute's library measures over 2000 square metres, making it one of the largest mosaics in Moscow. Its authors are artists Leonid Polishchuk (born 1925) and Svetlana Shcherbinina (1930–2017), who studied at MIPIDI and Mukhina School of Art in Leningrad. They managed to visually 'break up' a regular cube by placing scenes directly on the building's corners. This work stands out from all the other works by Moscow monumentalist artists thanks to its tragic quality and a metaphysical dimension of the kind characteristic of the Mexican artists David Siqueiros and José Orozco. The words 'Kindness', 'Honour', 'Conscience', and 'Knowledge' are shown above the central entrance to the library under open books whose pages look more like medical bandages. The left-hand wall features a depiction of 'Heredity' with a female face and two children's heads, while on the right-hand wall we see 'Heart', and behind it, 'Brain'. The corners portray compositions with multiple figures: 'Healing' (therapy), 'Salvation' (surgery), 'Hope' (oncology), and 'Birth' (obstetrics). 'Healing' is based on a real story of illness: 'Aleksandr Sergeevich Seregin was returned to life on 5 October 1975'. The panel was listed as an item of cultural heritage in 1992.

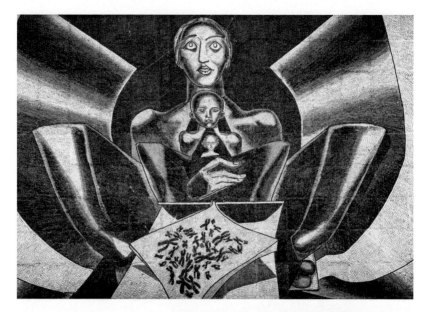

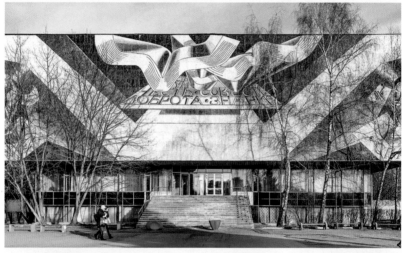

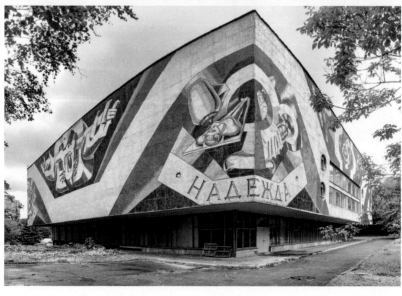

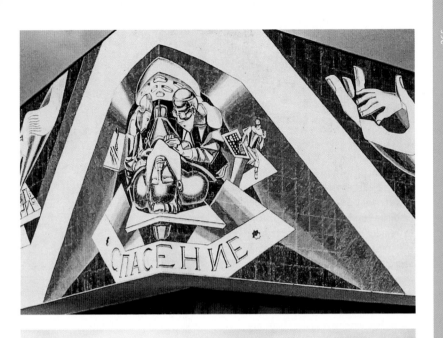

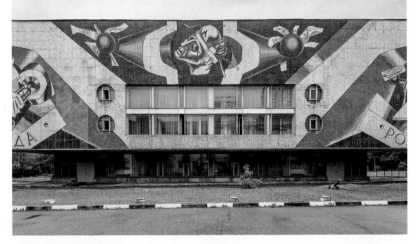

The swimming pool
of the Vodopribor Factory
(now S. S. S. R. Fitness Club)
Novoalekseevskaya ulitsa, 25

091 A

Kunegin, V. V.
1987

The main entrance to this brick building is decorated with four mosaic panels designed by Vyacheslav Kunegin, a graduate of Stroganov School of Art and a pupil of Vladimir Vasiltsov. The two end panels are extremely understated, containing only a star and a jug against a homogeneous background. The two central panels depict a woman in flippers, a man, Neptune in a crown and with a trident, a column with a Corinthian capital, and sea creatures. Two extensive walls inside are decorated with Roman mosaic, where we also see a combination of the abstract forms of waves, sails, and clouds with human figures. Kunegin's mosaic stands out among works from this time for its pastel colours, the care taken in assembling the pieces, and its use of ancient-classical subjects, echoing the work of Evgeny Kazaryants in plasticity and viscosity of form.

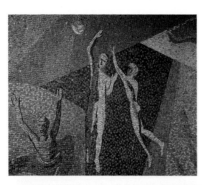
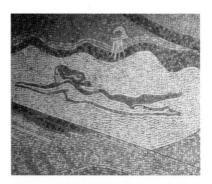
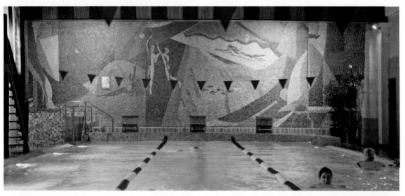

4

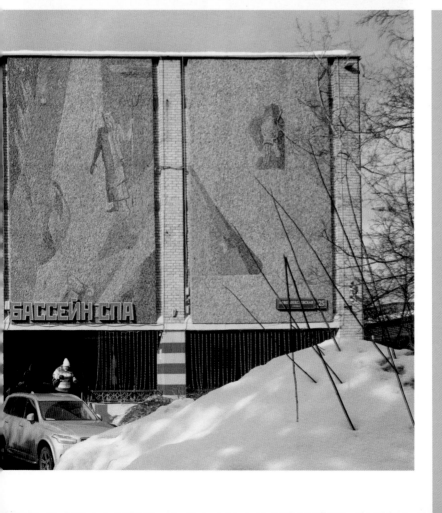

Institute of Oncology (now N. N. Blokhin National Medical Research Oncological Centre). Façade of the conference hall
Kashirskoe shosse, 24/3

092 A

Melnikov, D. E.
1979

One of the walls of this brick building is decorated with elongated panels assembled from pre-prepared tiles. It was designed by the monumentalist artist Dmitry Melnikov (born 1935), a graduate of the Surikov Institute and a pupil of Alexander Deyneka, Boris Chernyshev, and Dmitry Zhilinsky, and author of mosaic panels in Moscow, Krasnoyarsk, Sochi, and the Urals. The three works depict the hard workers of the country of Soviets. The images of builders, metalworkers, and female kolkhoz workers allude to the severe style of the 1960s and reveal a naturally graphic approach and an unexpected palette of red and light blue.

4

Moscow Aviation Institute

Volokolamskoe shosse, 4/7

Potikyan, M. L. (?)
'Aviation and its Development'
1980

Inside the Aviation Institute, rockets, satellites, and emblems 'fly out' from human hands. The hammer and sickle (the USSR emblem), a profile of Lenin, and a mark of quality form a composition in shades of white and dark blue.

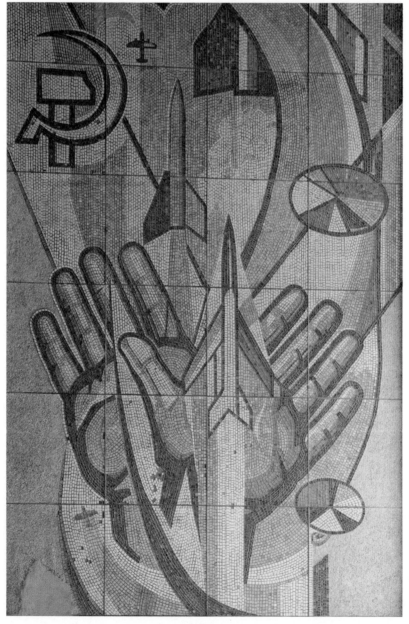

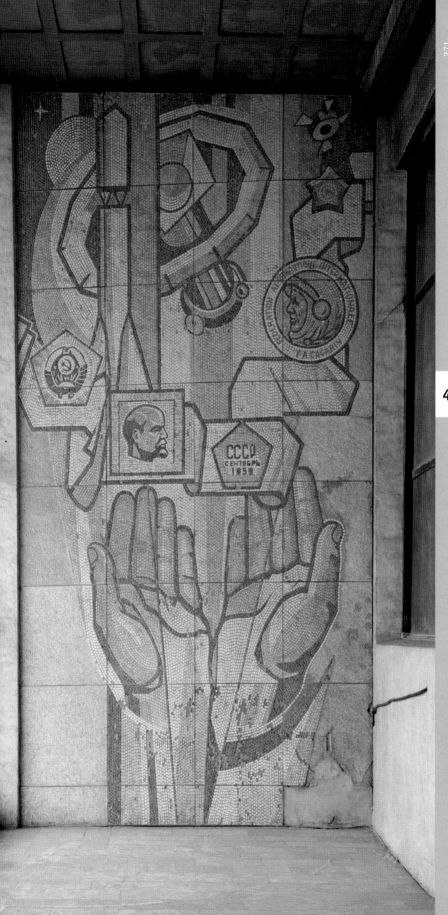

272

**Moscow Institute
of Radio Technology,
Electronics, and
Automation (MIREA).
Main block**
architect: Opryshko, V.
Prospekt Vernadskogo, 78/1

Unknown artist
1976–1978

The institute's extensive concave stone-clad façade is decorated with mosaic inserts and relief figures made from metal.

From left to right, the unknown authors (an artist and a sculptor) expound the history of science. Abstract compositions made from dark and pink marble include symbols of science, a sad male face with a long moustache reminiscent of a countenance in an icon, and a character from an epic. Figures of scholars from various ages, electrical discharges, radio signals, artificial satellites, etc. are depicted in metal … The slightly shaky composition is impressive for its postmodernist combination of science and folklore and its large area of mosaic work.

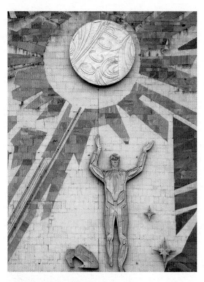

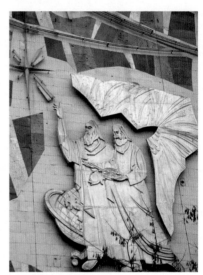

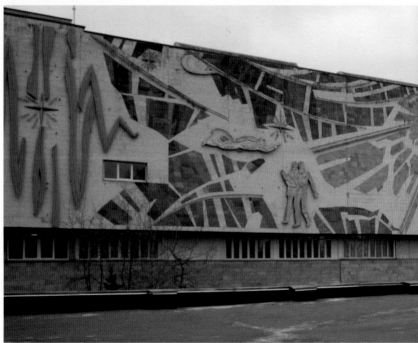

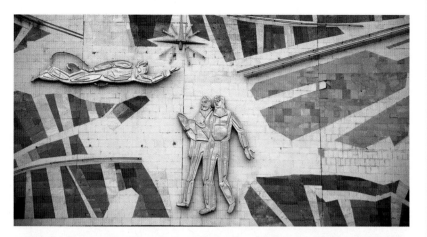

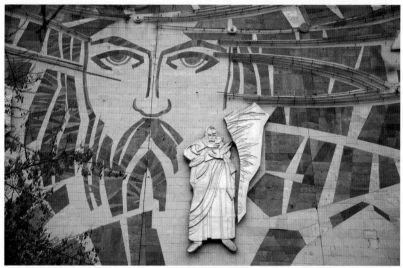

Directorate for Mechanisation of Decoration at Glavmosstroy (now Stroytekhservis)

Kolskaya ulitsa, 12/2

095 A

Anisimova, T. D.
'Workers on Construction Sites'
1974

Housing a planning and design organisation for managing residential and civic construction projects, this two-storey

brick building erected in 1968 is decorated with a mosaic panel on the theme of space. The building may have housed another institution in the past or it may be the case that it was decided to decorate an architecturally simple structure with a pre-prepared panel. The composition by Tamara Anisimova (1934–1989) is in shades of white and light blue and is underlined by a red contour in its lower part. A satellite flies out from two gigantic hands, and stately male figures are depicted against a background of geometric shapes.

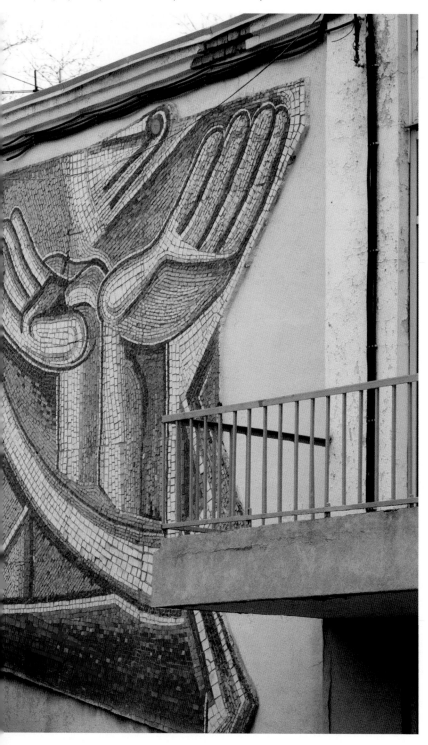

4

House of Optics at the 'S. I. Vavilov State Optical Institute' All-Russian Research Centre
Prospekt Mira, 176

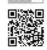
096 A

Kazaryants, E. G.
'Macroworld – Microworld.
Macrocosm – Microcosm'
(1971)–1974

This large panel with an abstract composition in distinctive colours is located in the internal courtyard of the House of Optics and is not immediately visible from prospekt Mira. Artist Evgeny Kazaryants (Kazarov, 1927–2013) won a city competition to design the mosaic for the building in 1971. The theme he proposed was 'Macroworld – Microworld.

Macrocosm – Microcosm'. Kazaryants began studying under Georgy Rublev at the legendary MIPIDI (Moscow Institute of Applied and Decorative Art), whose director was Alexander Deyneka. However, the institute closed in 1953 as it was a hotbed of formalism, and Kazaryants defended his diploma work in Leningrad at the Higher School of Industrial Art (formerly the Stieglitz School of Art). A notable member of the 'new wave' in monumental art, Kazaryants began with large wall paintings in the socialist realist style. His mosaic panel on the façade of the House of Optics represents reality seen through the glass of a microscope and a telescope, demonstrating the fundamental similarity of aerodynamic natural forms and variability in their interpretation. The sphere in the centre can be interpreted as both the planet Earth and an enormous lens.

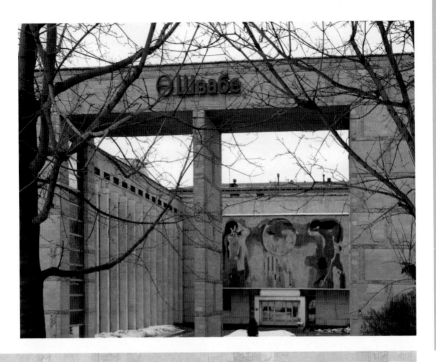

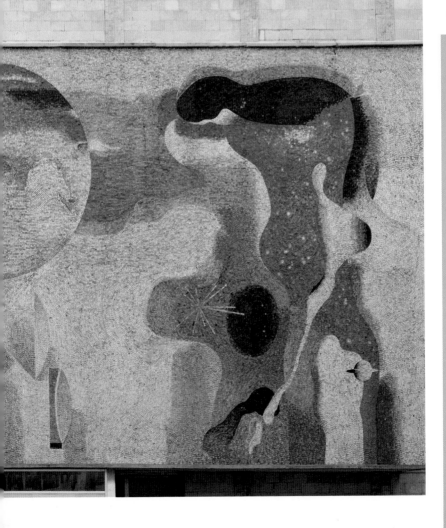

Scientific Production Association at the Central Research Institute of Machine Building Technology

Sharikopodshipnikovskaya ulitsa, 4

097 I

Mironova, N. F.
1974–1975

The two windowless walls of the main entrance to this research institute have a pattern of mosaic tiles forming an abstract composition of circles and lines that recalls non-figurative pictures by Vasily Kandinsky and Robert Delaunay. Machine building technologies are represented symbolically by the artist Ninel Mironova (1926–2018), who was also prolific in the medium of tapestry. Indeed, the entire composition with its dense mesh of interlocking geometrical figures recalls the pattern on a carpet.

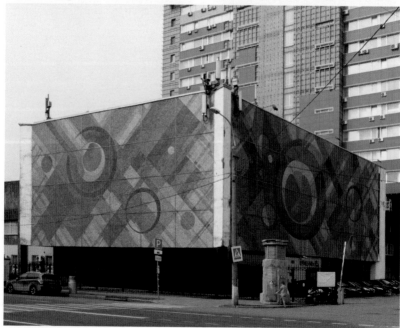

4

**All-Union Institute for
Research into
Electric Power**
Kashirskoe shosse, 22/3

Mironova, N. F.
'Energy'
1981

Founded in 1944 as the Central Research Electro-Technological Laboratory, this institute is now a research and technology centre. Abstraction had already been 'legalised' in the 1980s. The technological aesthetic implied the symbolic depiction of electro-mechanical processes and equipment.

4

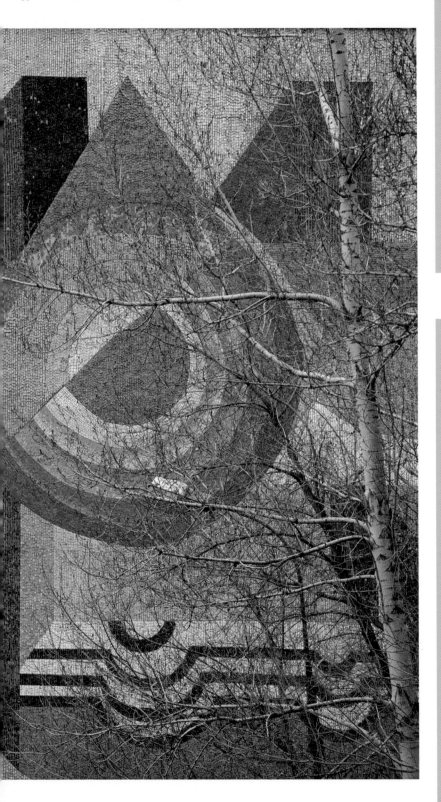

Moscow
Technology Lyceum
(now Mosenergo College)
Kirovogradskaya ulitsa, 11/1

Unknown artist
(1970(?))–1980s

The first storey of this seven-storey large-panel building, erected in 1987, is decorated with an extensive mosaic panel. The disc of a power generator and a real sun are shown on either side of powerlines stretching above the chimneys of a thermal power station and a hydro-electrical station. The ceramic mosaic assembled from large pre-prepared tiles is beautifully harmonious in terms of volumes and colours. Its recognisable forms are extremely geometricised, even abstract in places. Mosaic panels on the lyceum's first floor depict a sailing ship, an airplane, an automobile, parachutes, formulae, models of atoms and crystals, and attributes of the exact sciences and decorate a balcony and a wall space between windows. The author of these three-colour compositions and the exterior panel remains unknown.

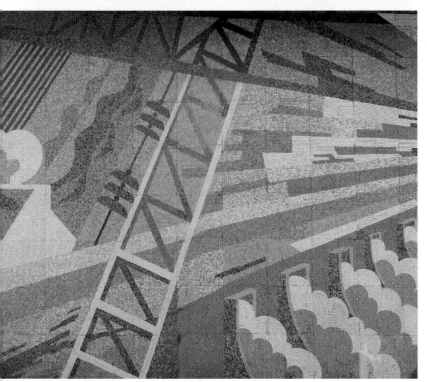

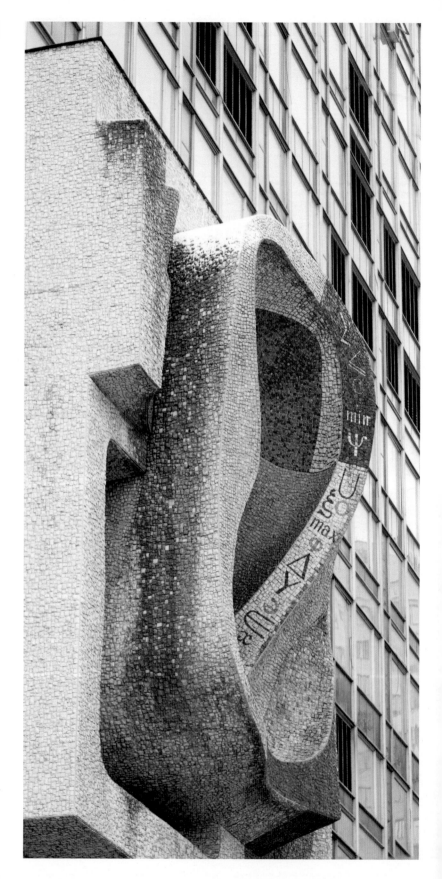

Central Economics and Mathematical Institute (TsEMI) of the Russian Academy of Sciences
Nakhimovsky prospekt, 47

100 A

Vasiltsov, V. K., Zharenova, E. A.
'Moebius Strip'
1976

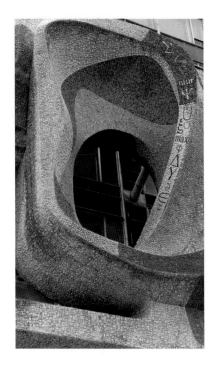

Jakov Belopolsky designed this site at the intersection of Profsoyuznaya ulitsa and ulitsa Krasina (now Nakhimovsky prospekt) in the monumental modernist style. The architect was the 'architectural artist' Leonid Pavlov, a pupil of the avant-garde architects the Vesnin brothers and Ivan Leonidov. It is designed in the form of two square slabs that are stepped in relation to one another and whose only articulation are grids of windows. One of the blocks was intended for computers, the other for people. Pavlov opted to use the Moebius strip – 'an eye looking into the inner workings of mother nature, a magic module' – as the building's emblem. The plastic form was designed by Eleonora Zharenova (born 1934). The eye soon came to be known as 'the ear'. Despite its abstract shape and the concealed fastenings attaching it to the façade, it looks like a decorative element on this monumental building.

4

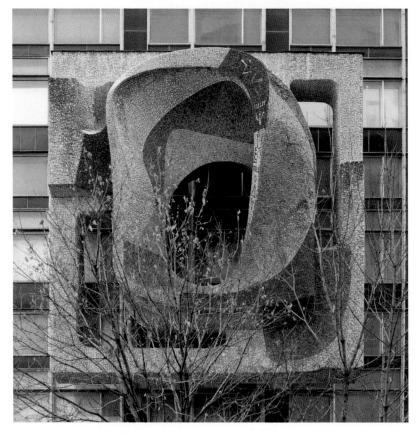

**Construction Technical
School No. 30
(now Stolitsa Educational
Complex)**
Kharkovsky proezd, 5A

Aleksandrov, K. K.
'Sea Spiral'
1982

The main entrance to this construction school is decorated with a mosaic designed by Konstantin Aleksandrov (born 1941), who also worked in the areas of stained glass, wall painting, and ceramics. The basis chosen for this yellow and dark blue composition was the fossil shell shape of the Silurian cephalopod. Its entire surface is covered with octopuses, skates, corals, crabs ...

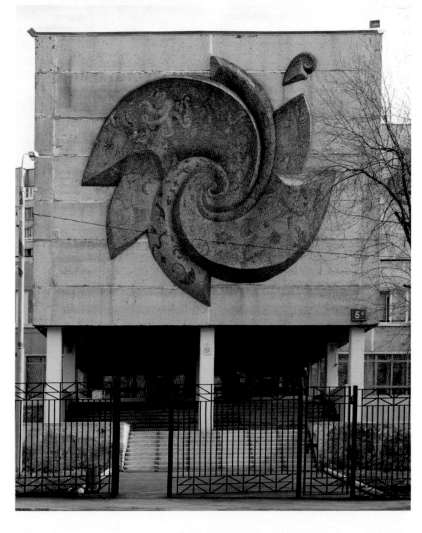

A. S. Pushkin State Institute of the Russian Language
Akademika Volgina ulitsa, 6

102 A

Vasiltsova, A. V., Korzheva, A. G.
1990

The three large panels on the façade of the Institute of Russian Language, the leading educational institution for training teachers of Russian as a foreign language, were decorated by Anastasiya Vasiltsova, a graduate of the Stroganov School of Applied Art and the daughter of artists Eleonora Zharenova and Vladimir Vasiltsov. Letters floating across fields of colour are kept in balance by a large capital letter A in type sitting above the main entrance.

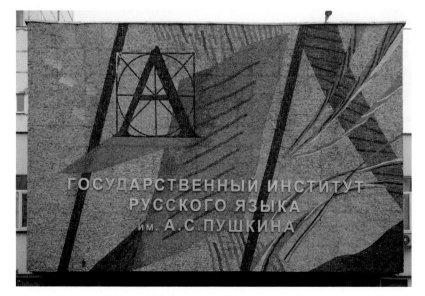

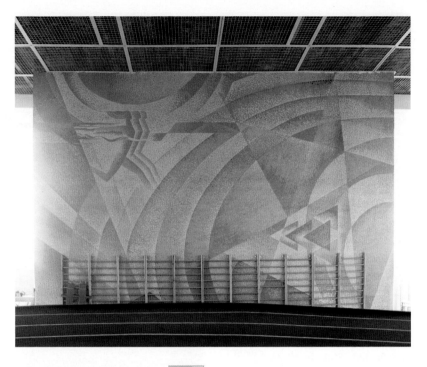

Palace of Sport of Moskvich Leninsky Komsomol Automobile Factory, swimming pool, training pool

Volgogradsky prospekt, 46/15, bldg. 7

Potikyan, M. L.
'Sun', 'Run'
1976

The Moskvich Sports Club was established in 1961 by a resolution of the Presidium of the All-Union Council of Voluntary Sports Societies of Professional unions on the basis of the physical culture collective at MZMA (Moscow Small-Engine Automobile Factory, subsequently renamed AZLK). This enormous sports complex in Tekstilshchiki was built at the initiative of Valentin Kolomnikov, the director of AZLK. Clad in stone and featuring an extensive area of glazing, the mighty building contains numerous halls, the two largest of which are decorated with monumental panel walls. The mosaic in the 50 × 20-metre swimming pool and bath is reflected in the water. Here, seagulls, the sun, and waves are depicted in a generalised, abstract manner that is reminiscent of the avant-garde rayonism movement. The training pool is decorated with a panel depicting three female figures running, with the running tracks transitioning seamlessly into a rainbow.

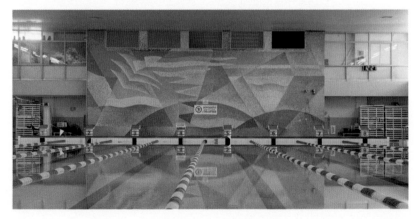

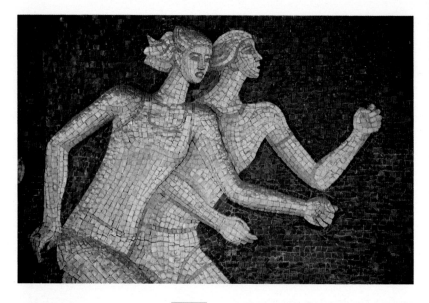

Krylya Sovetov
Palace of Sport

Tolbukhina ulitsa, 10/4, bldg. 1

Kapustin, V. V.
(1977)–1981

The brutalist Palace of Sport located at Molodezhnaya metro station was built for the 1980 Olympic Games by the architects A. Obraztsov, V. Churilov, and O. Saveliev for the All-Union Research Institute of Technology for Light and Special Alloys (VILS). The building's roof, exterior panels, and window frames were all made at VILS. After the Olympics, the intention was to use the palace for training sessions and show games involving the factory's hockey team, Krylya Sovetov ('Wings of the Soviets'). The palace's foyer is decorated with reliefs and a mosaic featuring themes involving winter and summer sports: hockey players, skiers, figure skaters, ice skaters, football players, fencers, runners, and a hang-glider pilot are spread between arches and tree trunks. The sad faces of the sports players and a degree of surrealism in the subject matter tell us that the genre of the mosaic has exhausted itself and that this is the beginning of the end of the age of monumental propaganda.

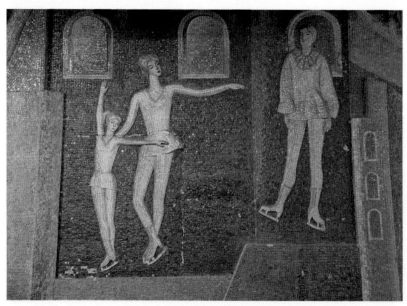

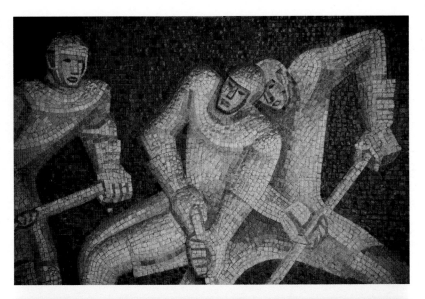

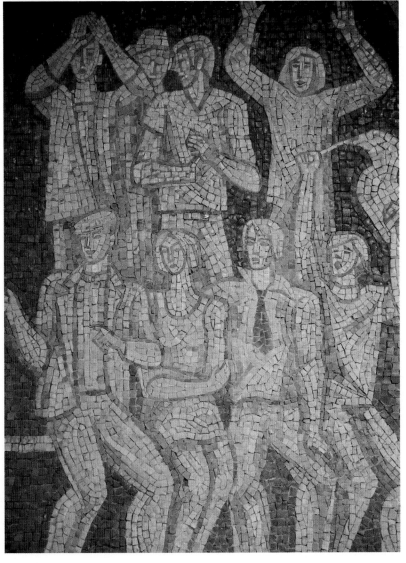

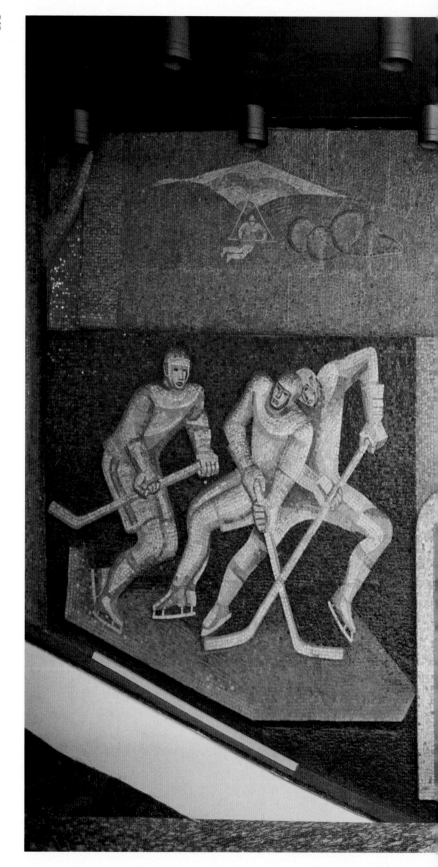

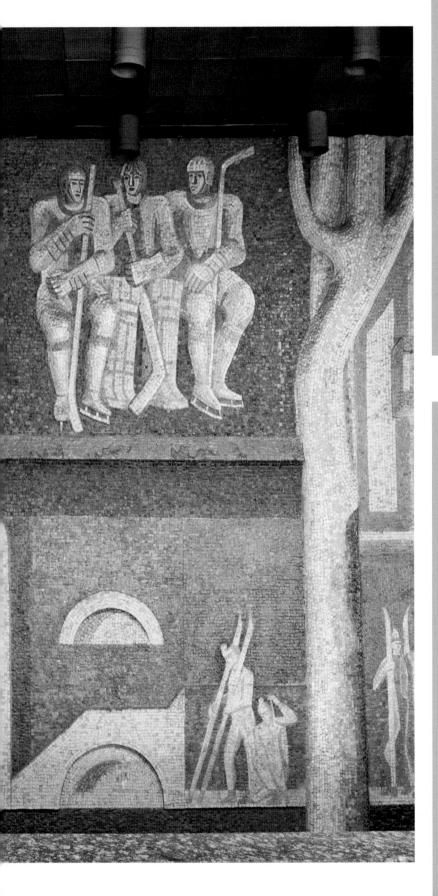

4

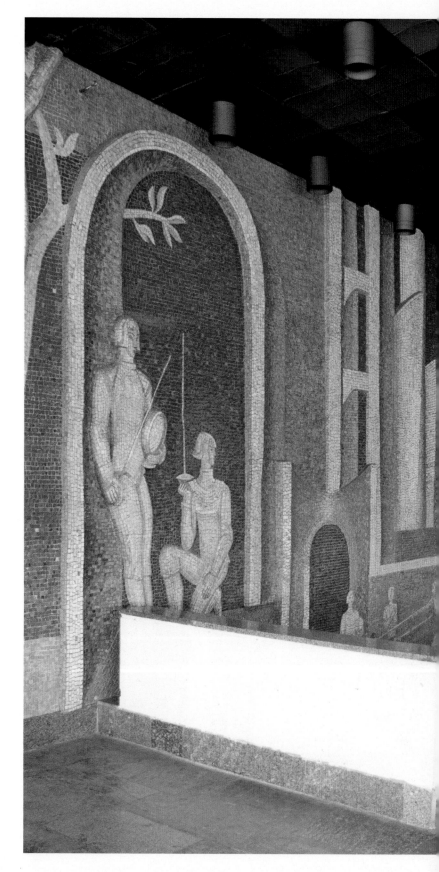

4

Moscow State Institute of International Relations (MGIMO), conference hall

105 A

Prospekt Vernadskogo, 76

Unknown artist
1976 (1983)

Three metal reliefs depicting Spasskaya Tower in the Kremlin and two allegorical figures project onto the stone cladding above the main entrance to the complex of the Moscow Institute of International Relations (MGIMO), which was designed by Mikhail Posokhin, the city's chief architect, together with M. V. Pershin and B. N. Kolotov. There are also full-height figures standing above the entrance doors inside the block housing the conference hall. They are: a cosmonaut, a builder, a female artist, and two other women – one with a wreath above her head, the other with a laurel branch and a red flag. The distinctive plastic design in shades of dark blue and gilded smalt covering a metal framework, a pole, and laurel leaves highlights allegories of construction, space, art, fame, and statehood. The late-modernist aesthetic of monumental design is responsible for the quality of sorrow in the mood of the faces depicted here and indeed for all the virtuosity of the mosaic work and pattern, it softens the pomposity of the propaganda.

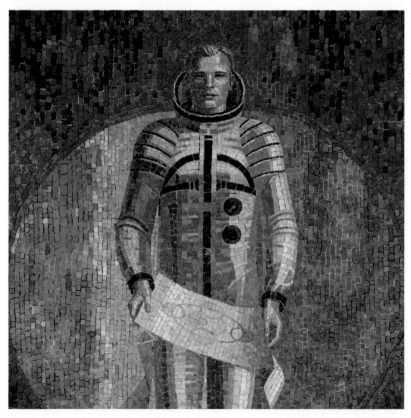

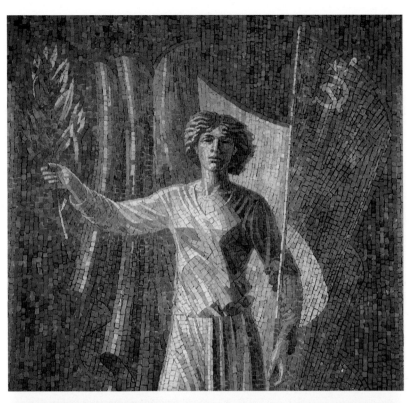

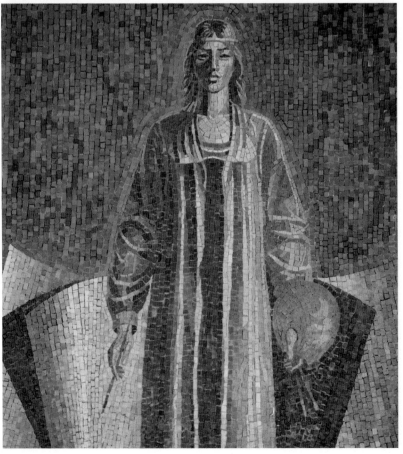

Hotel Universitetskaya, vestibule

Michurinsky prospekt, 8/29

106 H

Shorchev P. A.,
Schorcheva, L. K.
'M. V. Lomonosov'
(1975)–1976

Lyudmila and Petr Shorchev (1940–1994 and 1939–1996 respectively) were graduates of Moscow Higher School of Applied Art (Stroganovka) and collaborated on almost all of their projects. The wall in the vestibule of the Hotel Universitetskaya is one of their most enigmatic and allegorical works. It combines different spatial and temporary aspects of reality. The genius of Mikhail Lomonosov, the founder of Moscow University, is represented by a multitude of figures and attributes of science, including a globe, a technical drawing, and an architectural model ... The lower right corner depicts experiments by the natural scientist Lomonosov. It is not clear how the female figures bent over in the centre of the composition were intended to be interpreted.

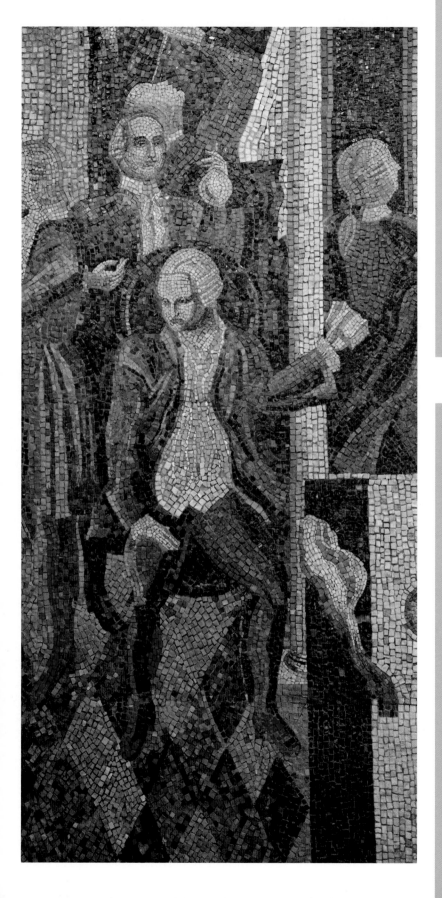

**Hotel Izmaylovo,
Alpha block,
restaurant,
stage in the Green Hall**
Izmaylovskoe shosse, 71a

*Shorchev, P. A.,
Shorcheva, L. K.*
1980

107 A

The stage at the Izmaylovo Restaurant
was given an 'everlasting' mosaic back-
drop. Lyudmila and Petr Shorchev deco-
rated the concave surface of the wall with
geometric fields and generalised outlines
of musical instruments (an accordion, a
guitar, and a violin). Lightning-like zig-
zagging waves of sounds are visible flying
off the instruments.

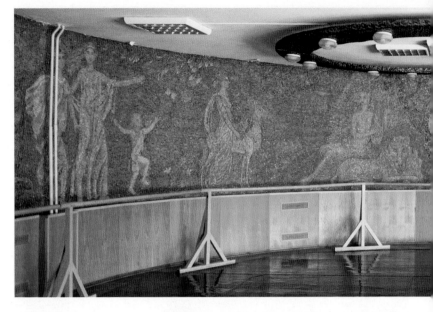

Lyre Children's Music School (now S. T. Richter Children's Arts School), concert hall

Kashirskoe shosse, 42/3

108 A

Vladimirova, O. N., Zelenetsky, I. L.
'The Charms of Music'
(1976)–1977

The semi-sphere is one of the main elements in the architecture of this non-standard school building that was designed by architects G. S. Ter-Saakov and N. G. Anisiforov and decorated with sculpture, wall painting, and mosaic. The small-piece mosaic on the concave wall of the concert hall is reminiscent of medieval tapestries. The same can be said of its subject. The centre of the composition features a grey-bearded gusli player sitting under a 'world tree'. Deer and lions have gathered around him. Women and children in ancient-classical dress move towards the centre of the hall, a lioness gives two boys a ride on her back, and a shepherd plays a pipe. In 1997 the school was renamed after the pianist Svyatoslav Richter, who performed here.

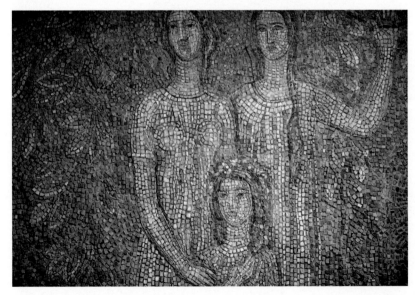

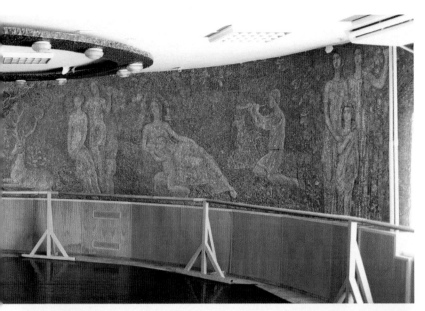

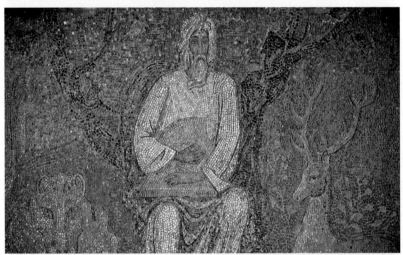

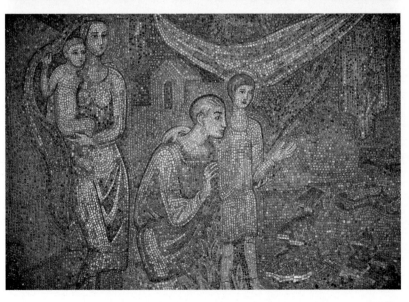

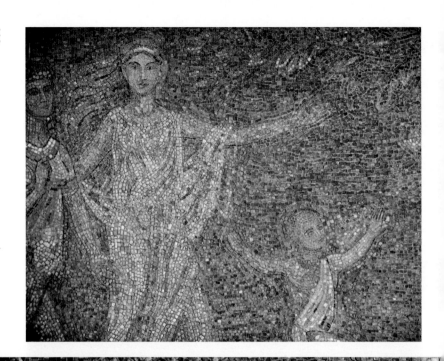

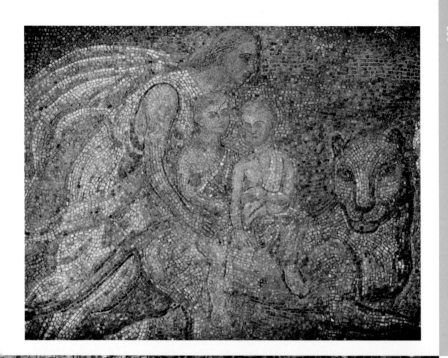

4

Palace of Culture of the '50th Anniversary of the USSR' Automatic Lines Factory (now R-studios, film production complex), foyer
Podemnaya ulitsa, 9

Bobil, Y. P., Litvinova, L. V.
'Festivity'
1977

The Palace of Culture on Podemnaya ulitsa is currently in private ownership, which makes it difficult for passers-by and indeed local residents to view the monumental 'Festivity' panel. The walls in the palace's vestibule depict people dancing in a variety of colours and sizes – a red boy, a cherry-coloured guitarist, and young couples. A yellow girl jumps over a skipping rope. She is being painted by a yellow artist standing at a sketch box easel. Another group of women are preparing a young girl in white clothes for the festivity, placing a symbolic wreath on her head. The entire composition would look factitious were it not for the touching characters of the overtly sorrowful, sad clown Piero and a violin player, beside whom sits a woman wearing historical dress.

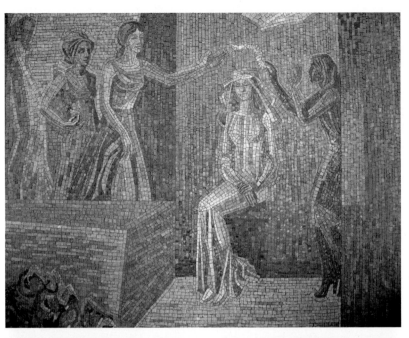

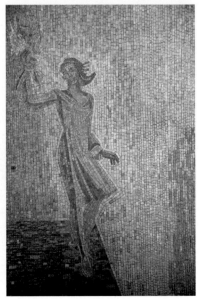

**Institute of Vocational
Training for Executive
Workers and Specialists
at the Ministry of
Intermediate Products
of the RSFSR
(now International
Industrial Academy)**
1st Shchipkovsky pereulok, 20

Bobyl, Y. P.
'Still Life'
(1978)–1980

This concrete relief faced in natural stone
and yellow-orange smalt depicts agricul-
tural cultures (corn, rye wheat, barley-
oats, and other plants) in general forms

that often resemble upturned human
palms. The artist Yuly Bobil (1935–1988)
was born in a village not far from Kiev and
studied the working of metals and oth-
er materials at Stroganovka in Moscow.
He subsequently taught at Stroganovka.
In 1974 Bobil executed the abstract con-
crete relief on the façade of the Research
Institute for Chemistry and Mechanics.
The mosaic on the façade of the Institute
of the Ministry of Intermediate Products
has a sculptural quality. The relief is clad
in light-coloured stone, and the yellow
smalt that 'illuminates' it from the inside
gives this still life a natural feeling. Yet
the powerful brutalist shape is essentially
given to this building entrance group on-
ly in relief.

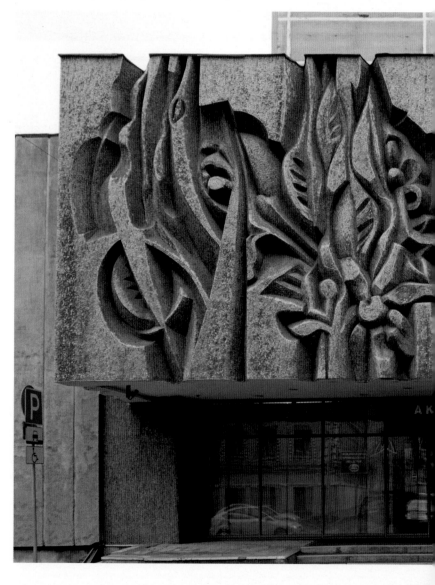

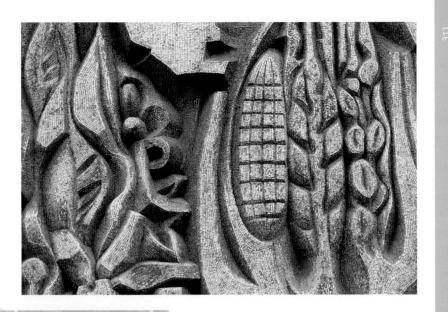

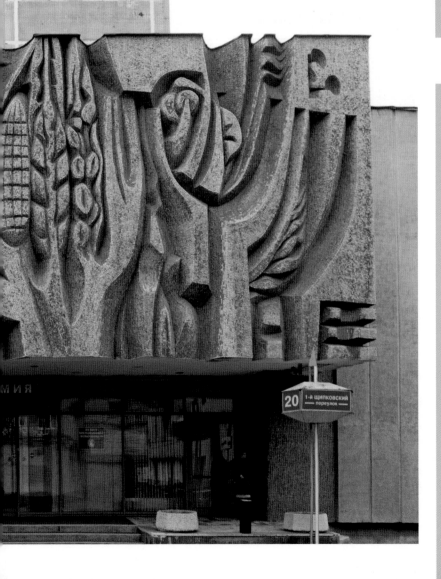

**Palace of Culture
of Moscow Aviation
Institute
(DK MAI)**
Dubosekovskaya ulitsa, 4A/1

Nesterov, G. V.
1977

The artist Gennady Nesterov (born 1925), a graduate of the Moscow Architecture Institute, used mosaic panels to decorate the façades of the Institute of Oil and Gas in the Algerian capital of Algiers and the Polytechnical Institute in Conakry in the Republic of Guinea. At the latter he depicted a black man soaring, his chains broken. Nesterov used natural stone to represent cosmonauts floating through space at DK MAI. Two male figures touch hands against a background of planets, stars, and abstract geometrical figures. One of the spacesuits bears the inscription 'CCCP' ('USSR').

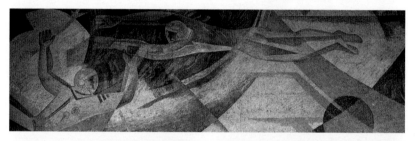

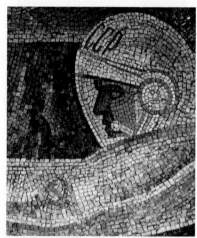

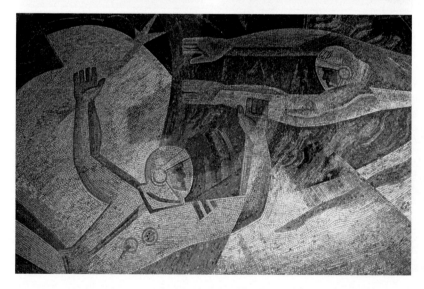

Institute for Research into Remote Radio Communications (NII DAR)

1st ulitsa Bukhostova, 12/11, bldg. 53

112 A

Unknown artist
1970s (?)

One of the walls in the internal courtyard of NII DAR is decorated with a mosaic that depicts figures of scientists in a relatively realistic manner in stone and smalt. The figures mutate into abstract forms that bring to mind the diverging waves of long-distance radio communication. The site now houses a factory, but was used for repair workshops during the First World War and workshops for repairing damaged tanks during the Second World War. The factory began manufacturing radar-location systems for air defence in the late 1940s and made space equipment in the 1960s. The factory's spaces are rented now out to tenants. Overgrown with bushes and trees, the mosaic looks like 'architectural superfluity'.

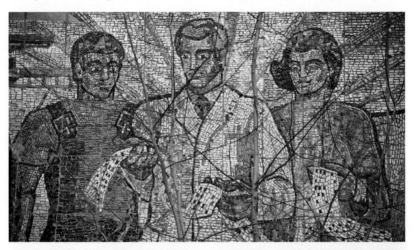

Design and experimental office of A. N. Tupolev
Naberezhnaya Akademika
Tupoleva, 17

Unknown artist
1978

Andrey Tupolev (1888–1972) was a Soviet product engineer and a colonel general responsible for overseeing the design of more than 100 airplane models. He established his own design office in 1922. An extensive wall in the vestibule of his design office's new building was decorated with smalt mosaic in yellow and light blue in the late 1970s. The mosaic

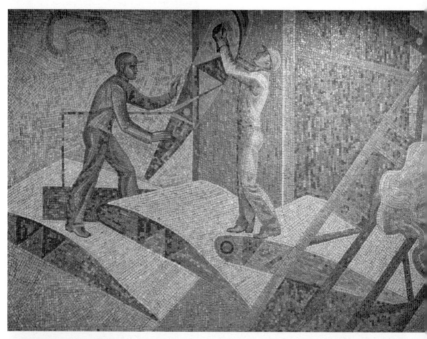

portrays scenes demonstrating work on airplane design mixed with depictions of the assembly of flying machines and even of a cosmonaut in a spacesuit about to be launched into outer space. There is also a distinctive picture of an airplane cabin resembling an avant-garde depiction of the future, for instance, Georgy Krutikov's *Flying City*.

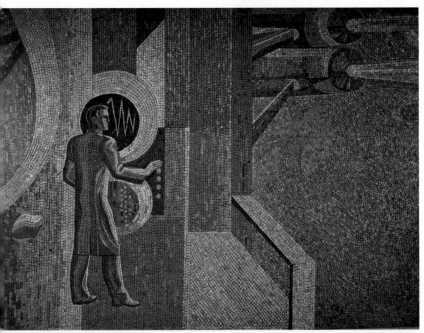

4

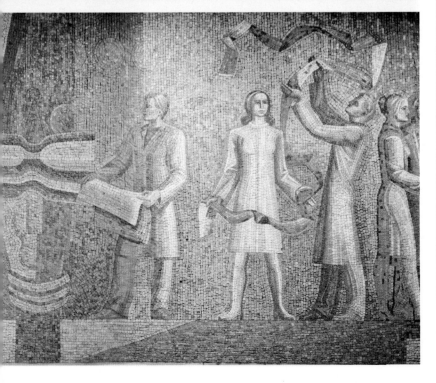

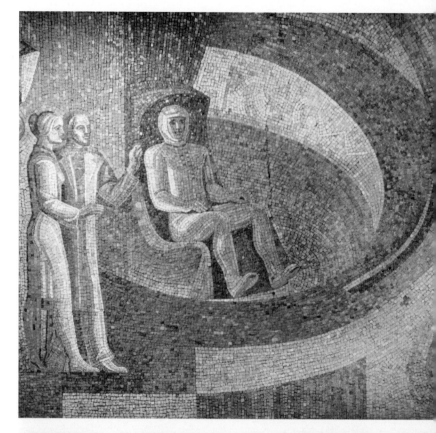

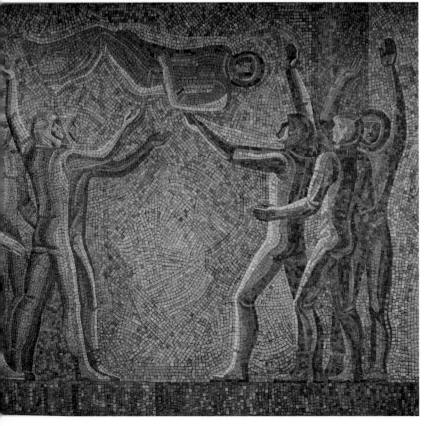

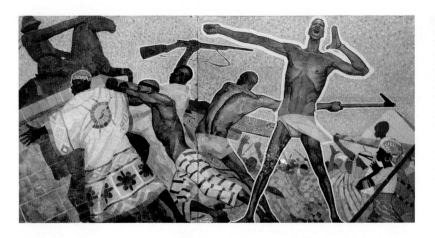

Institute of Africa
at the Russian Academy
of Sciences
Spiridonovka ulitsa, 30/1

114 B

Konovalov, V. A., Sorochenko, K. K.,
Khayutina, L. E.
'Liberation' *1961–1962*

Aleeva, T. A.
'Africa – to Africans'
Early 1960s

The 'Liberation' panel by Viktor Konovalov (1912–1995), Konstantin Sorochenko (1912–late 1980s), and Lyubov Khayutina (1915–1996) was moved to the Institute of Africa in 1962. It originally decorated house 16 in Starokonyushenny Lane (with 'Africa – to Africans' by Tatyana Aleeva; 1920–?). The Mansion of Tarasov was built according to a design by Ivan Zholtovsky in 1909–1912 in a style resembling Palladio's Palazzo Thiene in Vicenza. It was handed over to the institute in 1979. Dubbed 'the Russian Tiepolo' by his teacher Igor Grabar, Konovalov also decorated Kievskaya metro station, while Sorochenko and Khayutina created mosaics on Novoslobodskaya, Komsomolskaya as well as in the conference hall of Moscow State University. The black and yellow liberation mosaics differ in technique: while 'Liberation' was created with natural stone, the second panel is made of ceramic slabs.

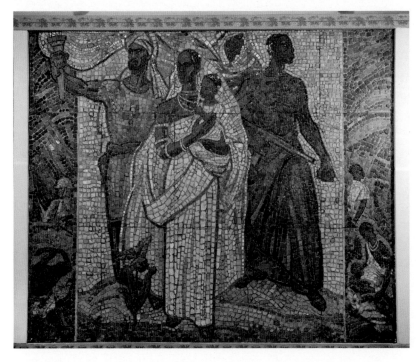

Ulitsa 1905 Goda metro station, vestibule, underground hall

115 B

Korolev, Y. K.
'The Flame of the Struggle', '1905'
1976

Ploshchad Presnenskoy zastavy was re-named Krasnopresnenskaya ploshchad in 1940 in recognition of the uprising of workers and railway workers in Moscow in December 1905. Architect Rimidalv Pogrebnoy, who designed 18 stations in Moscow's metro, built a modernist glass rotunda on ploshchad Krasnopresnenskya Zastava in 1976. It appears to refer pas-sengers to the neoclassical rotunda at Krasnopresnenskaya, the next station on the Circle Line. Looking through the glass of the pavilion at Ulitsa 1905 Goda met-ro station, you can clearly see the red mo-saic frieze by Yury Korolev – even in the evening. Korolev previously worked with military themes in mosaics in the 1960s. The centre of the long panel here shows a worker holding up a hammer. Around him are armed strikers and a woman with her fists held high. Fists holding standards and symbolising the 'flame of the strug-gle' are also visible in the mosaics on the escalator tunnel down to the station.

4

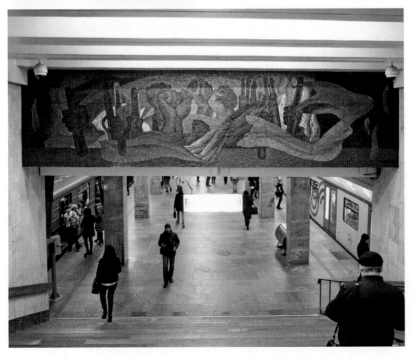

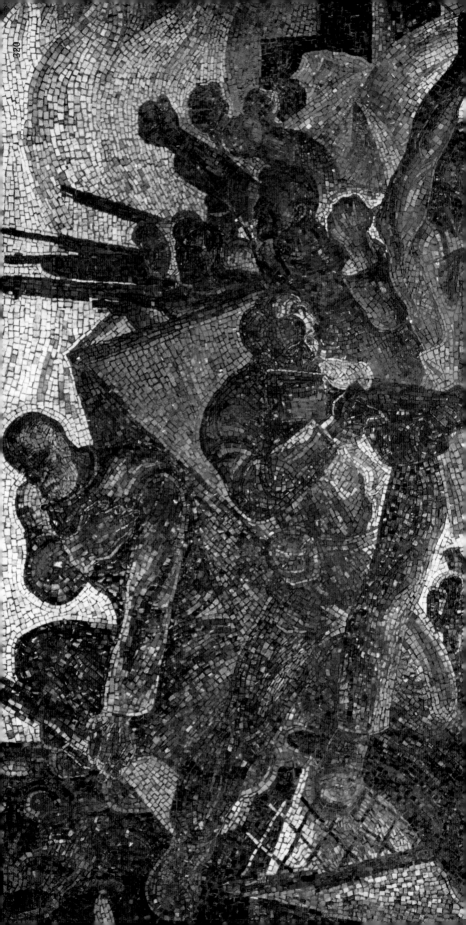

**Sviblovo metro station,
underground hall**

Korolev, Y. K.
'Emblems of Russian Cities',
'Epic Stories', 'Song'
1978

Folklore topics in Moscow mosaics are rare, unlike in Georgia or Ukraine, where folk motifs and patterns are often found in monumental art. Rimidalv Pogrebnoy, who worked with Korolev on Ulitsa 1905 Goda station, designed Sviblovo metro station. The mosaic panels here are in reds

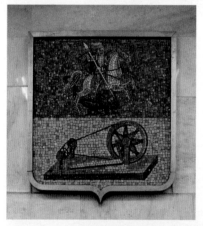

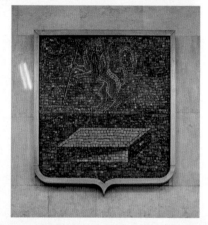

and blacks, with allusions to the colours of Russian embroidery and wall paintings. Against the background of an enormous setting sun, a red horse carries a *bogatyr* (epic hero) directly towards an old man playing the gusli with a lion and gigantic flower blooms lying at his feet. Young women in folk tunics sing a song amid sheaves of rye and the same enormous flowers. The station's northern entrance features a smalt panel entitled 'The Tale of Igor's Campaign' ('Epic Stories'), while 'Young Women in Folk Clothes' ('Song') is placed at its southern entrance.

4

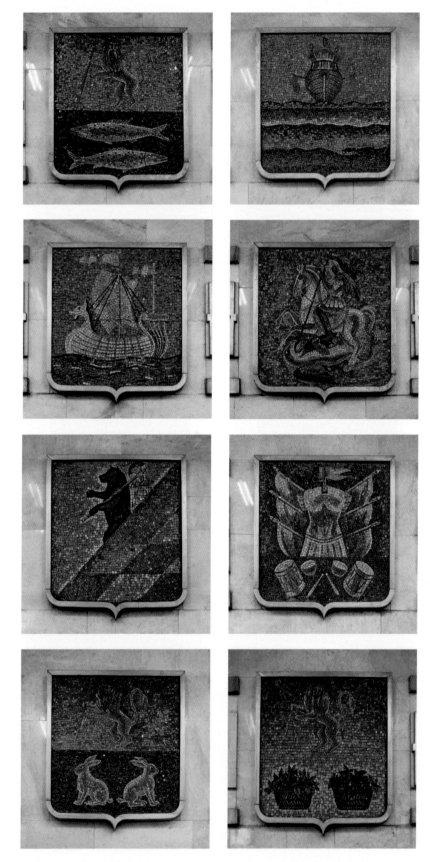

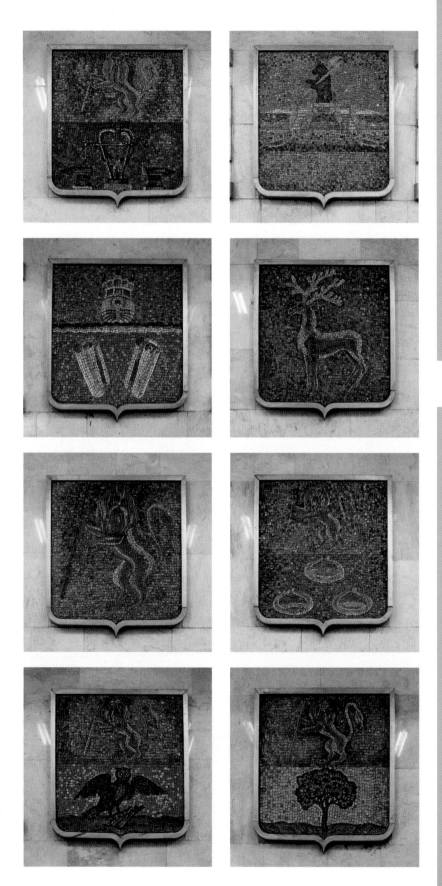

Izvestia building, foyer of the conference hall
Tverskaya ulitsa, 18/1

Andronov, N. I., Vasnetsov, A. V.
'The History of Printing'
('Man and Printing')
(1974) – 1979

Nikolay Andronov (1929–1998) and Andrey Vasnetsov (1924–2009) designed the foyer of the building constructed for *Izvestia,* the newspaper that was founded in March 1917 and continues to be published to this day. They used a grey stone imitating the newspaper's style. The history of printing is depicted on four walls – from Ivan Fedorov, the first printer, to the Soviet campaign to eliminate illiteracy and front-line printing houses during the Second World War. Here too we find mosaics portraying themes that acquired cult status during the Soviet era – Aleksandr Radishchev's *Journey from St Petersburg to Moscow* and Pushkin's *Sovremennik,* as well as mentions of Chernyshevsky, Dobrolyubovand, and Herzen. There is also an obligatory quotation from Lenin: 'A newspaper is not just a collective propaganda tool and collective agitator, but also a collective organiser.' Frozen figures in pleated clothes bring to mind theatre scenes from historical productions, while the brief texts allude to the aesthetic of the poster.

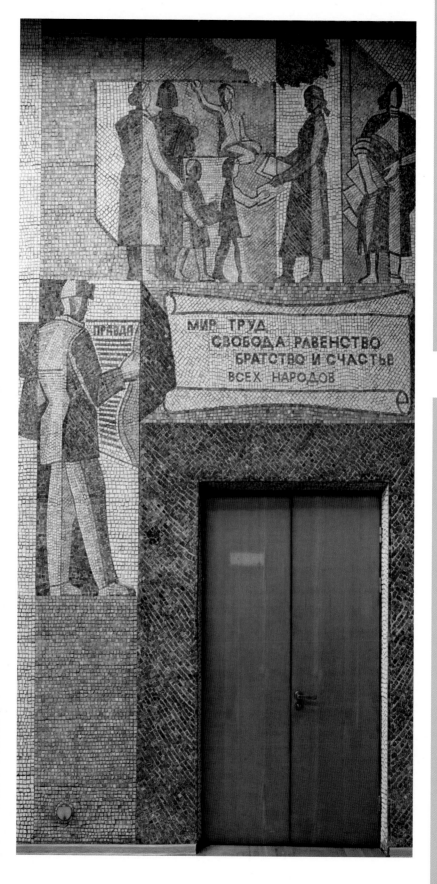

**Savelovskaya
metro station,
underground hall**

118 A

*Andronov, N. I.,
Andronova, M. N.,
Shishkov, Y. A.,
Rodin, Y. L., Rodin, V. L.*
'The History of Railway Transport'
(1988)–1989

Unlike stations that present subjects taken from different ages by means of a frieze showing a succession of scenes or marginal scenes, long-platform metro stations offered monumentalist artists the opportunity to create separate panoramic compositions (Avtozavodskaya metro station is an example from the 1940s). At Savelovskaya, the artists based their mosaic on the theme of transport, given that it was from the railway station of the same name here that trains departed for the north-west of the country. Ships, steam trains, a horse-drawn tram line, and railway bridges and stations embodied in austere shades of ochre and light blue take on a lyrical dimension thanks to the figures of children and foals. The assembly of the mosaic pieces was supervised by Nikolay Andronov, one of the founders of the severe style and a graduate of the I. E. Repin Institute in Leningrad and the V. I. Surikov School in Moscow.

4

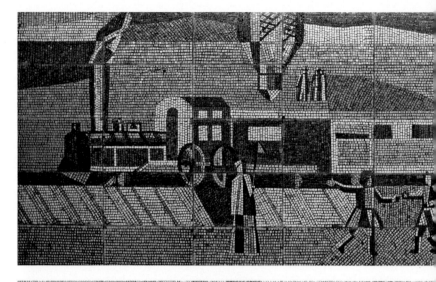

**Nagatinskaya
metro station,
underground hall**

*Vasiltsov, V. K.,
Zharenova, E. A.*
'Historical Moscow'
1983

One of the most original stations in the Moscow metro stands out on account of Leonid Pavlov's bold decision to reserve the entire space of the trackside walls for Florentine mosaics. The station was initially named 'Nizhnie Kotly' after the village that previously stood here – the site of Kolomenskoye and the wooden palace of Aleksey Mikhaylovich. These historical associations suggested the themes for the mosaics. Vladimir Vasiltsov and Eleonora Zharenova, pupils of Vladimir Favorsky, turned the station's walls into large panels with a succession of geometrical fields in marble of different colours, historical subjects, and lyrical compositions (such as a bouquet of field flowers). The foundation of Moscow in 1147 and the city's coat of arms featuring St George slaying a snake with a spear; the wall of the Kremlin and the Terem Palace; the Cathedral of Basil the Blessed; and a sitting bear: these recognisable symbols and Moscow attractions do not resemble simple commissioned illustrations such as we find at Kievskaya metro station, but rather form a beautifully orchestrated symphony inside the laconic architectural space.

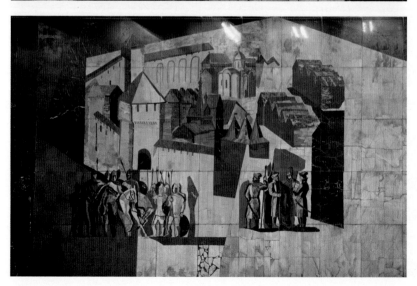

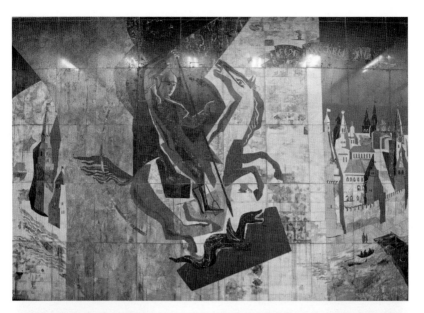

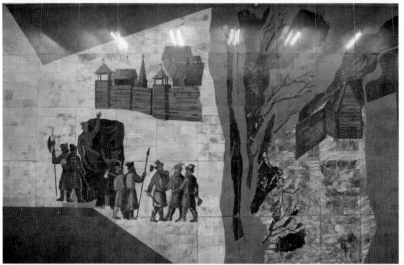

4

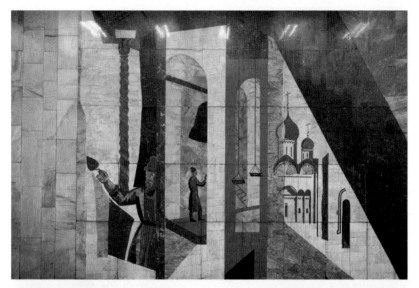

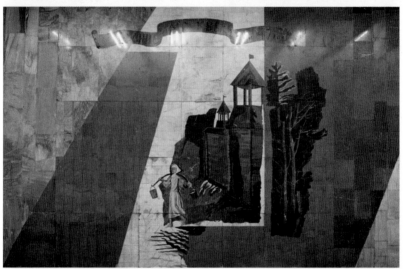

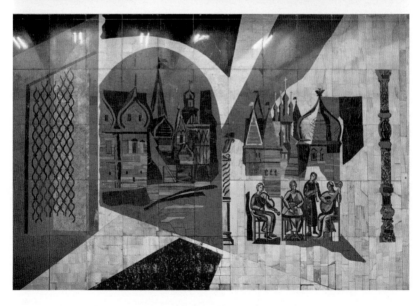

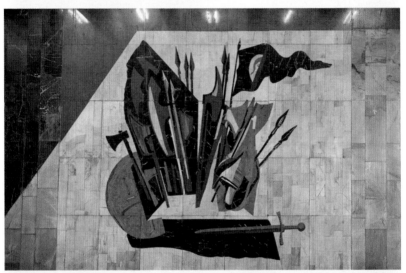

**Marksistskaya
metro station,
underground hall**

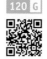

120 G

Marksistskaya metro station was designed by Nina Aleshina, who replaced Aleksey Dushkin as chief architect at Metrostroy, the organisation responsible for constructing the metro. Aleshina worked together with Mikhail Alekseev (born 1939) on Kuznetsky Most and Domodedovskaya metro stations, where Alekseev created metal structures and reliefs. The arches at Marksistskaya, a three-span station, recall the architectural design of Kuznetsky Most. They are faced in red marble – the same material was used for the Florentine mosaic depicting 'The Triumph of the Ideas of Marxism' in generalised form. Next to the station is the *Serp i molot* ('Hammer and Sickle') railway platform and a very large steelworks (also called *Serp i molot*), which was founded before the revolution and ceased production in 2011.

*Alekseev, M. N.,
Novikova, L. A.
(1979)–1980*

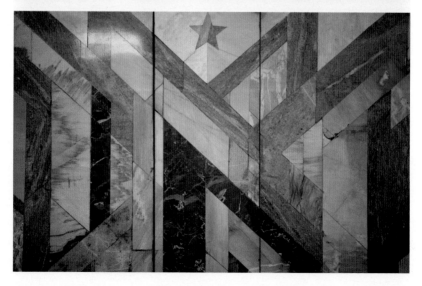

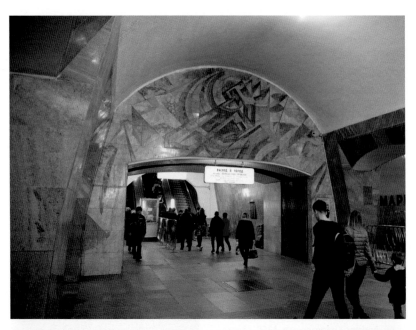

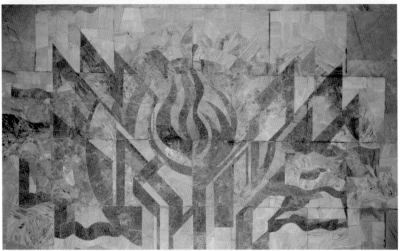

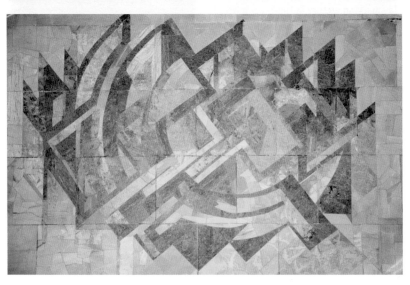

4

Lenino metro station (now Tsaritsyno), underground hall

Kuznetsov, A. N.
'V. I. Lenin: Founder and Leader
of the Party and the State'
1984

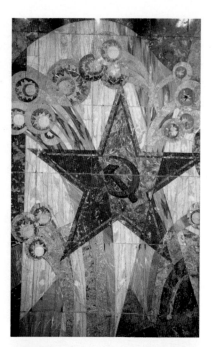

Lenino metro station was designed by architects Viktor Cheremin and Aleksandr Vigdorov. The theme chosen for the station was the slogan 'V. I. Lenin: Founder and Leader of the Party and the State'. The standard design project for this columned station envisaged that the theme should be developed on the trackside walls and on the entrance friezes in marble mosaic by Andrey Kuznetsov. A 1200-square-metre area of wall is covered with marble tiles whose abstract 'radial' pattern forms six panels. The entire history of the Soviet state is represented here in symbols. The date 1917 is inscribed against the background of a book with the revolutionary slogans 'All Power to the Soviets!', 'Peace for the Peoples!', 'To the Citizens of Russia,' and 'Land for the Peasants!'. The Aleksandrovskaya Column and the coffers of the arch on Palace Square in Petrograd are also present. Symbols from the 1920s come next: a hammer and a plough in a five-pointed star against the background of a sheaf, metal structures, and cogs. The 1940s are represented by the firework display marking victory in the Second World War. The end of the 1950s is symbolised by a proton synchrotron accelerator and the first satellite. Andrey Kuznetsov claimed to have deliberately avoided figurative representation, though there is a profile of Lenin at the station entrance above the escalators. Behind the profile of the 'leader' are attributes of 1920s life under Lenin – factory chimneys, the Shukhov radio tower, airplanes, and a power station. The other entrance features 'The Kremlin' panel, at the centre of which is the dome of the USSR Council of Ministers building. On 5 November 1990 Lenino station was renamed Tsaritsyno after the nearby residence of Empress Catherine II, which is now a museum and park.

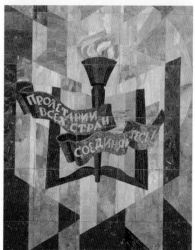

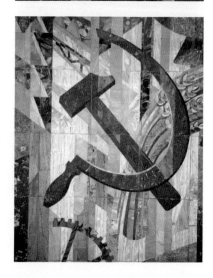

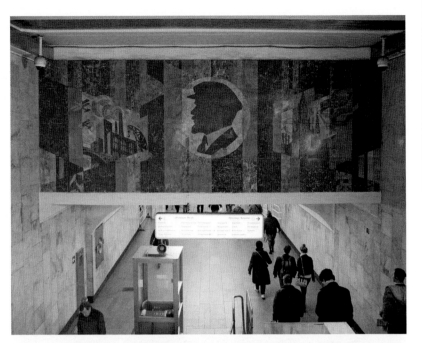

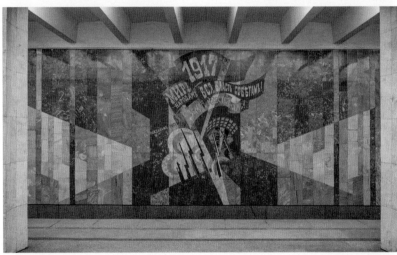

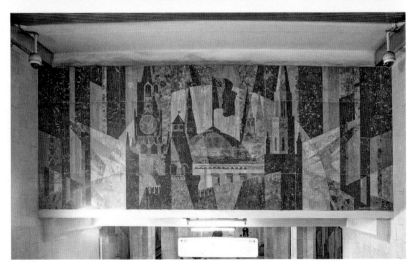

Chekhovskaya metro station, underground hall

Shorchev, P. A.,
Shorcheva, L. K.
Panels based on motifs
taken from the works
of Anton Chekhov
1987/1989–1991

All the subjects featured in the mosaics at Chekhovskaya station are relatively free interpretations of literary motifs. The familiar seagull in flight has, for example, become a vanquished dove, and the Shorchevs' bored ladies could better be described as heroines from the age of romanticism. Aleksey Zagorsky was one of the mosaicists behind the Florentine panels. He said that the Shorchevs differed in their attitudes to how their life-size sketches were realised in stone. Petr Shorchev immediately approved the mosaic work, whereas Lyudmila took a fundamental dislike to it, but there was no time to change anything. More than 17 types of natural stone – including lazurite, rhodonite, fluorite, onyx, jade, nephrite, amazonite, and jasper – were used for the mosaics on the station's trackside walls. Viktor Cheremin, the chief architect of the Moscow metro system, and his colleague Aleksandr Vigdorov worked with the Shorchevs on another station in the Moscow metro system: Timiryazevskaya.

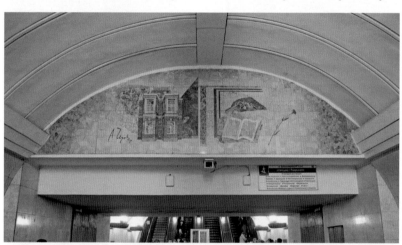

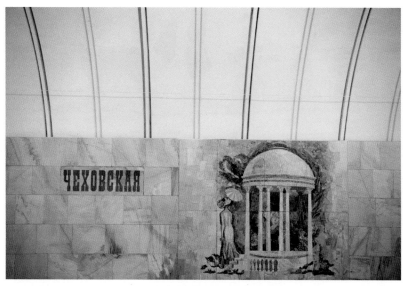

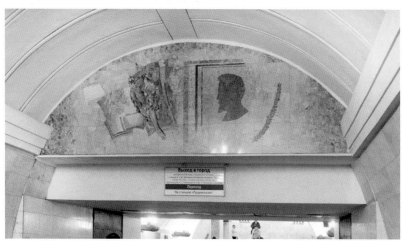

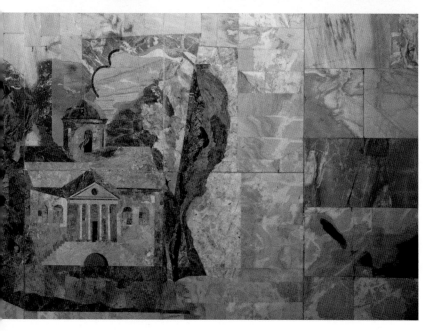

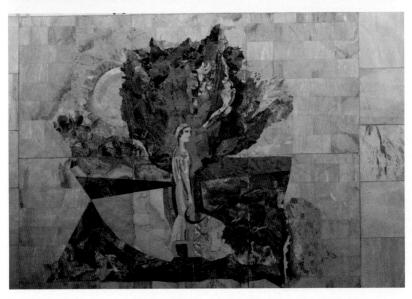

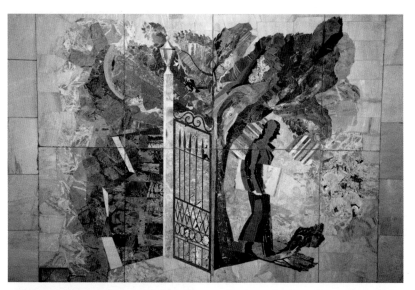

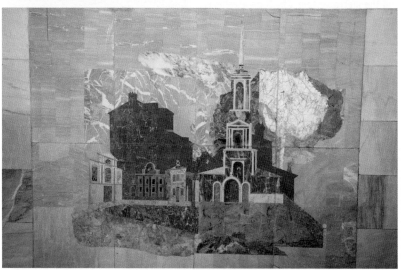

4

Chertanovskaya metro station, vestibule

Alekseev, M. N.,
Novikova, L. A.
1983

The district of Chertanovo – a 'model' res-idential micro-district with underground garages and extensive infrastructure that achieved cult status – was planned in the 1970s and for the most part settled with residents by the time of the 1980 Olympics. Chertanovskaya metro station was designed for the anniversary of the founding of Metroproekt – the organisa-tion responsible for planning and design-ing the metro system – by Nina Aleshina using the architectonics employed at Avtozavodskaya and Kroptkinskaya met-ro stations. The 'Construction of New Moscow' theme found in the underground hall also occurs in mosaics in the sta-tion's above-ground vestibule. Yellow-orange builders erect a house of the same colour against the background of a grey/dark-blue sky, where a young wom-an stands at the open window of a new apartment looking into the distance. A curtain fluttering in the wind and a vase with flowers on the floor emanate the ro-manticism of Khrushchev's 'Thaw' and the population's newly realised desire to live in separate, as opposed to commu-nal, apartments.

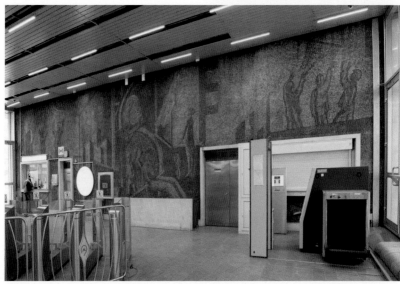

**Timiryazevskaya
metro station,
underground hall**

124 A

*Shorchev, P. A.,
Shorcheva, L. K.*
'Nature and Man'
1991

Dedicated to Kliment Timiryazev (1843–1920), a plant physiology and photosynthesis researcher who once met Charles Darwin, this station was designed by the Shorchevs in a similar style to Chekhovskaya. The two top panels of the platform hall are in a similar sentimental postmodernist key. Figures arranged under a tree at the station exit and Timiryazev and colleagues at the station's far end are depicted in stone in various colours. A ray of light strikes the microscope – the natural scientist's principal tool.

4

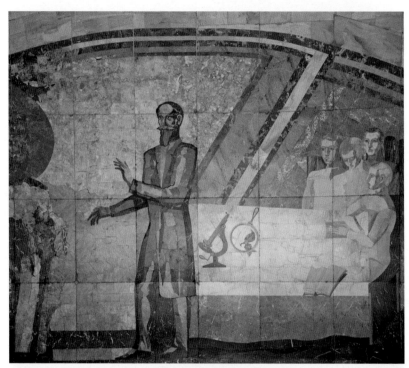

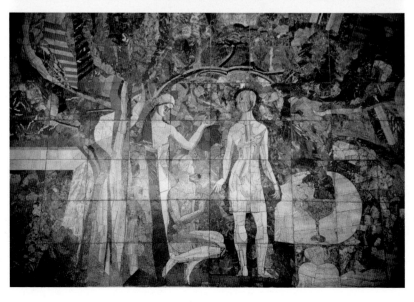

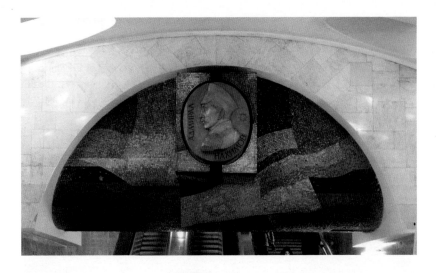

Nakhimovsky prospekt metro station, underground hall

125 A

Mosiychuk, A. M.
1983

In the south of Moscow, many toponyms derive from the south of Russia. Russian naval commanders and the history of the Russian navy inspired the decoration of Nakhimovsky Prospekt metro station. Its principal hero is Admiral Pavel Nakhimov (1802–1855), who died during the defence of Sevastopol in the Crimean War. Anatoly Mosiychuk placed a metal relief profile of the famous naval commander on a background of abstract mosaic panels at the north entrance to the underground hall. The reverse side of this wall features a sailing ship in natural stone and smalt. The south entrance is decorated with sculptural compositions on the same theme.

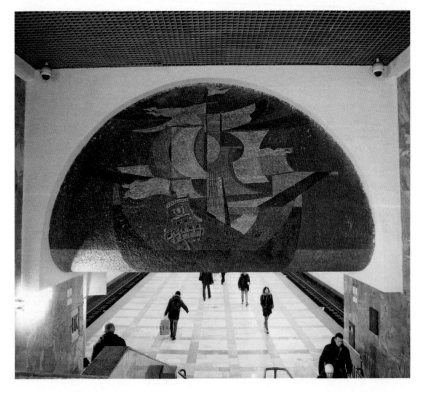

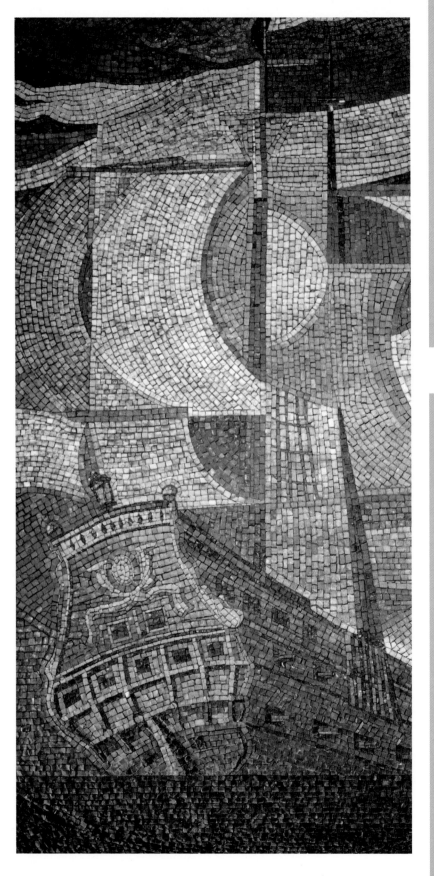

4

Sevastopolskaya metro station, underground hall

126 A

Ikonnikov, O. A.
'Sevastopol, Hero City'
1983

Another underground *sorokonozhka* ('centipede') – the standard type for shallow metro station with two rows of columns – was decorated with mosaic reliefs by sculptor Oleg Ikonnikov (1927–2004), a pupil of Alexander Deyneka and one of the authors of the sculptural composition at Ulitsa 1905 Goda metro station. For

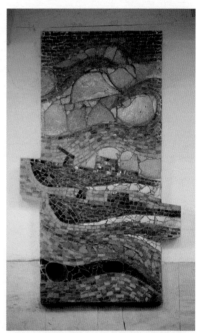

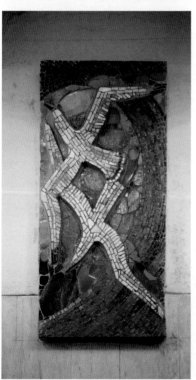

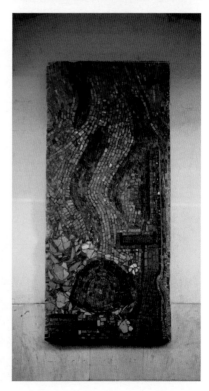

Sevastopolskaya, Ikonnikov made rectangular relief tiles with thematic subjects – local attractions (the Eternal Flame at the Obelisk of Glory, the Monument to the Sunken Ships), symbols of Sevastopol's experience during the Second World War (a machine gun, a helmet with a five-pointed star, a St George ribbon), and signs of the ancient city by the sea (an amphora and a column, military ships, sailing ships, and seagulls with fish). The compositions are arranged in smalt of various different sizes and are slightly strident in terms of their colours. Alas the inelegant draughtsmanship does not correct this situation.

4

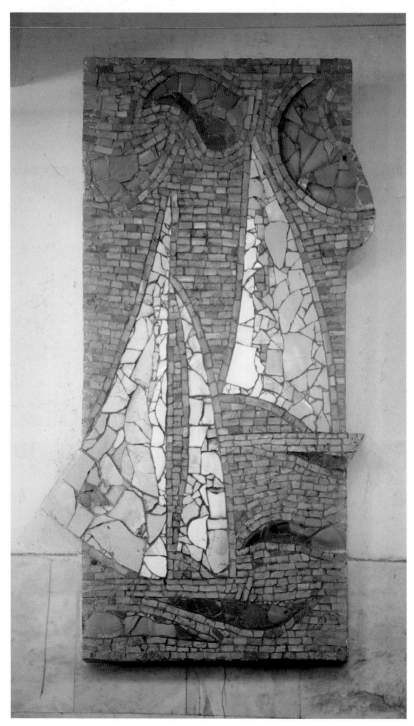

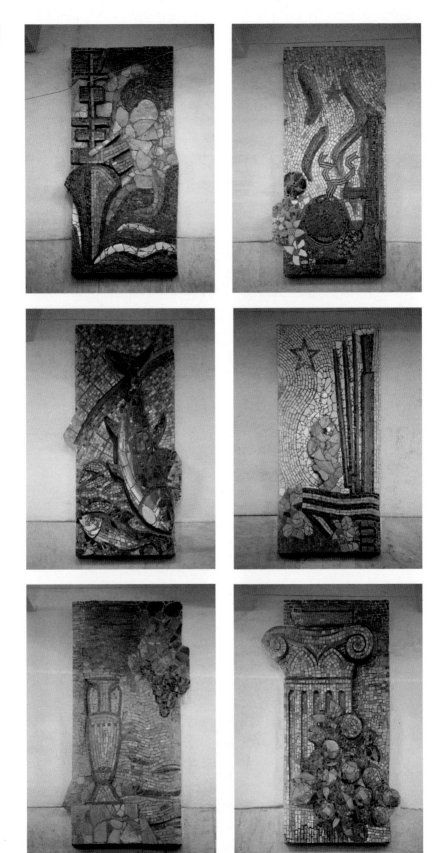

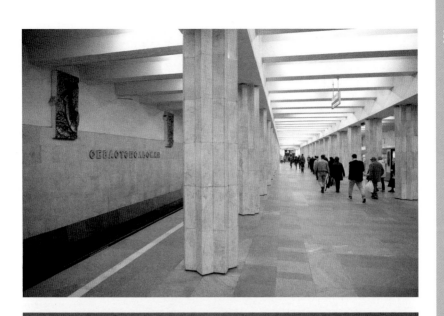

4

Neklyudov, B. P., and others. 1983. Yuzhnaya metro station. 'Seasons of the Year'. 127A

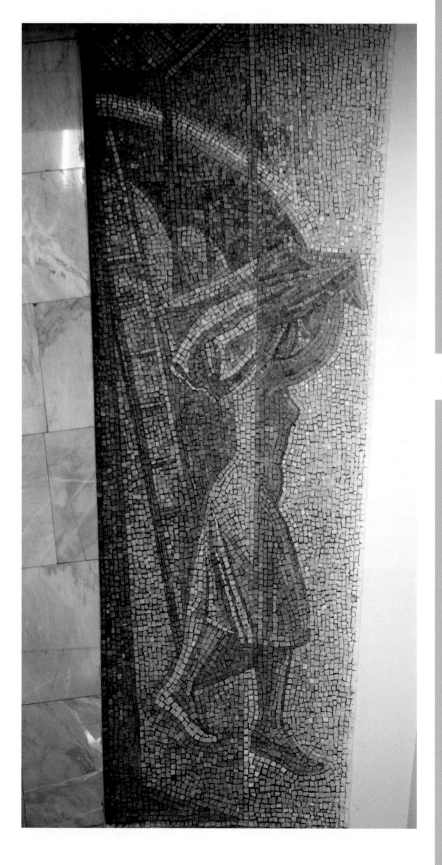

Yuzhnaya metro station, underground hall

127 A

Neklyudov, B. P., Kuznetsov, V., Bikeykin, V.
'Seasons of the Year'
1983

The distinctive compositions designed by the artist Boris Neklyudov (1938–2014) for Yuzhnaya metro station develop the sacramental theme of the seasons of the year. Winter, spring, summer, and autumn are represented by female figures, while the colour of the smalt symbolises the weather – light-blue for winter and spring, red for summer and autumn. There is a strip of marble mosaic on the plastered wall between the smalt mosaics – an unexpected and rare combination of materials. Neklyudov made use of Florentine and Roman mosaic, wall painting, stained glass, and sgraffito and designed the marble mosaics for one of the rooms at the Cathedral of Christ the Saviour in 2000.

**Utrish Delphinarium
(now Palace of Watersports
of Moskomsport Moscow
Olympic Centre for
Watersports)**
Mironovskaya ulitsa, 27

Unknown artist
1970s

Here, streams of dark-blue, green, and pink water carry fish and capsules containing people. The composition consisting of ceramic tiles and smalt 'embellishes' the top part of the Olympic Water Sports Palace. The Moscow branch of the Utrish Delphinarium, which is based in the village of Bolshoy Utrish in the Krasnodarsky region on the shore of the Black Sea, closed in 2011.

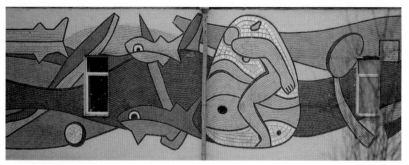

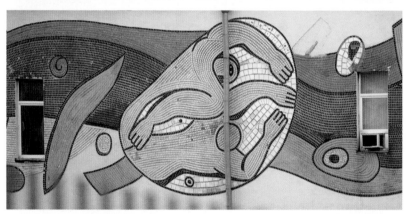

4

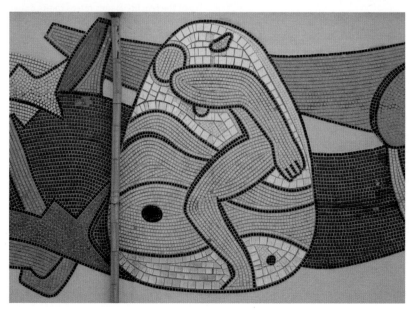

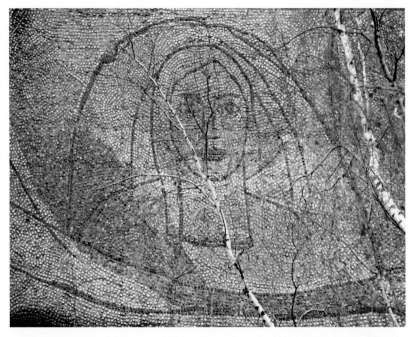

**Professional and
Technical School No. 19
(now Services
College No. 10),
3rd teaching block**
Dmitrovskoe shosse, 79/3

129 A

Unknown artist
1970s

The frieze on this brick building is decorated with mosaic made from stone with infrequent inserts of smalt. Outlines of female faces are entwined with ribbons and decorated with spots of colour in the style of printed graphic art. The plasticity of the female images refers to the drawings of Picasso. The mosaics have been attributed to followers of Boris Milyukov, a monumentalist artist who was inspired by the work of Picasso.

Central House of Hunters and Fishers
Golovinskoe shosse, 1

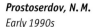

Prostoserdov, N. M.
Early 1990s

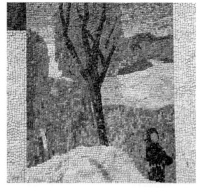

The free-standing building of the House of Hunters and Fishers was erected following a decision taken in 1962 by the All-Russian Congress of Societies of Hunters. Construction took longer than expected, but it was ultimately hastened by a promise to provide housing to Olympic sports delegations. However, Olympic athletes would never live in the building. The eight-storey structure instead accommodated the Hotel Okhotnik ('Hunter'), a shop for hunters, work rooms, a cinema and concert hall, a meeting room, a taxidermic workshop, a garage, a restaurant, and a buffet. Part of the exterior wall of this two-storey block is decorated with a distinctive portico featuring a forest growing between its pylons against the background of a grey sky. Above, a black-and-green sun framed by ribbons 'shines' and the figure of a hunter is visible behind a snow drift of natural stone.

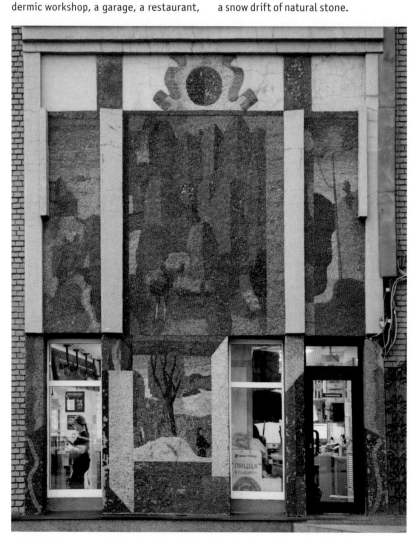

House on Izmaylovsky val
Izmaylovsky val, 20

131 A

Zamkov, M. V.
1989

The end wall of this eight-storey factory administrative building erected in 1982 was decorated with a mosaic likely designed by Maksim Zamkov (1959–1997), the son of the well-known artist. The author's signature, 'M. Zamkov', is clearly visible in small pieces of green stone in the lower right corner of the abstract composition, which is intersected by the black lines of 'cables'.

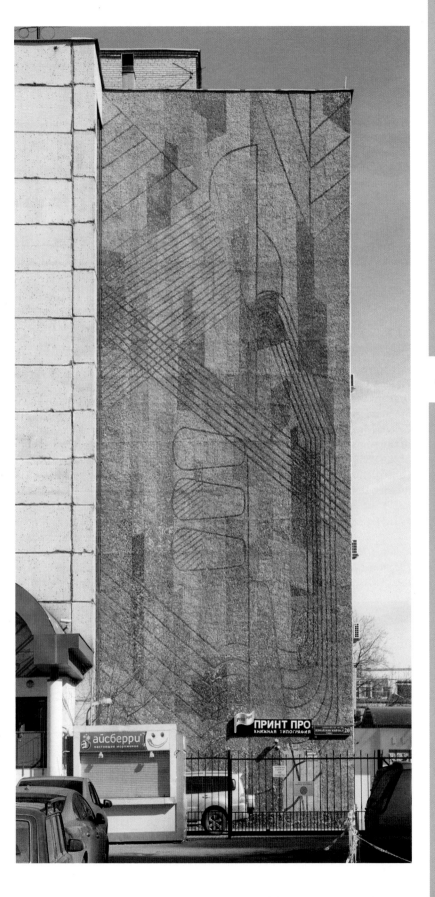

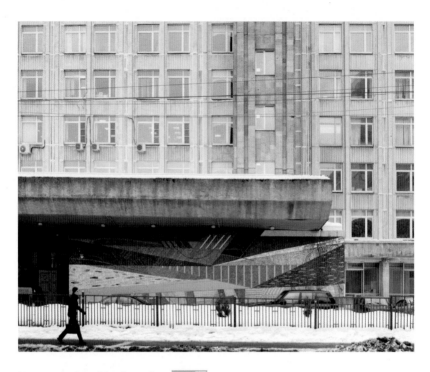

Moscow Order of Lenin and Order of the Red Labour Standard Institute of Railway-Transport Engineers of the Ministry of Communications of the USSR (now Institute of Roads, Construction, and Structures of the Russian University of Transport, MIIT)
Minaevsky pereulok, 2

132 A

Alalov, A. M.
(Bogachev, N. V., Ryleev, A. M.)
Late 1980s

The abstract composition at the entrance to this institute was assembled from smalt, natural stone, and fragments of ceramic tiles. The ornamental pattern of some of the fragments alternates with a precise rhythm of elongated strips, a clear reference to the rhythm of rails and bridges (an apt allusion given the field in which the institute specialises). It is possible to distinguish the initials 'A.A.' – evidently standing for Aleksandr Alalov (1950–1989), a graduate of Stroganovka – in the lower right corner of the composition, which is in shades of grey and red.

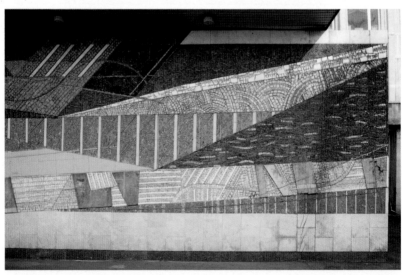

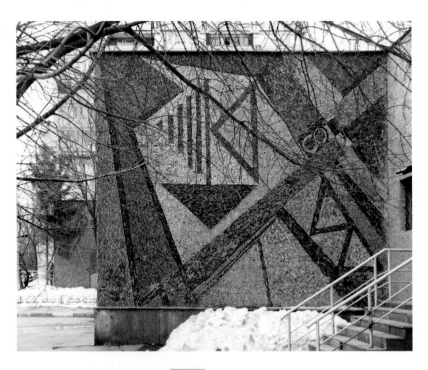

Komfort
(shop)
Dukhovskoy pereulok, 16

 133 **I**

Dubtsov, M. M.
1986

The mosaic decoration at the furniture shop Komfort consists of tiles of smalt and natural stone. The abstract composition of geometrical shapes in a range of restrained colours is not very expressive and does not succeed in making this one-storey shop stand out among the multi-storey buildings in the surrounding dormitory district.

4

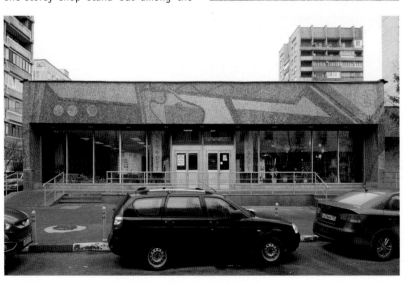

**M.Y. Lermontov
Library No. 76,
interior, façade**
Barbolina ulitsa, 6

*Pavlovsky, S.A.,
Grigorieva, N. G.*
'M.Y. Lermontov', 'A Solitary Sail Gleams
White', 'Untitled'
(1982)–1984

The panel composed of natural stone and smalt by Serafim Pavlovsky (1903–1989) is a portrait of the romantic poet Mikhail Lermontov (1814–1841). This library/reading room opened in 1919 at Krasnye vorota, where Lermontov was born. It was subsequently moved to the annex of a 14-storey residential brick building. The library entrance is also decorated with a mosaic – with abstract strips composed of geometrical figures of natural stone. The laconic minimalism of the portrait of this writer and poet derives from the yellow and grey colour scheme and the grey cement grout line.

Library No. 77 (No. 52)
Konenkova ulitsa, 23

135 A

Khodasevich-Léger, N. P.
1972

Nadia Khodasevich-Léger (1904–1982), the cousin of poet Vladislav Khodasevich and an assistant to the artist Fernand Léger, created a series of portrait mosaics depicting, among others, Lev Tolstoy, Petr Tchaikovsky, Vladimir Lenin, Maksim Gorky, Yuri Gagarin, Maya Plisetskaya, Dmitry Shostakovich, Sergey Eisenstein, and even Ekaterina Furtseva, the USSR Minister of Culture. 65 vertical panels with monochrome black-and-white faces on bright smalt backgrounds allude to the modernist aesthetic and resemble works by the artist's spouse, Fernand Léger. Khodasevich-Léger created the series of portraits in 1972 for a solo exhibition in France. She later gave the majority to the USSR, with 20 being sent to the *naukograd* ('town of science') of Dubna near Moscow in the 1980s. They were installed in the public garden at the Mir Palace of Culture on ploshchad Kosmonavtov beside the Oktyabr Palace of Culture and at a home for the elderly. The portrait of Vladimir Mayakovsky was placed at the entrance to the Mayakovsky Library in Moscow.

4

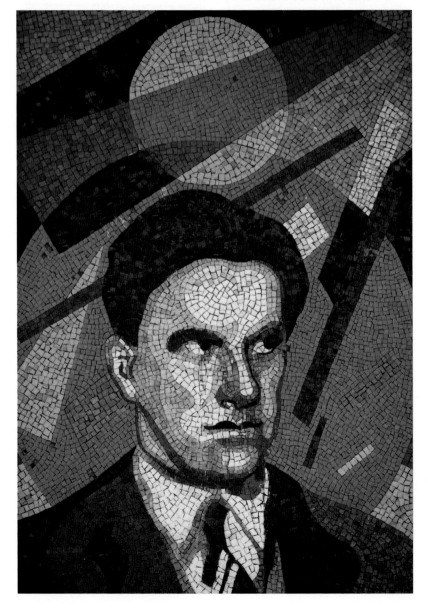

**Tushino City
Children's Hospital
(now Z. A. Bashlyaeva City
Children's Clinical Hospital),
main entrance to the main block**
Geroev Panfilovtsev ulitsa, 28

136 A

Kazakov, B. I.
1989

Boris Kazakov (1927–2019) studied monumental painting under Alexander Deyneka at the Moscow Institute of Decorative and Applied Art and was granted the title of a Distinguished Artist of the RSFSR. He created two mosaic panels for the main entrance to the main block at Tushino Children's Hospital. Both works were assembled from pre-prepared tiles. The first mosaic depicts a sporting family and uses a naturalistic polychromatic range of colours, while the second panel is in a grey 'grisaille' colour scheme.

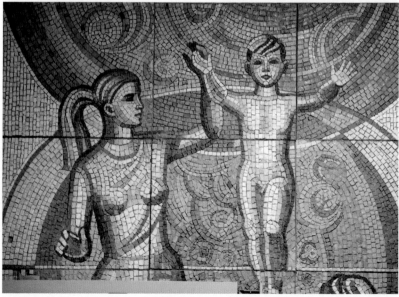

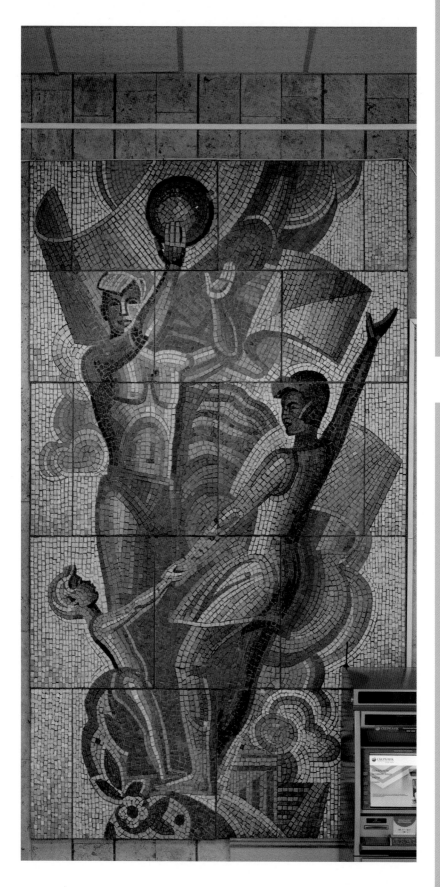

4

Zhenskaya moda ('Women's Fashion', shop)
Izmaylovskoe shosse, 6

137 A

Romanova, E. B.
'Women and Fashion'
1982

The decorative panel at this 25-storey prefabricated residential building was composed from natural stone and smalt according to a design developed by artist Elena Romanova (1944–2014), a graduate of the Surikov Institute and a pupil of Alexander Deyneka. Romanova, who painted portraits of well-known contemporaries including Vasily Shukshin, Alla Pugacheva, Lyudmila Petrushevskaya, and Valery Zolotukhin, uses this monumental panel to depict stages in the development of European fashion. A barefooted Greek woman in ancient-classical dress stands at the centre of the composition at Zhenskaya moda. Another four

figures in historical dress are positioned around her, with the woman on the lower right embodying modernity. Overall, the composition is of schematic design. The abstract background and geometrical ornaments have no overarching structure. The most memorable element is the figure of a trendy young woman from the 1980s in a yellow jumpsuit and high heels with hair let down – a rare and original image in Soviet monumental mosaic.

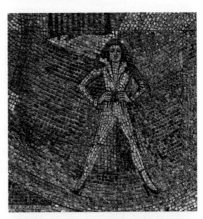

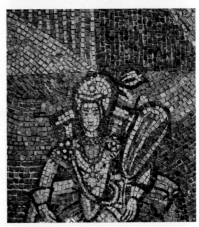

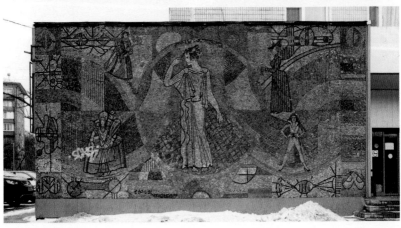

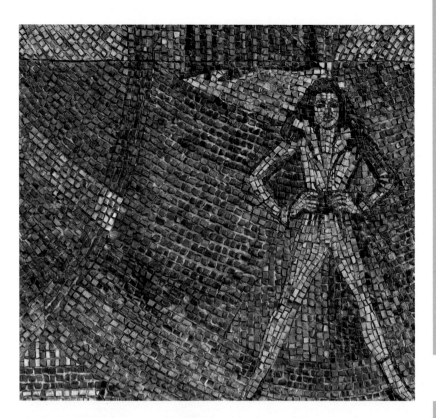

4

**Frezer ('Milling Machine')
Moscow M. I. Kalinin
Factory of Cutting
Instruments, a wall in
the canteen**
1st Frezernaya ulitsa, 2/1, block 2

138 A

Tarakanova, N. N.
1983

This composition of geometrical figures and milling machines is supplemented by a miniature figure of a worker, an ear of wheat, an artificial satellite, and a hammer and sickle in relief. The rhythm of the triangles of different sizes brings all of these elements together into one, demonstrating the applicability of cutting tools in various different industries. Natalya Tarakanova (born 1932), a graduate of Stroganovka, is the author of the mosaic wall at the factory of cutting instruments. The smalt panel in red, yellow, and blue colours remains a bright accent on this factory building – a nine-story concrete cube, most of which is currently granted by lease. The factory ceased to exist in the 2000s.

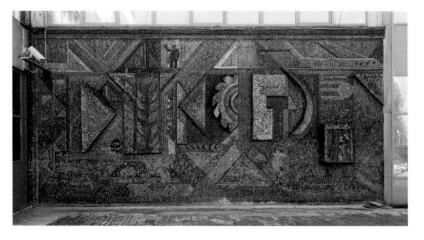

Moscow Wool-Making Factory 139 A
**(now Oktyabr
business centre)**
Petra Alekseeva ulitsa, 12/22

Unknown artist
Dismantled
Early 1970s

The compositions on the walls of this factory, which made woollen fabrics, represent the production process. Frozen male and female figures, many of whom are shown in profile in the Egyptian manner, calmly observe thread being wound onto bobbins and inspect the contents of test tubes. Assembled from bricks, the composition has a graphic textured edge. The figures of factory workers are anatomically detailed. The mosaic is made of tiles and has a graphic textured edge.

4

Moscow Factory of Animal Glue and Mineral Fertilisers (now Kontakt business centre)
Ostapovsky proezd, 5

Unknown artist
1970s (?)

The main entrance to one of the old factory's brick blocks is decorated with a mosaic panel shaped like the Cyrillic letter П ('p'). A male figure and two female figures in white coats with glass vessels and sheets of paper appear against background strips of different colours. The upper part of the composition features a hammer and sickle floating between open palms. A model of the atom, a mark of quality, and other symbols are visible at the sides. The glue-boiling and bone-processing factory was founded in 1874 by Fedor Grachev, who made sausages. After the revolution, the factory was renamed 'Kleytuk' ('glue' or 'tallow'). It now houses a small plant making glass, glue, and polyethylene pipes. Other spaces at the factory are rented out.

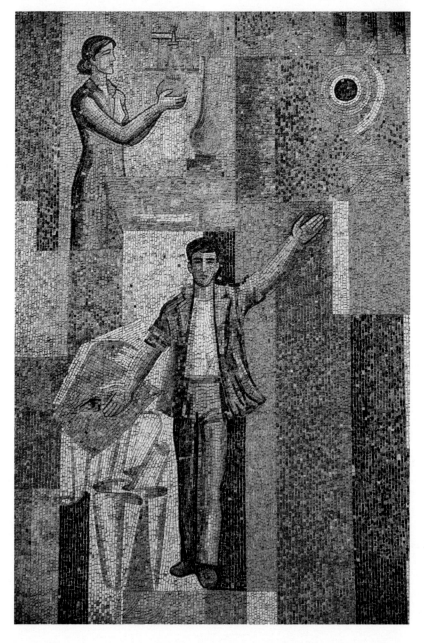

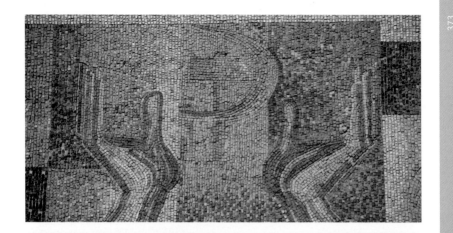

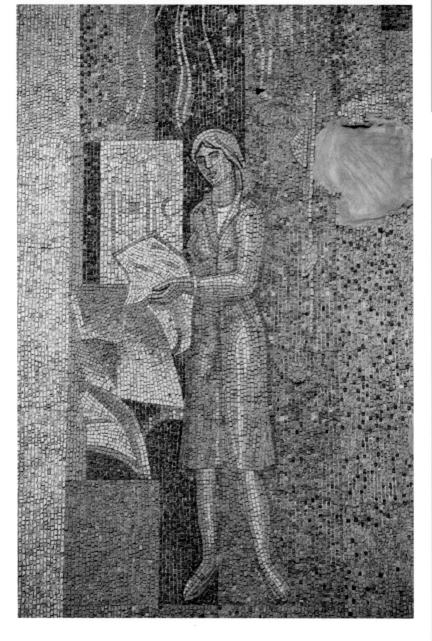

4

Index of Soviet-era monumental mosaics in Moscow

This list is in chronological order and contains mosaics that have been identified by the authors of this book. Some mosaics mentioned in the literature on this subject have proved impossible to find in Moscow, given that many organisations in possession of mosaics have ceased to exist and art historians and researchers have not given precise addresses for them. Many mosaics are on sites to which it was not possible to gain access. Many have been dismantled or are undergoing restoration. And alas, some were lost after being photographed. Some of the photographed works are included in this index, but not in the main part of this book (pages 1–373). The list is necessarily incomplete: additional mosaics continue to be identified and dates of known works and the names of their authors continue to be established.

No.	Year	Author	Object	Status	Number in book
1	1925	Frolov, V. A.	Emblem of the USSR, emblem of the RSFSR, emblem of the USSR. Kiev Station	Dismantled	
2	(1929)–1930	Workshop of Frolov, V. A.	Lenin's Mausoleum. Red Square	Inaccessible	
3	(1934)–1938	Unknown artist	Rodina Cinema (architects: Kornfeld, Y. A., Kalmykov, V. P.). Semenovskaya ploshchad, 5	Depicted	
4	(1935)–1937	Lansere, E. E., Feynberg, L. E., workshop of Frolov, V. A.	'Flags'. Frunze Military Academy (Combined Arms Academy of the Armed Forces of the Russian Federation). Devichiego Polya proezd, 4	Inaccessible	
5	1938	Deyneka, A. A, studio of Frolov, V. A.	'A Day in the Life of the Country of Soviets' (34 panels). 'Oranges', 'Bomb Locomotives in the Afternoon', 'Bomb Trucks at Night', 'Bomb Trucks at Night'/ Double, 'Domna at Work', 'Long Jump Parachutist', 'Flag of the USSR', 'Ball Game', 'Kremlin by Day', 'Kremlin at Night', 'Skier', 'Sailor on Watch', 'Mother and Child', 'At the Construction Site (Cranes)', 'Parachutes in the Sky', 'Parachutes in the Sky'/ Double, 'Pioneers with a Model', 'Gliders', 'Swimmers Jump', 'Sunflowers', 'Portico', 'Searchlight', 'Skydiving at Night', 'Pole Vault', 'Rye (Combine)', 'Sculpture (Statue)', 'Pines in the North', 'Sports Aircraft', 'Stratosphere Balloon', 'Flowering Apple Tree', 'Seagulls Above Water', 'Chkalovsky Plane', 'Electrification', 'Apples are Ripe'. Mayakovskaya metro station, underground hall, architect: Dushkin, A. N.	Depicted	001B
6	(1940)–1943	Bordichenko, V. F., Lekht, F. K., Pokrovsky, B. V.	'Heroes' ('Parade on Red Square'). Avtozavodskaya metro station, vestibule, architect: Dushkin, A. N.	Depicted	003I

Unknown artist. Panel on the façade of Rodina Cinema, (1934)–1938. 3

7	(1940)–1943	Bordichenko, V. F., Pokrovsky, B. V., Lekht, F. K., workshop of Frolov, V. A.	'The Soviet People during the Great Fatherland War'. Avtozavodskaya metro station, architect: Dushkin, A. N.	Depicted	027I
8	1943	Pokrovsky, B. V.	'The Front and Rear in the Fight against the German Occupiers'. Novokuznetskaya metro station, end wall of the underground hall, architects: Taranov, I. G., Bykova, N. A.	Depicted	004G
9	1943	Bordichenko, V. F., Mashkovtseva, E. D.	'Fanfare in Honour of the People and its Leader, I. V. Stalin' ('Fanfare Players Announcing Victory'). Paveletskaya metro station on the Zamoskvoretskaya Line, vestibule	Depicted	005I
10	1943	Deyneka, A. A., workshop of Frolov, V. A.	'Gardeners', 'Steelworkers', 'Machine Builders', 'Builders', 'Aviators', 'Skiers', 'Parade of Gymnasts'. Novokuznetskaya metro station, vestibule, underground hall, architects: Taranov, I. G., Bykova, N. A.	Depicted	002G
11	(1940)–1945	Bordichenko, V. F., Pokrovsky, B. V., (Ivanov, A. T.)	Baumanskaya metro station, end of the underground hall, architect: Iofan, B. M.	Depicted	006D
12	(1940)–1947	Bordichenko, V. F.	'15 Soviet Republics'. Ploshchad Revolyutsii metro station, eastern vestibule, architects: Zenkevich, Y. P., Dushkin, A. N., Demchinsky, N. I.	Depicted	008F
13	1947	Rabinovich, I. M.	'Flags of Victory'. Baumanskaya metro station, vestibule	Depicted	007D
14*	1950	Deyneka, A. A., Arakelov, V. N.	'Portraits of Great Scholars'. Lomonosov Moscow State University (MGU), main building, vestibule, Vorobievy gory, 1	Depicted	020H
15	1950	Rabinovich, I. M.	'Stalin's Plan for Transforming Nature'. Paveletskaya metro station on the Circle Line, vestibule	Depicted	009I

* object to which there is limited access.

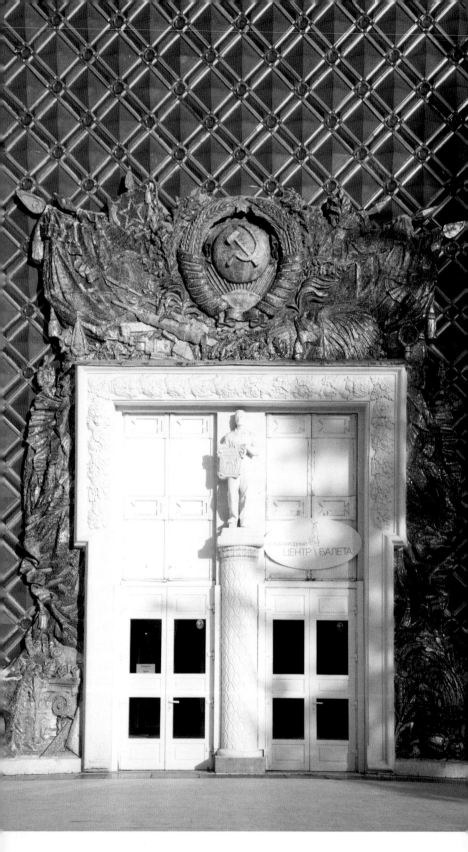

P. N. Isaev and others. Panel on the façade of the Building Materials Pavilion
(No. 62, 'Preserving Nature'), 1954. VDNH. 28

No.	Year	Author	Object	Status	Number in book
16	1950	*Rabinovich, I. M.*	'Red Square'. Paveletskaya metro station on the Circle Line, vestibule	*Depicted*	**026I**
17	1951	*Opryshko, G. I.*	'The Flowering of Soviet Belorussia'. Belorusskaya metro station on the Circle Line, underground hall, architects: Taranov, I. G., Bykova, N. A.	*Depicted*	**022B**
18	1951	*Rublev, G. I., Iordansky, B. V.*	'Lenin on the Background of the Emblems of the Soviet Republics', 'Workers Parade', Dobryninskaya metro station, vestibule, architect: Pavlov, L. N., Tatarzhinskaya, Y. V.	*Depicted*	**028I**
19	1952	*Vartanyan A. V.*	Armenia (shop). Tverskoy bulvar, 28	*Depicted*	**013C**
20	1952	*Korin, P. D., Bordichenko, V. F., Pokrovsky, B. V. assisted by Sorochenko, K. K., Khayutina, L. E.*	'Peace Throughout the World'. Novoslobodskaya metro station, end wall of the underground hall, architect: Dushkin, A. N.	*Depicted*	**010C**
21*	(1951)–1953	*Korin, P. D. assisted by Sorochenko, K. K., Khayutina, L. E.*	Lomonosov Moscow State University (MGU), principal building, conference hall, stage. Vorobievy gory, 1	*Depicted*	**021H**
22	(1952)–1953	*Opryshko, G. I.*	'The Triumph of the Labour of the People of Soviet Ukraine'. Kievskaya metro station on the Arbatsko-Pokrovskaya Line, vestibule	*Depicted*	**023E**
23	1953	*Korin, P. D., Ryabov, P. D.*	Smolenskaya metro station on the Arbatsko-Pokrovskaya Line, vestibule	*Depicted*	**024F**
24	1953	*Velizheva, M. A. Orlovsky, A. L.*	'First Tractor Team'. Kievskaya metro station on the Circle Line, underground hall, architects: Katonin, E. I., Skugarev, V. K., Golubev, G. E.	*Depicted*	**030E**
25	1953	*Myzin, A. V., Ivanov, A. T. and assisted by Anikanov, M., Akhmarov, C. G., Boguslavskaya, O., Bykova, G. Z., Vasilieva, L., Vatutin, N., Dorofeev, A., Zakharov, V. M., Kalmykova, G., Kirova, I., Kornoukhova, A. F., Kozhanov, E. G., Konov, F., Korin, B. A., Lobanikhin, B., Lukashevker, A. D., Lukovtsev, B., Permyakov, Y. P., Rozova, L. A., Rybalchenko, V., Ryabov, L. M., Sekretarev, I. V., Semenov, V., Sidorov, M., Sorochenko, K. K., Surskaya, R., Sukhov, V., Fedyushkin, B., Filatov, V., Fuks, V. I., Khayutina, L. E., Khryashchev, V., Cherepanova, Sheremetev, V., Shilovskaya, T. A.*	'The Rada at Pereyaslavl. 8/18 January, 1654', 'Battle of Poltava', 'Pushkin in the Ukraine', 'Chernyshevsky, Dobrolyubov, Nekrasov, and Shevchenko in St Petersburg', 'Lenin's Iskra', '1905 in Donbass', 'Soviet rule is proclaimed by V. I. Lenin', 'M. I. Kalinin and G. K. Ordzhonikidze at the Opening of Dnieper Hydroelectric Station. 1932', 'Public Festivities in Kiev', 'The Reunification of the Entire Ukrainian People in a Single Ukrainian Soviet State', 'The Liberation of Kiev by the Soviet Army. 1943', 'Victory Firework Display in Moscow, 9 May 1945', 'Friendship Between Russian and Ukrainian Kolkhoz Workers', 'Socialist Competition between Metalworkers in the Urals and Donbass', 'Commonwealth of the Peoples is the Source of the Socialist Motherland's Prosperity', 'Decorated with Orders, Flourishes Ukraine, Republic of Workers and Peasants'. Kievskaya metro station on the Circle Line, architects: Katonin, E. I., Skugarev, V. K., Golubev, G. E.	*Depicted*	**030E**
26	(1951)–1954	*Kazakov, S. M., Sergeev, A. M.*	'Russian Weapons'.	*Depicted*	**029D**
		Bordichenko, V. F., Pokrovsky, B. V., Kornoukhova, A. F., Ryabov, L. M., Sorochenko, K. K., Fuks, V. I., Khayutina, L. E., Chernyshev, B. P., Shilovskaya, T. A. et al, supervised by and using the drawings of Korin, P. D.	'Aleksandr Nevsky', 'Dmitry Donskoy', 'Minin and Pozharsky', 'Aleksandr Suvorov', 'Mikhail Kutuzov', 'Soviet Soldiers and Officers by the Walls of the Reichstag', 'Speech by V. I. Lenin', 'Mother Motherland', 'The Order of Victory'. Komsomolskaya metro station on the Circle Line, architect: Shchusev, A. V.		

* object to which there is limited access.

No.	Year	Author	Object	Status	Number in book
27	1954	*Bembel, A. O.*	'Motherland'. Pavilion of the Belorussian SSR (Pavilion No. 18, 'Electric Equipment', 'Republic of Belarus'), architects: Zakharov, G. A., Chernysheva, Z. S. VNDH. Prospekt Mira, 119	*Depicted*	**016A**
28	1954	*Isaev, P. N., Yaroslavskaya, M. E., Solomonovich, V. M., Zagarbynin, A. N., Naroditsky, A. I.*	Construction Materials Pavilion (No. 62, 'Preserving nature'), architects: Lutsky, G.I., Lopovok, L.I. VNDH. Prospekt Mira, 119	*Depicted*	
29	1954	*Orlov, S. M., Antropov, A. P., Slonim, I. L., Rabinovich, S. D., Shtamm, N. L., Dobrynin, P. I.,*	'Machine Operator' and 'Female Tractor Driver'. Mechanisation Pavilion (No. 34, 'Mechanisation and Electrification of Soviet Agriculture', 'Machine Building', 'Urban Planning', 'Space'), architects: Andreev, V. S., Taranov, I. G., Bykova, N. A. VNDH. Prospekt Mira, 119	*Depicted*	**017A**
30	1954	*Orlov S. M., Antropov, A. P., Slonim, I. L., Rabinovich, S. D., Shtamm, N. L.*	'Tractor Driver and Kolkhoz Woman'. Arch of the main entrance, architect: Melchakov, I. D. VNDH. Prospekt Mira, 119.	*Depicted*	**015A**
31	1954	*Ryleeva, Z. V.*	'Emblem of the Ukrainian SSR'.	*Depicted*	**014A**
		Orlov, S. M., Antropov, A. P., Slonim, I. L., Shtamm, N. L,	'Maidens with Laurel Wreaths'. Pavilion of the Ukrainian Soviet Socialist Republic (No. 58, 'Agriculture'), architects: Tatsy, A. A., Chuprina, V. I. VNDH. Prospekt Mira, 119.		
32	1954	*Architects: Topuridze, K. T., Konstanti-novsky, G. D.; sculptors: Dobrynin, P. I., Petrov, I. M.*	'Golden Ear' (fountain). VDNH. Prospekt Mira, 119	*Depicted*	**019A**
33	1954	*Architect: Topuridze, K. T., sculptor: Dobrynin, P. I.*	'Stone Flower' (fountain) VDNH. Prospekt Mira, 119	*Depicted*	**018A**
34	1954	*Favorsky, V. A.*	TsSKA swimming pool, architects: Averintsev, B. I., Gaygarov, N. I. Leningradsky prospekt, 39, bldg. 9	*Depicted*	**012A**
35	1957 (1955?)	*Opryshko, G. I*	V. I. Lenin'. Biblioteka imeni V. I. Lenina metro station, end wall of the underground hall	*Depicted*	**025F**
36	1957	*Chernyshev, B. P., assisted by students at Moscow Architecture Institute (MARKHI)*	'Maiden from the Fiery Earth', 'Youth from the Marquises Islands'. From the series 'Festival Guests'. The Green Theatre at Gorky Central Park of Culture and Leisure (TsPKiO) (Stas Namin Theatre of Music and Drama). Krymsky val ulitsa, 9/33	*Depicted*	**031H**
37	1957	*Unknown artist*	Dinamo-Centre Sports Complex. Petrovka ulitsa, 26/9	*Not depicted*	
38	(1959)–1960	*Gushchin, V. N.*	'The Bottom of the Sea' (fountain). Embassy of the People's Republic of China	*Inaccessible*	
39	(1959)–1960	*Chernyshev, B. P., Shilovskaya, T. A., Lukashevker, A. D.*	'Choristers'. Usievicha ulitsa, 15/2	*Depicted*	**065A**

V. I. Fuks. 'The Novgorod Boat'.
Panel on the end wall of a house on ulitsa Yablochkova, 1962. 55

E. S. Zernova. 'Bathyscaph', 1968. P. P. Shirshov Institute of Oceanology at the Russian
Academy of Sciences. Photo: M. V. Shilina. 96

No.	Year	Author	Object	Status	Number in book
40	(1959)–1962	*Ablin, E. M., Gubarev, A. A., Lavrova-Derviz, I. I., Derviz, G. G., Drobyshev, I., Pchelnikov, I. V.*	'Young Followers of Lenin', 'Pioneer's Badge'. Panels on the end wall of the theatre building, signs of the zodiac on the floor in the interior of the main building. Moscow Palace of Pioneers, architects: Pokrovsky, I. A., Egerev, V. S., Kubasov, V. S., Novikov, F. A., Paluy, B. V., Khazhakyan, M. N., engineer Ionov, Y. I. Kosygina ulitsa, 17	*Depicted*	033H
41	1960	*Pavlovsky, S. A.*	'Moscow-Leningrad'. Inside Leningradsky Station.	*Dismantled*	
42	1960	*Chernyshev, B. P., Shilovskaya, T. A., Gridin, V. A., Lukashevker, A. D., Kornoukhova, A. F.*	'Pioneria'. Palace of Pioneers (Palace of Creativity of Children and Young People on Miussy). Aleksandra Nevskogo ulitsa, 4	*Depicted*	032B
43	1960	*Unknown artist*	'Petushok' Kindergarten No. 2136 at the State Space Scientific and Production Center named after M. V. Khrunichev. Novozavodskaya ulitsa, 10	*Not depicted*	
44	1960 (?)	*Dekhto, Y. A., (Arakelov, V. N., Ter-Grigoryan, S. L. (?))*	'Lenin and the Bolsheviks'. Ilyich locomotive shed. Nizhnyaya ulitsa, 17/1	*Depicted*	036B
45	1960–1961	*Deyneka, A. A, the mosaic workshop at the Academy of Arts of the USSR under the supervision of Ryabyshev, V. I.*	'Emblems of the Soviet Republics'. State Kremlin Palace, architects: Posokhin, M. V., Mndoyants, A. A., Stamo, E. N., Shteller, P. P., Shchepetilnikov, N. M. Moscow Kremlin.	*Depicted*	037F
46	1961	*Chernyshev, B. P.*	'Tamara'. Usievicha ulitsa, 15	*Depicted*	065A
47	1961	*Unknown artist*	Institute of Molecular Genetics of National Research Centre 'Kurchatov Institute' Akademika Kurchatova ploshchad, 2	*Not depicted*	

48	1961 (?)	Unknown artist	Humanitarian College for Information and Library Technologies No. 58. Shelkovskoe shosse, 52	Depicted	
49*	1961–1962	Konovalov, V. A., Sorochenko, K. K., Khayutina, L. E.	'Liberation', 'Liberated Africa'. Institute of Africa at the Russian Academy of Sciences. Spiridonovka ulitsa, 30/1	Depicted	114B
50*	1962	Dauman, G. A., Shvartsman, M. M.	'The Taming of Atomic Energy', 'Penetrating the Essence of the Atom', 'Untitled'. Moscow Institute of Engineering and Physics, principal building, vestibule; library. Kashirskoe shosse, 31	Depicted	042A
51	1962	Kuliev, A. A.	'Builders'. Hotel. Varshavskoe shosse.	Not found	
52	1962	Opryshko, G. I.	'Space'. Central Airport Terminal. Lenngradsky prospekt, 37/6.	Dismantled	
53	1962	Protopopov, G. E.	Residence of the ambassador of the People's Republic of China.	Inaccessible	
54	1962	Talberg, B. A., the mosaic workshop led by V. I. Ryabyshev at the USSR Academy of Arts	'1812': 'The People's Militia and the Fire of Moscow', 'The Victory of the Russian Army and the Expulsion of Napoleon'. 'Battle of Borodino' Panorama Museum. Kutuzovsky prospekt, 38	Depicted	038A
55	1962	Fuks, V. I.	'Novgorod Boat'. Yablochkova ulitsa, 22/1	Depicted	
56	1962	Elkonin, V. B., in collaboration with Vasnetsov, A. V.	'Space'. Club at the Post Office of the Moscow-Kazan Railway.	Not found	
57	1962	Elkonin, V. B., in collaboration with Vasnetsov, A. V., Aleksandrov, Y., Vasnetsova, I. I.	'Underwater World'. Swimming pool at DOSAAF Aeroclub, façade. Volokamskoe shosse, 88 (?)	Not found	
58	1962	Unknown artist	The A. N. Nesmeyanov Institute of Organoelement Compounds of Russian Academy of Sciences. Vavilova ulitsa, 28	Not depicted	
59	1963 (?)	Korin, P. D.	'The Worker and the Kolkhoz Woman'. Paveletskaya metro station on the Circle Line, end wall of the underground hall	Depicted	040I
60	1963–1964	Anisimova, T. D.	Façades and interiors of standard kindergartens on ulitsa Fonvizinna, Dmitrovskoe shosse, Mikhalkovskoe shosse	Not found/ Dismantled	
61	1963–1964	Anisimova, T. D.	State public school No. 1213, pre-school department, subsection 3. 3rd Nizhelikhoborsky proezd, 5a	Depicted	
62	1964	Zhernosek, E. P., Potikyan, M. L.	'Sport', 'Sport and Children'. Stadium of Young Pioneers (Tsarskaya ploshchad residential complex). Leningradsky prospekt, 31	Transferred	034B
63	1964	Reykhtsaum, E. E.	'K. Marx'. Okhotny Ryad metro station, eastern pavilion	Depicted	041F
64	1964	Fuks, V. I.	Façades of residential buildings in Medvedkovo, Degunino, Beskudnikovo	Not found / Dismantled	

* object to which there is limited access.

No.	Year	Author	Object	Status	Number in book
65	1964	Unknown artist	Moscow Factory for Thermal Automation (MZTA). Mironovskaya ulitsa, 33	Depicted	048A
66	(1961)–1965	Korolev, Y. K.	'The People and the Army are One'. Central Museum of the Armed Forces of the Russian Federation. Sovetskoy Armii ulitsa, 2/1	Depicted	039C
67	1965	Titov, V. A., Tsyganov, Y. P.	Memorial plaque to V. L. Durov. Museum/house 'Grandpa Durov's Nook'. Durova ulitsa, 4	Depicted	
68	1965	Chelombiev, V. N.	'Underwater World'. Children's swimming pool in Izmaylovo	Not found	
69	1965	Unknown artist	Principal directorate of the USSR Hydrometeorological Service. Bolshoy Predtechensky pereulok, 11–13	Depicted	043E
70	1965	Unknown artist	Auto-tractor Electric Equipment Factory (ATE-1). Elektrozavodskaya ulitsa, 21/41	Depicted	059A
71	1966	Zhernosek, E. P.	'Youth. Spring. Love'. Palace of Marriage (now Ryazansky ZAGS), 1st Novokuzminskaya ulitsa, 3	Depicted	049A
72	1966	Neizvestny, E. I	Novoe Donskoe Cemetery, columbarium No. 20. Ordzhonikidze ulitsa, 4.	Depicted	060I
73	1966	Fuks, V. I. (?), (Tutevol, K. A. (?))	'Runners'. Beskudnikovsky bulvar, 12	Depicted	047A
74	1966	Chernyshev, B. P.	'Moscow'. Leningradsky prospekt, 43/2	Depicted	065A
75	1966	Sheremet, K. I.	Krasny Oktyabr Palace of Culture, café.	Not found	
76	1966	Edelshteyn, K. V.	V. I. Lenin Central Stadium (now Luzhniki Sports Complex). Training skating rink. Luzhniki ulitsa, 24	Dismantled	
77	(1966)–1967	Ablin, E. M.	Council for Mutual Economic Assistance (now the Government of Moscow), Hotel Mir canteen, restaurant. Novy Arbat ulitsa, 36	Inaccessible	
78	1966–1967	Opryshko, G. I.	'The Riches Inside the Earth'. Council for Mutual Economic Assistance (now the Government of Moscow), façade of the conference hall, interior wall. Novy Arbat ulitsa, 36	Depicted	056E
79	1967	Andronov, N. I., Vasnetsov, A. V., Osin, O. I., Elkonin, V. B., Syrkin, L. Z.	'October's Conquests'. Oktyabr Cinema, Novy Arbat ulitsa, 24	Depicted	055F
80	1967	Glebova, A.	2nd Moscow Watch Factory (Slava). Leningradsky prospekt, 8	Dismantled	
81	1967	Gulov, V. I., Kazakov, B. I., Skripkov, Y. N. Ter-Grigoryan, S. L.	'Science'. Institute for Research Sapfir (now Sapfir Scientific Manufacturing Enterprise). Shcherbakovskaya ulitsa, 53/2	Depicted	053A
82	1967	Zernova, E. S.	'The Defence of Sevastopol'. Sevastopol Pioneers' Club	Not found	
83	1967	Kazakov, B. I.	'Land to the People'. Stele in front of the Perovsky District Executive Committee building	Not found	

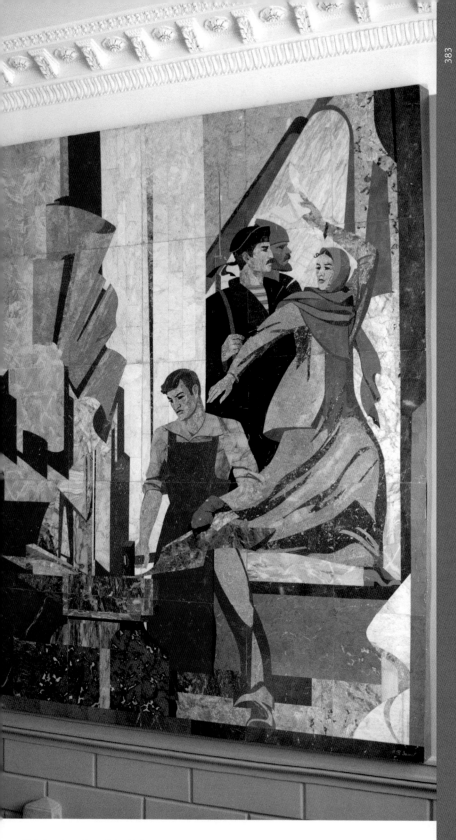

V. K. Zamkov. Part of the 'Culture, Art, Theatre' panel (copy of a previous work by the same author), 1980. Central Museum of the Revolution in the USSR (now the State Central Museum of the Contemporary History of Russia). 236

V. I. Fuks, 'The Youth of the World', 1980.
Hotel Molodezhnaya (now Park Tower Hotel), vestibule. 243

No.	Year	Author	Object	Status	Number in book
84	1967	Kuznetsov, A. N.	'Mothers of the World'. Prospekt Mira metro station on the Circle Line, vestibule	Depicted	072C
85	1967	Opryshko, G. I.	'Nature and Marble. Restaurant Sedmoe Nebo	Dismantled	
86	1967	Opryshko, G. I.	'Russian Gemstones'. Arbat restaurant. Novy Arbat ulitsa, 21	Not checked	
87	1967	Pavlovsky, S. A.	'Morning of the Space Age'. Dobryninskaya metro station, end wall in the underground hall	Depicted	064I
88	1967	Potikyan, M. L.	'Kirov'. Kirovsky District Executive Committee of the Communist Party of the Soviet Union	Not found	
89	1967	Titov, V. A.	'V. I. Lenin'. 17-metre-high stele. Junction of Kashirskoe shosse and Varshavskoe shosse	Dismantled	054A
90	1967	Chermushkin, G. V.	Embassy of Mongolia in the USSR, interior	Inaccessible	
91	1967	Unknown artist	Gas Industry Pavilion (Pavilion No. 21). VDNH. Prospekt Mira, 119	Depicted	
92	1967	Unknown artist	School No. 208 (A. S. Makarenko Intermediate School No. 656). Beskudnikovsky pereulok, 4A	Depicted	062A
93	1967	Unknown artist	Svoboda Factory (now Kosmeticheskoe obiedinenie 'Svoboda'). Vyatskaya ulitsa, 47/4	Depicted	067A
94	(1965)–1968	Orlovsky, A. L.	'Seasons of the Year'. Hotel Rossiya, interior courtyard	Dismantled	

95	1968	*Zamkov, V. K.*	Hotel Rossiya, post office	*Dismantled*	
96*	1968	*Zernova, E. S.*	'Bathyscaph'. P. P. Shirshov Institute of Oceanology at the Russian Academy of Sciences. Nakhimovsky prospekt, 36	*Depicted*	
97	1968	*Nikolaev, I. V., together with Grigoriev, Y. L., Kazansky, I.*	'Post'. International Post Office, customer service hall. Myasnitskaya ulitsa, 26, bldgs. 1, 3	*Dismantled*	
98*	1968	*Chernyshev B. P., Shilovskaya, T. A., Lukashevker, A. D., Gridin, V. A., Slepyshev, A. S.*	'Volga', 'Cities on the Volga'. Volga Cinema, foyer. Dmitrovskoe shosse, 133	*Depicted*	**063A**
99	1968	*Unknown artist*	'Assembling Moskvich Automobiles'. Moskvich Leninsky Komsomol Automobile Factory (now Techno Hall shopping centre). Volgogradsky prospekt, 32/8	*Depicted*	**066A**
100	1968	*Unknown artist*	Residential building, external walls of entrances. Sofii Kovalevskoy ulitsa, 8	*Not depicted*	
101	(1965)–1969	*Korolev, Y. K.*	'Space'. Intermediate School No. 548 (now School No. 630) Varshavskoe shosse, 12	*Depicted*	**068A**
102	(1965)–1969	*Reykhtsaum, E. E.*	'V. I. Lenin'. Central Museum of V. I. Lenin (Museum of the Patriotic War of 1812). Ploshchad Revolyutsii, 2/3	*Not checked*	
103	(1968)–1969	*Zamkov, V. K.*	'Appassionata'. Ministry of Culture of the RSFSR	*Not found*	
104	1968–1969	*Chernyshev, B. P.*	'Motherland' (late 1940s–1968), 'Art' (early 1950s), 'Forest Fairy' (1954–1955), 'Flight of the Valkyries' (1954–1955), 'Mistress of Copper Mountain' (approximately 1957), 'Russia' (1960–1961), 'Circassian Girl' (1965). Pervomaysky Cinema. Pervomayskaya ulitsa, 93/20	*Dismantled*	
105	1969	*Gulov, V. I.*	All-Union Research Institute of Glass Machine Building	*Not found*	

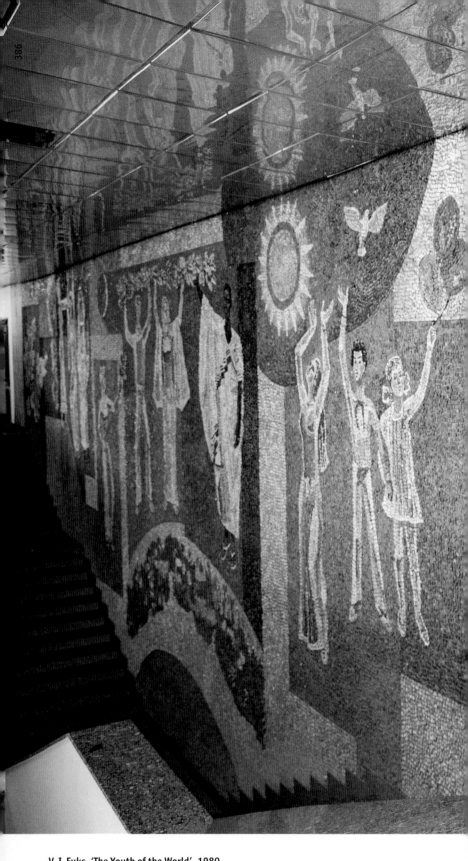

V. I. Fuks. 'The Youth of the World', 1980.
Hotel Molodezhnaya (Park Tower Hotel), vestibule. 243

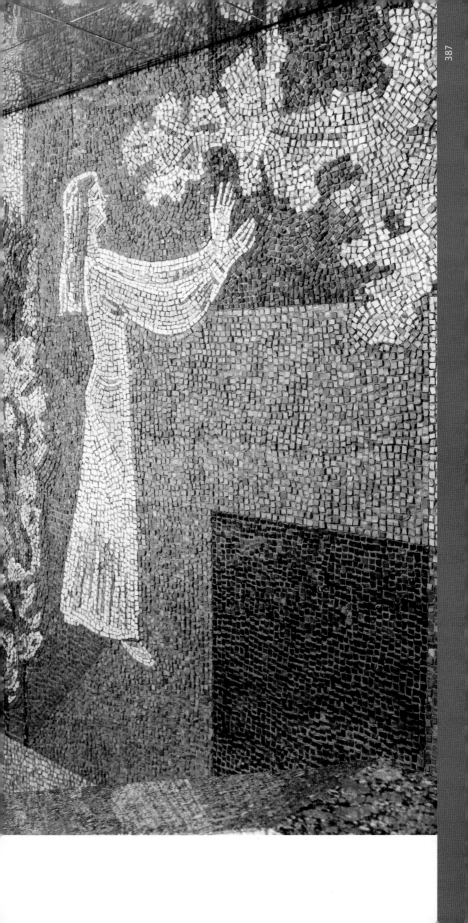

Unknown artist. 'Types of Sport', 1980.
Prospekt Mira, pedestrian underpass. 245

No.	Year	Author	Object	Status	Number in book
106	1969	*Kuznetsov, A. N.*	'Red Drummer'. Krasnoselskaya metro station, vestibule	*Depicted*	**073D**
107	1969	*Merpert, D. M.*	'The Art of Film'. Central House of Filmmakers, restaurant. Vasilievskaya ulitsa, 13/1	*Depicted*	**069B**
108*	1969	*Titov, V. A.*	'Bauman'. Moscow Bauman Higher School of Technology (now Moscow State Technical University), library, main building, auditorium 345. 2nd Baumanskaya ulitsa, 5/1	*Depicted*	**074D**
109	Early 1960s	*Aleeva T. A.*	'Africa – to Africans' at the Russian Academy of Sciences. Spiridonovka ulitsa, 30/1	*Depicted*	**114B**
110	Late 1960s	*Ryabov, L. M.*	'Maksim Gorky' Park Kultury metro station on the Sokolnicheskaya Line, vestibule	*Depicted*	**070H**
111	1960s	*Zernova, E. S.*	'Books are Mankind's Memory'. Donskaya ulitsa, 39/4	*Depicted*	**078I**
112	1960s	*Unknown artist*	'The Tale of Tsar Saltan'. Angarskaya ulitsa, 45/1	*Dismantled*	
113	1960s	*Unknown artist*	'The Humpbacked Horse'. Angarskaya ulitsa, 49/1	*Dismantled*	
114	1960s	*Unknown artist*	'The Tale of the Fisherman and the Fish'. Angarskaya ulitsa, 53/1	*Dismantled*	

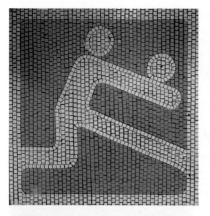

115	1960s	Unknown artist	'Sadko'. Angarskaya ulitsa, 57/1	Dismantled	
116	1960s	Unknown artist	'Springboard Diving'. Beskudnikovsky bulvar, 7, bld. 1	Dismantled	
117	1960s	Unknown artist	'Rowing'. Beskudnikovsky bulvar, 13	Dismantled	
118	1960s	Unknown artist	'Runners'. Beskudnikovsky bulvar, 21/1	Dismantled	
119	1960s	Unknown artist	'Airplanes'. Beskudnikovsky bulvar, 27, bldg. 1	Dismantled	
120	1960s	Unknown artist	'Soviet Cartoon Characters'. Underground passage near house 8 on Kutuzovsky prospekt (former 'Dom Igrushki', the House of Toys)	Not depicted	
121	1960s	Unknown artist	Urban clinical hospital No. 68 (Demikhov GKB). Shkuleva ulitsa, 4, bldgs. 8 and 10	Depicted	**061A**
122	1960s	Unknown artist	Residential building, mosaic on the wall in the courtyard. Malaya Sukharevskaya ploshchad, 1/1	Not depicted	
123	1960s	Unknown artist	Perovsky Commercial Engineering Plant. Perovskaya ulitsa, 71	Not depicted	
124	1960s	Unknown artist	Taxi park No. 1. Grafsky pereulok, 9	Not checked	
125	1960s	Unknown artist	Taxi park No. 7. 2nd Chernogryazskaya ulitsa, 6	Dismantled	

* object to which there is limited access.

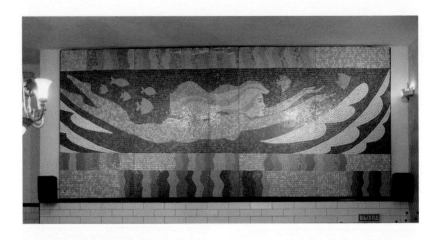

Unknown artist. Panel at the Palace of Culture of the Sickle and Hammer Factory. Café Progress, 1980s. 292

No.	Year	Author	Object	Status	Number in book
126	1960s (?)	*Unknown artist*	Bar Progress. Transferred from the weaving mill (Vladimirskaya oblast). Frunzenskaya naberezhnaya, 30/5	*Not depicted*	
127	1960s (?)	*Unknown artist*	'All Power to the Soviets!' Trolleybus Depot No. 5. Khodynskaya ulitsa, 5/2	*Depicted*	**071B**
128	1960s (?)	*Unknown artist*	Molniya Mechanical Engineering Plant. Ryazansky prospekt, 6A	*Not depicted*	
129*	1960s (?)	*Unknown artist*	Danilovskaya manufaktura. Varshavskoe shosse, 9, bldg. 1B, KNOP block	*Depicted*	**052A**
130	1960s (?)	*Unknown artist*	The First State Bearing Plant (OAO 'Moskovsky Podshipnik'; Mutabor Club). Sharikopodshipnikovskaya ulitsa, 13/32	*Not depicted*	
131	(1960(?))–1970s	*Unknown artist*	State Research Institute of Graphite-Based Structural Materials (NIIGrafit) Elektrodnaya ulitsa, 2	*Not depicted*	
132	1969–1970	*Vavakin, Y. V.*	Voykov Iron Foundry. Leningradskoe shosse, 16	*Dismantled*	
133	(1969)–1970	*Zamkov, V. K.*	Trekhgornaya manifaktura Palace of Culture	*Not found*	
134*	1970	*Dauman, G. A., Kozubovsky, E., Fedotov, A.*	Main Calculating Centre of USSR Gosplan (now the Analytical Centre at the Government of the Russian Federation). Prospekt Akademika Sakharova, 12	*Depicted*	**075C**
135	1970	*Dubtsov, M. M.*	'Yauza'. Restaurant in the vicinity of Semenovskaya metro station	*Not found*	
136	1970	*Kazakov, B. I.*	'The Working Class'. Sickle and Hammer Factory, stele	*Dismantled*	
137	1970	*Frolov, A. V.*	Embassy of the Republic of Cuba in the USSR	*Inaccessible*	
138	1970	*Fuks, V. I., together with Sidorov, M., Gridin, V. A., Karamyan, K.*	'Armenia'. Erevan Cinema, foyer. Dmitrovskoe shosse, 82	*Dismantled*	

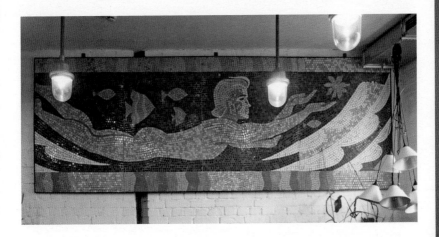

139	(1966)–1971	*Korolev, Y. K.*	'My Motherland' ('Russia'). Moscow Central Bus Station. Shchelkovskoe shosse, 75	*Depicted*	**076A**
140	(1969)–1971	*Milyukov, B. P.*	'Creation'. Moscow State Union Planning Institute (now Moselektronproekt). Kosmonavta Volkova ulitsa, 12	*Depicted*	**077A**
141	(1970)–1971	*Sheremet, K. I.*	Krasny bogatyr Factory, engineering block, vestibule. Krasnobogatyrskaya ulitsa, 2	*Not checked*	
142	1971	*Bobyl, Y. P., together with Litvinova, L. V.*	'North', 'South', 'East', 'West'. All-Union Research Institute of Sources of Electricity (now Kvant scientific and manufacturing enterprise), canteen. 3rd Mitishchinskaya ulitsa, 16	*Not checked*	
143	1971	*Frolova, L. K.*	The Embassy of Yugoslavia in the USSR, interior	*Not found*	
144	1971	*Edelshteyn, K. V.*	Central Moscow Hippodrome, riding ring. Begovaya ulitsa, 22	*Dismantled*	
145	(1968)–1972	*Unknown artist*	'Autumn'. Seasons of the Year Restaurant (now Garage Museum of Contemporary Art). Gorky Central Park of Culture and Leisure. Krymsky Val ulitsa, 9/32	*Depicted*	**050I**
146	1972	*Bobyl, Y. P., together with Litvinova, L. V.*	'Good Day'. Kalibr Factory, canteen, vestibule. Godovikova ulitsa, 9	*Not checked*	
147	1972	*Zernova, E. S.*	'The Sea and People'. Department of Ichthyology at the Extramural All-Union Institute of Food	*Not found*	
148	1972	*Zernova, E. S. (?)*	Headquarters of the youth volunteer fire brigade. Moskovsky prospekt, 4	*Depicted*	**044A**
149	1972	*Pamyansky, B. L.*	'Flags'. All-Union Research Technological-Design Institute for Natural Diamonds and Instruments (VNIIALMAZ). Gilyarovskogo ulitsa, 65	*Not checked*	
150	1972	*Khodasevich-Leger, N. P.*	Library No. 77 (No. 52). Konenkova ulitsa, 23	*Depicted*	**135A**
151	1972–1973	*Tutevol, K. A.*	'Relay'. Training block of the V. I. Lenin Institute of Physical Culture and Sport (Sports Research Institute at the State University of Physical Culture, Sport, Young People, and Tourism). Sirenevy bulvar, 4	*Depicted*	**082A**

* object to which there is limited access.

Unknown artist. Panel at the Fili Palace of Watersports, 1988. 284

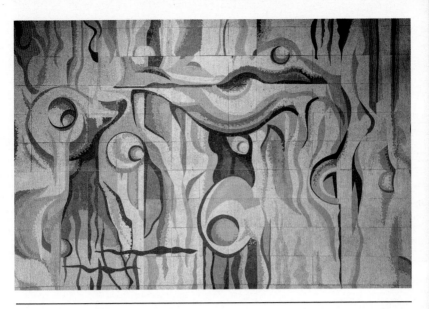

No.	Year	Author	Object	Status	Number in book
152	1973	*Beloyartseva-Vaysberg, G.*	Service station for light automobiles. Varshavskoe shosse, 170G, bldg. 21	*Not depicted*	
153	1973	*Vladimirova, O. N.*	Hotel Altai, vestibule. Botanicheskaya ulitsa, 41	*Dismantled*	
154	1973	*Ivanov, S. I, Kolesnikov, V. V.*	'Champions', 'Football', 'Sporting Gymnastics', 'Snorkellers'. Fili (now Konstruktor) Sports Complex. Bolshaya Filevskaya ulitsa, 32	*Depicted*	**081A**
155	1973	*Kuliev, A. A.*	'The Birth of Glass'. Institute of Glass. Dushinskaya ulitsa, 7/1	*Depicted*	**080A**
156	1973	*Osin, O. I.*	'Man and the City'. Central Institute of Standardised Design, vestibule	*Not found*	
157	(1971)–1974	*Kazaryants, E. G.*	'Macroworld – Microworld. Macrocosm – Microcosm'. House of Optics at the 'S. I. Vavilov State Optical Institute' All-Russian Research Centre. Prospekt Mira, 176	*Depicted*	**096A**
158	1974	*Anisimova, T. D.*	'Workers on Construction Sites'. Directorate for Mechanisation of Decoration at Glavmosstroy (now Stroytekhservis). Kolskaya ulitsa, 12/2	*Depicted*	**095A**
159	1974	*Dubtsov, M. M., Ilyin, N. V.*	Moskvich Leninsky Komsomol Automobile Factory (now Techno Hall shopping centre), car service: lobby, workshop. Volgogradsky prospekt, 32/8	*Dismantled*	
160*	1974	*Kuliev, A. A.*	'Art'. Palace of Culture of the First State Ball-Bearing Factory (now Theatre Centre on Dubrovka, Aquamarine Circus of Dancing Fountains). Melnikova ulitsa, 7/1	*Depicted*	**084I**
161	1969	*Kuliev, A. A.*	'Sport'. Pravda sports complex (now X-Fit fitness club), swimming pool. Pravdy ulitsa, 21/2	*Depicted*	**083A**
162	1974	*Reykhtsaum, E. E.*	'Northern Lights'. Diamond Fund. Moscow Kremlin	*Not checked*	

* object to which there is limited access.

Unknown artist. Panel at the Fili Palace of Watersports, 1988. 284

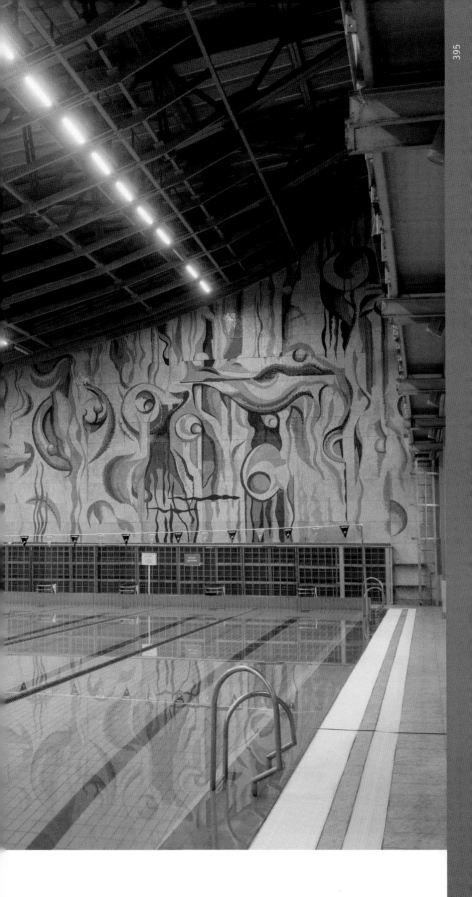

**Unknown artist. Foyer of Moscow Wool-Making Factory
(now Oktyabr Business Centre), early 1970s. 211**

No.	Year	Author	Object	Status	Number in book
163	1974–1975	Mironova, N. F.	Scientific-Production Association at the Central Research Institute of Machine Building Technology (NPO TsNIITMASh). Sharikopodshipnikovskaya ulitsa, 4	Depicted	097I
164	1975	Bubnov, V. A.	'Spring in the City'. Café Mayskoe.	Not found	
165	1975	Vasiltsov, V. K., Zharenova, E. A.	'Nature and Modernity'. Zhiguli car-servicing station, interior	Dismantled	
166	1975	Vasiltsov, V. K., Zharenova, E. A.	'Energy'. USSR Ministry of Energy, engineering block, foyer of the conference hall	Dismantled	
167	1975	Reykhtsaum, E. E.	'Festivity'. Restaurant Aragvi. Tverskaya ulitsa, 6/2	Dismantled	
168	1975	Elkonin, V. B.	'Russian Hospitality'. USSR Ministry of Architecture (now Ministry of Agriculture of the Russian Federation), second-floor hall. Sadovaya-Spasskaya ulitsa, 11/1	Dismantled	
169	(1975)–1976	Verkman, L. Y.	'Seasons of the Year'. Perekop Cinema. Kalanchevskaya ulitsa, 33/12	Dismantled	
170	(1975)–1976	Shorchev P. A., Schorcheva, L. K.	'M. V. Lomonosov'. Hotel Universitetskaya, vestibule. Michurinsky prospekt, 8/29	Depicted	106H
171	1976	Vasiltsov, V. K., Zharenova, E. A.	'Moebius Strip'. Central Economics and Mathematical Institute (TsEMI) of the Russian Academy of Sciences. Nakhimovsky prospekt, 47	Depicted	100A
172	1976	Derviz, G. G.	Hotel Moskva (now Four Seasons Hotel Moscow). Okhotny ryad ulitsa, 2	Dismantled	
173	1976	Ivanov, V. V.	Trekhgornaya Manifaktura. Rodichelskaya ulitsa, 15/1	Depicted	051E
174	1976	Korolev, Y. K.	'The Flame of the Struggle', '1905'. Ulitsa 1905 Goda metro station, vestibule, underground hall	Depicted	115A
175*	1976	Potikyan, M. L.	'Sun', 'Run'. Palace of Sport of Moskvich Leninsky Komsomol Automobile Factory (Moskvich Sports School for Olympic Reserve), swimming pool, training pool. Volgogradsky prospekt, 46/15, bldg. 7	Depicted	103A
176*	1976 (1983)	Unknown artist	Moscow State Institute of International Relations (MGIMO), conference hall. Prospekt Vernadskogo, 76	Depicted	105A
177*	(1976)–1977	Vladimirova, O. N., Zelenetsky, I. L.	'The Charms of Music'. Lyre Children's Music School (now S.T. Richter Children's Arts School), concert hall. Kashirskoe shosse, 42/3	Depicted	108A
178	1976–1978	Unknown artist	Moscow Institute of Radio Technology, Electronics, and Automation (MIREA; architect: V. Opryshko), main block. Prospekt Vernadskogo, 78/1	Depicted	094A
179	1977	Aksenov, K. N.	'V. I. Lenin'	Not found	
180	1977	Alekseev, M. N.	House of Pioneers, Sovetsky District, Chertanovskaya metro station	Not found	
181*	1977	Bobyl, Y. P., Litvinova, L. V.	'Festivity'. Palace of Culture of the '50th Anniversary of the USSR' Automatic Lines Factory (now R-studios Film-Production Complex), foyer. Podemnaya ulitsa, 9	Depicted	109A

* object to which there is limited access.

No.	Year	Author	Object	Status	Number in book
182	1977	Dzhabarova, G. T.	SU-173 building	*Not found*	
183	1977	Nesterov, G. V	Palace of Culture of Moscow Aviation Institute (DK MAI; now MAI Palace of Culture and Technology). Dubosekovskaya ulitsa, 4A/1	*Depicted*	**111A**
184	1977	Ter-Grigoryan, S. L.	Memorial stele in memory of F. E. Dzerzhinsky, architect: Andreev, V. S. Public garden beside house 112. Prospekt Mira	*Depicted*	**035A**
185	1977	Shteyman, A. G.	'The History of Medicine'. Central Clinical Hospital of the Fourth Main Department of the Ministry of Health of the USSR (Central Clinical Hospital and polyclinic), vestibule. Marshala Timoshenko ulitsa, 15	*Not found*	
186	1977	Elkonin, V. B.	'Garden: Seasons of the Year'. Ministry of Agriculture of the USSR (Ministry of Agriculture of the Russian Federation), foyer of conference hall. Sadovaya-Spasskaya ulitsa, 11/1	*Dismantled*	
187	1977	Elkonin, V. B., Andronov, N. I.	'Flags of October'. House of Artists on Kuznetsky Bridge, façade	*Not found*	
188	(1967)–1978	Egorshina, N. A., Andronov, N. I.	'Nordic Forest'. Café Pechora, interior	*Dismantled*	
189	(1977)–1978	Students of the MARKHI	(commissioned by the Vodopribor Factory) Children's playground at the house 18, Novovoalekseyevskaya ulitsa	*Not depicted*	
190	(1977)–1978	Tyulenev, L. V.	KIM Kuntsevsky Platinum-Needle Factory, canteen. Dorogobuzhskaya ulitsa, 14	*Not checked*	
191	1978	Vasiltsov, V. K., Zharenova, E. A.	'The USSR Constitution of 1977'. Executive Committee of the Council of People's Representatives and the Communist Party Committee of Sovetsky District (now Town Hall, Chertanovo District), main vestibule	*Dismantled*	
192	1978	Zamkov, V. K.	'Portrait of Simon Bolivar'. Institute of Latin America at the Russian Academy of Sciences. Ordynka ulitsa, 21/16	*Not checked*	
193	1978	Korolev, Y. K.	'Emblems of Russian Cities', 'Epic Stories', 'Song'. Sviblovo metro station, underground hall	*Depicted*	**116A**
194	1978	Unknown artist	'Labour' Sports Training Centre. Varshavskoe shosse, 14/1	*Not depicted*	
195	1978	Osin, O. I., together with Mironov, K. V.	'Rhythms'. All-Union Research Institute of Intersectoral Information (Kompas Centre of Scientific Technology for the Defence Complex), main entrance. Volokamskoe shosse, 77	*Inaccessible*	
196	1978	Reykhtsaum, E. E.	'Yakov Sverdlov'. Central Museum of the Revolution of the USSR (State Central Museum of the Contemporary History of Russia). Tverskaya ulitsa, 21	*Inaccessible*	
197	1978	Smirnov, A. V.	'Near Space'. Café Luna	*Not found*	
198*	1978	Unknown artist	Design and experimental office of A.N. Tupolev. Naberezhnaya Akademika Tupoleva, 17	*Depicted*	**113A**

* object to which there is limited access.

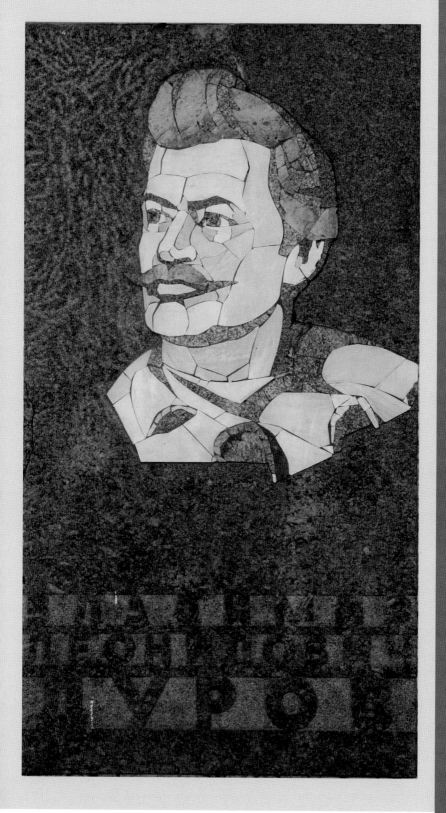

V. A. Titov, Y. P. Tsyganov. Memorial plaque to V. L. Durov on the museum house
'Grandpa Durov's Nook', 1965. **67**

Unknown artist. Panel inside Humanitarian College of Information and Library Technologies No. 58, 1961 (?). 48

No.	Year	Author	Object	Status	Number in book
199	1978	*Unknown artist*	Kindergarten No. 81 at the Vodopribor Factory. (School No. 1503, preschool building). Novoalekseevskaya ulitsa, 18, bld. 5	*Not depicted*	
200	(1973)–1979	*Polishchuk, L. G., Shcherbinina, S. I.*	'Human Healing'. Library of the 2nd Medical Institute (N. I. Pirogov Russian National Research Medical University). Ostrovityanova ulitsa, 1/5	*Depicted*	090A
201*	(1974)–1979	*Andronov, N. I., Vasnetsov, A. V.*	'The History of Printing' ('Man and Printing'). Izvestia building, foyer of the conference hall. Tverskaya ulitsa, 18/1	*Depicted*	117C
202	(1976)–1979	*Kulakov, V. A.*	'The Culture of Old Rus'. Hotel Rossiya, interior	*Dismantled*	

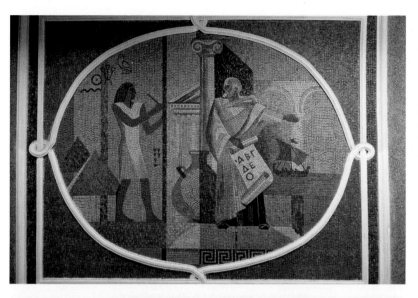

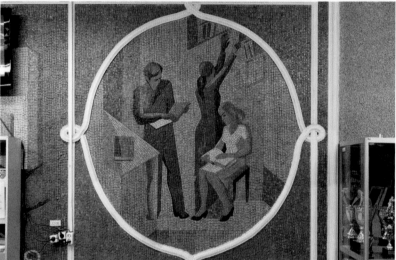

203	(1978)–1979	Derviz, G. G.	'South', 'City'. Polyclinic of the Moscow Factory of Polymetals, interior	Not found	
204	1979	Berezhnoy, I. G.	'Children's Book'. Sushchevsky val ulitsa, 49	Depicted	079A
205	1979	Verkman, L. Y.	'Recreation'. Canteen No. 17 of Sokolnichesky District, interior	Not found	
206	1979	Zakharov, G. A., Shaposhnikova, E. S.	Restaurant Nairi, interior	Not found	
207	1979	Melnikov, D. E.	Institute of Oncology (now N. N. Blokhin National Medical Research Oncological Centre), façade of the conference hall. Kashirskoe shosse, 24/3	Depicted	092A
208	1979	Neklyudov, B. P.	'Pictures'. Canteen at the Institute of Further Training of at the Ministry of Semi-manufactured Articles	Not found	
209*	1979	Talberg, B. A.	'Hospitality'. Cultural centre at the Olympic Village (Philharmonia 2, S. V. Rakhmaninov Concert Hall), foyer. Michurinsky prospekt, Olympiyskaya derevnya, 1	Depicted	088A

* object to which there is limited access.

No.	Year	Author	Object	Status	Number in book
210	1979	*Teblyashkin, G. N.*	'South'. Restaurant Pitsunda, interior	*Not found*	
211	Early 1970s	*Unknown artist*	Moscow Wool-Making Factory (now Oktyabr Business Centre). Petra Alekseeva ulitsa, 12	*Depicted (building #22 dismantled)*	139A
212	1970s	*Vdovin, V. I.*	Molambumiz Moscow Laminated Paper and Polymer Products Factory (now Lambumiz). Ryabinovaya ulitsa, 51a/1	*Not checked*	
213	1970s	*Unknown artist*	All-Russian Voluntary Fire Society. Gilyarovskogo ulitsa, 29	*Depicted*	046C
214	1970s	*Unknown artist*	Professor A. A. Ostroumov City Clinical Hospital No. 33 (State Clinical Hospital named after the Bakhrushin Brothers). Stromynka ulitsa, 7	*Not depicted*	
215	1970s	*Unknown artist*	D. I. Mendeleev Moscow Institute of Chemical Technology (D. I. Mendeleev University of Chemical Technology of Russia). 1st Miusskaya ulitsa, 3	*Not depicted*	
216	1970s	*Unknown artist*	Sokolniki Park. Pesochnaya alleya	*Depicted*	
217	1970s	*Unknown artist*	Perovsky ZAGS. Perovskaya ulitsa, 43	*Not depicted*	
218	1970s	*Unknown artist*	Professional and Technical School No. 19 (now Services College No. 10), 3rd teaching block. Dmitrovskoe shosse, 79/3	*Depicted*	129A
219	1970s	*Unknown artist*	Taxi park No. 5 (car service 'EuroAutoUniversal'). Goncharnaya naberezhnaya, 9/16/1	*Not depicted*	
220	1970s	*Unknown artist*	Utrish Delphinarium (Palace of Watersports of Moskomsport Moscow Olympic Centre for Watersports). Mironovskaya ulitsa, 27	*Depicted*	128A
221	1970s (?)	*Unknown artist*	Reinforced-Concrete Structures Factory (KZhBK-2). Ryazansky prospekt, 26	*Depicted*	
222*	1970s (?)	*Unknown artist*	Moscow Factory of Animal Glue and Mineral Fertilisers (now Kontakt business centre). Ostapovsky proezd, 5	*Depicted*	140A
223	(1970(?))–1980s	*Unknown artist*	Moscow Technology Lyceum (now Mosenergo College) Kirovogradskaya ulitsa, 11/1	*Depicted*	099A
224	1970s (?)	*Unknown artist*	Institute for Research into Remote Radio Communications (NII DAR). 1st ulitsa Bukhostova, 12/11, bldg. 53	*Depicted*	112A
225	(1976)–1980	*Shorchev, P. A., Shorcheva, L. K.*	'Oriental Motifs'. Hotel Vostok, block 3, vestibule	*Not found*	
226	(1978)–1980	*Bobyl, Y. P.*	'Still Life'. Institute of Vocational Training for Executive Workers and Specialists at the Ministry of Intermediate Products of the RSFSR (now International Industrial Academy). 1st Shchipkovsky pereulok, 20	*Depicted*	110I

* object to which there is limited access.

**Unknown artist. Wall in the grounds
of Reinforced-Concrete Structures Factory 2, 1970s (?). 221**

T. D. Anisimova. School No. 1213, 1963–1964. 61

No.	Year	Author	Object	Status	Number in book
227	(1978)–1980	*Bortsov, P. A.*	Krylatskoe rowing canal. Krylatskaya ulitsa, 2	*Dismantled*	
228	1978–1980	*Unknown artist*	Dinamo-Centre Sports Complex. Petrovka ulitsa, 26/9	*Dismantled*	
229	(1979)–1980	*Alekseev, M. N., Novikova, L. A.*	Marksistskaya metro station, underground hall	*Depicted*	**120G**
230*	1980	*Ablin, E. M.*	Diving tower. Olympiysky Sports Complex. Swimming pool, diving pool. Olimpiysky prospekt, 16/1	*Depicted* *Dismantled*	**058C**
231	1980	*Ablin, E. M.*	Sovintsentr (World Trade Centre), congress centre, atrium. Krasnopresnenskaya naberezhnaya, 12	*Depicted*	**057E**
232	1980	*Broydo, I. M.*	Hotel Salyut, restaurant. Leninsky prospekt, 158	*Dismantled*	
233	1980	*Vasiltsov, V. K., Zharenova, E. A.*	Hotel Izmaylovo, Beta building. Izmaylovskoe shosse, 71B	*Not found*	
234	1980	*Zamkov, V. K.*	'Emblem of the RSFSR'. Building of the Council of Ministers of the Supreme Council of the RSFSR, interior	*Not found*	
235*	1980	*Zamkov, V. K.*	'Culture, Art, Theatre'. The Cultural Centre at the Olympic Village (now Philharmonia 2, S. V. Rakhmaninov Concert Hall), foyer. Michurinsky prospekt, Olimpiyskaya derevnya, 1	*Depicted*	**087A**
236	1980	*Zamkov, V. K.*	Central Museum of the Revolution of the USSR (now State Central Museum of the Contemporary History of Russia). Tverskaya ulitsa, 21	*Depicted*	

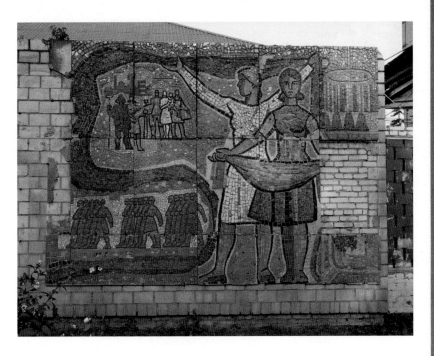

Unknown artist. Kosinskaya Knitwear Factory. 311

237	1980	*Kayarzants, E. G., Kayarzants, I. E.*	Olympic Village, Café Michurninsky prospekt, Olympiyskaya derevnya, 1	*Not found*	
238	1980	*Kulakov, V. A., together with Kulakova, G.*	'Still Lifes'. Hotel Izmaylovo, Vega building, banqueting halls. Izmaylovske shosse, 71B	*Not found*	
239	1980	*Oreshin, V. M.*	'GOELRO'. Power Station 21. Izhorskaya ulitsa, 9	*Inaccessible*	
240*	1980	*Potikyan, M. L. (?)*	'Aviation and its Development'. Moscow Aviation Institute. Volokolamskoe shosse, 4/7	*Depicted*	**093A**
241	1980	*Teroshin, S. I.*	Café Kamenny tsvetok, interior	*Not found*	
242	1980	*Filatchev, O. P.*	'V. I. Lenin'. Museum of Moscow N. E. Bauman Higher College of Technology (now Moscow State University of Technology). 2nd Baumanskaya ulitsa, 5/1	*Inaccessible*	
243	1980	*Fuks, V. I.*	'Youth of the World'. Hotel Molodezhnaya (now Park Tower Hotel), vestibule. Dmitrovskoe shosse, 27	*Depicted*	
244	1980	*Shorchev, P. A., Shorcheva, L. K.*	Hotel Izmaylovo, Alpha block, restaurant, stage in the Green Hall. Izmaylovskoe shosse, 71a	*Depicted*	**107A**
245	1980	*Unknown artist pictograms by Belkov, N. S.)*	'Types of Sport'. Prospekt Mira, pedestrian underpass	*Depicted*	
246	1980	*Unknown artist*	Dinamo-Centre Sports Complex. Petrovka ulitsa, 26/9	*Not depicted*	

* object to which there is limited access.

No.	Year	Author	Object	Status	Number in book
247	1980	*Unknown artist*	Sports pavilion at the stadium of Moscow Electric-Lamp Factory (MELZ). Gorodok imeni Baumana ulitsa, 1/38	*Depicted*	**085A**
248*	(1977)–1981	*Kapustin, V. V.*	Krylya Sovetov Palace of Sport. Tolbukhina ulitsa, 10/4, bldg. 1	*Depicted*	**104A**
249	(1980)–1981	*Ivanov, S. I., together with Morkovin, V.*	'Flora and Fauna'. Administrative block of a factory making synthetic washing products, canteen	*Not found*	
250	1981	*Kornoukhov, A. D.*	Vega Association, foyer	*Dismantled*	
251	1981	*Mironova, N. F.*	'Energy'. All-Union Institute for Research into Electric Power. Kashirskoe shosse, 22/3	*Depicted*	**098A**
252*	1981	*Talberg, B. A., artists executors: Andreev, V. V., Zakharov, V. M., Korin, B. A., Sekretarev, I. V.*	'Architectural Landscapes'. Sovintsentr (World Trade Centre), staircase No. 6. Krasnopresnenskaya naberezhnaya, 12	*Depicted*	**089E**
253	1982	*Aleksandrov, K. K.*	Construction Technical School No. 30 (now Stolitsa Educational Complex). Kharkovsky proezd, 5A	*Depicted*	**101A**
254	1982	*Makarevich, I. G.*	Block 14, Marble Hall. Moscow Kremlin	*Dismantled*	
255	1982	*Petrov, A. I.*	Sports complex at Krasny Oktyabr Factory	*Not found*	
256	1982	*Romanova, E. B.*	'Women and Fashion'. Zhenskaya moda ('Women's Fashion', shop). Izmaylovskoe shosse, 6	*Depicted*	**137A**
257	1982	*Yakubasov, I. I.*	Meatpacking factory, tasting room, interior	*Not found*	
258	(1981)–1983	*Kulakov, V. A.*	Hotel Oktyabrskaya (now President Hotel), winter garden. Bolshaya Yakimanka ulitsa, 24	*Not depicted*	
259	(1982)–1983	*Potikyan, M. L.*	Kristall Factory	*Not found*	
260	1983	*Alekseev, M. N., Novikova, L. A.*	Chertanovskaya metro station, vestibule	*Depicted*	**123A**
261	1983	*Vasiltsov, V. K., Zharenova, E. A.*	'Historical Moscow'. Nagatinskaya metro station, underground hall	*Depicted*	**119A**
262	1983	*Neklyudov, B. P., Kuznetsov, V., Bikeykin, V.*	'Seasons of the Year'. Yuzhnaya metro station, underground hall	*Depicted*	**127A**

* object to which there is limited access.

Unknown artist. Sokolniki Park. Pesochnaya alleya, 1970s. 216

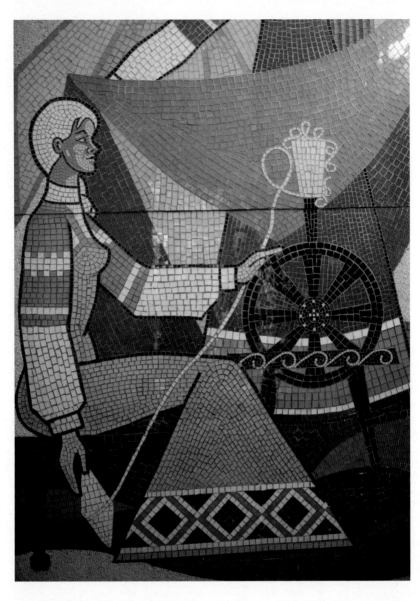

Unknown artist. Foyer of Moscow Wool-Making Factory
(now Oktyabr Business Centre), early 1970s. 211

No.	Year	Author	Object	Status	Number in book
263	1983	Ikonnikov, O. A.	'Sevastopol, Hero City'. Sevastopolskaya metro station, underground hall	*Depicted*	**126A**
264	1983	Mosiychuk, A. M.	'Russian Naval Commanders and the History of the Russian Navy'.Nakhimovsky Prospekt metro station, underground hall	*Depicted*	**125A**
265	1983	Tarakanova, N. N.	Frezer ('Milling Machine') Moscow M. I. Kalinin Factory of Cutting Instruments, wall in the canteen. 1st Frezernaya ulitsa, 2/1, block 2	*Depicted*	**138A**

266	1983–1985	Dubtsov, M. M.	'German Settlement, 16th Century.' Apartment building, butt. Bauman ulitsa, 35/1/9	Not depicted	
267	(1982)–1984	Pavlovsky, S. A., Grigorieva, N. G	'M. Y. Lermontov', 'A Solitary Sail Gleams White', 'Untitled'. M. Y. Lermontov Library No. 76, interior, façade. Barbolina ulitsa, 6	Depicted	134A
268	1984	Blagonadezhin, A. F.	Restaurant Sozvezdie	Not found	
269	1984	Kuznetsov, A. N.	'V. I. Lenin: Founder and Leader of the Party and the State'. Lenino metro station (now Tsaritsyno), underground hall	Depicted	121A
270	(1982)–1985	Vasnetsov, A. V., together with Kokhanov, A., Larchenko	'Notable Dates in the History of our Country', 'Medals of the Soviet Union'. Administrative building of the Ministry of Defence of the USSR, interior	Not found	
271	(1984)–1985	Zamkov, V. K.	'Guarding Peace', 'Order of the Soviet Union'. Ministry of the Defence of the USSR	Not found	
272	(1984)–1985	Shepletto, Y. I.	Residential building in Domodedovo	Not found	
273	1985	Barteneva, N. S.	Orthopaedic Footwear Factory	Not found	
274	1985	Vasiltsov, V. K.	'Decorative Composition'. Vozdvizhenka ulitsa, pedestrian underpass	Not depicted	
275	1985	Neklyudov, B. P.	Statirikon Arkady Raykin State Theatre. Sheremetievskaya ulitsa, 8	Not checked	
276	1985	Reykhtsaum, E. E.	'Yuri Gagarin'. Museum of Astronautics	Not found	
277	1986	Grigorieva, N. G.	Hotel Pekin, 13th storey. Bolshaya Sadovaya ulitsa, 5	Dismantled	
278	1986	Dubtsov, M. M.	Komfort (shop). Dukhovskoy pereulok, 16	Depicted	133I
279	1986	Unknown artist	Residential building, external wall of the entrance. Zadonsky proezd, 30 bld. 1	Not depicted	
280	(1986)–1987	Zamkov, V. K.	Moscow Palace of Youth, architects: Belopolsky, Y. B., Belenya, M. E., Posokhin, M. M., Khavin, V. I., interior. Komsomolsky prospekt, 28	Not checked	
281	1987	Kunegin, V. V.	Swimming pool of Vodopribor Factory (now S.S.S.R. Fitness Club). Novoalekseevskaya ulitsa, 25	Depicted	091A
282	1987	Silaev, N. L.	'V. I. Lenin'. Institute for Research into Transport	Not found	
283	(1986)–1988	Korolev, Y. K.	Moscow Palace of Youth, architects: Belopolsky, Y. B., Belenya, M. E., Posokhin, M. M., Khavin, V. I. Komsomolsky prospekt, 28	Depicted	086H

No.	Year	Author	Object	Status	Number in book
284*	1988	*Unknown artist*	Fili Palace of Watersports. Bolshaya Filevskaya ulitsa, 18	*Depicted*	
285	(1988)–1989	*Andronov, N. I., Andronova, M. N., Shishkov, Y. A., Rodin, Y. L., Rodin, V. L.*	'The History of Railway Transport'. Savelovskaya metro station, underground hall	*Depicted*	118A
286	1989	*Dronov, A. I.*	Experimental Factory of the Research Institute for Automation and Instrument Manufacture (now N. A. Pilyugin Research Institute for Automation and Instrument Manufacture). Vvedenskogo ulitsa, 1	*Inaccessible*	
287	1989	*Zamkov, M. V.*	Izmaylovsky val, 20	*Depicted*	131A
288	1989	*Kazakov, B. I.*	Tushino Children's City Hospital (now Z. A. Bashlyaeva Children's Clinical Hospital), main entrance to the main block. Geroev Panfilovtsev ulitsa, 28	*Depicted*	136A
289	1989	*Shishkov, Y. A.*	Soyuzpechat Central Retail and Subscription Agency (now Rospechat Business Centre), vestibule. Marshala Zhukova prospekt, 4	*Not checked*	
290	Late 1980s	*Alalov, A. M., Bogachev, N. V., Ryleev, A. M.*	Moscow Order of Lenin and Order of the Red Labour Standard Institute of Railway Transport Engineers of the Ministry of Communications of the USSR (now Institute of Roads, Construction, and Structures of the Russian University of Transport, MIIT). Minaevsky pereulok, 2	*Depicted*	132A
291	1980s	*Unknown artist*	Medical emblem. Novopeschanaya ulitsa, 8/2	*Depicted*	011A
292	1980s	*Unknown artist*	Serp i molot Palace of Culture Zolotorozhsky Val ulitsa, 11. (Moved to Café Progress). (1) Presnensky Val, 38; (2) Volokolamskoe shosse, 1 (3) Sadovaya-Triumfalnaya ulitsa, 4/10	*Depicted (1); (2)*	
293	1980s	*Unknown artist*	Serp i molot Metallurgical Plant. Zolotorozhsky Val ulitsa, 11. Transferred to the Bébé de la mer restaurant. Pertovka ulitsa, 30/7		
294	1980s (?)	*Unknown artist*	Bar Progress. Transferred from the weaving mill in Kolomna. Gilyarovskogo ulitsa, 68/1	*Not depicted*	
295	1980s (?)	*Unknown artist*	'nuw.store' shop. Design factory 'Flacon', transferred from the workers canteen of the factory in Aleksandrov. Bolshaya Novodmitrovskaya ulitsa 36/1, entrance 2	*Not depicted*	
296	1987/1989–1991	*Shorchev, P. A., Shorcheva, L. K.*	Panels based on motifs taken from the works of Anton Chekhov. Chekhovskaya metro station, underground hall	*Depicted*	122C

Unknown artist. 'Communications USSR'. International Post Office Moskva-2. **315**

297	(1988)–1990	*Potikyan, M. L.*	Energiya Scientific and Production Association, laboratory block	*Not found*	
298	1990	*Vasiltsova, A. V., Korzheva, A. G.*	A. S. Pushkin State Institute of the Russian Language. Akademika Volgina ulitsa, 6	*Depicted*	**102A**
299	1990	*Neklyudov, B. P.*	Directorate of the Moscow Metrostroy. Tsvetnoy boulevard, 17	*Not checked*	
300	1990	*Yakubasov, I. I.*	Dzerzhinsky Telephone Exchange, interior of the assembly hall	*Not found*	
301	(1990)–1991	*Zamkov, V. K.*	'War, Victory, Peace'. K. E. Voroshilov Military Academy of the Order of Lenin and Red Army Academy of the Order of Suvorov of the General Staff of the Armed Forces of the USSR (now Military Academy of the General Staff of the Armed Forces of the Russian Federation). Prospekt Vernadskogo, 100	*Inaccessible*	
302	1991	*Derviz, G. G.*	Prophylactic Centre at the Polymetals Factory, swimming pool	*Not found*	
303	1991	*Zaryanov, N. A., Shishkova, M. Y.*	'Metro'. Professional and technological college, vestibule	*Not found*	
304	1991	*Shorchev, P. A., Shorcheva, L. K.*	'Nature and Man'. Timiryazevskaya metro station, underground hall	*Depicted*	**124A**

* object to which there is limited access.

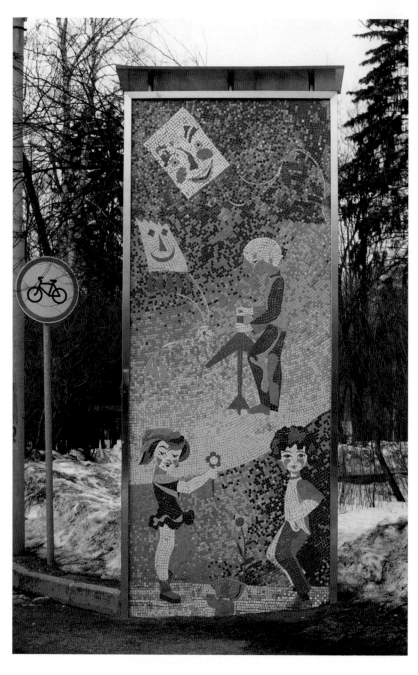

Unknown artist. Sokolniki Park. Pesochnaya alleya, 1970s. 216

No.	Year	Author	Object	Status	Number in book
305	1994	*Vasiltsov, V. K., Zharenova, E. A.*	'The History of Large Fires in Moscow'. Principal Directorate of the Fire Service for the City of Moscow (now Principal Directorate of the Russian Ministry for Extraordinary Situations for the City of Moscow). Prechistenka ulitsa, 22/2	*Depicted*	**045F**
306	Early 1990s	*Prostoserdov, N. M.*	Central House of Hunters and Fishers. Golovinskoe shosse, 1	*Depicted*	**130A**

No.	Year	Author	Object	Status	Number in book
307	Date unknown	*Unknown artist*	Car Pool No. 3, stele in the courtyard. 4th Kabelnaya ulitsa, 2	*Not checked*	
308	Date unknown	*Unknown artist*	Beskudnikovsky Construction Materials Factory (now OAO BKSM). Standartnaya ulitsa, 6	*Inaccessible*	
309	Date unknown	*Unknown artist*	S. I. Mamontov Children's School, vestibule. Yaroslavskoe shosse, 65	*Dismantled*	
310	Date unknown	*Bagdasarov, Bogdanov, Shamov, Yudin*	Institute of Haematology and Blood Transfusions (now National Medical Centre for Research into Haematology). Novy Zykovsky proezd, 4	*Not depicted*	
311	Date unknown	*Unknown artist*	Kosinskaya Knitwear Factory, factory gate. Bolshaya Kosinskaya ulitsa, 27	*Depicted*	
312	Date unknown	*Unknown artist*	Red Barracks. Krasnokazarmennaya ulitsa, 4/10/10	*Not checked*	
313	Date unknown	*Unknown artist*	Multi-speciality clinic. Donskaya ulitsa, 28	*Depicted*	
314	Date unknown	*Unknown artist*	Research Institute for Space Instrument Manufacture (now OOO Sinertek). Starokirochny pereulok, 2	*Inaccessible*	
315	Date unknown	*Unknown artist*	'Communications USSR'. International Post Office Moskva-2. Nizhnyaya Krasnoselskaya ulitsa, 5, bldg. 10	*Depicted*	
316	Date unknown	*Unknown artist*	'Communications USSR'. International Post Office Moskva-2. Stromynka ulitsa, 20a	*Not Depicted*	
317	Date unknown	*Unknown artist*	Directorate for Home Affairs for the North-West Administrative District. Marshala Rybalko ulitsa, 4/1	*Inaccessible*	
318	Date unknown	*Unknown artist*	Kotovsky Dry-Cleaning and Clothes-Dyeing Factory No. 1	*Dismantled*	
319	Date unknown	*Unknown artist*	School No. 1257, pre-school department. 3rd Roshchinskaya ulitsa, 2	*Dismantled*	
320	1972•	*Ermolaev, G. I.*	A memorial plaque. Medical Sechenov Pre-University. 1st Borodinskaya ulitsa, 2	*Not depicted*	
321	1973•	*Unknown artist*	Salon «Gemstones» (Museum «Samotsvety»). Narodnogo Opolcheniya ulitsa, 29, bldg. 1	*Not depicted*	
322	1970s•	*Unknown artist*	School No. 779 (No. 1205), end wall. Vavilova ulitsa, 91	*Not depicted*	

• These mosaics were identified by the authors just before the publication of this guide, and have therefore been placed in the index list without taking chronological order into account.

Index of names

This index includes only the names of artists, designers, sculptors, and architects whose works are included in the main part of this book (pages 1–373).

Index of names

This index includes only the names of artists, designers, sculptors, and architects whose works are included in the main part of this book (pages 1–373).

Bibliography

Anikina, N. I., *Illyuzii I realnost. Tvorchestvo moskovskikh monumentalistov 70-90-x godov glazami zainteresovannogo nablyudatelya* (Ekaterinburg: 2005)

Bazazyants, S. B., *Khudozhnik, prostranstvo, sreda: Monumentalnoe iskusstvo i ego rol v formirovanii dukhovno-materialnogo okruzheniya cheloveka. Khudozhnik i gorod* (Moscow: 1983)

Bordichenko, V. F. *1989–1982: Monumentalnoe iskusstvo, zhivopis, grafika: Katalog* (Moscow: 1987)

Bronovitskaya, A., Malinin, N., Kazakova, O., *Moskva: arkhitektura sovetskogo modernizma, 1955-1991: spravochnik-putevoditel* (Moscow: 2016)

Bychkov, Y. A, Desyatnikov, V. A., 'Soviet Monumental Art', *Novoe v zhizni, nauke, tekhnike. Iskusstvo* (Moscow: 1979), no. 12

Chernyshev, B. P., *1906–1969: Zhivopis. Grafika. Monumentalnoe iskusstvo. Skulptura* (Moscow: 2007)

Chervonnaya, S. M., 'Soviet Monumental Art', *Besedy ob iskusstve; Vypusk 8* (Moscow: 1962)

Desyatnikov V. A., *Khudozhniki Podmoskovya* (Moscow: 1977)

Gershkovich, E., *Moskovskoe metro: arkhitekturny gid* (Moscow: 2018)

Kafedra Monumentalno-dekorativnoy zhivopisi SPGKhPA im. A.L. Shtiglitsa. Kniga-spravochnik (St Petersburg: 2010)

Khudozhnik i gorod. Sb. St/Sost. M. L. Terekhovich (Moscow: 1988)

Kostina, O. V., *Boris Talberg: Monumentalnoe iskusstvo. Zhivopis. Grafika* (Moscow: 1982)

Lebedeva V., *Sovetskoe monumentalnoe iskusstvo shestidesyatykh godov* (Moscow: 1973)

Maleschka, M., *DDR. Baubezogene Kunst. Kunst im öffentlichen Raum 1950 bis 1990* (Berlin: DOM publishers, 2018)

Milyukov, B. P., *Zhivopis. Grafika: Katalog* (Moscow: 1991)

Monumentalnoe iskusstvo SSSR. Avt.-sost. V. P. Tolstoy (Moscow: 1978)

Moskovskie monumentalisty: Albom/Avt.-sost. M. L. Terekhovich (Moscow: 1985)

Na strazhe mira: zhivopis, skulptura, grafika, satira, plakat, monumentalno-dekorativnoe iskusstvo, teatralno-dekoratsionnoe iskusstvo: vsesoyuznaya khudozhestvennaya vystavka: k 20-letiyu pobedy sovetskogo naroda v Velikoy Otechestvennoy voyne (Moscow: 1965)

Nikiforov, Ye. et al., *Decommunized: Ukrainian Soviet Mosaics* (Berlin: DOM publishers: 2017)

Palavandishvili, N., Prents, L., *Art for Architecture Georgia: Soviet Modernist Mosaics from 1960 to 1990 (Architectural Guide)* (Berlin: DOM publishers, 2019)

Pavlovsky, S. A., *Zhivopis. Grafika. Monumentalnoe-dekorativnoe iskusstvo: Katalog vystavki* (Moscow: 1986)

Pekarovsky, M. P., *Monumentalno-dekorativnoe iskusstvo v arkhitekture obshchestvennykh zdaniy* (Moscow: 1968)

Reykhtsaum, E. E., *Zhivopis, grafika, monumentalnoe iskusstvo: Katalog vystavki* (Moscow: 1990)

Sarabyanov, D. V., *Nikolay Andronov: Zhivopis. Monumentalnoe iskusstvo* (Moscow: 1982)

Shchedrina, G. K., *Sovetskoe monumentalnoe iskusstvo (Problemy internatsionalnogo i natsionalnogo)* (Leningrad: 1981)

Sovetskoe monumentalnoe iskusstvo '73 (Moscow: 1975)

Sovetskoe monumentalnoe iskusstvo '74 (Moscow: 1976)

Sovetskoe monumentalnoe iskusstvo '75-77 (Moscow: 1979)

Sovetskoe monumentalnoe iskusstvo no. 4 (Moscow: 1982)

Sovetskoe monumentalnoe iskusstvo no. 5 (Moscow: 1984)

Spravochnik chlenov Moskovskogo otdeleniya VTOO 'Soyuz khudozhnikov Rossi'i (MOSKh Rossii) (Moscow: 2003)

Stepanov, G. P., *Kompozitsionnye problemy sinteza iskusstv* (Moscow: 1984)

Tolstoy, V. P., *Monumentalnoe iskusstvo SSSR* (Moscow: 1978)

U istokov sovetskogo monumentalnogo iskusstva, 1917–1923/V. P. Tolstoy (Moscow: 1983)

Valerius, S. S., *Monumentalnoe zhivopis. Sovremennye problemy* (Moscow: 1979)

Voeykova, I. N., *Khudozhniki-monumentalisty* (Moscow: 1969)

Volova, L. S., *Oleg Osin: monumentalnoe iskusstvi, zhivopis, grafika: Katalog vystavki* (Moscow: 1985)

Voronov, N. V, 'Monumental Art Yesterday and Tomorrow', *Novoe v zhizni, nauke, tekhnike. Iskusstvo* (Moscow: 1988), no. 6

Vsesoyuznaya selskokhozyaystvennaya vystavka. Putevoditel. Pod red. Akad. N. V. Tsitsina (Moscow: 1954)

Vsesoyuznaya selskokhozyaystvennaya vystavka. Putevoditel. Pod red. Akad. N. V. Tsitsina (Moscow: 1955)

Zernova, E. S., *Vospominaniya monumentalista* (Moscow: 1985)

Zinoviev, A. N., *Ansambl VSKhV: arkhitektura i stroitelstvo* (Moscow: 2014)

Moscow

0 5 km

420

A

NORTHERN
OKRUG

M-11

E-105

NORTH-
WESTERN
OKRUG

WESTERN
OKRUG

M-9

A-106

WESTERN
OKRUG

E-30

E-101

Moscow
Vnukovo
International
Airport

NOVOMOSKOVSKY
OKRUG

A-130

NORTHERN
OKRUG

NORTH-EASTERN
OKRUG

E-115

Losiny Ostrov
National Park

EASTERN
OKRUG

EASTERN
OKRUG

A-103

M-7

B **C** **D**

E **F** **G**

H **I**

SOUTH-
EASTERN
OKRUG

Moskva

SOUTH-
WESTERN
OKRUG

SOUTHERN
OKRUG

M-2

M-

Moscow; inside the Moscow Automobile Ring Road (MKAD)

0 5 km

E-115

135

RTH-EASTERN OKRUG

095

116

Losiny Ostrov National Park

014 015 016 017

018 019 054

EASTERN OKRUG

EASTERN OKRUG

096

076 A-103

035 091

112 128 082

134 131

107

079

048 053

085

132

059

137

044 M-7

113

080

066

109 138

049

140

103

052

061

SOUTH-EASTERN OKRUG

8

Moskva

SOUTH-EASTERN OKRUG

119

098 042

E-30

125

092

126

108

123

099

SOUTHERN OKRUG

27

121

101

M-4

M-2

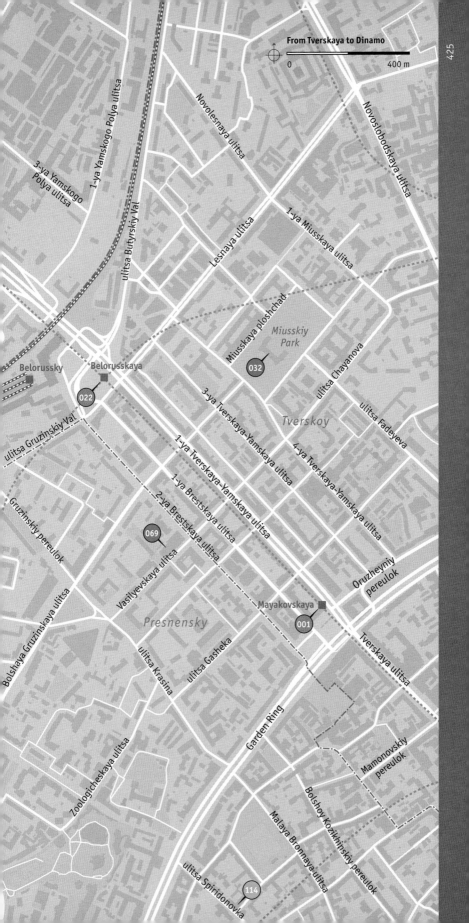

From Tverskaya to Dinamo

0 400 m

3-ya Yamskogo Polya ulitsa

1-ya Yamskogo Polya ulitsa

Novolesnaya ulitsa

Novoslobodskaya ulitsa

ulitsa Butyrskiy Val

Lesnaya ulitsa

1-ya Miusskaya ulitsa

Miusskaya ploschad

Miusskiy Park

032

ulitsa Chayanova

Belorussky

Belorusskaya

022

ulitsa Gruzinskiy Val

3-ya Tverskaya-Yamskaya ulitsa

Tverskoy

ulitsa Fadeyeva

Gruzinskiy pereulok

1-ya Tverskaya-Yamskaya ulitsa

4-ya Tverskaya-Yamskaya ulitsa

1-ya Brestskaya ulitsa

2-ya Brestskaya ulitsa

069

Vasilyevskaya ulitsa

Bolshaya Gruzinskaya ulitsa

Oruzheyniy pereulok

Mayakovskaya

001

Presnensky

Tverskaya ulitsa

ulitsa Krasina

ulitsa Gasheka

Garden Ring

Mamonovskiy pereulok

Zoologicheskaya ulitsa

Bolshoy Kozikhinskiy pereulok

Malaya Bronnaya ulitsa

ulitsa Spiridonovka

114

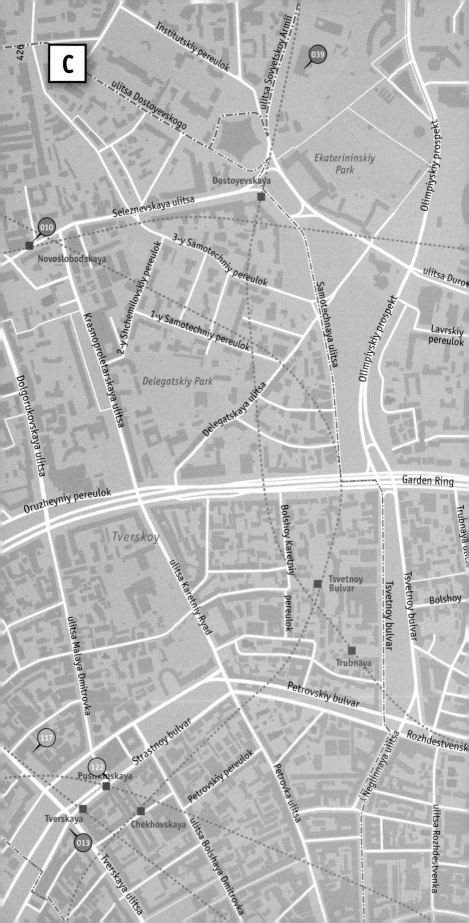

0 400 m

Davydovskiy pereulok

Bolshaya Pereyaslavskaya ulitsa

Meshchansky

058

ulitsa Shchepkina

Prospekt Mira

Protopopovskiy pereulok

Astrakhanskiy pereulok

Kalanchevskaya ulitsa

072

046

ulitsa Gilyarovskogo

prospekt Mira

Grokholskiy pereulok

1-y Koptelskiy pereulok

Bolshaya Spasskaya ulitsa

Dokuchayev pereulok

ulitsa Shchepkina

Sukharevskaya

Sukharevskiy pereulok

Posledniy pereulok

Krasnoselsky

Ulanskiy pereulok

prospekt Akademika Sakharova

Garden Ring

Orlikov pereulok

075

Bolshoy Sergiyevskiy pereulok

ulitsa Sretenka

Kostyanskiy pereulok

Myasnitskaya ulitsa

Pechatnikov pereulok

bulvar

Sretenskiy bulvar

Turgenevskaya

Sretensky Bulvar

Chistye Prudy

Basmanny

Milyutinskiy pereulok

Bolshoy Kharitonevskiy pereulok

Chistoprudniy bulvar

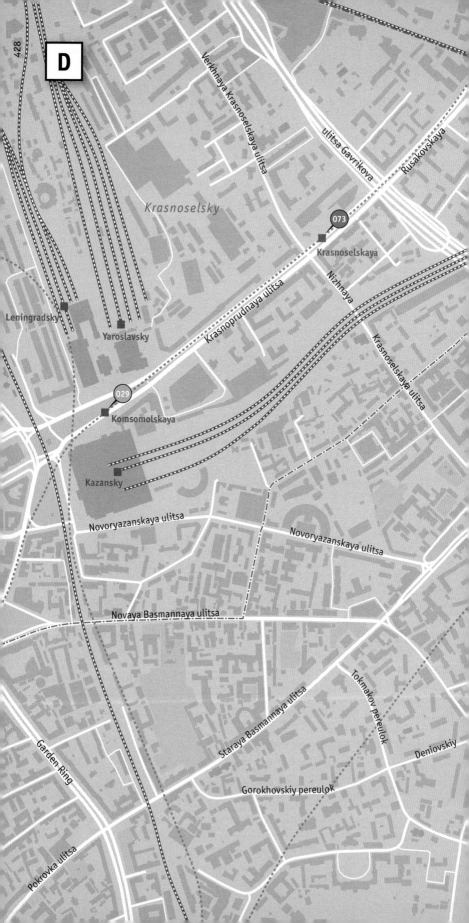

From Komsomolskaya to Baumanskaya

0 400 m

ulitsa Gastello

Sokolniki

ulitsa Zhebrunova

ulitsa Gastello

EASTERN OKRUG

CENTRAL OKRUG

ulitsa

Novaya Perevedenovskaya ulitsa

Balakirevskiy pereulok

Perevedenovskiy pereulok

Bakuninskaya ulitsa

ulitsa Fridrikha Engelsa

ulitsa Bolshaya Pochtovaya

Bakuninskaya ulitsa

Rubtsov pereulok

006

007

Baumanskaya

Rubtsovskaya naberezhnaya

Jauza

Poslannikov pereulok

Malaya Pochtovaya ulitsa

Starokirochniy pereulok

Gospitalnaya ulitsa

pereulok

Baumanskaya ulitsa

2-ya Baumanskaya ulitsa

Lefortovskaya naberezhnaya

074

Lefortovskiy Park

Lefortovskiy Tonnel

Basmanny

Radio ulitsa

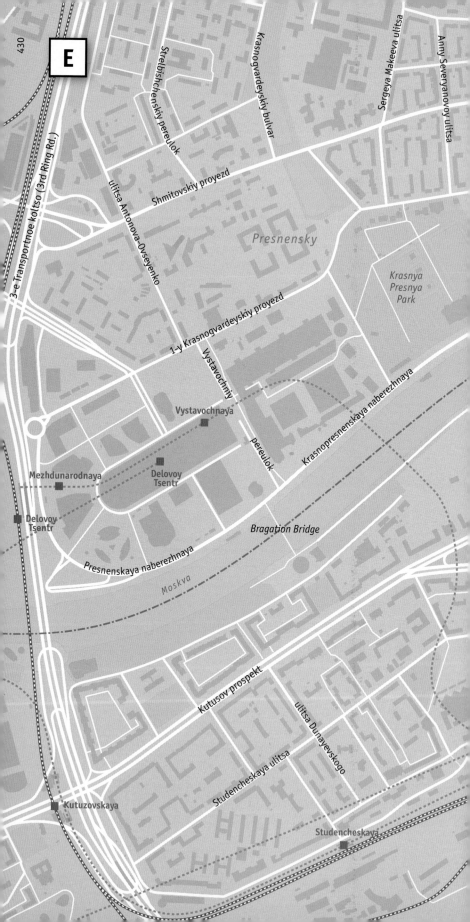

E

3–e Transportnoe koltso (3rd Ring Rd.)

Strelbishchenskiy pereulok

Krasnogvardeyskiy bulvar

Sergeya Makeeva ulitsa

Anny Severyanovoy ulitsa

ulitsa Antonova-Ovseyenko

Shmitovskiy proyezd

Presnensky

Krasnya Presnya Park

1-y Krasnogvardeyskiy proyezd

Vystavochniy

Krasnopresnenskaya naberezhnaya

Vystavochnaya

Mezhdunarodnaya

Delovoy Tsentr

Delovoy Tsentr

pereulok

Bragation Bridge

Presnenskaya naberezhnaya

Moskva

Kutusov prospekt

ulitsa Dunayevskogo

Studencheskaya ulitsa

Kutuzovskaya

Studencheskaya

Kievskaya and Krasnaya Presnya

Krasnopresnenskaya

Bolshoy Predtechenskiy pereulok

Novovagankovskily pereulok

ulitsa Zamoronova

0 400 m

043

Rochdelskaya ulitsa

051

1905 goda ulitsa

089

057

Nikolayeva ulitsa

Glubokiy pereulok

Krasnopresnenskaya naberezhnaya

Konyushkovskaya ulitsa

CENTRAL OKRUG

WESTERN OKRUG

056

ul. Noviy Arbat

naberezhnaya Tarasa Shevchenko

Ukrainskiy bulvar

Novoarbatskiy
Bridge

Rostovskaya naberezhnaya

Kutusov prospekt

Dorogomilovo

Arabat

1-ya Borodinskaya ulitsa

Bolshaya Dorogomilovskaya ulitsa

ulitsa Mozhayskiy Val

Borodinskiy Bridge

030 023

Bryanskaya ulitsa

Kievskaya

Moskva

Berezhkovskaya naberezhnaya

Rostovskaya naberezhnaya

7-y Rostovskiy pereulok

Kiyevsky

ulitsa Plyushchikha

Khamovniki

Savvinskaya naberezhnaya

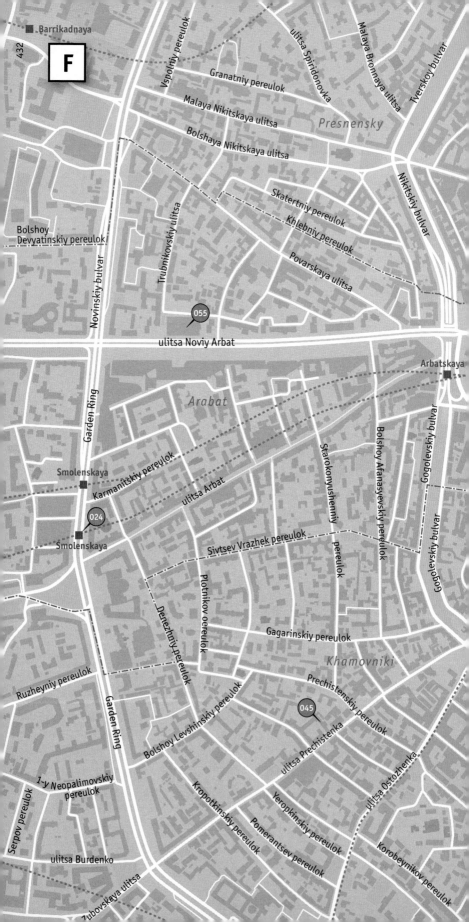

F

Barrikadnaya

Vspolniy pereulok

Granatniy pereulok

ulitsa Spiridonovka

Malaya Bronnaya ulitsa

Tverskoy bulvar

Malaya Nikitskaya ulitsa

Presnensky

Bolshaya Nikitskaya ulitsa

Skatertniy pereulok

Nikitskiy bulvar

Bolshoy
Devyatinskiy pereuloki

Trubnikovskiy ulitsa

Khlebniy pereulok

Povarskaya ulitsa

Novinskiy bulvar

055

ulitsa Noviy Arbat

Arbatskaya

Arabat

Garden Ring

Bolshoy Afanasyevskiy pereulok

Gogolevskiy bulvar

Smolenskaya

Karmanitskiy pereulok

ulitsa Arbat

Starokonyushenniy pereulok

Gogolevskiy bulvar

024

Smolenskaya

Sivtsev Vrazhek pereulok

Plotnikov pereulok

Denezhniy pereulok

Gagarinskiy pereulok

Khamovniki

Ruzheyniy pereulok

Prechistenskiy pereulok

Garden Ring

045

Bolshoy Levshinskiy pereulok

ulitsa Prechistenka

1-y Neopalimovskiy
pereulok

ulitsa Ostozhenka

Serpov pereulok

Kropotkinskiy pereulok

Yeropkinskiy pereulok

Pomerantsev pereulok

Korobeynikov pereulok

ulitsa Burdenko

Zubovskaya ulitsa

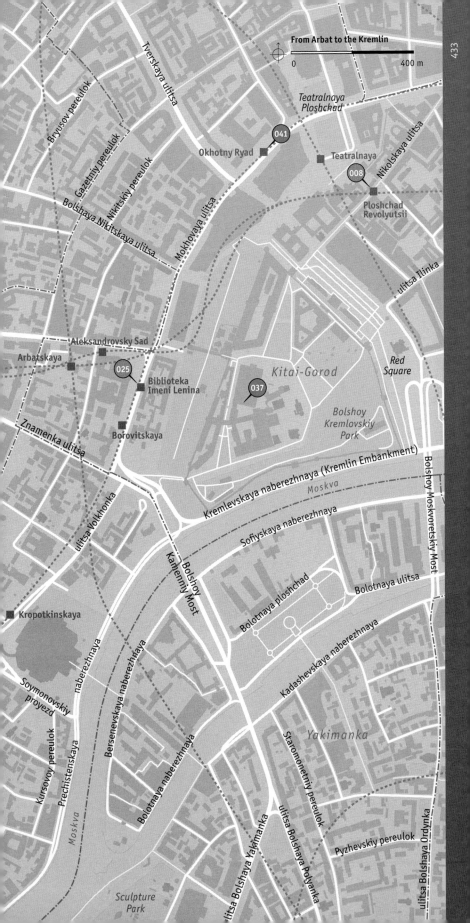

From Arbat to the Kremlin

0 400 m

Teatralnaya
Ploshchad

041

Okhotny Ryad

Teatralnaya

008

Nikolskaya ulitsa

Ploshchad
Revolyutsii

Tverskaya ulitsa

Bryusov pereulok

Gazetniy pereulok

Nikitskiy pereulok

Bolshaya Nikitskaya ulitsa

Mokhovaya ulitsa

ulitsa Ilinka

Aleksandrovsky Sad

Arbatskaya

025

Biblioteka
Imeni Lenina

Kitai-Gorod

Red
Square

037

Bolshoy
Kremlovskiy
Park

Znamenka ulitsa

Borovitskaya

Kremlevskaya naberezhnaya (Kremlin Embankment)

ulitsa Volkhonka

Moskva

Bolshoy Moskvoretskiy Most

Sofiyskaya naberezhnaya

Bolshoy Kamenniy Most

Bolotnaya ulitsa

Kropotkinskaya

Bolotnaya ploshchad

Kadashevskaya naberezhnaya

naberezhnaya

Bersenevskaya naberezhnaya

Bolotnaya naberezhnaya

Staromonetniy pereulok

Yakimanka

Soymonovskiy
proyezd

Prechistenskaya

Kursovoy pereulok

Moskva

ulitsa Bolshaya Yakimanka

ulitsa Bolshaya Polyanka

Pyzhevskiy pereulok

ulitsa Bolshaya Ordynka

Sculpture
Park

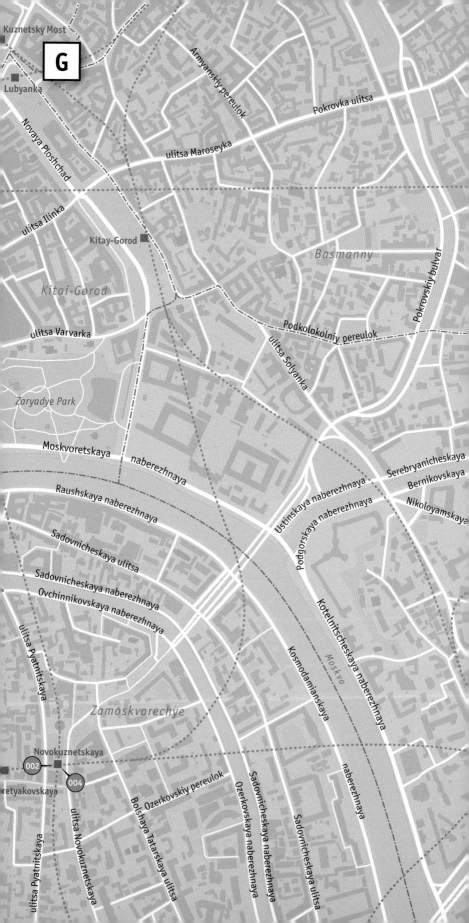

Taganskaya and Zamoskvorechye

0 400 m

Basmanny

Kurskaya

Kursky

Podsosenskiy pereulok

Chkalovskaya

Garden Ring

Nastavnicheskiy pereulok

Kostomarovskiy pereulok

naberezhnaya Akademika Tupoleva

Zolotorozhskaya naberezhnaya

Kostomarovskaya naberezhnaya

Nikoloyamskaya naberezhnaya

Andronevskaya naberezhnaya

naberezhnaya

naberezhnaya

ulitsa

Nikoloyamskaya ulitsa

Bolshoy Drovyanoy pereulok

Tagansky

ulitsa Alexandra Solzhenitsyna

Tovarishcheskiy pereulok

Bolshaya Andronyevskaya ulitsa

ganskaya

120

Marksistskaya

ulitsa Bolshiye Kamenshchiki

Vorontsovskaya ulitsa

Markistskaya ulitsa

Taganskaya ulitsa

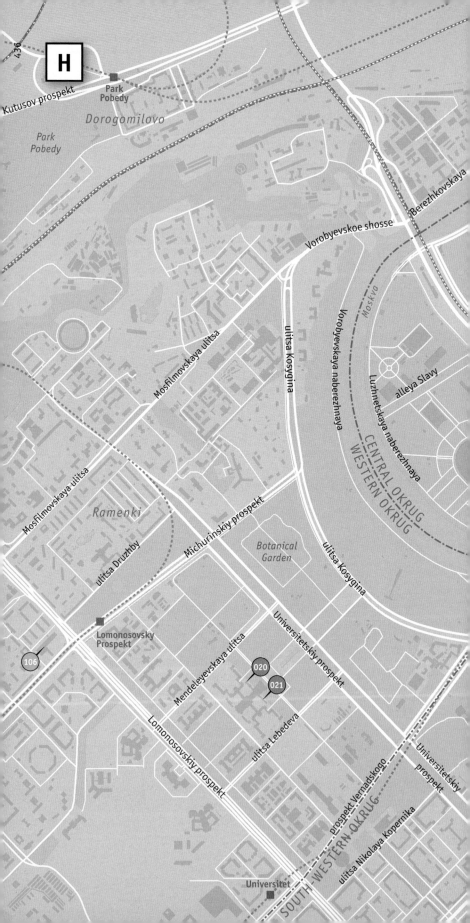

Vorobievy Gory and Khamovniki

0 400 m

Park Kultury
070

naberezhnaya

Bolshaya Pirogovskaya ulitsa

Mataya Pirogovskaya ulitsa

Nesvizhskiy pereulok

Khamovniki

Frunzenskaya
086

Komsomolskiy prospekt

Frunzenskaya naberezhnaya

Moskva

031

Sportivnaya

Luzhniki

3-e Transportnoe koltso (3rd Ring Rd.)

Komsomolskiy prospekt

Luzhniki Olympic Complex

Neskuchniy Sad

Leninskiy prospekt

Vorobyovy Gory

ulitsa Kosygina

Leninsky Prospekt

Ploshchad Gagarina

033

Gagarinsky

Leninsky prospekt

prospekt 60 let Oktyabrya

SOUTHERN OKRUG

ulitsa Vavilova

Akademichesky

ulitsa Shvernika

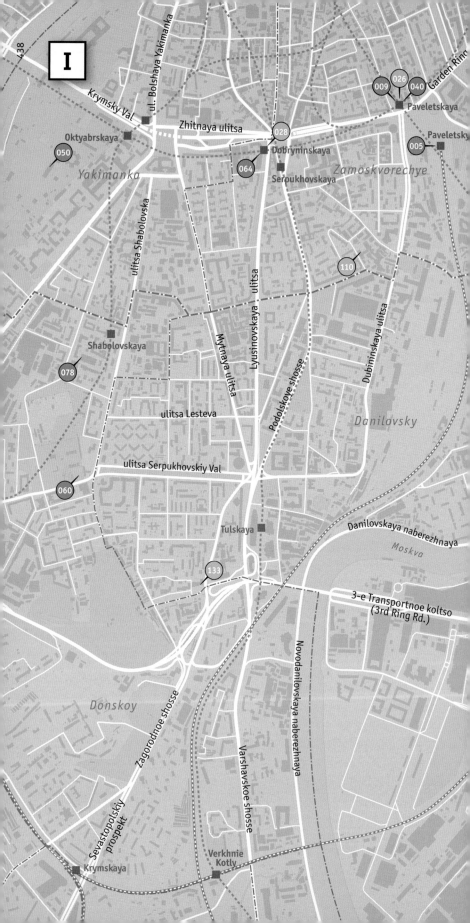

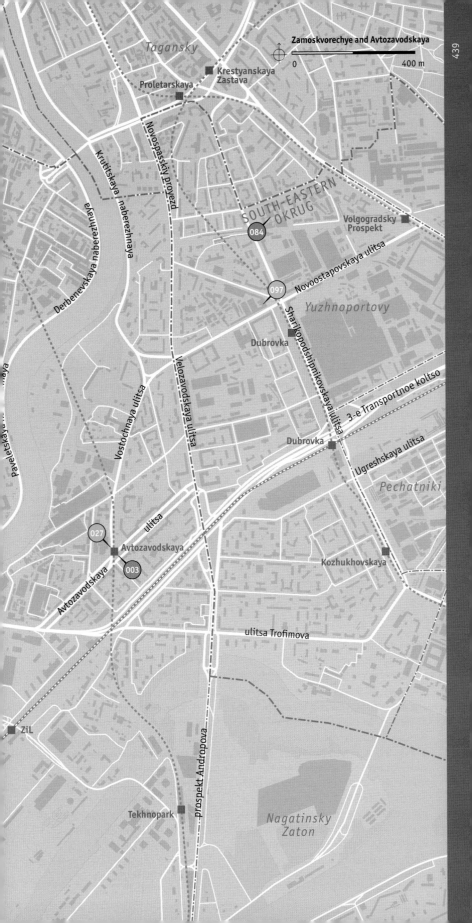

Zamoskvorechye and Avtozavodskaya

0 400 m

Tagansky

Krestyanskaya
Zastava

Proletarskaya

Novospasskiy proyezd

Krutitskaya naberezhnaya

Derbenevskaya naberezhnaya

SOUTH-EASTERN
OKRUG

084

Volgogradsky
Prospekt

097

Novoostapovskaya ulitsa

Yuzhnoportovy

Sharikopodshipnikovskaya ulitsa

Dubrovka

Velozavodskaya ulitsa

Vostochnaya ulitsa

Paveletskaya naberezhnaya

3-e Transportnoe koltso

Dubrovka

Ugreshskaya ulitsa

Pechatniki

027

ulitsa

Avtozavodskaya

003

Avtozavodskaya

Kozhukhovskaya

Avtozavodskaya

ulitsa Trofimova

ZiL

prospekt Andropova

Tekhnopark

*Nagatinsky
Zaton*

About the authors

Anna Bronovitskaya

Anna Bronovitskaya is a candidate in art history and research director at the Institute of Modernism. She is a teacher at Moscow Architecture School and taught at Moscow Architecture Institute from 1992–2016. She edited the journals *Project Russia* and *Project International* from 2004–2014. She teaches twentieth-century architecture at the Garage Museum of Contemporary Art. Her writing includes: *Arkhitektura Moskvy, 1920–1960* ('Architecture of Moscow, 1920–1960'; 2006), *Moskva: arkhitektura sovetskogo modernizma. 1955–1991. Spravochnik-putevoditel* ('Moscow: The Architecture of Soviet Modernism. 1955–1991. Reference book'; 2016).

James Hill

James Hill is a British photographer and photojournalist. He is a graduate of Oxford University and London College of Printing. He worked in Russia from 1991, including for the *New York Times* from 1995 onwards. From 1998 he lived in Rome, from where he travelled to photograph wars launched by the USA in Afghanistan (2002) and Iraq (2003). Among the many awards he has received are the World Press Photo, the Pulitzer Prize, and the Visa d'Or at Visa Pour l'Image in Perpignan. His books of photographs include *The Castle* (2019), *Somewhere Between War and Peace* (2014), *Victory Day* (2013), and *In Russias* (2009).

Evgeniya Kudelina

Evgeniya Kudelina is an art manager, archivist, and graduate of the Faculty of Philology at Moscow State University. She was assistant curator for exhibitions of French and Russian photographers in Moscow (Malleray Art Consulting) from 2004–2007 and worked for the editorial department of Multimedia Art Museum from 2005–2010. She coordinates exhibition, curatorial, theatre, and publishing projects for artist Oleg Kulik, including: 'I believe' (2007); 'Vespers for the Virgin Mary' (Théâtre du Châtelet, Paris, 2009); 'Oleg Kulik. The Mad Dog or Last Taboo Guarded by Cerberus Alone' (2012).

Anna Petrova

Anna Petrova is a culturologist, art critic, editor, graduate of Moscow State University, and candidate in philology. She has worked for Moscow House of Photography, the Shchusev Museum of Architecture, and the publisher Kulikovo Pole, and has curated the photography and contemporary-art exhibitions 'Long-distance shot. Photographers of Vladivostok' (2019) and 'Simple Equality = Internal Modernism' (2016). Her works include: *Russky kostyum v fotografiyakh XX–XIX vv.* ('Russian Costume in Photographs of the 19th-20th Centuries'; 2010), *Moskovskoe metro. Arkhitekturny gid* ('The Moscow Metro. An Architectural Guide'; 2018).

Acknowledgments

The compilers thank the following for help in identifying and attributing mosaic works:

Dmitry Ablin, Konstantin Konstantinovich Alexandrov, Mikhail Nikolaevich Alekseev, Maria Nikolaevna Andronova, Natalia Ivanovna Anikina, Galina Nikolaevna Bogacheva, Nikolai Vasilyevich Bogachev, Ekaterina Vasilyevna Bubnova, Anastasia Vasiltsova, Ivan Velizhev, Mirrel Alexandrovna Velizheva, Marianna Vasilyevna Evstratova, Mikhail Matveevich Dubtsov, Eleonora Alexandrovna Zharenova, Nikolai Zakharychev, Igor Lvovich Zelenetsky, Alexander Zinoviev, Olga Kazakova, Yuri Sergeevich Kvasnikov, Alexander Davydovich Kornoukhov, Maria Vladilenovna Krasilnikova, Larisa Nikolayevna Kuznetsova, Tatyana Andreyevna Kuznetsova, Tatyana Larina, Ekaterina Milyukova, Varvara Moskvitina, Marat Nasibullov, Ekaterina Neklyudova, Ivan Neklyudov, Maria Ovchinnikova, Vladimir Parshukov, Leonid Grigoryevich Polishchuk, Polina Poludkina, Denis Romodin, Eva Rukhina, Maria Silina, Lyudmila Mikhailovna Ter-Grigoryan, Sergey Leonovich Ter-Grigoryan, Natalia Borisovna Talberg, Marina Leonidovna Terekhovich, Vadim Titov, Vasily Tyulenev, Natalia Elkonina

The compilers thank the following for help with taking photographs:

ADG group
Antiq Store
Aquamarine Circus of Dancing Fountains
Alfa Izmaylovo hotel complex
The Analytical Centre at the Government of the Russian Federation
Restaurant Armenia
Z.A. Bashlyaeva Children's Clinical Hospital
Central House of Film-Makers
Department of Sport of the City of Moscow
Humanitarian College of Information and Library Technologies No. 58
Fili Palace of Watersports
Elektrozavod Gallery
The Institute of Africa at the Russian Academy of Sciences
Kontakt Business Centre
KR Properties
Krylya Sovetov Palace of Sports
M.Y. Lermontov Library No. 76
Moscow Aviation Institute
Moscow Engineering Physics Institute
Main Moscow Directorate of the Russian Ministry of Extraordinary Situations
The Moscow Metropolitan
Moscow State Philharmonic Society
Moscow State Bauman University of Technology
Moscow State Institute of International Relations
Moscow State University
Moscow Union of Artists
Mosenergo Public Joint-Stock Company
Moskvich Sports School of the Olympic Reserve
Museum of the Contemporary History of Russia
Oktyabr Business Centre
AO Olimp
Olympiysky Sports Complex
Park Tower Hotel
S.T. Rikhter Children's School of Art
ZAO Ritual-Servis
R-studios film studios complex
Ryazansky Branch of ZAGS
Sapfir Research Enterprise
School No. 1213
P.P. Shirshov Institute of Oceanology at the Russian Academy of Sciences
S.S.S.R Fitness Club
Stas Namin Music and Drama Theatre
State Kremlin Palace
Stolitsa Educational Urban-Planning Complex
Tashir Group
Tupolev Public Joint-Stock Company
Hotel Universitetskaya
AO Vystavka Dostizheniy Narodnogo Khozyaystva
World Trade Centre

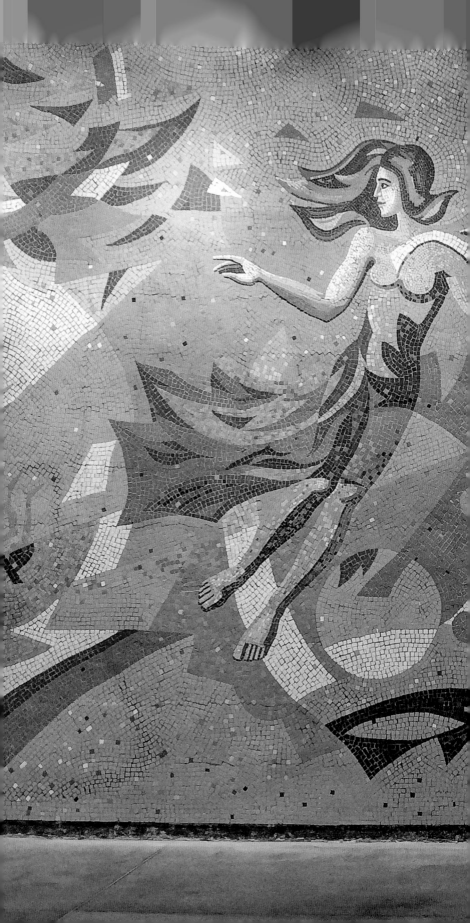

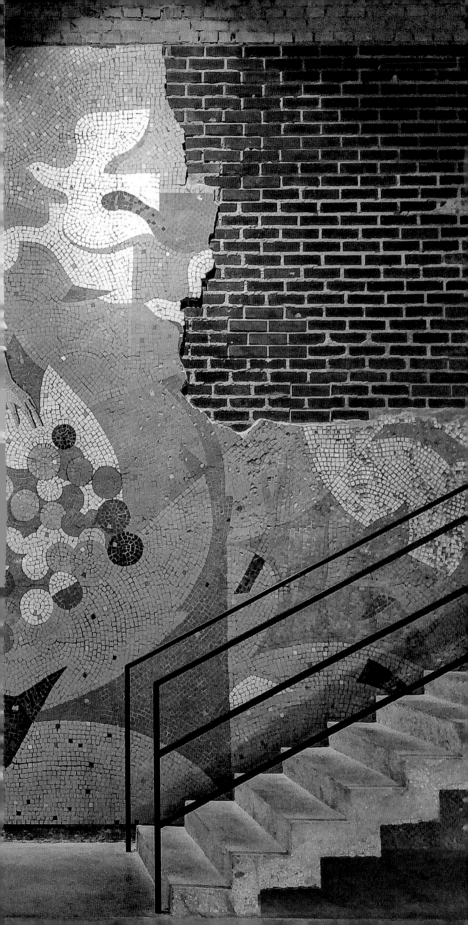

The *Deutsche Nationalbibliothek* lists this publication in the *Deutsche Nationalbibliografie*; detailed bibliographic data are available on the Internet on *http://dnb.d-nb.de*

ISBN 978-3-86922-068-0 (English edition)
ISBN 978-3-86922-079-6 (Russian edition)

© 2022 by DOM publishers, Berlin
www.dom-publishers.com
www.dom-publishers.ru (Russia)

Idea and photographs
James Hill

Object search, attribution, compilation
Evgeniya Kudelina

Compilation, general editing
Anna Petrova

Introduction and scientific editing
Anna Bronovitskaya

Translation
John Nicolson

Editor of the Russian edition
Karina Diemer

Design
Igor Son

Proofreader
Sandie Kestell

Indexing
Martina Filippi

Maps
Katrin Soschinski

Printing
OOO «IPK Pareto-Print», Tver
www.pareto-print.ru